City Creatures

CITY CREATURES

Animal Encounters in the Chicago Wilderness

EDITED BY GAVIN VAN HORN
AND DAVE AFTANDILIAN

Assistant Editor for Art: Lisa Roberts
Assistant Editor for Poetry: James Ballowe

CENTER
FOR
HUMANS
& NATURE

The University of Chicago Press *Chicago and London*

GAVIN VAN HORN is the director of Cultures of Conservation for the Center for Humans and Nature, a nonprofit organization that focuses on and promotes conservation ethics. He writes for, edits, and curates the *City Creatures* blog at www.humansandnature.org/blog.

DAVE AFTANDILIAN is associate professor of anthropology at Texas Christian University. He is the editor of *What Are the Animals to Us?: Approaches from Science, Religion, Folklore, Literature, and Art.*

PUBLISHED IN COLLABORATION WITH
THE CENTER FOR HUMANS AND NATURE

The University of Chicago Press, Chicago 60637
The University of Chicago Press, Ltd., London
© 2015 by The University of Chicago
All rights reserved. Published 2015.
Printed in China

24 23 22 21 20 19 18 17 16 15 1 2 3 4 5

ISBN-13: 978-0-226-19289-5 (cloth)
ISBN-13: 978-0-226-28929-8 (e-book)
DOI: 10.7208/chicago/9780226289298.001.0001

Library of Congress Cataloging-in-Publication Data

Van Horn, Gavin, author, editor.
City creatures: animal encounters in the Chicago wilderness /
edited by Gavin Van Horn and Dave Aftandilian; assistant editor for art Lisa Roberts;
assistant editor for poetry James Ballowe.
pages: illustrations; cm
Essays, poems, and artwork about the wildlife that inhabits the city of Chicago.
Includes index.
ISBN 978-0-226-19289-5 (cloth: alk. paper) — ISBN 978-0-226-28929-8 (e-book)
1. Urban animals—Illinois—Chicago. 2. Human-animal relationships—Illinois—Chicago.
3. Animals and civilization—Illinois—Chicago. I. Aftandilian, David, author, editor. II. Title.
QH541.5.C6V36 2015
591.75′60977311—dc23 2015001523

♾ This paper meets the requirements of ANSI/NISO Z39.48-1992
(Permanence of Paper).

Contents

2. Neighborhood Associations

3. Animals on Display

4. Connecting Threads

Acknowledgments

Gavin Van Horn bows in gratitude to his favorite city creatures on the planet, Marcy and Hawkins, and offers respectful nods of appreciation to the Others who have opened his heart and mind to different ways of knowing the city: Peregrine Falcon, Coyote, Great Blue Heron, and sweet Iona, the oddball Labrador Retriever.

Dave Aftandilian would like to thank Sarah F. Rose, for sharing my love of animals both wild and domestic; Emily Aftandilian, for nurturing that love since childhood; and all of the many animals who have deepened my experience of nature, self, and spirit, including Aviva the cat, several neighborhood mobs of crows, the swallows and waterbirds of the Trinity River, and my grandmother Marcella Harman's robin redbreasts.

Together, Gavin and Dave would like to thank the Center for Humans and Nature (CHN), and in particular its president Brooke Hecht and founder Strachan Donnelley, for their logistical, financial, and moral support of the City Creatures project, including the CHN Fellowship award that facilitated Dave's participation. We would also like to express our sincere appreciation to Chicago Wilderness and the many organizations and individuals involved with the coalition for all they have done to document and conserve biodiversity in the greater Chicago region.

Special thanks are due to everyone at the University of Chicago Press who helped shepherd *City Creatures* from manuscript to book, including Christie Henry, Editorial Director for the Sciences, who believed in this project from its inception and has enthusiastically supported it ever since; Erin DeWitt, Senior Manuscript Editor, for her close and sympathetic reading and editing; Matt Avery, for his lovely book design; Joan Davies, for keeping all of the many parts of this complex project moving smoothly in the right direction; and to Ellen Gibson, Marketing Manager, and Lauren Salas, Promotions Manager for Reference and Regional Books, for helping get the word about *City Creatures* out to the wider world.

We are also deeply grateful to all of the essayists, poets, and artists who have contributed to *City Creatures*, both in this volume and on our blog; to Lisa Roberts, Assistant Editor for Art, and James Ballowe, Assistant Editor for

Poetry, for their significant and much-appreciated editorial contributions; and to the many and diverse beings who have inspired the contents of this book, our fellow kin in the mystery of life, all the city creatures of the Chicago Wilderness and beyond. Finally, we offer a special remembrance to the four contributors who passed away during the preparation of this book: Brooks Blair Golden, David Hernandez, Ellen Lanyon, and Patricia Monaghan.

Permissions

These credits are listed in the order in which the relevant contributions appear in the book.

A shorter version of Terra Brockman's "Keeping Chickens" was published as "Chicken Keepers" in the May 29, 2014, issue of the *Christian Century*.

Tom Montgomery Fate's "Falling Apart" first appeared as a chapter in *Cabin Fever: A Suburban Father's Search for the Wild* (Beacon Press, 2011), 121–33, and is reprinted with the permission of Beacon Press.

Amy Newman's "Raccoon" first appeared in *Nat. Brut*, no. 2 (January 2013), and is reprinted by permission of the author.

Amy Newman's "The Fox" first appeared in *Kenyon Review* 31, no. 4 (Fall 2009): 166, and is reprinted by permission of the author.

Patricia Monaghan's "The Oracle of Wasps" first appeared in the *NILAS Newsletter* (Spring/Summer 2004): 9, and is reprinted by permission of the author's widower, Michael McDermott.

David Hernandez's "Pigeons" is reprinted by permission of the author's widow, Batya Hernandez.

James Ballowe's "A Museum of Change in Illinois" first appeared in the *Living Museum* 66, nos. 2–3 (Summer/Fall 2004): 3, and is reprinted courtesy of the author and the Illinois State Museum.

Photographs in Curt Meine's "Washed Up on the Shores of Lake Michigan" are provided courtesy of the collection of the Chicago Academy of Sciences and its Peggy Notebaert Nature Museum.

Todd Davis's "The Alewives" first appeared in his book *Some Heaven* (Michigan State University Press, 2007), and "The Fish in the Cage" first appeared in his book *The Least of These* (Michigan State University Press, 2010). Both are reprinted with the permission of Michigan State University Press.

The 1881 Army Corps of Engineers map of the Calumet region in John Rogner's "Calumet: Requiem or Rebirth?" is provided courtesy of the Southeast Chicago Historical Society.

Introducing City Creatures

DAVE AFTANDILIAN AND
GAVIN VAN HORN

They're here among us, in the city, right now. Flying overhead, tunneling underneath, swimming nearby, even walking right alongside us, yet most of us never see them. Aliens? Not quite. City creatures—the many, surprisingly varied wild and domestic animals with whom we share our apartments and alleys, backyards and gardens, forest preserves and parks.

Since this is a book about encounters with these often-forgotten animal others, we couldn't help but share some of our own stories here at the beginning. The first involves a ghostly messenger from the winged tribe. Although I'm just about the opposite of an early riser, I will never forget one chilly morning walk through the University of Chicago campus in Hyde Park (DA). Cutting through the quad behind Bond Chapel to visit some of my favorite trees, I suddenly heard a cacophony of crows in the canopy. Looking up, I learned why a group of crows is called a "mob": dozens of crows were yelling at the top of their lungs and dive-bombing a much larger, pale intruder. As I drew closer, I recognized the moon-heart face of a barn owl, one of the crows' greatest enemies. At night the owl would have the upper wing, but here in the daylight, far outnumbered and harried unceasingly, she or he seemed to decide that flight was the better part of valor. So off the owl went, swooping silently, with the crows in hot pursuit. I felt as if I had wandered onto a movie set in which humans had little or no part to play; a drama with a fully feathered cast and a well-worn but still powerfully moving script.

And then there was the mystery critter on Fifty-Fifth Street near the Toasters—Hyde Parker slang for the two towering condo buildings my wife and I passed on our way to the much-missed Hyde Park Co-op grocery store. Walking across Fifty-Fifth, we saw a small crowd of passersby gathered around a rather bedraggled-looking furry creature. Huddled near one of the trees planted into a hole cut through the sidewalk cement, it was too small to be a dog but was bigger than a cat. At first its identity eluded us—maybe a big rat? a beaver? But then, as it turned around, we saw its thick, black, rounded tail; glossy, pudgy body; and bewhiskered countenance: a muskrat! How it got there we hadn't a clue—it made sense that there might be muskrats along the Lake Michigan

shore or in one of the lagoons behind the Museum of Science and Industry, but either of those potential muskrat homes was more than a half mile of busy city streets away.

As we pondered the mystery, the group of strangers united in a common purpose: helping the muskrat get back to the lake it must have come from. We asked one of the people in the group, a homeless man with a shopping cart, if he might be willing to take the muskrat to its aquatic home. After a bit of persuasion and light bribery, he agreed, and we all watched him trundling off east toward the lake with his furry passenger. I learned two lessons that day: first, there are more wild animals living in Chicagoland than I had ever imagined, and, second, encounters with city creatures like these can bring people together in a way that little else can.

Our next story is about the first contact I (GVH) made with coyotes in Chicago, which happened while I was in my apartment. The coyotes didn't actually come into the apartment—they aren't that bold yet, although one was discovered a few years ago in the drink cooler of a downtown Quiznos sub shop. Late one night while I was reading, unmistakable squealing yelps, whines, and yip-howls wafted up to my third-floor window. I involuntarily put my book down . . . and smiled.

I had moved to Chicago not long before, and with those yips, the city suddenly became more *animated* for me—in the root sense of the word, *anima*: to possess breath, spirit, or soul. Any lingering apprehension about migrating to the third-largest metropolitan area in the United States faded. *If this city can be a home for coyotes*, I thought, *then it can be a home for me, too.*

I've seen coyotes several times since then. I repeatedly encounter one pair on twilight walks across a rough-around-the-edges city golf course that hugs a human-made tributary of the Chicago River. I first spotted this coyote pair through a drizzling rain and initially mistook them for deer in profile. But their movements and posture, as well as the diminishing distance between us, soon revealed that they were not deer. One of the two was more furtive than the other and made for the woods, quiet as an owl in flight. The remaining coyote inspected me for a minute or so, glancing between me and his mate, as if to say, *I think it's okay. C'mon.* He then dropped behind a small rise, poking his head up from different angles to determine what I was doing or going to do. I stood still. He decided to join his partner. Half an hour later I moved on, but an internal nudge caused me to look back over my shoulder one last time before I reached a neighborhood street. When I turned around, a single coyote was sitting on its haunches, facing my direction. He had circled back, behind the spot where I initially saw the pair. I was being watched.

The city is alive; it has *anima*. It moves and breathes; gives birth and dies; hunts, plays, and watches. The human presence may often seem to dominate, disregard, displace, and disrupt other kinds of animal life, but the *anima* of what we now call Chicago is not gone. Not by a long shot—in fact, there's reason to believe that this spirit is expanding. Coyotes are only one example of the creatures that are thriving in urban areas around the world.

Storying Animals, Reanimating Chicago

City Creatures aims to reanimate Chicago in our eyes: to help introduce readers to the unexpected diversity of finned, feathered, scaled, and furry animals who live alongside us in the city and suburbs. And in turn, we hope that learning about these animals will inspire readers to care about and for them.

Toward those ends, we adopt a story-based approach, both in words and images. For as long as we have been human, and quite possibly well before that, people have been telling stories about animals. While we can't hear the animal tales that were surely spun around the dancing hearth fires of our earliest ancestors, we can see cave paintings from 30,000 years ago—some of our first representational artworks—which focus almost exclusively on animals, in carefully observed and vividly depicted detail. These animal beings fired our imaginations and nurtured our spirits as we pondered ultimate questions about our place in the world; about what it means to be *human* animals, both like and unlike all the others.

But why stories? Partly because, as Jonathan Gottschall argues in his book *The Storytelling Animal*, "We are, as a species, addicted to story. Even when the body goes to sleep, the mind stays up all night, telling itself stories" (xiv). Because we seem hard-wired to love them, "stories can accomplish what no other form of communication can—they can get through to our hearts with a message," as conservationist Will Rogers puts it in his introduction to *The Story Handbook* (1). Moreover, we also remember information better if it is in story form. In other words, stories are a much better way to teach than, say, dry recitations of scientific data. This is why indigenous peoples around the world have always used stories to share their knowledge with children and adults alike.

Stories can also help us build relationships and a sense of shared community with other animals. For example, in an essay he wrote for the book *What Are the Animals to Us?*, Boria Sax coins the term "totemic literature" to describe "an approach . . . based primarily on understanding the changing bonds that people have with other forms of life that share our planet" (1). In this sense, stories about animals—totemic literature—can help focus our attention on the relationships we have with other animals. Furthermore, stories that foreground other animals as agents, as the essays, poetry, and artworks in *City Creatures* do—as subjects rather than objects, acting with consciousness and intention in the world—can help us relate to them on a more equal footing.

Telling stories about animals can also make them present to us and change the ways we perceive them. In the case of the often unseen and unthought-of animals with whom we share the city, stories can shift them from invisible and insubstantial to tangible and consequential. For example, the Koyukon of interior Alaska express both scientific and spiritual understandings of animals through stories of the Distant Time, the time before time, at the dawn of creation when humans and animals were one people. But these stories are also intimately tied to close observations of and interactions with living animals in the present. This means that for the Koyukon, as Tim Ingold has argued in his

book *Being Alive*, "every encounter with an animal is ... equivalent to hearing its story retold. Thus as people go about their business in the woods, they are continually connecting stories of other lives to their own. It is in these connections that the meanings of the stories are found, and from them people draw moral and practical guidance on how to carry on" (172). Coming back to our Chicago context, we suspect that you will not look at so-called "nuisance species" like squirrels or opossums, foxes or monk parakeets, crickets or deer, in quite the same way after reading the stories about them in *City Creatures*.

For all these reasons, then, the stories we tell about animals matter, both to our lives and to theirs. But storying animals is just the first step in reanimating Chicago. The next step is seeking out your own encounters with city creatures and sharing stories about those encounters with others. We explain why this step is so important in the next section.

Why City Creatures?

How do we come to know, and become present to, a *living* city? Some of the readers of this book may be scientists by profession, but many more are probably part-time naturalists, urban explorers, creative artisans, outdoor enthusiasts, green-space lovers—or *naturally* curious, at least. It is our hunch that such readers have an animal to thank for feeling connected to the city as a living place. Why? Nonhuman animals are arguably the most available and perhaps most compelling means of understanding larger ecological, geographic, and historical issues regarding the relationships between humans and urban nature.

Other readers might not be convinced: Aren't cities places full of "junk" species—pigeons, squirrels, starlings, rats, and unwanted creepy-crawly insects? The first image a person might call to mind when thinking of urban wildlife might be those animals that are feared as disease-carriers, or that wreak havoc in attics or dumpsters, or that are so ubiquitous, like sparrows, that they are virtually ignored. "True" wildlife may be considered something only found on a television screen, a video game, or in some deep jungle.

This book provides evidence to the contrary. An extraordinary range of animals and a variety of possibilities for encountering them exist throughout metropolitan areas. Moreover, this book offers a new set of lenses through which to view those species that are common but nevertheless have their own remarkable ways of being.

Animals also provide alternative ways to experience familiar places, revealing that the city is not simply a human social network but an ecological web of interactions. Other species can crack open our tendency to focus exclusively on human comings-and-goings; they help us to see urban worlds with new eyes, feel the city in a different way, know its textures and respond to the needs of our co-inhabitants more fully. The menagerie that this book presents speaks to the ways in which nonhuman animals can instill in us a renewed sense of care and concern for place.

Indeed, it is the variety of places in the Chicago region—from isolated pocket parks to thousands of contiguous acres, from sedge meadows to tallgrass prairies to oak-hickory woodlands—that attracts such a diversity of animal life, some of which is globally rare or locally endangered. Everyday, ordinary places we traverse—sometimes a bus ride away, sometimes right outside one's back door—create unique opportunities in urban areas for encounters with non-human others. In some ways, those everyday experiences may be the most important of all.

In *The Thunder Tree*, lepidopterist and writer Robert Michael Pyle puts it this way: "People who care conserve; people who don't know don't care. What is the extinction of the condor to a child who has never known a wren?" (147). To be sure, Chicago's muddy stream embankments, overgrown housing lots, and abandoned fields threaded with bike trails are not the "jewels" of any national park or wilderness area. They are, however, critical to nurturing our sense of connection to nature and the development of a caring perspective. Without those places, we can't directly experience and thereby relate to and with other creatures. One year a copper-colored butterfly gently bends a flower stalk; the next year it is gone, concrete substituted for milkweed.

One theme of this book is to anticipate and counteract what Pyle calls the "extinction of experience," the loss of contact with other animals due to the disappearance of *informal* natural habitats—the "wilds" of our backyards, our neighborhoods, and the interstitial spaces of urban exploration. These are the secret gardens of adaptable plants and animals, the fertile grounds of imagination for children who later become adults who care about conservation. City creatures draw our attention to the life that pulses through our everyday worlds. They can also help us rethink what our responsibilities to nature are by reframing our ideas about where nature is.

A Changing Conservation Paradigm

As the world rapidly urbanizes, some worry that we are losing a vital sense of what it means to be fully human. In the year 1800, only 3 percent of the human population lived in cities. Now 80 percent of us live in urban areas in the United States and 50 percent globally. It seems certain that cities will increasingly be the settings in which most humans experience nonhuman nature. Does this mean that more humanized environments portend a critical rupture in our ability to connect with the nonhuman?

Not necessarily. Retraining our vision of cities as places of inhabitation and encounters with nature is key to taking care of nature everywhere. In the late nineteenth century, as industrial production grew in the United States, city planners and social reformers advocated for parks, gardens, and other urban beautification projects as cultural medicine for social ills. Yet nature in its supposedly purer forms was still associated with the sublime, the *out there*, the *not-city*, the untrammeled and untamed beyond the edge of the frontier of exploration. This nature came to be regarded as a refuge from the enervating impacts of

urban life, and the early environmental preservation movement sought to keep human presence to a minimum in these remaining wildlands.

In the early decades of the twentieth century, progressively minded leaders and government agencies also promoted the proper management of forests and watersheds as a public responsibility. Lands were protected by federal fiat for the purpose of what we might now call "ecosystem services," the provision in perpetuity of the "goods" that nature has to offer, such as drinking water and timber. In both cases, wild nature was something apart, to be communed with or properly used, but not something to be lived with or in. Cities were viewed as the antithesis of wildlands.

No longer. People are increasingly devoting attention to the wildness threaded throughout metropolitan areas. Many nature-loving Chicagoans are likely familiar with *restoration ecology*, which is the (often sweat-intensive) process of bringing a historic ecosystem or landscape back to a condition resembling its former functionality and biological diversity. Beginning with pioneering efforts in the 1960s, and evolving into a volunteer-driven movement in the 1970s, citizen-led restoration projects now engage thousands of committed volunteers throughout the Chicago metropolitan area.

Much good work has been done in terms of nursing native species and fragmented habitats back to health, but another paradigm is emerging that may help us further rethink the importance of urban areas. *Reconciliation ecology*, a term coined and defined by evolutionary ecologist Michael Rosenzweig, "is the science of inventing, establishing, and maintaining new habitats to conserve species diversity in places where people live, work, or play" (7). Reconciliation ecology involves situations in which people both intentionally (and unintentionally) create critical habitat for other species, while still making a living themselves. So while ecological restoration involves diminishing and, where possible, reversing human impact so that other species can reestablish themselves, reconciliation ecology argues that humans can create and build novel systems that are suited to other species' needs. In short, by knowing the lifeways of other species, we can deliberately create places of cohabitation.

Such efforts foster ecological empathy, engaging us in the long-term work of living with grace and skill in our everyday worlds. It asks of us that we anticipate the impacts of our actions and take responsibility for our historical shortsightedness. When other animals are in our midst, their lives amount to more than dry facts in a textbook, or characters in a children's story, or charismatic megafauna in a National Geographic special. Active reconciliation means trying to understand what other animals need, and what we can give to move toward a more satisfying and artful coexistence—including and perhaps especially in urban environments.

Urban Ecology and Place-Based Experience

There is growing interest among ecologists in studying urban nature (as several essays in this volume demonstrate); indeed, the increasing attention to urban ecology and applied ecological research may reflect a broader public

appreciation for nature in metropolitan areas. A growing number of writers—for example, Lisa Couturier, Stephen DeStefano, Lyanda Lynn Haupt, John Tallmadge, and Esther Woolfson—are challenging the outmoded vision of the city as an entity separate from nature.

In this book, we also want to call attention to the city as an entity that is embedded within and arises out of nature. The city is a human-constructed membrane of more and less permeable natural materials—bearing affinities with the termite mound, the beehive, or a monk parakeet colonial "condominium." As a cultural artifact, a rearranging of organic and inorganic materials, the city may or may not endure. It depends—in the strict sense of that word—because it is deeply dependent on the quality of the relationships that create and sustain it. These relationships include those with our nonhuman neighbors who have carved out niches for themselves, often quite successfully, amidst densely settled human populations.

Humans aren't the only city dwellers. It may well be that the endurance of any given city, its necessary reinvention as a human and humane lifeworld, depends on opening our eyes to the nature that never left; the nature that constitutes our common air, water, and land; and the nature that is seeping, crawling, stalking, trotting, and flying through and back into the city. Through the art, poetry, and essays in this book, we seek to place the dialogue about urban conservation front and center and contribute to an ethic of care for the everyday places where people live and work. In so doing, we hope to foster place-based perception *and* emotional connection with the more-than-human world.

Why Chicago?

The metropolitan region of Chicago, which is what this book takes as its place of inhabitation and imagination, provides an example of an urban region rich in nonhuman life. Chicago is defined by, indeed derives its name from, its relation to the landscape. Chicago is the place where a soporific river meets a massive glacier-carved lake. A place where oak savanna meets tallgrass prairie, shrub swamp meets flatwood forest, and humans meet nonhuman otherness. Just two hundred years ago, Chicago was a portage site, a way to carry a canoe from Lake Michigan to the interior waterways of the continent. Consistently throughout its history—due to its geography, topology, and hydrology—Chicago has been a meeting place for many animal species.

A former titan of the Industrial Age and now one of the world's largest cities, Chicago is notable as a place of rapid change. Possibly no other city in the world grew so quickly. The explosive growth of its railroads, its commodity markets, its coal and steel production, its pollution, and its social strife, as classes clashed and labor movements collided with authorities, flared from and fueled the heartbeat of America's industrial apogee. As historian William Cronon documented so well, however, don't let the smokestacks fool you: Chicago was and is "Nature's Metropolis," connected for better or worse in every way to its hinterlands.

Nature lovers, amateur naturalists, community organizers, urban agricultur-

alists, social workers, and concerned citizens have always been part of the fabric of the city. Turn-of-the-century city planners pushed for and established the country's first county-wide forest preserve system. Early naturalist groups such as the Chicago Academy of Sciences (later incorporated into the Peggy Notebaert Nature Museum) and institutions such as the Field Museum and the Lincoln Park and Brookfield Zoos brought citizens into contact with natural wonders from around the world.

Chicago was also one of the birthplaces of the science of ecology, with luminaries like Henry Chandler Cowles leading his University of Chicago students on regular field trips to study ecological succession at the Indiana Dunes. As mentioned earlier, the city is also responsible for some of the earliest volunteer-driven, citizen-led ecological restoration projects, which had their origins in the forest preserves that thread their way through *urbs* and suburbs. Such citizen-science efforts in the Chicago region are now complemented by major interdisciplinary research projects, such as the National Science Foundation's multi-year Urban Long-Term Research Areas (ULTRA-Ex) study, for which Chicago is a pilot site; the RESTORE project (Rethinking Ecological and Social Theories of Restoration Ecology); and "100 Sites for 100 Years" (more formally known as the Chicago Wilderness Land Management Research Program), which is comparing different forms of long-term ecological management and their impacts.

One clear manifestation of the evolution of understanding, researching, and advocating for city creatures in the Chicago region was the formation in 1996 of Chicago Wilderness. A coalition of groups spanning the greater Chicago metropolitan region, from southeastern Wisconsin to southwestern Michigan, Chicago Wilderness is now comprised of over three hundred organizations, and it has become a national and international model for regional-scale conservation work. Two things in particular stand out about the collaborative efforts of Chicago Wilderness: (1) the urban landscape is a critical site of attention, incorporated into a larger vision of protecting and restoring biodiversity throughout the region, and (2) opportunities for people to engage with everyday nature—as a place of learning, discovery, care, and psychological and spiritual connection—are promoted as a means to a relational understanding of self and community. Documents like Chicago Wilderness's *Atlas of Biodiversity* attest that the Chicagoland region is a hot spot for biodiversity, if we know where and how to look for it. Chicago stands as evidence that cities are not biological deserts; they are not castaway landscapes. As we learn to care where we are in our daily experiences, our cities matter—more than ever—for how we come to think about *all* places.

Road Map to *City Creatures*

Now that we've provided you with a rationale for the book as a whole, it's almost time to dive in. Before one undertakes a journey, though, it's always wise to consult a map, so that you know what to expect. Here, then, is a road map

of the places to which *City Creatures* will take you, and why we chose this path rather than another.

We have organized *City Creatures* into six sections, each of which highlights one sort of place in which Chicagoans (and other urban dwellers) might encounter animals in the city and suburbs: "Backyard Diversity," "Neighborhood Associations," "Animals on Display," "Connecting Threads," "Water Worlds," and "Coming Home to the City." An appendix rounds out the book with a list of print and online resources to which readers can turn for additional information about urban animals, within and beyond Chicagoland.

Each section of the book, in turn, serves as its own sort of diversified habitat. In each you will encounter many different kinds of animals, as well as multiple approaches to telling their stories. Essays and poetry, photographs and paintings; natural and social sciences, ethics and visuals arts—all combine to reveal the myriad roles that animals play in the city, and the many different ways in which we human animals interact with the others.

"Backyard Diversity" explores the often-intimate encounters with animals that take place in or near our home places: in backyards and kitchens, vacant lots and windowsills, gardens and rooftops. Sometimes these encounters are numinous, suffused with an almost-mystical resonance, at least in our memories; sometimes they are wrenching, even terrifying; and other times they are filled with the complicated ambiguity to which we post-postmoderns have become resignedly accustomed. From chickens to foxes, crows to fireflies, raccoons to starlings, these animals comfortably cross the boundaries we draw between "wild" and "domestic" spaces, often making us quite uncomfortable in the process.

"Neighborhood Associations" takes us a step further into the places where human and animal communities intersect in Chicagoland. Here we meet and mingle with animals every day in liminal spaces neither fully wild nor fully domestic. Coyotes visit Goose Island, and squirrels set up shop in Oak Park; honeybees buzz about the West Side, and crickets chirp in church basements. Sometimes our associations with these animals bring us together, as in dog parks, sanctioned or illicit; but sometimes they bitterly divide us, as in disputes over how to manage overpopulated suburban deer.

This section also highlights cultural and historical factors that shape community engagements with animals. Photographs evoke our historical connections with working animals in the city, from horses who pulled our carriages to pigs who provided us with pork via the Union Stock Yards. Paintings and poems share Latina/Latino experiences of urban animals; for example, finding common cause with downtrodden pigeons, "the spicks of Birdland." And at the American Indian Center of Chicago, Native peoples and birds share a prairie garden and use it to teach their young.

In "Animals on Display," we visit places we traditionally go to watch the animals: museums, zoos, and aquaria. Some of the contributions focus on how much we can learn from looking at animals in these places, on how we can come closer to wild animals by first getting to know them, and how to observe and

depict them in more controlled spaces. But others address our discomfort with seeing animals behind bars or "stuffed," in quarters far too close for comfort, and with taking our children to see them there.

We step into the urban wilds with "Connecting Threads," which explores the parks and forest preserves and other protected areas that provide crucial habitat for local and migrating animals throughout Chicagoland. From the Magic Hedge at Montrose Point and Lincoln Park on the North Side to Northerly Island in the Loop to Wooded Isle in Jackson Park on the South Side, the green spaces described in this section offer human visitors a chance to commune with Canada geese and king rails, hawk moths and black-crowned night herons, massasauga rattlesnakes and leafhopper insects, and even water bears and *Oppiella nova* in the soil beneath our feet.

Much less familiar, but arguably even more important in ecological terms, are the "Water Worlds" that contributors limn in the next section. Fittingly, several contributors focus on Lake Michigan and the creatures who inhabit it, both native and introduced, including whitefish and alewives. We wade through wetlands with citizen-scientists counting frogs for the DuPage County Forest Preserve District, and witness the death and potential rebirth of the Lake Calumet region on the far South Side, with its rich avian and piscine fauna. And we canoe down Bubbly Creek, aka the South Fork of the South Branch of the Chicago River, paddling past trash and sewage smells along the way, but also three species of herons and a sandhill crane.

The final section, "Coming Home to the City," brings us full circle, introducing us to some of the wild animals who, like us, have come to call Chicago home—or who might, if we let them. Some of them appear like ghosts, haunting us in the twilight hours: was that a dog—or a coyote? Others bring to mind our own immigrant origins, such as the radiant monarch butterflies, who, like so many other Chicagoans, have made the long journey from Mexico to the Midwest. Still others announce their presence more assertively: through the deafening squawks of naturalized monk parakeets, for example, or an explosion of pigeons around a human feeding them. And then there are those whose presence depends on our readiness for their return: If wolves come to recolonize Chicagoland from the north, will we make a place for them? Should we, or should we not?

This, then, is a book about animals in the city: migrants, colonizers, dispersers, adapters, homebodies. We tell the stories of these animals' inhabitation, their displacement, their successful return. But, of course, this book is also about one animal in particular. This animal is the one telling these stories about encounters with the others—through the media of essays, poetry, and art. If there is a single strong but implicit theme running throughout the pages that follow, it is that as we tell these stories—as we celebrate, lament, puzzle, engage, avoid, and wonder at these many forms of life—we can discover how to better and more fully inhabit our urban and peri-urban areas. As we do so, the city can become what it has been and is becoming for so many other animals: home.

Recommended Resources

Books

Couturier, Lisa. *The Hopes of Snakes: And Other Tales from the Urban Landscape.* Boston: Beacon Press, 2005.

Cronon, William. *Nature's Metropolis: Chicago and the Great West.* New York: Norton, 1991.

DeStefano, Stephen. *Coyote at the Kitchen Door: Living with Wildlife in Suburbia.* Cambridge, MA: Harvard University Press, 2010.

Gottschall, Jonathan. *The Storytelling Animal: How Stories Make Us Human.* Boston: Houghton Mifflin Harcourt, 2012.

Haupt, Lyanda Lynn. *The Urban Bestiary: Encountering the Everyday Wild.* New York: Little, Brown, 2013.

Ingold, Tim. *Being Alive: Essays on Movement, Knowledge, and Description.* London: Routledge, 2011.

Pyle, Robert Michael. *The Thunder Tree: Lessons from an Urban Wildland.* Boston: Houghton Mifflin, 1993.

Rogers, Will. "Introduction." In *The Story Handbook: Language and Storytelling for Land Conservationists*, edited by Helen Whybrow, 1–3. San Francisco: Trust for Public Land, 2002.

Rosenzweig, Michael L. *Win-Win Ecology: How the Earth's Species Can Survive in the Midst of the Human Enterprise.* Oxford: Oxford University Press, 2003.

Sax, Boria. "Introduction to Part 1: From Totems to Tales." In *What Are the Animals to Us?: Approaches from Science, Religion, Folklore, Literature, and Art*, edited by Dave Aftandilian, Marion W. Copeland, and David Scofield Wilson, 1-4. Knoxville: University of Tennessee Press, 2007.

Tallmadge, John. *The Cincinnati Arch: Learning from Nature in the City.* Athens: University of Georgia Press, 2004.

Woolfson, Esther. *Field Notes from a Hidden City: An Urban Nature Diary.* London: Granta Books, 2013.

Websites

Chicago Wilderness: www.chicagowilderness.org

Chicago Wilderness, *The Atlas of Biodiversity*: www.chicagowilderness.org/what-we-do/protecting-green-infrastructure/epdd-resources/biodiversity-and-natural-habitats/the-atlas-of-biodiversity/

Chicago Wilderness: 100 Sites for 100 Years: www.flickr.com/people/65456385@N02/

NSF ULTRA-Ex (Chicago Wilderness): http://ltm.agriculture.purdue.edu/ultra.htm

RESTORE Project, http://fieldmuseum.org/explore/department/ecco/restore

❋ 1 ❋

BACKYARD DIVERSITY

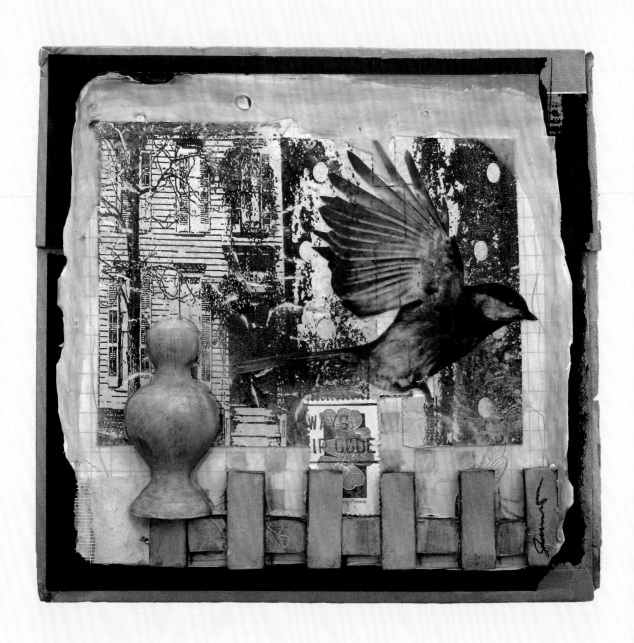

JANICE F. MEISTER, *Up Not Out*

Keeping Chickens

TERRA BROCKMAN

It was a cold but sunny mid-November day when a half dozen kindergartners at the Academy for Global Citizenship, a Chicago Public Charter School on the Southwest Side, introduced me to Buttercup, Daisy, and Puddles. Like the students, the school's resident hens were a diverse trio: one gold-speckled brown, one glistening iridescent black, and one fluffy white. But all had the glittering eyes and brilliant red combs of healthy hens, and they clucked conversationally with one another, as contented hens will do.

The children chattered away alongside the hens, comfortable with them yet respectful of their space—neither cuddling them as if they were pets, nor keeping a wary distance as they would with wild animals. When I asked the kids if they had hens at home, they looked at me as if I had stepped in from another planet. Of course not, they said, these were school hens, just like the school garden, and the school cafeteria that cooks organic meals from scratch. That a school might not have organic meals or a garden or hens was a thing of which they were as yet blissfully unaware.

Although those particular children did not have hens at home, Chicago and its suburbs are key players in the backyard chicken movement that has swept the country since the early 2000s. "Urban Chicken" now has its own *Wikipedia* entry, and there are over 200,000 members of the go-to website BackYardChickens.com. Even mainstream companies are capitalizing on the burgeoning interest in knowing where our food comes from: Urban Outfitters has opened new stores called Terrain to meet the need of urban farmers, and Williams-Sonoma features an "Agrarian" line of products. The hens have come home to roost in Chicagoland too, hatching the Chicago Chicken Enthusiasts website (www.chicagochickens.org) and its lively Google group discussion forum and Facebook page, as well as giving Buttercup, Daisy, and Puddles a home at the Academy for Global Citizenship.

When recess was over, I followed the children as they scampered across the asphalt to line up in front of the school door. I had come to join them for their afternoon class, a review of everything they had learned in their "Chicken Unit." Having grown up the fourth of five generations of a central Illinois farm family,

I have more than a passing familiarity with chickens as rural livestock. What I was interested in was urban chicken keeping, and their keepers in general.

"Keep it" are two words that have echoed in my mind ever since I heard farmer and philosopher Wendell Berry say that there is really only one commandment concerning the creation: "Keep it." I later found the passage in Genesis: "The Lord God took the man and put him in the garden of Eden to till it and keep it" (Gen. 2:15). Digging deeper, I found that the English translations for "till" and "keep" come from the Hebrew *abad* and *shamar*. These are not arcane or abstruse terms, but wonderfully straightforward words that describe common activities. *Abad* is the root of words related to work, service, or serving. *Shamar* means to protect or preserve, or to keep. It turns out that the original version of the gentle benediction that ended every Lutheran church service of my childhood, "The Lord bless you and keep you . . ."—which comes from the famous blessing that the descendants of Aaron were to pronounce over the people of Israel—uses the word *shamar*.

If Genesis 2:15 and Wendell Berry are correct, our primary task in this world can be reduced to one word: *shamar*. We are here to tend and keep, preserve and protect, the ecosystem we share with every other living and nonliving thing—including the plants and animals that feed us.

How urban chicken keepers relate to their chickens, and how keeping chickens situates humans in the larger ecosystem, seemed a good way to explore the question of how well we humans are "keeping" the creation as a whole. Chickens might be good teachers, I reasoned, because they occupy a distinct space between pets and wildlife. Pets we love like family members. Wildlife, particularly the charismatic megafauna, we admire for their beautiful, wild otherness. But chickens? They do not fit into either of the animal categories to which we are most accustomed. They are not pets and not wildlife; they are neither completely wild nor fully tame. What they are, domesticated jungle fowl prized by many cultures for their powers of divination, leads to our complex relationship with them, and to lessons they can teach us about ourselves, our fellow humans, our fellow creatures, and our common world.

And so I found myself sitting in a pint-size chair in a colorful classroom at the Academy for Global Citizenship, curious to see how city schoolchildren keeping a few chickens might illuminate the question of our responsibility "to keep" the creation. The teacher calmed the kids down with a few yoga stretches, and then started a PowerPoint presentation to review the parts of a chicken, eliciting exclamations of "Wing!" "Beak!" "Comb!" "Feathers!" "Feet!" and "Tail!"

Then the teacher asked, "What are the five things the animals who live with us need?" Hands shot up around the room: "Food!" was the first answer, followed quickly by "Water!" And then a discussion of "shelter" and how animals needed sun and air to be healthy, but also protection from the sun on hot days, and from wind, rain, and snow.

I was intimately familiar with animals' food, water, and shelter needs, since meeting those needs had comprised the chores I did every morning and eve-

ning growing up on a small farm. Even on the coldest, darkest winter morning, I lugged two sloshing five-gallon pails of water to my cow, Frosty, and made sure she had enough hay before running down the lane to catch the school bus. Each of my six siblings did the same, looking after the food, water, and shelter needs of their sheep, chickens, goats, rabbits, cows, and pony.

As far as I was concerned, food, water, and shelter covered basic animal needs. But in the classroom more hands were up, waving the bodies attached to them, vying for attention. "Friends," shouted one student. The teacher nodded as she clicked to a photo of a flock of chickens in a green pasture, "And what else?" "Love!" shouted three or four kids in unison, putting their arms around themselves and rocking back and forth in what was obviously the school's sign language for love.

Love. Chicken love. That was not an animal need I would have thought to articulate. But, reflecting on the summers spent on my grandparents' farm, "love" was certainly present, as were "friends" in the large flock of laying hens. Sometimes a flock of young males shared the chicken yard as well—the "fryers," we called them, knowing they would end up as the crispiest fried chicken on the planet one Sunday afternoon, a fact that complicated but did not contradict the love that was showered upon all the chickens my grandparents kept.

On that central Illinois farm where both my grandfather and father had been born, taking care of the hens and gathering their eggs each day was not so much a chore as a mission. Each day eggs appeared in the straw-filled nesting boxes, sometimes still warm to the touch. Their size and shape seemed custom-made to cradle perfectly in a child's hand. Upon returning to the house, I'd show the basket to Grandma, and she would *ooohh* and *aaahh* over it. Then she'd ask, "Did you thank the hens?" The time or two I forgot, she had me go back out and do it—a little bit of tough love, but love nonetheless, toward me and toward the hens.

A habit of gratitude becomes second nature when you grow up with a grandmother who insists that you thank the hens every time you gather their eggs. Even now, fifty years later, this is the question that echoes in my mind every time I eat an egg. And whether I do it out loud, as I did as a child at my grandmother's prompting, or internally, as I most often do today, I always thank the hens.

Thinking back, the hens on that farm had all five of the things the children had identified: food, water, shelter, friends, and love. Yet none had names like Daisy, Buttercup, or Puddles; in fact, none had names at all. Perhaps it was because when their egg-laying days were over, well, then, their days were over too. I'm not sure what end-of-life issues the hens and children at the Academy for Global Citizenship will face, but the topic is one of the busiest threads on the Chicago Chicken Enthusiasts' discussion forum.

In my own farm upbringing, the end came swiftly, and then Grandma's hens underwent a transubstantiation into the most delicious chicken soup, with the rich flavors that come only with a long, happy life. And that is certainly an odd

notion—to love a creature, and then to eat it. But then again, so is the notion of eating the body and drinking the blood of a deity. That sort of institutionalized cannibalism, or Holy Communion, only began to make sense to me after I read these lines from "The Host" by William Carlos Williams:

> There is nothing to eat,
> seek it where you will,
> but the body of the Lord.
> The blessed plants
> and the sea, yield it
> to the imagination intact.

Once I learned to conflate "the body of the Lord" with "the blessed plants and the sea," a dinner of salmon and asparagus became a true communion. Similarly, if you keep chickens, then a breakfast of scrambled eggs and chives will also become an intimate spiritual union with a particular piece of "the body of the Lord." It's breakfast, but it's also an unborn chicken. With every bite, a backyard chicken keeper can recognize the inherent interconnectivity and interdependence that sustains us all, and begin to live in the mystery of a world in which life begets life, acknowledging that death is always part of the circle of life.

If we are dependent upon "the body of the Lord," then it is imperative that we keep it, and keep it well. That brought me back to Wendell Berry, who has written extensively about farming and eating, famously proclaiming that "eating is an agricultural act" and that "how we eat determines, to a considerable extent, how the world is used" (149). These quotes are from his essay "The Pleasures of Eating" in *What Are People For?*, where he also points out that our contemporary economic order encourages us to be mindless consumers of food because the products of nature and of agriculture have become nearly indistinguishable from the products of industry. An industrial egg now rolls off an assembly line the same way a tube of toothpaste does, as anyone who has ever visited one of the concentrated animal feeding operations (CAFOs) that produce nearly all eggs consumed in the United States knows all too well. Berry warns that when we lose the connection between our food and the living creatures and the soil it comes from, then both eater and eaten are exiled from biological realities. He concludes, "The result of this exile is a kind of solitude, unprecedented in human experience, in which the eater may think of eating first as purely a commercial transaction between him and his supplier, and then as a purely appetitive transaction between him and his food, but not as something in the realm of the living world" (148).

Backyard chicken keeping is an antidote to this alienation and appetitive transaction. It brings people out of exile and places them firmly in "the realm of the living world," as even a cursory glance at the Chicago Chicken Enthusiasts' discussion shows. When you keep chickens, you enter the world of complex

interconnections and messy contradictions, of the problems of chicken sex, of poop on eggs, of predators—sometimes including your own lovable yet murderous pooch—and, of course, those difficult end-of-productive-life decisions. Dealing with these issues is not easy, but it does intimately connect us to our food, how it comes to us, and how it fits into the larger world, where—let's face it—everything eats everything, and someday maggots and worms will eat us.

When we don't keep chickens or tend other food sources, we experience a sort of collective eating disorder because our experience of eating is detached from the natural order of things. And so our recognition of the kinds of creatures we humans are, and of the rights and responsibilities of a well-lived life, is also disordered.

The idea that keeping chickens might help recenter and reorder our lives led me to Mike, who keeps Henrietta Thoreau and three of her friends in his backyard in a central Illinois city that shall remain nameless because the town ordinance prohibits chickens. "I'm curious," I said to Mike. "How do you relate to your hens?"

"Well, when I come home, I get a glass of wine, and go into the yard to watch my chickens. They're entertaining, and they chill me out," says Mike. "But they're not too bright. They're interested in you because you are where their food comes from. They don't realize that the situation is reciprocated: *They* are where *our* food comes from." He chuckled, collecting three warm brown eggs.

And yet the human-avian relationship is far more than a utilitarian one. In the beginning, which was roughly 8,000 years ago according to the gospel of *Gallus gallus*, people began to bring a particular red fowl from the jungles into their living spaces. The reason is unclear, though the general consensus is that it was not for what a farm girl like me had supposed: a close and convenient food supply. Rather, the evidence suggests that wild red jungle fowl were integrated into human society to predict the future. After a moment's thought, this actually does make sense to anyone who has ever kept chickens: the hen's squawk foretells an egg; the rooster's crow presages the dawn.

The idea that chicken oracles—if poked, prodded, or pulled apart in just the right way—would predict the future is as old as the evidence of the first domesticated chickens. That role was so important that domesticated chickens quickly spread with human communities all over Asia and Africa. And everywhere chickens went, they continued to prognosticate.

And so it was that the ancient Etruscans came to draw a circle in the sand and divide it into segments, one for each letter of their alphabet. They scattered seeds around the circle, and then brought out the oracle chicken and set it down in the center of the circle, as scribes gathered around. Those scribes carefully observed which sections of the circle the chicken stepped in and pecked from, and wrote down the corresponding letter. After the chicken was finished, they used their observations and notes to answer pressing questions and predict the future.

While we tend to look upon practices such as this alectryomancy with an air of superiority, which one of us has not made a wish and pulled apart the fused clavicles—the furcula, or wishbone—of a holiday turkey? It turns out there is a direct line from the avian-inspired prognostication of the Etruscans, to the Romans, and via them to the Anglo-Saxons, and to their descendants, the Puritans, and from them to the Thanksgiving tradition of many Americans today. When I was growing up, not a turkey or chicken dinner went by without the ritual of drawing straws to see which two of my six siblings would put their fingers around one half of the wishbone, make a wish, and then pull it apart.

Similar traditions are carried out throughout the world. Among the Karen people of Burma, chicken bones are examined for what their holes and divots, crooks and crannies, can foretell. Among the Ho people of Chota Nagpur in India, chickens are used only for divining and never as food. Consuming chicken is also taboo for the Vedda of Sri Lanka, the Sabimba of Malaysia, and several different peoples in the Solomon Islands.

Nor are oracle chickens restricted to faraway times or places. The phenomenon is common across much of Africa and has reached the New World and the twenty-first century. When I lived in New York City and when I've walked along Lake Michigan near Belmont Harbor, I've seen evidence of chicken sacrifices. Whether they were slaughtered for prognostication or propitiation, it's hard to say, but the sacrifice was clearly not food-related, for no part of the animal was eaten. In general, it seems, most cultures agree with Cambodia's Khmer people, to whom the greatest value of chickens is as fortune-tellers, secondly as fighting cocks, and only incidentally as food.

Yet food is why most people, urban or rural, keep chickens in the United States today. And the vast majority of those chickens do not have a sacred role as mediators, nor are they considered part of the body of the Lord that we should revere and keep. They may have food, water, and shelter, but they are not given respect, gratitude, or love. Certainly no one thanks the modern "battery hens," whose eggs roll off onto a conveyor belt as soon as they are laid.

During my confirmation into the Lutheran Church, I was told not just that there was sin, but that there are two kinds—sins of omission and sins of commission. With an inward groan, I realized that in most situations in life I was pretty much damned if I did and damned if I didn't. And it's true that we who eat eggs from industrial sources are no doubt guilty of both. We are party to the sins of commission: the de-beaking of the baby chicks immediately after hatching; their close confinement with thousands of other hens, without room to stretch their legs or flap their wings; the whole life of the bird lived without sunlight, green grass, or fresh air; without the ability to chase a cricket, take a dust bath, or fly up to a roost at night. But on top of all that is the sin of omission: no one ever thanks these long-suffering hens for their eggs.

Any kindergartener could see that a battery hen, or a CAFO-raised turkey, is loveless and friendless. As I left the Academy for Global Citizenship, Puddles, Daisy, and Buttercup looked at me with a hard gleam in their eyes. If they could divine the future, I thought, they would say it looks grim—unless we restore

our rightful relationship to creation, to tend it and keep it, with love and with gratitude. But that seems such a weighty and nigh impossible thing for mere humans to do, I thought, returning the slightly accusatory avian stares.

As I lingered by their coop, I thought about the fresh eggs they lay each day, and how good they must taste. And I remembered a line from Psalm 34: "Taste and see that the Lord is good." Tasting, I mused . . . tasting is directly experiencing something for yourself, living in the world, opening your mouth to sweet honey and bitter herbs, your mind to ambiguity, your heart to gratitude. . . .

Suddenly it occurred to me that the passage in Genesis 2:15 about tilling and tending the Garden of Eden is about praxis. God translated a heavy and seemingly impossible responsibility, to care for creation, into the daily practice of tending a garden. What a relief! And what better way to care for the planet than with place-based actions and reflections that start in our own backyards, and that we work at little by little, day by day?

Keeping chickens allows us to practice *shamar* and engage in caring for a piece of creation as part of our everyday lives—an idea that had never occurred to me before I met Buttercup, Daisy, and Puddles. And so I thanked the hens once again.

Acknowledgments

A shorter version of this essay was published under the title "Chicken Keepers" in the *Christian Century*, May 29, 2014.

Recommended Resources

Books

Berry, Wendell. *What Are People For?* Berkeley: North Point Press, 1990.

Brockman, Terra. *The Seasons on Henry's Farm: A Year of Food and Life on a Sustainable Farm.* Chicago: Surrey Books, 2009.

Drowns, Glenn. *Storey's Guide to Raising Poultry.* 4th ed. North Adams, MA: Storey Publishing, 2012.

Potts, Annie. *Chicken.* London: Reaktion Books, 2012.

Smith, Page, and Charles Daniel. *The Chicken Book.* 1975. Reprint, Athens: University of Georgia Press, 2000.

Websites

BackYard Chickens: www.backyardchickens.com

Chicago Chicken Enthusiasts: www.chicagochickens.org. There is also a lively discussion forum on the Chicago Enthusiasts Google Group (https://groups.google.com/forum/#!forum/chicago-chicken-enthusiasts) and Facebook page (https://www.facebook.com/chicagochickens), and the Windy City Backyard Chicken Resource Guide (https://docs.google.com/file/d/0B4Mg7sIgd6IOUUhBMVc3Z00tMjA/edit).

Sources of Good Eggs from Healthy Hens in the Chicago Area

If you can't get fresh eggs from your own backyard hens or those of a neighbor, you can find them at many farmers' markets and Community Supported Agriculture farms (CSAs); find one near you at www.localbeet.com or www.localharvest.org. Here is a sampling:

· Genesis Growers, Vicki Westerhoff, Green City Market and through CSA
· Kinnikinnick Farm, Dave Cleverdon, Green City Market
· Meadowhaven Farm, Jeanne Sexton, CSAs and Green City Market
· Organic Pastures, Larry and Marilyn Wettstein, Evanston Market
· Tempel Farms Organics, Chris and Tanya Cubberly, Logan Square Farmers' Market

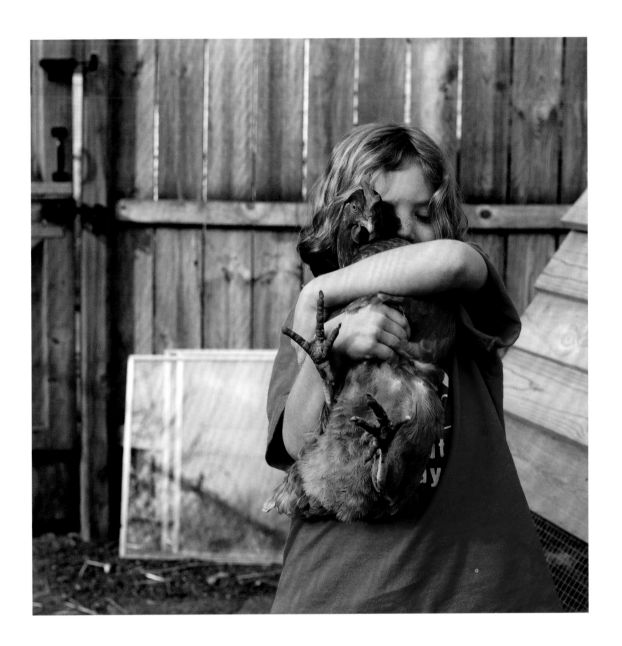

COLLEEN PLUMB, *Holding Backyard Chicken*

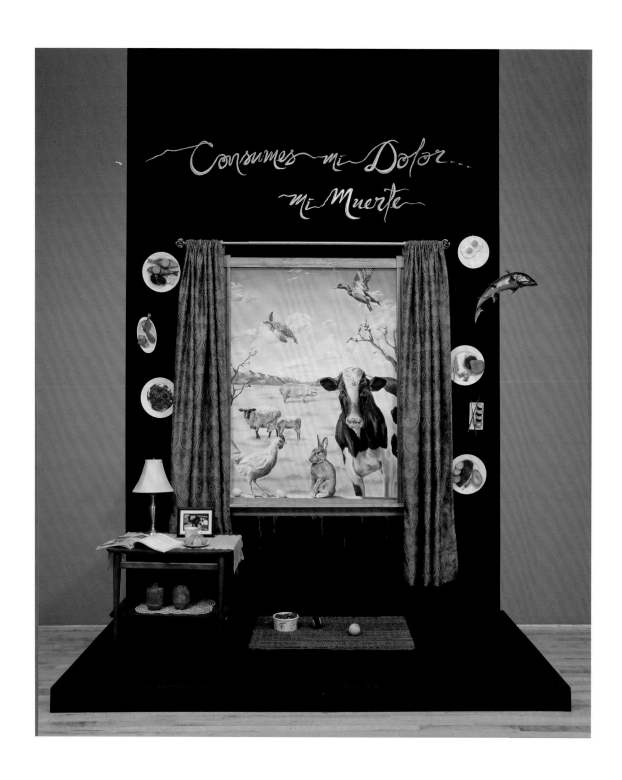

ALMA DOMÍNGUEZ, *Consumes mi dolor ... mi muerte*
(You consume my pain ... my death).

"*Día de los Muertos*, or Day of the Dead, is a Mexican celebration of ancient Mesoamerican origins that commemorates the deceased. It is a way to remember forever our loved ones, family members, friends, and even celebrities who have now passed on to a 'better place.' The traditional altars that are constructed for Day of the Dead, however, omit a very important group: other animals that cohabit and coexist with us on Earth, and who are a fundamental part of our lives—even though we often ignore their presences. For those creatures that we do notice, we tend to create an arbitrary division between our beloved pets, whom we often treat like members of the family, and the animals that we consume, who are often mistreated and exploited. Industrial animal agriculture—in its fervor to produce more and meet public demand for plentiful, cheap meat—is capable of astonishing levels of savagery, treating animals more like things than living beings. *Consumes mi dolor … mi muerte* represents my efforts to honor animals as part of Day of the Dead celebrations, to remember the animal souls that are no longer with us, and to celebrate the civilizations of ancient Mexico, which had strong and beneficial relationships with animals."—A.D.

Looking Up

MELINDA PRUETT-JONES

I've struggled with the notion of "city" since I was a child. I grew up in a typical small-town subdivision in the San Francisco Bay area in the 1950s, a time when similar-looking subdivisions were popping up everywhere. Our house was on a third of an acre next to our neighbors on their third of an acre, and so it was for the hundred or so homes in our neighborhood.

Our property happened to be bounded on the north by a rusty barbed-wire fence that was known to the community as the "city line." This confused me to no end when I was little, because from the front of our house, to the south, we also had a commanding view of "The City," the San Francisco skyline from the Golden Gate Bridge clear 'round to the East Bay Bridge, glimmering on the other side of the bay. San Francisco's tallest buildings floated above the fog on hot summer days, and the city's grid of streetlights seemed to close the distance across the water in the evenings. The bay created a natural barrier between our town—where I lived, played, went to school, and got on with the business of growing up—and The City of glass and steel that loomed so large in my worldview.

What I admired from a distance—The City across the water—was entirely separate from my home, my neighborhood, our small community with winding roads, a single traffic light, and no building larger than the firehouse or grocery store. Other people lived in The City, including many of my relatives. My parents grew up there. But me, I was not a City kid.

The old barbed-wire fence behind our house offered no helpful information to me as a child about what distinguishes a jurisdictional boundary. But it played an important role in shaping my early sense of place. I've since gained a deeper appreciation of how children develop a sense of place, and how these understandings change over time, from geographers who study this topic. Very young children, when asked to illustrate where they live, will draw a picture of their house and yard. Older children will draw their block, then eventually their community, and later their larger geographical area, be it urban, suburban, or rural. Our sense of place grows as we grow. I am, without question, textbook material.

The rusty old fence was a landmark feature on the landscape, something to

climb over or under, and to avoid getting my clothes caught on, but it was no barrier to youthful enterprise. It marked the gateway to exploring ever-expanding horizons. Our neighborhood was on one side of the wire, open space on the other. Nature on the far side of the fence was indistinguishable from what we found on our side; there was just more of it over there. As a consequence, perhaps, my idea of "city," even as an adult, is deeply colored by my earlier struggle to reconcile the meaning of that falling-down fence line.

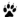

It doesn't take much for me to be overcome with the urge to lie down on the ground and look up. I attribute this magnetism to the sensation of feeling the ground beneath me. My heart slows. I feel connected to the surface beneath me—grass, sand, snow, forest duff, concrete, whatever—and I experience an immediate sense of calm. Occasionally I fall instantly to sleep and take a short, unscheduled nap. But really, it's about the view.

Since as far back as I can remember, I've found this vantage point full of beauty and wonderful surprises, any time of the day or night. The patterns and movement of clouds or tree branches, for example, captivated me as a child. The quality of light on a clear day is mesmerizing—what makes a purple sky? Stars on a moonless night are spellbinding. Things with wings are nearly always a part of that space, always stretching my imagination with their capacity for flight. It's what's happening above me that keeps me on the ground long enough to enjoy the other creatures that occupy the space along with me or that might be passing by.

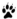

As kids, my brothers and I roamed every inch of the hills just over the barbed-wire fence. We explored the rocky outcroppings, climbed oak trees, ate miner's lettuce along the streams in the darkest glades of the woodlands, flew down grass slides on strips of cardboard as soon as the hills browned in the early summer, and managed to avoid an early death on the rope swing over the ravine with its fifty-foot drop.

It was a lot of running around, more often than not among a mass of kids of different ages in constant motion, tearing from one adventure to the next. My trademark was to find the tallest, deepest grass, weave my way into it, lie down, and disappear. The horde, having become familiar with my vanishings and not the least bit worried about them, would move on, leaving me to my private space, my view, looking up.

It was in these ground-level microcosms that I practiced stillness, patience, and observation. *We are talking hours and hours of stillness.* It was excellent grounding for the behavioral ecologist that I would become.

I had many early encounters with animals, either watching them or interacting with them, on both sides of the fence. California voles, for instance, were

everywhere in our neighborhood and often lived underneath the ground where I lay. I don't ever remember catching an adult vole, but I could catch the juveniles. I'd watch their comings and goings, greetings and scuffles, transport of goods such as food and nesting materials. Unlike me, I imagined they lived in "cities."

With a half-turn, I could focus on the fence lizards, stocky little creatures with brown spiky scales running down their backs and tails, and silky sky-blue underbellies, who sunned themselves on the scrap woodpile from my dad's various construction projects. Catching a lizard combined patience with excellent hand-eye coordination. If I lay still enough, long enough, and moved fast enough at just the right time, the lizard became my afternoon companion, tail intact. There is no way to cheat in the art of snatching lizards by hand, and I had a pretty high capture success rate. The secret was capitalizing on the social drama going on in the woodpile. I'd make my move when my lizard target was busy posturing to a rival with a set of blue-bellied push-ups. Catching an alligator lizard, on the other hand, was less about skill and more about guts. The well-fed gopher snakes fell into this high-risk category, too, because both were notable for biting and not letting go for the rest of the day.

The western meadowlark was my daily alarm clock growing up. We didn't experience a dawn chorus of birds, given the grassland habitat that characterized our neighborhood. (Because we were part of a brand-new subdivision, landscaped yards had not yet transformed the community into a mixed woodland.) Instead, I woke up to the blast of a territorial male meadowlark singing from the telephone wire outside my window, his flute, trumpet, and rusty hinge notes mixing in with the constant tones of the foghorns and channel buoys drifting up from the bay.

The other birds typically found in our yard included California quail, mourning doves, scrub jays, juncos, and towhees. During the late winter, the pair of great horned owls that nested in the neighborhood preferred the telephone pole outside my window for a roost. The owls' familiar hoots spooked my brother but fascinated me. Red-tailed hawks perched on the posts of the barbed-wire fence, and I'd watch them hunt the vole populations on both sides of the "city line."

Things with wings were my fascination. On a few mornings each fall, catching a school bus to elementary school was an opportunity to witness a spectacle of nature. Though sunrises were coming up later each morning, it was early enough in the school year that my tights were still without holes in the knees from the inevitable crashes that resulted from running at breakneck speed down steep trails (actually, shortcuts through backyards and private property) to catch our bus. At the top of the hill, we could look down on a steady stream of migrating geese and ducks, of all sizes and colors, flying south through the bay over Raccoon Straits. The flocks were so large and dense that their formations obscured the water below them. We'd take off on our downhill sprint, catching

a great view of the avian river at the level they were flying, where I could see the brightening sky above them and the water below. At the bus stop, a block or so up from the houses perched above the bay, the sky above us was darkened by this mass of waterfowl. The sounds of their wings and their calls filled the air. As we all looked up in awe, there I'd be, flat on my back on the sidewalk, in order to get the widest possible view.

At school, I was preoccupied with questions about where these birds came from, where they were going, and who took charge so that they all followed the same flyway. We kids cut our own trails, without permission, throughout the neighborhood. Our trails were a study in geometry—they represented the shortest distance between two points. Was that what was going on up there with the geese and ducks?

It wasn't until I became a conservation professional, many decades after the wetland habitats these birds needed during migration had been fragmented and converted to new development and the waterfowl no longer flew their bay route, that I understood the relationship between their ancient migratory flyway and the disruption caused by the sprawling development of our northern California metropolis. By the time I was in high school, the great flocks of geese and ducks no longer passed through Raccoon Straits. As with the migrating waterfowl, the loss of our network of neighborhood trails to new homes and fence lines changed the way we kids navigated our community. Our critical habitats for childhood development were eventually overwhelmed by real estate development—which, ironically, displaced all the things I found most real.

My "not city" persona persisted, somehow, for a long time. This attitude was along the lines of "cities are great places to visit, but I wouldn't want to live there," despite the fact that I lived in and moved between several major metropolitan areas after leaving the Bay Area. One would think Seattle or San Diego would register as cities. When my husband was offered a university professorship in Chicago, however, *that* got my attention. Chicago. Definitely City. Big City.

At the core of my particular brand of city-directed prejudice was simply my need for that direct and familiar connection with the natural world that I grew up with, and my narrow-minded belief that wildlife, nature, and "cities" did not and could not go together. My passion for wildlife and my professional work took me away from urban centers to some of the wildest places on earth, which is where I encountered spectacularly interesting creatures. There was nothing glamorous about these research adventures—very hard work, tended to be dangerous, one crazy predicament after another. The opportunity to study exotic species in foreign landscapes was the powerful attractant, and I was deeply rewarded.

Without being aware of it, I developed a wide blind spot for my remarkable encounters with creatures at home, in the cities where I lived. While doing research on breeding birds on the north slope of Alaska, for example, I couldn't get over the unexpected encounters with the *wild* seabirds that regularly used

my head as a perch when we were checking their nests. I shouldn't have been surprised—I was the tallest thing on the expansive and treeless tundra, and was standing uncomfortably close to their nests. I was overcome with excitement nonetheless. Why? *Voluntary* animal contact + wild place = big moment.

Yet back in civilization and living in the heart of the densely urban Pacific Beach area of San Diego, I was able to lure a pair of *wild* scrub jays to our tiny apartment's second-story balcony with a handful of peanuts. By the time we left San Diego for Chicago, the jays and several sets of their fledglings were in and out of our apartment daily to search the couch, bookshelves, and potted plants for the peanuts we stashed all over. They'd perch on our shoulders and check out our pockets. They'd watch the *MacNeil/Lehrer NewsHour* with us. We relished every second of their *voluntary* proximity and loved their company, plus we developed a clinical interest in how the parents introduced their babies to our apartment, which doubled as a foraging patch. But because of my blind spot, I didn't think about this incredible experience in the context of an encounter with a *wild* animal in its *wild* place, created by neighborhood street trees, backyards, parks, school grounds, church lots, college campuses, and vegetable gardens.

Chicago cured me, permanently, of this blind spot. In fact, it transformed me. The greater Chicago region's wild places, collectively known as Chicago Wilderness, are a remarkable mosaic of the remaining prairies, woodlands, wetlands, dunes, and waterways that once covered this region. This rich natural heritage, over half a million acres of protected public open space, is linked by the vast and growing urban and suburban *wild* of the communities, industrial areas, and transportation corridors of the region. Chicago's natural areas and waterways are a gift from the early planners and civic leaders of the city of Chicago who could foresee the millions of people who would rely upon parks, preserves, and natural areas for their health and well-being. And, surprisingly, there is a stunning diversity of plant and animal communities, including many that are threatened or endangered, right in there among the 10 million or so people who live in their own complex tapestry of cultural communities.

So, I'm often asked, "What is the most endangered creature in Chicago's wilderness?" I'm quick to reply: "Children playing, exploring, discovering, taking risks, or flat on their backs looking up, *outside in nature.*"

Today's kids need nature, and nature needs kids. With more than 80 percent of the U.S. population now living in metropolitan areas, this mandate is fundamental to a society that values the public health, economic, and ecological benefits of local nature that sustain vibrant communities.

For the kids, it's about having fun in any natural environment, following their own instinctive curiosity. The encouragement of a caring adult cements the positive impact of these adventures. For millennia, children developed their brains by *playing* in nature. In general, juvenile creatures learn crucial skills from trial-and-error experiences in the natural world. These experiences

lay down neural pathways and shape their judgment, allowing them to excel in both physical and social environments. Being in nature improves children's emotional and physical health, helps them learn better, eases children under stress, and provides an ever-changing and unendingly complex environment in which to discover new things about themselves—not to mention the world around them. Myriad studies show how and why this is true.

For nature, it's about needing generations of kids who grow up with parks, woods, creeks, lakes, sand, veggie gardens, and rope swings as part of their daily experience, no matter where they live. If their connection to wildness is forged early on, children become adults who are more likely to be respectful stewards of nature and engaged community members.

In Chicago, kids who connect with the natural areas around them encounter city creatures that reflect the astounding biodiversity found in this region. Worms build soil and come out in the rain; wild assortments of insects pollinate our gardens; millions of small songbirds migrate through our street trees. (These transients could not survive their northerly or southerly migrations without a stopover in Chicago's vast woodlands—people may flock here for the pizza, but birds come through for the insect communities on our oaks.) Small mammals are busy at work below- and aboveground; resident birds nest everywhere, from the top of a drainpipe to the standing elm in a parkway to the most secret spaces in large protected landscapes; frogs and toads chorus in wetlands and ponds, and water snakes hunt in them. Larger animals include deer, coyotes, foxes, great blue herons, bald eagles, and beavers.

Yes, beavers. My first encounter with a wild beaver was across the street from our house, while I was strolling along one of Chicago's urban rivers with my kids. A Little League baseball game was going on in the park next to us, people and their dogs were walking up and down the well-worn path, and cars whizzed by on the four-lane road on the other side of the river. Cruising upriver at about our same pace, eyeballing us, was a beaver. The kids saw him first, and as we continued to walk along the path, he paddled near us, propelled by his enormous tail. A few minutes later he gave us the ultimate beaver farewell with an eardrum-rupturing slap of his tail and dived underwater. This utterly amazing encounter did not occur in the high country of the intermountain west or along a mighty wild and scenic river. It happened across the street. Not long after our first beaver adventure, the kids discovered the animal's lodge downstream. The beavers remain busy and visible, clearing parts of the riverbank, and have become a source of fascination for neighborhood children.

Whether by identifying with fledgling birds or learning about deer fawns, children tied into the rhythms of nature in the big city have the opportunity to hone their skills in stillness, observation, and respect for other creatures. The wild is present in all directions.

But, for me, I continue the habit of looking up. During a recent afternoon bike ride through a string of connected Cook County Forest Preserves, I stopped near a picnic pavilion bulging with multiple families of several generations gathered for a barbeque. Some children from this party were tearing around in a game of tag, while others were fishing or scouring the creek for

frogs and other creatures. Resting there, I just raised my arm and pointed to five hawks, of different sizes and patterns, soaring in a low circle on an air thermal above us. One of the fast-moving kids looked up, stopped, and came and lay on the grass near me. Many of the others followed. Not a word was spoken, nor was it needed. The shared experience of connecting to the aerial display of these magnificent hawks was all the communication required. Together, we all simply enjoyed the view.

Recommended Resources

Books

Carson, Rachel. *The Sense of Wonder.* 1965. Reprint, New York: Harper, 1998.

Dunlap, Julie, and Stephen Kellert. *Companions in Wonder: Children and Adults Exploring Nature Together.* Cambridge, MA: MIT Press, 2012.

Louv, Richard. *Last Child in the Woods: Saving Our Children from Nature-Deficit Disorder.* Chapel Hill, NC: Algonquin Books, 2005.

Sobel, David. *Mapmaking with Children: Sense of Place Education for the Elementary Years.* Portsmouth, NH: Heinemann, 1998.

Websites

Chicago Wilderness, "Leave No Child Inside": www.chicagowilderness.org/what-we-do/leave-no-child-inside/

Children and Nature Network: www.childrenandnature.org/directory/campaigns/

Garden for Wildlife: http://nwf.org/certify

Nature Rocks: www.naturerocks.org

No Child Left Inside National Coalition: www.cbf.org/ncli/

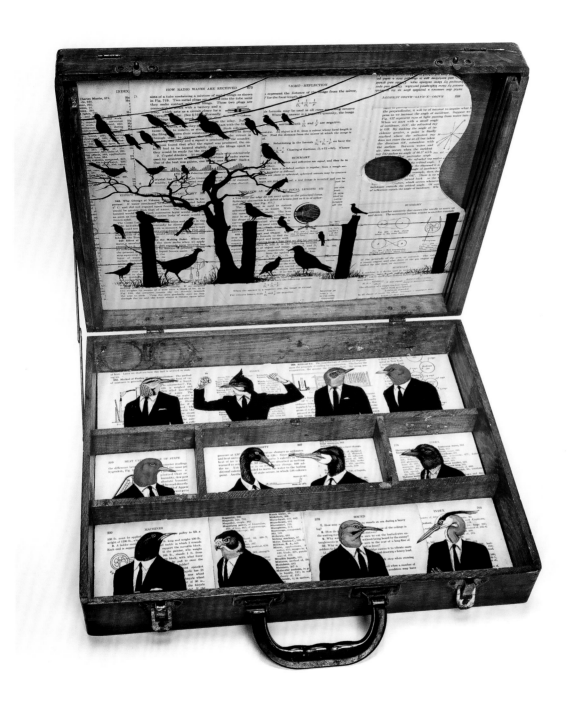

MARK CRISANTI, *Fieldguide*

Falling Apart

TOM MONTGOMERY FATE

How plain that death is only the phenomenon of the individual or class. Nature does not recognize it, she finds her own again under new forms without loss.

HENRY DAVID THOREAU, March 11, 1842, from a letter to R. W. Emerson
(quoted in Robert Richardson's *Henry Thoreau: A Life of the Mind*, 114)

Our cat Rosie, a gray tabby who now weighs just four pounds, is dying. She's completely deaf, nearly blind, and has been since spring. But she holds on and we can't bring ourselves to put her to sleep. She was five weeks old when my wife, Carol, and I found her at a shelter—the same week we moved to Chicago from Iowa to start our new lives together—twenty-one years ago. The kids say that she's over one hundred—that a cat year equals five human years. One of my days feels like five to Rosie. The idea intrigues me. How does that work? Is cat time slower because they never worry—about what to say or wear or if they are late to a meeting? Does Rosie have some sort of heightened kitty consciousness that allows her to live more in the present? Or maybe if I curled up in a bright square of sunlight on the oak floor for a few hours each day, those hours would begin to slow for me, too, to elongate, to become something else. I wish the present would slow down.

I care for Rosie like she is an aging grandmother. I buy her gourmet food and litter: the aged cheddar cheese and albacore tuna dry blend for seniors and the odorless, all-natural multi-cat litter with "quick clumping technology." Each morning I pour some milk in a Mason jar lid and take it down to her in the basement. She can no longer manage the stairs, but lately seems to prefer the basement. Today I can't see her, but I can hear her. She makes bizarre sounds now—odd, mournful meows that sound like a baby crying. It started when she lost her hearing. No longer sneaky or surprising, she half creeps, half limps out of the shadows of my workroom toward what seems to be the highlight of her day—a few ounces of skim milk. Yesterday she peed on our clean laundry rather than in the litter box, which is right next to our clothes dryer. And I find her nuggets of poop all over the basement. It's not her fault; things are decaying, falling apart. It is, it seems, *her time.*

I think of this decay now, sitting outside at dusk on the back porch of our house. The wild green buzz of summer is gone. The robins and goldfinches and bluebirds have flown south or are preparing to. It is the fall. And everything falls—not just the leaves. The temperature falls as the earth again tilts away from the sun. Darkness falls more quickly as the days shorten. Plants droop and dry up and break apart. Trees fall into dormancy and stop growing. Their leaves and seeds fall into the cool air, and then to the ground, where they will rot and root and become something new. This is the season of *decay*—a word that means "to fall away"—to return to your constituent parts, to what you are made of. We die and fall apart, but the parts go on. The same is true for the human species.

Yesterday I saw our friend John at the YMCA. He lives four blocks away from us, but I know him mainly through Carol, who works with his wife, Ellen. They are both school social workers who run programs that assist new immigrant families. Ellen has cancer. She's just fifty-six and their family is very close; she's the kind of mother you can "see" in her three boys. So when I ask John, "How are you doing?" as he stands ready to get on the treadmill, it's a huge question— probably too big to be asked. "Oh, as well as I can," he says. His eyes are exhausted and teary, and I can only presume he is running from and toward the enormous weight of loss, of losing Ellen. I wish I could think of something comforting and useful to say.

"Let us know if there's anything we can do to help." I say "us," but we both know I mean Carol, in whom I can also feel the pending loss of Ellen. Ever since Ellen called to say they were stopping radiation, and that she had perhaps two months left, Carol has been depressed and preoccupied. I imagine the questions that she carries: *Why is this happening? Why Ellen? What really matters anymore? How do I live in gratitude for Ellen's life, and for life in general? How long can an hour be, or a day, measured against the end of a life?*

Carol visited Ellen this afternoon. Tonight in bed she was writing about it in her journal. When I asked her how it went, she broke down. Unable to speak, she handed me the journal.

> *Went to see Ellen today. She's in a lot of pain. The radiation damaged her bones and joints. "I don't know when I should give up," she said. "I'm not done yet. I'm just not done. That's what John and I keep saying to each other. I have more to do. My son said he'd move up the wedding for me. I really want to see him get married. I really do." (Now we are both crying.) "But I want to see him have babies too." Then she just wailed and John came in to see if she was OK. And then we all cried for what was coming, for what we couldn't stop.*

A week later John called us to see if someone could come over and stay with Ellen for a couple of hours in the afternoon while he picked up his son at the

airport. Ellen is near the end, but no one knows exactly how near, so her sons fly in whenever they can to spend a day or two with their beloved mother. I told John that Carol was gone, but that my daughter Abby and I could come over. Before we went, I reminded Abby that Ellen was very sick. "I remember from when they came over for dinner," she says. "She can't talk or walk very good."

When we arrive, John takes us into the living room, where Ellen is sleeping on a fold-out sofa. "I don't know if she'll wake up while you're here," he says, "but here's some water and a Popsicle if she wants it." He gives us his cell phone number. Then he kisses her, says, "I love you." Her eyes open to these words. She's groggy, but John explains clearly and gently: "Tom and Abby are here with you until I get back from the airport if you need anything."

"Who?"

"Tom. *Carol's* Tom, and Abby."

"Oh, OK," she says faintly, in her low voice, which is a bit slurred now. Then Abby greets Ellen, but she doesn't seem to notice. John sets Abby up on a nearby computer with a blinking, beeping video game and then is off to the airport. I sit down in a chair next to the sofa bed.

Ellen has always had a striking presence; she was the kind of person in whom you sense compassion even before they speak. But I barely recognize her now. Her long silver-brown hair is gone, and her bald head is only partly covered by a bandanna above her emaciated body. I'm taken aback by all that has fallen away, yet am also keenly aware of her spirit, of her presence.

She stays awake after John leaves. I feel awkward sitting next to a woman I admire but don't know well enough for a sacred moment like this—and when she is completely vulnerable. So I ask a sequence of dumb questions, including, "How are you doing?" At this, she starts coughing so I ask if she wants some water. She says yes and raises her right arm to show she wants to sit up. I try to support her back, but she grimaces whenever she moves her gaunt body. Finally, I get her sitting up with her feet over the side of the bed. There is no back support, and no position that feels good, so she kind of leans/falls over against me—shoulder to shoulder.

"I think I need to lean on you," she says, "Is that OK?" And for the first time I hear *Ellen*, the humor, the presence. She is comforting *me* in my awkwardness.

"Yeah," I say, smiling. "I think I can handle that." I give her a cup of water with a lid and straw. She takes some sips, gives it back, and looks up at me for a second. The spirit of humor, of fun, is suddenly gone. Her dark eyes seem to carry some deep but unwelcome wisdom—the acceptance of the unacceptable.

Then she starts coughing again, which worries me, because even the small coughs shake her whole body and seem to hurt her. I hold out the water, and she takes a few more sips and the coughing stops.

"Don't tell them about the coughing," she says. "They worry about every-thing." She leans back into my shoulder. Her head hangs down; her gaze falling to the carpet. "How sad that we don't see the miracle in these little things," she says in a gravelly whisper. "The little things aren't little."

I didn't know if she was talking about the water, or the carpet, or just being alive. But I could sense the dark spiral of her sadness, of loss, of time itself—

how her seconds and minutes and hours were no longer numbers hurriedly scribbled in a datebook but the whole living, loving, and breathing world—the one that was/is always here, but which she will leave. The littlest things: the delight or sorrow in her sons' eyes, the eternal rhythm of the ocean at her favorite seashore, or the wonder of an evening walk with John through this very ordinary neighborhood. The littlest things aren't little: warm air, cool water, human touch.

Ellen and I just sit there for a while leaning on each other, with the beeping electronic music of the computer game in the background.

"Is she doing OK?" Ellen asks, now suddenly aware of Abby.

"Yeah, she's fine," I say. Abby looks over and smiles.

A few minutes later Ellen says she has to go to the bathroom, which I wasn't prepared for. Facing her on the sofa, I lean over and lift her under both arms. She grabs the back of my arms and pulls. She is light and fragile when I lift her to her feet, but all of her joints hurt, so she exhales loudly and groans. Immediately sensing my worry, she says, "I'm OK," before I can ask. And then she looks up at me, and somehow we both recognize that we are in a dance position, as if, in spite of her weakness, we are about to cha-cha across the kitchen. Maybe it's because last year Ellen, John, Carol, and I all went square dancing together. I'm not sure. But we both recognize the absurdity of the moment.

"You lead," she finally says, a sparkle of light flickering back up into her eyes. We are each grasping each other's forearms, though I'm lifting and she's leaning.

"Do you know the box step?" I ask. She can't smile like she used to, but I can hear it in her voice—a lightness.

"Yep," she says. And then we shuffle-slide across the kitchen tiles in tiny increments. It takes four or five long minutes to go fifteen feet. But we finally make it. I close the door. Ten minutes later, when she opens the door, we resume our dance position and slowly waltz back to the sofa, where she lies down exhausted.

Today I found Rosie in the basement with two feet in the litter box and two feet out. She couldn't lift any of her legs to move in either direction. She may have been standing like that for an hour. Her fur is dirty and matted because she can no longer clean herself. And she's shaking. I put my hand on her back: "Oh, Rosie, this just isn't fair." She turned her head toward me and tried to purr, but it came out garbled and high pitched, like a sound some other animal makes—maybe a guinea pig. I pick Rosie up, clean off the clumps of urine-soaked litter that stick to her feet and legs, and lay her on her rug. Carol and I have known this cat for half our lives, and so I'm convinced that Rosie understands my sympathy, that she draws comfort from my voice.

And I don't think this is far-fetched, since more and more biologists are beginning to discover that nonhuman animals also have emotional lives. Amid the sadness of the past few months over the pending loss of Ellen, and of Rosie, I've been thinking and reading more about this—about how other animals

grieve—in hopes of better understanding how we are related, how we belong to the same cycle of life. The accounts I've read document grieving in a range of species (wolves, cats, moose, dolphins, llamas, and others) and often concern the death of a parent or mate. The grieving animal demonstrates disturbed behavior and often refuses to leave the dead body, and/or tries to revive it, and/or carries it elsewhere. Jane Goodall writes about a young chimp (Flint) who becomes lethargic after the death of his mother (Flo). He remains near the death site, refuses food, becomes ill and malnourished, and eventually dies from his depression. In her book *Elephant Memories*, Cynthia Moss writes of a group of elephants trying to revive a family member (Tina) who has been shot by poachers. After Tina dies, the other elephants stay with the carcass and gently touch it with their feet and trunks, before slowly covering it up with dirt and branches. I find all of these stories both moving and useful, in part because they remind me of the obvious—that we *evolved*, that emotion is a part of our inherited biology.

After work that day I run home, pick up Rosie, and take her to the local vet. When the doctor examines Rosie, he finds cataracts, a urinary tract infection, and more infection (and perhaps tumors) in her lungs. He says she is in much pain, and that putting her to sleep is a "reasonable and humane" option. I put Rosie back in the little cardboard carrier and talk with the secretary about our options.

"We offer euthanasia by injection and cremation," she says, and hands me a price list:

$210: Private cremation. Rosie's body would be burned separately. All of the ashes would be hers.
$170: Semi-private cremation. Rosie would be burned with other animals, whose bodies would only be divided by a few bricks. Rosie's ashes would be mixed with those of the dachshund or Dalmatian that were burned alongside her.
$85: Euthanasia only and they dispose of the body.
$65: Euthanasia and you keep the body.

We choose the low-budget option and tell the kids. They're sad, but since they've watched Rosie's decline, they also seem to have known this day was coming.

"What do you mean 'put her to sleep'?" Bennett asks. "I thought she was going to die."

"You're right. She is," Carol says. "It's not really sleep; it's death."

"Will it hurt her?" Abby asks.

"The doctor said that it won't. They give her a shot that puts her to sleep, but it's so strong a dose that after she's asleep for a few minutes, her heart will stop."

"And that's when she dies?" Bennett says, wanting confirmation.

"Yes. So they do 'put her to sleep,' but then she dies right after. She shouldn't feel any pain."

The next morning the kids all say their good-byes to Rosie as we make their lunches in the kitchen. Tessa is cuddling Rosie in her arms while Abby and Ben-

nett pet her. We are all teary and, for a moment, quiet—words fail us, which is maybe why I feel even closer to Rosie, who "spoke" most eloquently with her warm, lithe body (yet whose habits and quirky personality I know better than most other friends'). "Remember how she always sat in my lap when I was reading?" Tessa asks.

"Yeah, she was like your shadow," I say. "She really loved you." This sparks a fresh round of tears. Twenty minutes later we get the kids off to school, but they all look a little lost, as if carrying some burden they can't quite recognize.

Early afternoon Carol and I take Rosie to the vet. They put us in a little sterile room where we sit with the cat we love and wait to let her go. "Do you want to hold her while they do it?" Carol asks, and we both tear up.

The doctor comes in. He is young and kind. "Have you had enough time to say your good-byes?" he asks.

"Yes," we both say, and Carol lays Rosie on my lap. The doctor says he'll inject her with pentobarbital, a barbiturate used for anesthesia. But the dose is tripled, so Rosie will go to sleep in a minute or so, and then a minute or two later her brain and heart will stop.

Rosie seems completely relaxed and happy to be on my lap. She is purring. This stops when he injects her thigh, but she is oddly calm to the stick. Then the doctor leaves us alone. We both have our hands on Rosie, and can feel her breath and the soft pump of her tired old heart. We say, "I love you," again to our loyal friend. And then, after twenty-one years—twenty-one human years—the rhythm of her heart stops. A last breath rises and falls away, and she is dead. And I remember why *spirit* means breath—how the body is not all there is.

We lay Rosie in an orange Nike shoe box. An hour later, when the kids arrive home from school, they want to see her. I open the box, put my fingers on her belly, and can't believe she is still warm. And the way she's curled up it's hard to believe that she's dead, that she won't wake up. It's both comforting and a little eerie. She *really* looks like she's sleeping. Bennett looks confused when he sees her. "She's dead?" he says, perhaps fearful of any surprises.

"Yeah," I say. "Her blood is still warm for a little while, but she's dead. We can bury her."

"How do you know for *sure* she's dead?"

Bennett doesn't say anything, but I know he's thinking about Chip and Patch, a pair of hamsters that died last fall. It was my fault. We left town for forty-eight hours and the weather abruptly changed. The temperature dropped from sixty down to thirty. We hadn't turned the furnace on yet, and so the hamsters froze to death. We found them cold and stiff and huddled together on the floor of their cage. But when we picked them up and held them for a minute, they blinked their eyes and started to move their legs and stretch. They had come back from the dead. Like two furry little frozen batteries, the hamsters' nervous system and heart were somehow jump-started by the warmth of our hands. They died two days later, but the miracle of their resurrection and the possibility that an animal could rise from the dead had stuck with Bennett.

So I confirm the finality of Rosie's death. "We're absolutely sure. The doctor even checked."

"OK," he finally said, now tearing up. I pull Bennett into my arms, and he curls into my lap with his head on my chest. He rarely cuddles like this with me, and never for very long. Unless he is sick or tired, after a few seconds he is up and gone. But today he settles in, and his warm body is a comfort—in the same way that Rosie was for him.

I close my eyes, and my mind wanders to another dead animal and another resurrection. Tessa was just four years old. We were blissfully walking along the lakeshore on a windy summer day. In the distance a seagull rested in the sand near the water. But it was in an odd, tilted position—sort of lying on its side. After a few more steps, I could tell it was dead—a huge herring gull that didn't look to have been injured or attacked. The pristine snowy-white body glowed with sunlight; the plump feathery breast billowed out in the wild gusts and then diminished in the calm. I tried to veer Tessa wide—away from the lake and the dead bird—by calling her attention to some cliff swallows nesting in a nearby dune. But she had already zeroed-in on the gull.

"What happened?" Tessa said, clearly worried. "Why doesn't she wake up? Why doesn't she open her eyes? Why isn't she moving? Can't she fly?"

Not having prepared for the moment, I finally just blurted it out, "She's dead, honey. She died." I pretended that I knew why: she had gotten very old, and that's what happens when you get old. I mentioned *The Lion King* and the circle of life and the death of my grandfather, but these didn't satisfy Tessa's curiosity.

"Will *you* die?" she soon asked.

"Yeah," I said. "But not for a very long time."

"And Mommy too?"

"Yes," I said. "But you shouldn't worry about it now sweetie . . ." This didn't satisfy.

"But how long is a long time?"

I was starting to feel inadequate.

And that's when it happened. A hard low gust of wind hit the bird from beneath and lifted its wings skyward. When the long primary feathers caught the gale, they abruptly fanned open. This sudden resistance unlocked the bird's elbows and wrists and opened the secondary feathers. In short, the beautiful dead seagull, now animated by the wind, seemed to have become an angel in front of our eyes. "Daddy?" Tessa said, with both concern and awe in her voice. I started to formulate an explanation—something about how even after we leave the world we are still a part of it. No, she would never understand that.

"That's cool, Daddy!" Tessa said before I could get a word out. She reached down with her little fingers and touched a wing that had come alive, and felt it tremble in the wind. I did the same. "She can't fly, can she?" Tessa said.

"No, not anymore," I said, now deciding to just answer the questions she asked. Then the wind died, the gull's wings fell back to her body, Tessa lost interest, and we continued down the beach.

We should have buried Rosie right away, but the next three days after her death were just too busy with school activities. And Carol was often over at Ellen and John's. Neither of us was in the right frame of mind for a cat funeral, nor had the time to dig a grave. So I put Rosie in a two-gallon Ziploc plastic bag and cleared a little space for her in the freezer. The kids were not alarmed by a dead body in the freezer, since we did the same thing with Chip and Patch. Except we kept them in there all winter because the ground had already frozen.

Saturday morning: I get up early to dig a grave in the backyard, but first pull out Rosie to let her thaw some. Her funeral is tonight. Bennett somehow senses what I am doing and soon appears in the backyard in his pajamas to watch me dig.

"Chip and Patch are right over there," he says.

"Yeah," I reply. "I'll bet they're both decayed by now."

Bennett nods: "It's kind of like the stuff in the compost bin, isn't it?" he says. And I was pleased that he got it, that he knew that bacteria and insects break down the bodies of animals just like they do melon rinds and orange peels.

"Yep. Chip and Patch will turn into some really good soil," I say.

That evening, just after dusk, we all gather at Rosie's grave site. I lay her mostly thawed body in the hole, and we all shovel some dirt in and say something we remember about her. Then I tamp the soil down hard to prevent a coyote or a raccoon from trying to dig her up. Tessa puts a rock about the size of her hand on top of the grave, and Carol sets a small white candle on top of the rock. After she lights it, we stand quietly for a minute watching the tiny flame flicker against the growing darkness. Later that night, while the kids are getting ready for bed, I find them all gathered in the bathroom peering out the one window that looks out on the backyard. "Look, Daddy, Rosie's candle is still burning," Abby says.

The next morning, while I'm mowing the backyard, Carol comes out waving and crying. "Ellen died," she says. "John just called." He asked Carol to coordinate and lead the memorial service, which will be in a week. Ellen will be cremated.

The next day is crazy. Carol's dad calls: while bicycling on an elder hostel trip in France, Carol's mom had become short of breath. They took her to a hospital in Paris to find blood clots in her lungs. The treatment was uncertain. It's frightening.

And Tessa just contracted a virulent flu. She has not been able to keep anything down for three days and is so dehydrated that we have to take her to the hospital. When they hook her up to the IV, it is like her body woke from hibernation. "Oh, I feel better," she keeps saying.

When we arrive home from the hospital, I check the e-mail and find that my niece Sarah's son was just born—Stefan—a beautiful baby boy! He is 19½ inches long, weighs 8 pounds, 1 ounce, and is "nursing like a champ." The wonder and elation of the e-mail, of a new beginning, is welcome news amid all the death and illness.

Thinking of Sarah and Stefan, I sink back in my chair at the computer and close my eyes for a minute. I tune out AOL and Google and the frenetic circus of useless information at my fingertips and fall back into memory—back into the timeless miracle of our children's births. Now, today, it seems that their lives have never stopped beginning, that the present and future have started to blur. Yet I remember those moments well: how the hours and minutes fell away so all that mattered was the soft, beautiful clock of Carol's body, and of Tessa's, and Abby's, and Bennett's. I remember the warm ticking of their blood, and each birth itself: the emergence—of a wet and squirming animal, a child—into the world. I remember their first cries, and their first sputtering breaths of oxygen, and how that breath soon fell into a rhythm, which has never stopped. It is a sacred rhythm—the fragile steady pulse of Creation—that they still carry, that we all do. A rhythm that lets the world fall apart so that it might be made whole.

Acknowledgments

An earlier version of this essay appeared in Tom Montgomery Fate's book *Cabin Fever: A Suburban Father's Search for the Wild* (Boston: Beacon Press, 2011), 121–33. It is reprinted here with Beacon's kind permission.

Recommended Resources

Books and Articles

Adams, Carol. *Prayers for Animals*. New York: Continuum, 2004.
Bekoff, Marc. *The Emotional Lives of Animals*. Novato, CA: New World Library, 2007.
King, Barbara J. *How Animals Grieve*. Chicago: University of Chicago Press, 2013.
Moss, Cynthia. *Elephant Memories: Thirteen Years in the Life of an Elephant Family*. Chicago: University of Chicago Press, 2000.
Parker-Pope, Tara. "Mourning the Death of a Pet." *New York Times* blog, April 21, 2010. http://well.blogs.nytimes.com/2010/04/21/mourning-the-death-of-a-pet/.
Pierce, Jessica. *The Last Walk: Reflections on Our Pets at the End of Their Lives*. Chicago: University of Chicago Press, 2012.
Yonan, Joe. "The Death of a Pet Can Hurt as Much as the Loss of a Relative." *Washington Post*, March 26, 2012. http://articles.washingtonpost.com/2012-03-26 /national/35448737_1_pet-owners-center-for-human-animal-interaction-dog.

Websites

Animal Health Foundation: www.animalhealthfoundation.net/index.html
Humane Society, "Coping with the Death of Your Pet": www.humanesociety.org /animals/resources/tips/coping_with_pet_death.html

Five Squirrels Froze

SUSAN HAHN

Right after the eve
for which we shopped for fancy
crackers for the caviar,
swallowed rich milk
chocolate and toasted
with domestic champagne,
the bad news flattens us
and all the holiday
clichés hung on to.

An illness in the family
that a stranger
has labeled goes far
beyond chatty complaints.
Having something we can name,
no one talks of it.
The house is cold and quiet.

Outside on the icy slope
of our roof, five squirrels froze
to death, or so we thought
for nothing we did
could rouse them.

When the game warden came,
they had vanished. He explained
they sometimes sun themselves
where they find the warmest spot.
Tonight we leave some bread and hope
they will be back, give us another chance
to see how they exist.

The One That Hums

KENDRA LANGDON JUSKUS

The bird, the one that hums,
sings a blue note
above the autumn garden's thrumming,

ochre silence. No hope:
winter rides a breeze
without remorse, roping

frost among the trees.
On every windowpane curl
its reminders of the old disease:

in new life old death unfurls.
See the frost's pattern
on the yarrow's fisted whorl

and the light draining to the south.
The autumn garden's a purple burn,
each seed head a gaping mouth.

Mysterium Opossum

LEA F. SCHWEITZ

I teach at the Lutheran seminary in Chicago's Hyde Park neighborhood. Our students are curious, perceptive, passionate, and active in the pursuit of justice. In my first years of teaching, I would hear students recall camping trips in Yellowstone National Park or hiking retreats in Superior National Forest as transformative experiences that left them with an unmistakable sense of being connected to something larger and something mysterious. My students' sense of the sacred was linked to their experiences of nature, but for many the urban experience of seminary was too remote from these places of "pristine wilderness." Chicago's landscapes were deemed too unnatural, and, as a result, spiritual lessons at nature's knee were quarantined to spring break camping adventures in Michigan or the occasional Saturday trip to the Indiana Dunes. Much to my regret, they seemed to be missing the opportunity to nurture "nature-assisted spirituality" in the city.

However, here was a teachable moment! Rather than exhorting and admonishing them to change their ways, I simply asked that they be ever vigilant for sightings of the sacred in the city. At first, students mainly brought back reports of acts of kindness between strangers in public. Then, slowly, we started to receive sightings of the sacred in urban nature. For example, there was the prairie restoration project on the lakefront that became a metaphor for the blessed community. It modeled the give-and-take of ecological and social communities that are rooted, diverse, welcoming, discerning, and an expression of the sacred.

And there were sightings of migratory birds that taught us spiritual lessons about the importance of the journey, trust, safe havens, and the meaning of home. Christian traditions have long histories of looking to animals for spiritual guidance. Although they are a minority report, Laura Hobgood-Oster has shown that animals have played important roles as exemplars of piety, messengers of the divine, and even saints and martyrs.

It was a delight to see students making connections between city creatures, urban nature, and the sacred. These encounters allowed them to reclaim an important piece of their spiritual lives in the city, to learn new ideas about where and how the sacred is active, and to unsettle long-held assumptions about what

nature is and is not. And soon enough, it was my turn: it wasn't long before a city creature showed up on my own doorstep to remind me that urban nature had spiritual lessons to teach me, too.

It was just before twilight on an early spring afternoon when an awkward something passed by the sliding-glass doors that look out onto our postage-stamp-size yard. This something did not escape the notice of my son, and it elicited one of my favorite questions from him: "What is that?"

Our little coach house in the Hyde Park/Woodlawn neighborhood on Chicago's South Side sits on an alleyway. Both the alley and the yard are major thoroughfares for the resident feral cats and squirrels. Many times a week, my son and I will be building towers with wooden blocks only to realize that our playtime has become a spectator sport for a furry feline friend. On this particular morning, something about the fur and the gait was different, and my son was curious. "What is that?" he asked again.

With that question hanging in the air, we ran to the window, pressed our noses to the glass—and looked. The tail was distinctly rat-like. Then, probably because of the noise of our hands and noses pressed to the window, the creature turned and peered back at us. He looked at us with beady little black eyes. We caught a glimpse of his pointy snout, mouthful of teeth, dirty-looking fur, and again that distinctly rat-like tail. Now, standing hand-to-paw with the creature on the other side of the glass, again, my son asked: "Mama, what is *that*!?"

With surprise, I said, "Why, it's an opossum!"

His next question was: "What's an opossum?"

I grew up in a very small town in northern Illinois; my hometown has no stoplights. After school, I played on a farm with cows and pigs and farm cats. We drove dark gravel roads on which we were more likely to meet a deer or raccoon than another car. In that landscape, opossum encounters were rare but not out of the ordinary. Growing up in the city, my son is exposed to a variety of animals: dogs in the parks, cats in the alleys, squirrels and pigeons and crows and sparrows on walks, farm animals and dinosaurs in books, and wild animals in zoos. Yet it's a challenge for him to get to know our neighbors—animal or otherwise. If the neighbor in question is a creature like the opossum, city kids like my son aren't likely to encounter them at all. After all, the Virginia opossum, *Didelphis virginiana*, does not rank very highly in the urban cultural imagination. In fact, the Virginia opossum does not rank very highly in anyone's imagination. It's the koalas and wombats and kangaroos that get all the attention among the marsupials. However, here was another teachable moment, and the teacher in me jumped at the chance to share some facts about the opossum.

To begin, I told him some things I already knew, including that the opossum is not an overgrown rat. As Joel Greenberg relates in his *Natural History of the Chicago Region*, the opossum's long, naked tail makes it look like a rat, but rats and humans are more closely related to one another than either is to the opossum. The opossum's fur looks dirty because it has a mixed coat of white under-

fur overlaid with gray or black guard hairs. Unfortunately, that grizzled fur does not protect their ears and tails from frostbite during cold Illinois winters.

Although they may act fierce, bare their teeth, and hiss, they are not likely to fight. Rather, if an opossum is threatened and there does not seem to be another way out, it will "play dead." The creature will fall involuntarily into a coma-like state and endure kicks, bites, beatings, and other afflictions without showing signs of suffering or concern. The strategy is that a dead animal will be ignored rather than tortured, but when that strategy fails, the opossum can keep up the act through the abuses. Then, somehow sensing that the danger has passed, the opossum "comes alive" and continues on its way.

Like other marsupials, the opossum has a pouch in which immature young grow for several months. The opossum is the only marsupial in North America, and it will eat whatever it can find. This could include almost anything from frogs, birds, and insects to fruit, pet food, and food waste scavenged from dumpsters.

Our curiosity now piqued, the next stop was the library to learn more about this nocturnal omnivore. The opossum is a well-known character in the stories of Native Americans. In some, the vain Opossum boasts of the beauty of his fluffy tail, only to have it stripped bare by Rabbit. In others, he attempts to beat Raccoon to a morning meal of crawfish, only to sleep through most of the day. As a trickster, Opossum has the reputation of stealing fire and giving it as a gift to humans.

Despite this rich folklore tradition, we didn't uncover much in the opossum genre of children's literature. Mem Fox's *Possum Magic* was one of the few children's stories we did find. It's a tale about a young Australian opossum that had been made invisible by her grandmother's magic so that she couldn't be seen—or eaten—by snakes. For the young opossum, it was nice to be safe, but it was better to be seen. The story is about the search for the magic that will make her visible again. It was a lovely tale about an adorable opossum in the Australian bush who wanted nothing more than to be visible to the world.

There was one striking similarity between the cute young Australian opossum in the bush and the urban opossum in our backyard: both were invisible. The body of the young Australian opossum was made invisible by her grandmother's magic to keep her safe. The opossum in our backyard had been mostly invisible, too, but he seemed to prefer it that way. *Possum Magic* is a sweet story, but it elided all the ambiguity of our encounter with the opossum. It misrepresented the opossum as a creature who, if given the choice, would choose to be seen. Instead, our opossum was a creature of the twilight hours, hiding under decks, and scurrying away from our direct gaze. He seemed to want nothing more than to remain invisible and unseen.

Ironically, it was all this talk about invisibility that revealed the hidden sacred in our encounter with the opossum. It forced me to question what else I might not be seeing in the opossum because neither the facts nor the books captured the sense of mystery that we felt while in his presence. I moved too quickly to teach my son the facts about opossums and almost missed a chance to learn from the opossum himself. Naming the creature and describing its hab-

its didn't answer my son's deeper question about who this opossum was, so he had to keep asking: "Mama, what *is* an opossum?"

In retrospect, the irony here is unnerving. I had been asking my students to be ever vigilant for sightings of the sacred in the city. I asked them to stay open and be willing to learn at all times from the world they encountered. Yet here, just outside our window, my son and I were graced by such an opportunity, and I nearly missed it because I did not expect to see the sacred in such an ordinary place or in the form of such an ugly, odd creature.

The whole experience has been unsettling and slowly transformed my sense of both the city and the sacred. The opossum revealed that if I'm painfully honest with myself, I, too, expect the sacred to appear in special places—in beauty, in quiet, in the peaceful spaces of the holy. I am more likely to be open to the sacred in a church, on a remote Michigan shoreline, or in the beautiful natural spaces of my daily urban life. Like my students, I had grown to see the sacred in the prairie restoration projects and the migratory birds, but I wasn't quite ready to see it active in the likes of the opossum.

The problem is that theologically I don't believe any of this. As a Christian and as a Lutheran, I trust in a God who can and does work anywhere, and I confess a God with a history of showing up in unexpected places. These places are unexpected because they are so ordinary. They are the everyday places where simple meals of bread, fish, and wine are shared. They are the mundane spaces in which communities gather to fight injustice and where the world cries out in suffering. The sacred peeks through this ordinary world in an ambiguous mix of the finite and the infinite, and it includes the opossum.

Our short time with the opossum was equal parts fear and fascination. Standing before this weird, creepy little creature, we didn't know whether to turn away from him or turn back to him. It was not the tranquil experience of beauty in the majestic flight of the sandhill crane or the graceful step of a deer or the loving companionship of our pets. There was something awesome and wonder-filled in our encounter with the opossum, but it was also uncanny and disturbing.

In part, it was the very uniqueness of this creature that contributed to our mixed reaction to it. We felt both a curiosity about this odd beast and, simultaneously, repulsion. Unlike other encounters with urban animals, the first reaction here was not to try to touch it. It was unlike the dogs in the park that might be up for a scratch behind the ears or the squirrels that manage to stay just out of reach during a good chase. With the opossum, we wanted a closer look—but not too close. This may be why I sought answers for me and my son in the familiar comfort of a library rather than in the unsettling presence of the opossum.

But being present with urban nature and the sacred that hides within it is rarely easy; it's ambiguous and unpredictable and fascinating, and sometimes frightening. In the ordinary course of life, the sacred appears in the experience of *mysterium tremendum et fascinans*. This phrase was most famously used by the influential twentieth-century theologian Rudolph Otto in *The Idea of the Holy*. It describes the experience of the sacred as one that overwhelms us as we confront a mystery that makes us tremble in fear; this is the *mysterium tremendum*.

At the same time, the immense mystery draws us in as we are filled with awe and wonder; this is the *mysterium fascinans*. Our experience with the "*mysterium opossum*" showed me how the sacred shows up in the city under the masks of ambiguity, and it revealed the limits I had imposed on the sacred in urban nature. It's too easy to say that we overlook these encounters with the sacred because we're too busy, too distracted, too disconnected, too everything. All true, perhaps, but the real trouble is more pernicious. The real problem seems to be with ambiguity itself.

Ambiguity is a liminal, twilight space. It's a thin place between the visible and the invisible, between the sacred and the ordinary. It runs counter to our fast-paced, productivity-minded cultural markers of success. Ambiguity slows down our thinking; it complicates our decision-making. Ambiguity is inefficient. In the presence of ambiguity, our first impulse is to seek resolution and clarity. Admirable as these goals for restoring order may be, too often they demand premature simplification, including the tendency to entrench in a position and to shut down the "opposing side."

From this perspective, the obvious solution to our "opossum problem" was to call an exterminator. When I related the story of our "opossum encounter" to other adults, more often than not, they offered a "helpful" recommendation to give me the number of "a guy who can take care of it." My friends and neighbors heard our story of the opossum with the implied question: "How do I get rid of it?" Quick, efficient, clear. Problem solved.

We're so accustomed to this train of thought that we forget that sometimes we have a choice to abide in the ambiguity rather than resolve it. We have more options available than exterminating the opossum or sanitizing him enough to make him fit for a storybook. We can choose to be present to the twilight places of ambiguity because here we might catch a surprising glimpse of the sacred.

We chose not to make that call to the exterminator. As a family, we took a lesson from my son and asked: "What's an opossum?" We took flashlights to the backyard to examine the various cracks and openings that might provide lodging or food or water. We looked for clues about this mysterious neighbor, all the while fearful that we might come face-to-face with him. As a family, we talked together about what it takes for an opossum to live well in our neighborhood and how we could find a way to live well with him.

I won't deny the ambiguity we continue to feel about the creature, which we suspect has taken up residence under our deck. There's the possibility of fleas, the nuisance of the holes under the fence, and the damage to the plants. But there's also the mysterious sacred in all its terrifying, fascinating ambiguity, living so close to us that he's present to us even when we can't see him. In the end, we are grateful that the ambiguity and mystery remain. The opossum taught us that by abiding in the ambiguity, we can remain open to the grace in him and to the possibility of other unexpected spiritual lessons in urban nature.

Recommended Resources

Books and Articles

Austin, Alfredo Lopez. *The Myths of the Opossum: Pathways of Mesoamerican Mythology.* Translated by Bernard R. Ortiz de Montellano and Thelma Ortiz de Montellano. Albuquerque: University of New Mexico Press, 1993.

Fox, Mem. *Possum Magic.* New York: Harcourt, 1991.

Greenberg, Joel. *A Natural History of the Chicago Region.* Chicago: University of Chicago Press, 2002.

Hobgood-Oster, Laura. "Holy Dogs and Asses: Stories Told through Animal Saints." In *What Are the Animals to Us?: Approaches from Science, Religion, Folklore, Literature, and Art,* edited by Dave Aftandilian, Marion W. Copeland, and David Scofield Wilson, 189–203. Knoxville: University of Tennessee Press, 2007.

Hoffmeister, Donald. *Mammals in Illinois.* Urbana: University of Illinois Press, 1989.

Hunter, Anne. *Possum's Harvest Moon.* New York: Houghton Mifflin, 1998.

Judson, Katharine B., ed. *Native American Legends of the Great Lakes and the Mississippi Valley.* DeKalb: Northern Illinois University Press, 2000.

McDaniel, Jay. "Practicing the Presence of God: A Christian Approach to Animals." In *A Communion of Subjects: Animals in Religion, Science, and Ethics,* edited by Paul Waldau and Kimberley Patton, 132–48. New York: Columbia University Press, 2006.

Otto, Rudolph. *The Idea of the Holy.* New York: Oxford University Press, 1958.

Roy, Susan Carole. "Paw Prints on Preaching: The Healing Power of Biblical Stories about Animals." In *What Are the Animals to Us?: Approaches from Science, Religion, Folklore, Literature, and Art,* edited by Dave Aftandilian, Marion W. Copeland, and David Scofield Wilson, 205–17. Knoxville: University of Tennessee Press, 2007.

Website

Faith in Place: www.faithinplace.org

Raccoon

AMY NEWMAN

Have you seen him attack? He wonders.
Stumbling like a suffering guest,
panicked in flowers. The gray dusk outlines

make nature almost sweet. The muscari like little edens,
young leaves in that innocent spring green
against bright flagstone—maybe it will storm;

the raccoon doesn't care about your weather,
your tulips, waxy and serene, the wretched love of pretty.
Distress shivers the trees. Even the squirrel evades, propelled,

conveyed, in haste. The raccoon is embarrassed
by your ignorance. He will tear it all to shreds.
Have you seen the savage teeth? He wants to know.

The raccoon is penitent like everyone else.
But he never averts an eye. He is ashamed
to eat and kill, he is ashamed

of his gait, the nocturnal shriek,
the malice, the contradictions in nature,
all fur and affliction, the difference

between his costume and his hunger, the ashen
obligations of survival. Oh the raccoon is ashamed,
he regrets his lot, but it doesn't stop him.

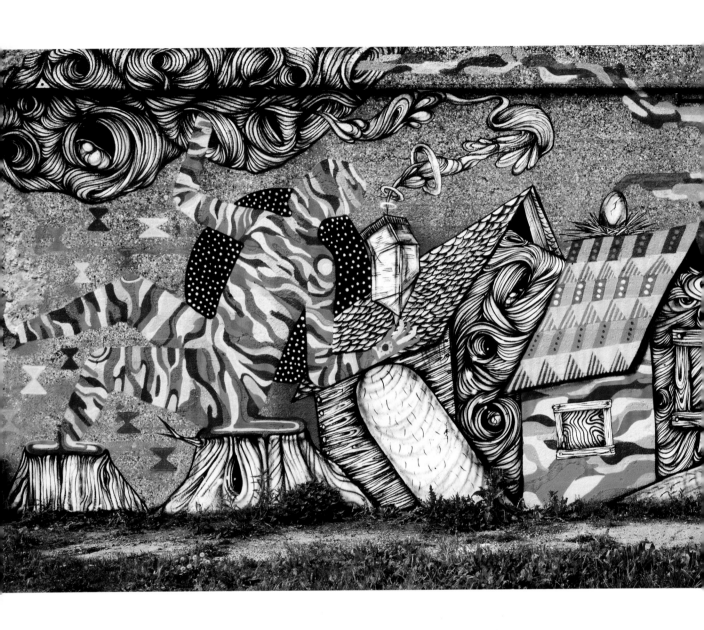

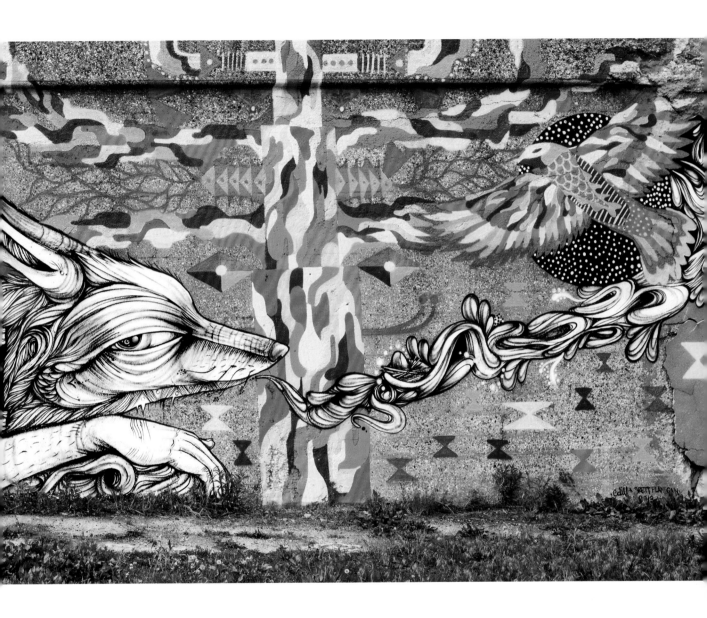

CANNON DILL AND BRETT FLANIGAN, *Fox*

The Fox

AMY NEWMAN

The fox didn't know it was tame.
I fed the fox; I provided the environment.
Just don't hurt the cats, I warned.

The fox was unaware it was tame.
It sat on the deck when it snacked on what I gave him.
Beneath the deck small birds pecked at the grasses.

The fox has pretty black legs and a red, curt body.
Sweet ambivalence! And with such sharp teeth!
The fox behaved like a fox, ignored

my one request, so I don't feed him anymore.
What are the signs of the world falling?
1) I don't open the door

2) A dry mouth, a parched tongue 3) The hunger
4) I disappear. It is colder as the season changes.
Whatever provided the daily bread no longer provides;

the hungry birds are bound for a thinning,
the scattered moles. Even my beautiful fox has bones,
severe and sour in the lamentable, angry,

exacting eye of autumn. At the root of the tale,
regret shifts her legs in bitter steps; she pretends not to notice
the languishing everywhere. Take care. Be well!

Bon voyage! Something or someone has turned the head
on the neck of giving. The fox had no idea
what it was to be wild, to be abandoned to wilderness.

A Eulogy for My Friends

That first day,
I felt triumph, when I saw your parents nesting just three feet from the
 ground.
I felt pleasure, when I saw your tiny, gaping beaks begging for food from your
 frantically foraging parents.
I felt elation, when I bundled you into the box I had especially built to carry
 you home safely on my bike.
I felt relief, every hour when each of you chirr-chirred loudly every time I
 approached your nest.
I felt sneaky, when I brought you to class, the store, the office, so that we
 could be close and I could feed you on time.
I felt pride, days later when you chirred and chirred for me but cowered in
 fear of every other human.
I felt accomplished, when it was clear my diet and feeding schedule provided
 you with the resources to fledge successfully.
I felt joy, as we played together and fought over worms.
I felt fear, when my brother would leave the door open, that you would fly
 away, for you have no homing instinct.
I felt like Mozart as we practiced new whistles together.

That last day,
I felt dismay, when I found that I had to leave and could not take you with me
 to my new home.
I felt bewildered, that I could not find other people fascinated by you, willing
 to clean your feces and feed you worms and mushy food.
I felt sorrow, that I could not release you.
I felt sad relief, when my brother left the door open and one of you flew away.
I felt sad peace, when I buried the other two of you.
I felt contentment, with your life and with your death.
I feel like Mozart, when your brethren "… from the sky, Praise me without
 pay, In [their] friendly way. Yet unaware that death, Has choked [your]
 breath …"

This morning,
Though I focused on my duty of shooting your brethren from their perches at
 a dairy farm,
I smiled, at the beauty of the flock and the pleasant tinny calls and whirring
 wings that filled the air,
and thought about raising another as a pet
so that I can live once again
closer to the joy your species brings to me.

I share this eulogy because it represents a poignant culmination to my attempt to find a consistent and rational position in a biological world so strongly influenced by humanity's actions and ignorance. Of myself, I demand not just a concrete rationale for my actions but also action based on that rationale. It is not enough for me to have a belief; I must act on that belief. However, this can be difficult when it involves life and death.

As a child, I discovered a seeming contradiction in human motivation versus action when I cut flowers to decorate the dining table: the flower, so desirable for beautifying the room, soon died because of my cut. This realization later expanded to considerations of sheep in a pasture versus on a plate, trees in a forest versus in the structure of a home, my own residence on a piece of land versus the millions of organisms that used to reside there. I came to understand that our species' dominance and influence lies largely in our ability to utilize other species, to mimic natural processes, and to manipulate environments. We are not more powerful, more enduring, nor more procreative than other species. But we do watch and learn how to exploit these characteristics of other species and natural systems.

The challenge of balancing my needs with those of the rest of creation gained clarity, but also complexity, as I learned the principles of conservation biology. This science strives for the ideals of preserving intact natural habitats and all their native species, while simultaneously considering the desires of humans to use species and their natural homes. One way I apply conservation principles is to do whatever I can to maximize native biodiversity everywhere (in both natural and human-dominated places) and to sustainably enjoy that biodiversity. "Sustainably" enjoying biodiversity requires a complex consideration of factors such as the species involved, how quickly they reproduce, and how abundant they are. Sustainability would likely preclude developing virgin ground and discourage cutting new roads or trails but might allow cutting flowers or trees or eating meat. Such an approach is not necessarily perfect nor superior to other perspectives, but it is the way I attempt to make justifiable decisions about my impact on this planet. Ultimately, this complexity predicted my eulogy because my friends were starlings, *Sturnus vulgaris*. Sometimes celebrated, often vilified, starlings exemplify the challenges of being *Homo sapiens*, the most influential species on the planet.

You have almost certainly seen a starling before; you've probably seen one

today. You, too, have even caused their death (though most likely only indirectly through your tax dollars and purchasing decisions). You and I make many decisions every day that result in death. Sometimes animals will die in our hands, but more often they die unseen, unheard, unnoticed, the result of something like growing cotton, mowing lawns, mining metal, and millions of other actions undertaken by others on our behalf.

We're often taught that death is bad and that compassionate people work to save life. However, the science of conservation biology considers not just the life currently present but also the life that may come, and how different forms of life have influenced each other in the past and may do so in the future. This gives us hope for sustainable, perpetual abundance and complexity of life. My little friends taught me that compassion, practiced in a way that is rational and consistent with scientific principles, may have painful consequences, with consolation coming only through a conviction that ecological relationships that have existed longer than our own species should not be destroyed through our actions.

Though computers and other electronic gadgets have given us new ways to do old things, for the most part, the world many people experience on a daily basis began around 1890. As measured by a human life, this was generations ago. As measured by ecological relationships, it was very recent. In 1890 people were reading the adventures of Sherlock Holmes, some by electric light, and using their AT&T telephones to talk about it. Cars were being produced and soon airplanes would be common, though bikes were the fashionable mode of transportation. A steel skyscraper was built in Chicago, a movie shown in New York, rubber gloves used in surgery, and corrugated cardboard was replacing wooden boxes. The forty-third and forty-fourth states entered the Union while the last battles between the U.S. Cavalry and American Indians were being fought. Vast bison herds were just a memory, and the equally astonishing passenger pigeon was nearly so. The plague locust seemed to have disappeared too (or at least everyone hoped so). John C. Frémont and Sitting Bull died that year, while Ho Chi Minh and Dwight D. Eisenhower were born. In 1890 the U.S. Census Bureau declared the American frontier closed—there were no major areas left to explore or settle between the American coasts.

Another curious and impactful thing happened in the year 1890. A pharmacist whose name could have belonged to a character from the *Wizard of Oz*, Eugene Schieffelin, made a contract with some unknown person in the Old World to capture a few starlings and pack them into wood and wire crates for shipment to New York City. The stress of overland shipment would have killed some, while the challenges of crossing the Atlantic Ocean by steamship would have killed still more. Once they reached the New World, the immigrants faced the parasites they brought with them, the new parasites and diseases of America, unfamiliar predators, competitors for food and shelter, and snowy winters more bitter than they had ever experienced. Yet some survived.

Schieffelin proudly released the immigrants, intending that they populate New York's Central Park. It's said that they spent the winter huddled in the eaves of the American Museum of Natural History. The next year, more star-

lings were brought to the city from Europe and released. In all, only about six-teen pairs survived to join the diverse American biota, but after a few winters of touch-and-go survival, they were here to stay. By the time the celebrated Mr. Schieffelin died in 1906, his starlings could be found throughout the boroughs of New York and much of the "Garden State" of New Jersey. And if he ever had grandchildren move to California, they would have been met with the rusty churrs and staccato whistles of his bird there, too. A mere fifty years after those first birds were released, their species had colonized our country from coast to coast. Despite a mortality rate that can be 75 percent in the first year, the progeny of those thirty-two foundlings now number nearly 200 million hun-gry birds.

The starling is one of the most common birds on our continent, responsible for nearly half of all bird/plane collisions, and costs millions of dollars in direct crop and feed damage, as well as millions more in cleanup and disease preven-tion. It kills other birds by outcompeting them for food, by taking over their nests, by killing their young directly, or simply by building nests on top of their eggs or young.

It wasn't just the starling that people were moving around the globe. Groups throughout the world sought to import living animal and vegetable material that had proved useful or interesting elsewhere and acclimatize it to new places. Thankfully (as we would say now, knowing the consequences of such introduc-tions), not all imported species survived. Dapper Java sparrows, the blackbird of four-and-twenty fame, the warbler-like European robin, and many others succumbed to the challenges of a frontier lifestyle. At the time, the loss of these individuals, imported with such high hopes and at such expense, was mourned. Today, though, we thank the kestrel that plucked the last bullfinch from the air, the cowbird that parasitized the nests of the chaffinches, and the roundworms that pierced the heart of the nightingale. These are European birds, adapted to survive the assaults of European predators and plagues. In turn, they too are predators of European seeds, insects, and flowers. The existing ecological re-lationships of the eastern United States had no interstices that would accom-modate the persistence of these species so, once released from the daily care of the cage, the life-and-death nature of nature took over, and today these birds remain uniquely Old World.

Within its native range, every organism has a circumscribed place in a crazy-quilt patchwork of soil type, day length, minimum and maximum temperatures, predator and prey, disease and host, and neighborly interactions. Whether mo-tivated by emotions such as fear (rational or imagined), love, aesthetics, nostal-gia, or greed; or for reasons of utility, hunger, ignorance; or simply by accident, humans have removed, covered up, and rearranged pieces of this patchwork, and continue to do so. We have ripped out patches and threads, obliterating patterns, muddling and homogenizing our biotic quilt.

As a child I could see this patchwork in the distribution maps found in field guides. Though I didn't yet understand why, few of the animals in these guides could be found near my home, but some species could be found in abundance. My insect collection was soon full of June bugs, Japanese beetles, European cab-

bage butterflies, and Chinese mantids. My collections of rocks, seeds, and pre-served tropical fish also grew, but I yearned for a pet bird.

I had read stories about boys who raised crows as pets, listened to my grand-mother tell the adventures of rehabilitating an injured owl in the laundry room, and saw mounted birds in museums. Once I was old enough to consider hav-ing my own adventures with a pet crow, I learned that, since the publication of those books, such activities had become a crime. When I found a dead great horned owl on the side of the road, I was told by an officer that to touch it was also a crime (or at least the legal penalty was greater than the crime of leaving it to rot in anonymity), since these owls, like nearly every species in our country, are protected by the Migratory Bird Treaty Act.

As I studied, I began to understand why my neighborhood was not as inter-esting as the books implied it should be and why such stringent protections of birds were necessary. Overharvest for the food and feather markets was a major problem and brought many species to the brink of extinction. Once such unsus-tainable hunting was banned, chemicals sprayed on our crops and lawns con-tinued to kill birds through a wide range of insidious means. Though laws strive to better regulate our home and industrial chemical use, domestic cats freely wander our neighborhoods, often eliminating all birds but the most tenacious and invasive species. Most damaging of all, habitat destruction, ranging from the construction of new buildings to the invasion of prairie by trees, eliminates the places necessary for biodiversity.

So, for regrettable but mostly good reasons, I was denied the opportunity of close association with the majesty of the owl, intelligence of the crow, dark ro-mance of the raven, beauty of the cardinal, and nearly all of the other species that children of an earlier era had kept as pets. But with starlings, an abundant and destructive bird, invading from a foreign habitat, the laws were different. Federal and state law afforded no protection; scientists, naturalists, and even some ethicists suggested its elimination.

Invader, vector, dominator . . . pest. These are all words used to describe this stubby-tailed, sharp-billed, oily-sheened bird. Because of their history, ecol-ogy, and destructive impact, the starling is an accessible bird—you can see it, touch it, be involved with it in any way you like. The exotic starling is the peo-ple's bird. Everyone sees it, even if they don't recognize it. If you want to learn how to hand-raise or rehabilitate a bird without the danger that you might kill a more "valuable" species, try a starling. If you want to practice your aim or learn taxidermy, the starling is a legal and useful subject.

So, when I found that nest, so close to the ground, with three naked chicks inside, I knew I had found my birds. I anticipated a lifetime of learning and fun. I could not anticipate the challenges I would face balancing my love for individual animals with my developing commitment to consistent action and ecological integrity. Even before these deeper issues, though, were social ones. People who might have been complimentary if I told them about a pet kestrel or amused by a pet jay were confused or even mocking when I told them about how well my little brood of churring starlings was progressing. "Why put so much effort into a dirt bird?" some asked. Even budgies and zebra finches got

more respect from friends than my brood. Yet I loved my birds; and not just because they were my helpless charges, but because starlings are intrinsically fascinating.

Once the youngsters fledged, I kept the feathers on one wing clipped. For many species this works as an effective way to keep a pet bird from flying away. Unfortunately, starlings are compact powerhouses that may be slowed by feather clipping, but they could still fly faster than I could run and land higher than I could climb. Furthermore, like most birds, starlings don't have the homing instinct of the city pigeon. If my starlings escaped, they would have simply joined a passing flock and I would never have seen them again. In such a situation, I would have missed the birds and worried that they would die painfully, but, more importantly, I would have worried that their survival could have a negative impact on native bird and insect populations.

Released into the wild, recent captives usually die a quick death of starvation, exposure, predation, or trauma. But, like my birds' pioneer ancestors, a few invaders may survive and breed. Sometimes their presence is obvious: swarms of colorful goldfish in a pond, piles of red-eared slider turtles basking on logs, the deafening thunder of coquí frogs at night. Other times released invaders are more difficult to detect: the crayfish hiding in the mud, the brown anole clinging under a branch, the feral cat under the deck. Whether their presence is easy to detect or not, these survivors frequently have negative consequences for their new home and the species that have been resident there for thousands or even millions of years. The result is biotic homogenization and impoverishment. Increasingly, the animals you see out your window are the same as those seen by your friends in distant places, and you both see fewer species overall. As homogenization increases, the beauty, inspiration, and distinctiveness of place are diminished.

With this knowledge, I felt good because I had done a small but productive thing by making pets of a species that should be exterminated; removing them from the environment but preserving their lives. But then, unexpectedly, I had to move out of the country and I began to worry. What was I to do? I wanted to keep the birds, but I could not take them with me. Who could care for them for the years I was away? Birds are hard to keep. They eat all day (and in the case of starlings, they need insects and other soft foods), poop all day (and in the case of starlings, have very splattery droppings), and their cage must be cleaned each day (and these birds were only bonded to me, so they would probably try to fly away when the cage was opened by someone else). So I needed a special person to help.

I approached several experienced bird-keepers. "Can you keep them for me?"
"No space."
"I only keep seed eaters."
"They aren't pretty."
"They're too aggressive for the other birds in my collection."
"Starlings? You've got to be kidding!"
I was stymied. My knowledge of ecology prevented me from simply opening the cage and bidding a hopeful farewell as the birds joined a local flock. While

it would be a conservation sin to damage populations of starlings in their native range in Eurasia, on the basis of similar principles, killing every starling in the North American continent would be a highly laudable action. And so I came to the point where a eulogy for my friends was necessary. There was no home for these individuals; not in captivity, not in wild North America, not in their ancestral Eurasian range. Of course the question might still remain: Would my birds have made a difference? In *A Sand County Almanac*, Aldo Leopold noted, "One of the penalties of an ecological education is that one lives alone in a world of wounds." I saw those wounds and I could not contribute to them. Better the pain of myself and my little friends—immaterial from a biological perspective, infinitely brief from a geological perspective—than contribute to a scourge that was still altering the autochthonous world.

Since I said good-bye to my birds, I have been able to work with and rehabilitate a wide range of species. The skills my little starlings taught me have benefited the lives of many individuals of native species who, hopefully, have augmented and helped increase local native populations. Though I work toward the day that starlings and other exotics can be eliminated from the habitats they have invaded, I also look forward to the day that I have both the space and time to share my home again with a starling or two.

Recommended Resources

Books and Articles

Coleman, John S., Stanley A. Temple, and Scott R. Craven. "Cats and Wildlife: A Conservation Dilemma." Madison, WI: Cooperative Extension Publications, 1997. Available online at http://web.extension.illinois.edu/wildlife/files/cats_and _wildlife.pdf.

Corbo, Margarete Sigl, and Diane Marie Barras. *Arnie, the Darling Starling*. Boston: Houghton Mifflin, 1983.

Leopold, Aldo. *A Sand County Almanac*. Oxford: Oxford University Press, 1949.

Linz, George M., H. Jeffrey Homan, Shannon M. Gaukler, Linda B. Penry, and William J. Bleier. "European Starlings: A Review of an Invasive Species with Far-Reaching Impacts." In *Managing Vertebrate Invasive Species: Proceedings of an International Symposium*, edited by Gary W. Witmer, William C. Pitt, and Kathleen A. Fagerstone, 378–86. Fort Collins, CO: USDA APHIS Wildlife Service, National Wildlife Research Center, 2007. Available online at http://www.aphis.usda.gov/wildlife _damage/nwrc/symposia/invasive_symposium/nwrc_TOC_index.shtml.

Lockwood, Julie L., and Michael L. McKinney, eds. *Biotic Homogenization*. New York: Kluwer Academic/Plenum, 2001.

West, Meredith J., and Andrew P. King. "Mozart's Starling." *American Scientist* 78, no. 2 (March–April 1990): 106–14.

Prayer for the Squirrel

MARTHA MODENA VERTREACE-DOODY

Not the red-brown rascal I watch late afternoons
chew leafless branches off the backyard lilac
as if to nibble winter away.
 The dazzling dare in his eyes.
The basement housed this grey one in prayerful darkness
several days before I see him
 scurry under the staircase—
the catcher says mid-morning after last night's call
when I abandoned wet sheets in the washer;
dirty towels on the floor. He nods at the squirrel
already dead, the live-trap
 baited with dinner: peanut butter,
apple wedges—now a useless boast. Hunger, the guy says,

or stress, "jittery varmint"—echoing my uncle hunting moles
under buttermilk sky, chill wind rising over the Ohio.
The body in rigor, the catcher adds.
 Wrapped in a plastic bag.
My fault, as I recall wood stairs creaking under my feet,
the exercise bike wheeling
 to the six o'clock news,
my voice screeching "Nessun Dorma"
as if sleep were ever that easy.

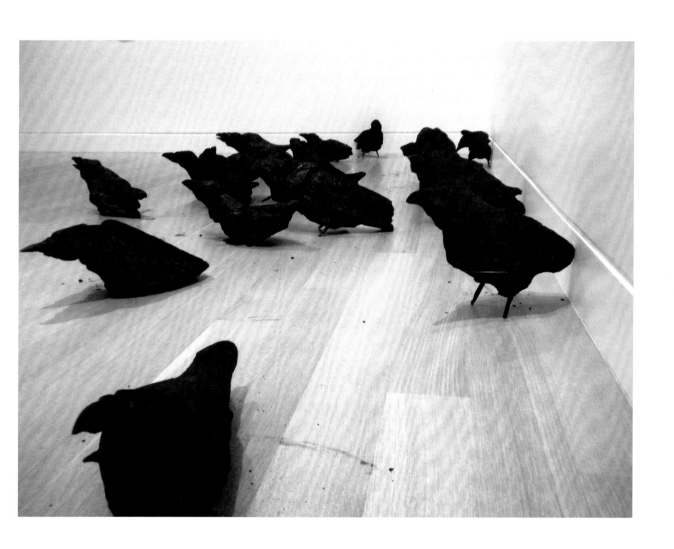

MASKULL LASSERRE, *Murder*

XAVIER NUEZ, *Asha: jewel of the Nile*

The Western Scarab

ED ROBERSON

All this glittering would be lightning bugs
were it not all architectural structuring:
tall buildings, their not being trees in a moonless wood.

Direct rather than danced mating of
vehicle as ovipositor to place,
seasonless traffic estrus that is us,

not the excited blush of luciferin
fluttering in-heat timed mystery around us,
a calling code of the instinct for another.

The more we learn
to see thickens the skies' populations,
eye-leveling the deeper

universe. A cloud of fireflies
in almost Magellanic isolation
levels, sighted through, into a plate of light.

They seemed as many as leaves, their lights
themselves stirring the lantern branches;
this grove, the woods, all one tree.

In my hand a solitary lamp lights my palm
making its way through the lines and mounds
bringing its measure

of illumination to our part traveled
across the disproportions together
each engaging the meaning of the distant fires

surrounding us. Danced bangles of signal
changing with each step or lifted
weightless as a destination into air,

where bodies shed even more
to nakedness from the bath
of their graves. The methane glow.

The life ball of shit,
rolled skyward out of the east,
reaching the west, become a smoke

of light stashed
in the backpack carapace.
Even unlit, the lightning smell.

Visits from a Messenger

NORA MOORE LLOYD

I have always marveled at the sheer strength, muscularity, and grace of large birds when I have seen them portrayed in wildlife films and public television shows. Seldom, however, do we human beings have an opportunity to become intimately acquainted with winged predators like Cooper's hawks, who tend to keep their distance. Because our daily life usually doesn't include close-up exchanges with those creatures, each such unexpected encounter can be a remarkable experience—if one chooses to suspend all other immediate life concerns and be truly present for this numinous overlap of existence. Such is the feeling I have each time a hawk visits me in my Chicago city-size plot of land—not a usual hangout for Cooper's hawks, although the cedar tree next door seems to be part of the attraction, since it provides an ideal bird's-eye view of all manner of neighborhood animals. Many Native North American peoples have shared the hawks' attraction to cedar, viewing it as a sacred medicine. When it is burned during prayer or purification rituals, its smoke helps open the soul and bring visions. In Ojibwe culture, cedar (*gi-shee-kan-dug*) represents the powers of the south direction and is used to purify one's body from disease and to protect oneself from evil.

But for those of us who live in an area mostly defined by artificial boundaries and human-made structures, appreciation for nature and our connection to the land is often an afterthought. I grew up in a northern suburb where 450 miles and two generations separated me from a traditional Ojibwe understanding of an established, centuries-old reciprocal relationship between human beings and nature. In the thirty years since I discovered my Wisconsin Ojibwe relatives, I have learned to appreciate the traditional Native view of the importance of balance within our environment and communities. Native peoples see our individual contributions—whether positive or negative—as part of a larger, interconnected whole; whatever we humans do affects every other being, and vice versa. Partly because of this conception of balance and the interconnection of all life, and partly as a matter of survival, for centuries Native people have been taught to take or harvest only what was needed at that time, leaving behind enough for self-seeding propagation and another fruitful season. For example, wild rice is harvested today on Wisconsin, Michigan, and Minne-

sota reservations in the same manner it has always been gathered: one person pushes a canoe forward through wild rice beds, and a second person uses two rice sticks to gently bend tall wild rice reeds over the canoe and tap hard enough so that ripe grains fall into the canoe. Using this method allows enough ripe grain to fall back into the lake to reseed and ensure good harvests the following year. The imbalance created by stockpiling extra amounts or overharvesting would be wasteful and threaten future resources, and is therefore avoided.

In 2005 I downsized to a hundred-year-old house on the city's far North Side. Part of the appeal was the small second-floor room with windows overlooking my backyard and my neighbor's gigantic cedar tree—the perfect location for an office that offers a chance to combine periodic daydreaming with observing urban wildlife, while also concentrating on work projects. A few days after unpacking, while I was working on the computer with cat on lap, a flurry of feathers in the nearby cedar caught my attention. A full-grown female Cooper's hawk (fig. 1) on a branch just fifteen feet away seemed intently focused on me (or my cat?). Her size and nearness took my breath away, and I sat motionless for several minutes, daring only side glances lest I scare her away. I often saw hawks and eagles on my trips to the Ojibwe reservation at Lac Courte Oreilles, Wisconsin, and had been taught by elders to be mindful of their significance, but this felt different. A hawk . . . in the city . . . at my house? Who would have thought? And, more importantly, why? When my neighbor, who had lived her entire eighty-some years directly across the alley from my house, assured me hawks had not been seen in the area before my arrival, I took it as a positive sign. Not surprisingly, the tribal elders I asked recommended that I simply consider the connection a gift. I had previously thought of gifts as something people exchanged on birthdays, holidays, and other special occasions. I was just beginning to understand that the Ojibwe notion of "gift" is different in the sense that they believe gifts—especially those brought by animals and other beings in the natural world—often also offer a lesson, and can arrive totally unexpectedly. Moreover, the recipient of a gift also has a responsibility to try to understand the message or lesson that it brings.

Over the course of several months, I became familiar with the hawk family, which consisted of a male, female, and juvenile. The cedar was a favorite perch, along with lofty positions in my tall maple or mulberry for better hunting. I soon realized the hawks' main reason for coming here was for a meal, not to visit me, as I had first imagined. With that in mind, I made sure the bird feeders were always full, and my backyard soon became a popular dining spot for songbirds, local pigeons, and other city critters. However, after I witnessed a few amazing mid-flight pigeon captures by the hawks and the resulting piles of nothing more than feathers, I began to feel guilty as I restocked the feeders. Whether in the city or on the Great Plains, nature's balance is already in place; what is the ripple effect of my interference by tilting the scale in favor of hawks? Another example of overthinking, which was easily settled by an elder's gentle reminder to be grateful for the experience, period. Thankfully, in that conversation he also thought it was time to explain why hawks appear: they often carry messages from the Creator or those who have passed on. Worries about my

FIGURE 1. Cooper's hawk perched on backyard fence. *Yard Hawk I*; photograph by the author.

having any measurable influence on the grand scheme of things by putting out birdseed evaporated soon thereafter.

Cooper's hawks are truly magnificent creatures in their appearance, wearing an artistic palette of color combinations—the adults have a regal bearing with mottled cream and tan feathers on a powerful, muscular breast, a rich metal-gray back and head, and black horizontal stripes on their tail feathers that starkly contrast with their piercing yellow or orange eyes and yellow legs (fig. 2). City hawks seem to have developed avian "street smarts" not required in rural areas, enabling them to tightly maneuver at high speed between tree branches, homes, and urban landscapes full of power lines, and I have an enormous respect for their survival skills. As a photographer, my first inclination is to grab my camera when they show up, rather than simply relishing the moment, so this is an ongoing lesson they are teaching me.

I did share images of the hawk family with friends in Chicago's Native community. For reasons explained above, hawks, like eagles, are considered to be honored creatures by many Native peoples, and so each hawk visit to my yard became an event to celebrate. Word spread of the unusual visitors to my house, and when I did manage to get a good photo, the positive effect was spread across many people as I brought large prints to show at the weekly elders' lunch at the American Indian Center. Just hearing about the North Side hawks triggered uplifting memories for many of earlier days spent living outside of the urban

FIGURE 2. Cooper's hawk in leaves. *Yard Hawk II*; photograph by the author.

environment on rural reservations, where direct interactions with nature and wildlife were a daily occurrence.

By chance a few winters ago, the big female landed on a branch next to the window while I was on the phone with my Salish friend Leonard. He had heard my stories and asked whether I had appropriately thanked the hawks for their visits. From the outset, I knew to offer tobacco on the ground as a traditional Native "thank you," but that was the extent of what I had done. The gaps in my tribal knowledge came rushing forward, and I asked him specifically what should be said. His answer, provided in the Lakota language that he had learned from his wife and father-in-law: *"How Kola, ma tahischi. Pilamaya yelo mitaku ye ho yasay yelo—Ni Mitakiapi."* ("Hello my friend, my brother. Thank you, my relatives, for sending your relative to me.")

I furiously wrote Leonard's message phonetically, Lakota not being in my vernacular, grabbed shoes and tobacco, and went outside under the cedar tree. After a heartfelt but likely unintelligible attempt to repeat the message, I left tobacco and returned to my computer. No sooner had I sat down than the hawk took off from the branch in a wide turn and flew directly toward me. Her beak shattered a hole in the storm window three feet away from me. The screech, crash, thud, and my scream seemed to happen simultaneously, and in an instant she disappeared from view, landing at the base of the tree. Fortunately, despite the force of the hit, she was unhurt but stunned. I, however, was inconsolable, convinced my action or words had caused a terrible accident. Tears streaming down my face, I rushed downstairs and outside to where she sat in the snow. Words of apology—*thank you . . . I'm sorry . . . oh no*—were all I could muster as she allowed me to crouch right next to her with tobacco. We watched each other for many minutes, all the while trying to absorb the positive energy that seemed to encircle us. Realizing the experience was likely not as comfortable for her, I quietly moved away to watch her from inside. She soon shook her head, rearranged her feathers, and hopped onto the fence. A moment later she flew off in her glory, leaving me utterly stupefied at what I had just witnessed.

In an effort to make sense of the event and assuage my guilt at creating a potentially harmful situation, I immediately called Leonard with a blow-by-blow description of the previous ten minutes. His only comment: "What kind of medicine do you have there, anyway?" Not surprisingly, since he had never heard of any hawk/human interaction that was remotely similar, Leonard believed that for whatever reason, the hawk had clearly chosen to come to me and that I should be honored. His opinion has been shared by every Native community member who has heard the story. Most importantly, after letting the "I wonder why me?" question bounce around in my head for a while, I realize the message may simply have been to pass it on—to give the experience, and the hawk nation it came from, a voice.

Living among 3 million other people in the city, it becomes easy to forget all those who have left footprints before us, both human and nonhuman. Most of us can easily pick out faces of friends in a big crowd but have trouble distinguishing between individual squirrels, dragonflies, or pigeons. My brief but extraordinarily personal experience with a wondrous creature on that February morning illustrates the importance of coexistence and developing an awareness of nonhuman animals as part of our community. Preservation and conservation of that balance begins with the recognition of how uniquely special the human-nonhuman relationship is in the city, and the value of taking a momentary break from today's information overload by looking through a wider lens. Personally, I now spend more time looking up at trees or under leaves. The hawks continue to visit my yard, and I am grateful for their frequent reminders to share the story with others. Perhaps the message became the messenger. *"How Kola, ma tahis-chi. Pilamaya yelo mitaku ye ho yasay yelo—Ni Mitakiapi."* "Hello my friend, my brother. Thank you, my relatives, for sending your relative to me."

Recommended Resources

Books

Barnouw, Victor. *Wisconsin Chippewa Myths and Tales and Their Relation to Chippewa Life*. Madison: University of Wisconsin Press, 1977.

Brown, Joseph Epes, and Emily Cousins. *Teaching Spirits: Understanding Native American Religious Traditions*. Oxford: Oxford University Press, 2001.

Callicott, J. Baird, and Michael P. Nelson. *American Indian Environmental Ethics: An Ojibwa Case Study*. Upper Saddle River, NJ: Pearson Prentice Hall, 2004.

Campbell, Joseph, with Bill Moyers. *The Power of Myth*. New York: Doubleday, 1988.

Deloria, Vine, Jr. *Spirit and Reason: The Vine Deloria, Jr. Reader*. Golden, CO: Fulcrum Publishing, 1999.

Johnston, Basil. *Honour Earth Mother*. Lincoln: University of Nebraska Press, 2003.

———. *Ojibway Heritage*. 1976. Reprint, Lincoln: University of Nebraska Press, 1990.

Vennum, Thomas, Jr. *Wild Rice and the Ojibway People*. St. Paul: Minnesota Historical Society Press, 1988.

Websites

American Indian Center of Chicago: http://aic-chicago.org

Lac Courte Oreilles Band of Ojibwe: www.lco-nsn.gov

The Oracle of Wasps

PATRICIA MONAGHAN

The steady traffic in that corner
of the garden is so obvious now,

especially when evening's slant light
gilds the travelers swooping down

to that flat rock I now know rests
beneath the lilies and white phlox,

that gateway to the city of wasps
with its rooms of secret paper

where the news is all of flowers
and the appetites of queens.

How many years of wasp time
have passed since last week

when, blindly weeding, I came
too close to those city gates?

So fast. So fast. I did not think
'wasp' or 'sting' or 'run,' so fast

was I struck, so fast did I run.
In waspland's history of struggle

surely that battle is remembered.
And what of the small warrior

who gave her life to drive me off?
Heroic ballads in wasp measure

surely are sung to her when bards
relate the history of the tribe.

Do they mention, I wonder, that
her venom now runs in my blood?

✻ 2 ✻

NEIGHBORHOOD ASSOCIATIONS

JOHANNES PLAGEMANN, *Chicago Wildlife,*
part of the Hubbard Street Mural Project

Keegan's Story

MARTHA MODENA VERTREACE-DOODY

From the *Chicago Sun-Times*, a story
about a North Side resident of Goose Island—
a little after six, Wednesday morning:
Found under a parked car
at a service center, a coyote
named Keegan.

The mackerel sky indifferent to Keegan's
plight, who still knows little of his own story—
except that baby coyotes
do appear even on Goose Island—
home of broken cars—
hunger blending into morning.

A flat swirl of morning
clouds reaches for Keegan
as he runs up the ramp to the fancy cars.
Four-month-old pup, leery of human stories,
of Canada geese on Goose Island
where trapped pups grow into coyotes;

who swim to Ma or Pa coyote
to learn that sometimes morning
means sleeping on a created island,
hunting for rats, squirrels, rabbits. Keegan
yips the moral of the story:
What is a car?

What is it to kill and eat a car?
Will a pack of coyotes
help? On the radio, the story
continues to spread the morning
news of docile Keegan
yielding to a catchpole, islanders

in no danger as Goose Island
welcomes Animal Care and Control cars,
a man pinning Keegan
to the floor. At least no other coyotes
howl with shame when morning's
TV flashes stories

of a July morning on Goose Island—
stories of a luxury car, of wild instincts gone awry,
of a big-eyed, long-legged coyote named Keegan.

Zoo Woods

MARTHA MODENA VERTREACE-DOODY

Snail tracks dry into a tattoo of maps on the sidewalk.
Elms speak of a sea of storms, today's undying wind
let loose across Salt Creek
 as gulls chase a hawk from his wild-wing
circling; men in green shirts or no shirts
jog across the field where starlings rise
 in neon waves as if riding the cold front.

I think of my mother's brown eyes following
a sparrow darting in the living room,
her strong alto singing of a garden
 "where the dew is still on the roses,"
as she presses two quarters in my palm
for a loaf of bread we do not need;

slides a nickel in my pocket for bubble gum;
then promises to explain
 over toast, strawberry jam.
 Today nothing major
stains the mud floor of a nearby quarry,
clean skeletons of semi-trucks like fish heads;

groans of wheels, gears
like the answer to my unspoken question
about a pile of feathers in the corner:
 my mother's warning—
the bird escaping from the house
carries someone's soul on his back.
 From the zoo, coyotes howl at sirens—
police cars, ambulances, fire brigades—anything
moving faster than they can.

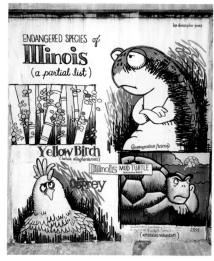

LESLIE BERISH, AUGUSTINA DROZE, RICKI HILL,
CHRIS JONES, NEIL SHAPIRO, AND THE HUBBARD STREET
MURAL PROJECT VOLUNTEERS

These animal images are just a few of the dozens that make up "The Mile of Murals" along Hubbard Street between Ogden Avenue and Desplaines Street. First painted in the 1970s by Ricardo Alonzo with hundreds of volunteers from the West Town Community Youth Art Center, the images were intended to inspire care and stewardship for Mother Earth. The murals have persisted through weather, weeds, taggers, and decay. Several were lost during a 2000 repair of the railroad embankment, which led one of the original painters, Fred Montano, and colleague Karen Smith to refurbish some of the remaining work and organize a new generation of artists to add to the gallery. Wildlife continues to dominate the imagery, making this a true urban "landscape."

A Tale of Two Squirrels
and One City

JOEL S. BROWN

They can be clowns in your yard or nightmares in your attic. In Chicago, as in many places, they are one of the most conspicuous denizens of the "urban game park." They seem so tame that people often misinterpret them as domesticated. In fact, they are completely wild, yet superbly acclimated to humans and our habitats. From their perspective, we humans have gone from being their most ferocious predators to their greatest benefactors. Oak Park, a turn-of-the-nineteenth-century suburb west of Chicago, tells the story. In 1900, there were none. By the 1950s, one species dominated the suburb. Now, some sixty years later, a second has almost replaced the first. Who are they? They are the neighborhood fox squirrels and grey squirrels. For the last twenty-five years, they have captivated me as both a wildlife scientist and a nature lover. How did they enter my head and my heart?

As it turns out, it is not just my story that intertwines with squirrels, but *our* story as Chicagoans. For the squirrels of our neighborhoods reflect our own history of urbanization, our social norms, and our economic development. And there is more. These squirrels represent one of our best opportunities to enjoy and learn from the urban game park. When squirrels live around us, we each have a squirrel story. Here's mine.

Some naturalists gravitate toward primates. What joy and fascination when we see reflections of ourselves in the faces and behaviors of chimpanzees and gorillas! For others, it's dolphins; as sea creatures, they are so different from us, yet they are also so familiar in their intelligence, sociality, language, and empathy. Then there are the bird-watchers or "twitchers"—you know them. They keep a "life list" of species they've seen, they're up early to catch the odd voice in the dawn chorus, and they travel great distances to glimpse a rare or accidental species.

Me? I like rodents. I really do. I love their upper and lower chisel-like incisors (their "front teeth"). These teeth are literally turned on their sides with enamel on the forefront followed by vertical layers of dentine (in human teeth the

enamel covers and protects the dentine). These ever-growing incisors erode from the softer back toward the harder front, producing self-sharpening chisels able to gnaw through just about anything: wood, power lines, and even metal. The unique incisors produce a somewhat blunt nose. All children know how to imitate the rodent's characteristic overbite when pretending to be a mouse, hamster, or gerbil.

Rodents, and in particular squirrels, did not always inspire an awe of nature in me. Parts of my childhood were spent on a mission in Zimbabwe (then Rhodesia). We enjoyed 15,000 acres of wooded savanna replete with wildlife—hippos in the reservoir, leopards and klipspringers on the granite outcroppings, and graceful kudus and reedbuck moving along the boundaries of acacia trees and grasslands. Nearby game reserves offered even more of Africa's big game, what we ecologists refer to as the "charismatic megafauna." These formative experiences journeyed with me to college in Southern California.

At Pomona College near the foot of the San Gabriel Mountains, I discovered the miniaturized version of the African safari thanks to my adviser William Writz, who hired undergraduates like me as field assistants. He trained us to mist-net birds, radio-track coyotes, noose lizards, and live-trap rodents in small metal boxes. Upon entering the oblong trap, the unsuspecting animal gains free room and board upon triggering a spring-loaded door as it reaches for the enticing bait of raisins, oats, and peanut butter.

To determine the effects of wildfires on the recovery of rodent communities, we set these traps throughout the rugged, steep, and shrubby vegetation so characteristic of the California coastal scrub. Accordingly, we caught, examined, and marked rodents by the hundreds—wood rats, voles, and deer mice. My favorites were the kangaroo rats with their strange hopping gait and the California ground squirrels. These squirrels, bigger than the other mice and rats, barely fit into our traps.

Upon capturing a squirrel, we would shake it into a pillowcase and grasp it by the scruff of the neck. These squirrels were so much more attentive than the other rodents. I recall the first time a squirrel outwitted me. I grasped the squirrel, and it gazed directly back at me. Then it relaxed and hung from my hand more limply. In response, my own grasp relaxed. Sensing this, the squirrel arched its back, positioned its hind feet on my hand, and gave a mighty kick. The speed and shock of this acrobatic maneuver produced its desired effect. Instantly freed from my grasp, the squirrel dropped to the ground, collected itself, and sped away, delivering an angry parting chirp—or was this vocalization a taunt? Regardless, this escape ruse worked not just once but many times. The California ground squirrels actually prepared me for the use of this same trick by the urban fox squirrels and grey squirrels of Chicago.

Yet at this point, I was still apart from the city squirrels. Gazing down from the mountains around Los Angeles, I was getting to know the wildlife of the undeveloped hills. These animals were adjacent to but generally separate from their urban cousins. But I knew then that the communities of smaller mammals excited me every bit as much as the charismatic megafauna that I remembered from my childhood experiences in Africa. From California, I moved to the Uni-

versity of Arizona for my doctoral work. In becoming an evolutionary ecologist, I studied desert rodents, the round-tailed ground squirrel and Harris antelope squirrel among them.

My study site near Tucson was almost but not yet urban. At the corner of this expanse of desert stood a billboard announcing: "Beyond this sign lies the industrial future of Tucson." And so it came to pass. Rather than this desert community coming to the city, the city came to it. Of my beloved rodents, one of them, the round-tailed ground squirrel, thrives as a city creature, often achieving higher densities and apparent success with humans than without. It likes golf courses, parks, and some backyards, a first clue for me that squirrels will and do adopt our world as their own.

Now begins my story with Chicago's squirrels. My path took me to the University of Illinois at Chicago (UIC), where for twenty-six years I have served as a researcher, teacher, and mentor for students. UIC, a decidedly urban campus with the Chicago skyline providing a dominating backdrop, had a squirrel population much like that of any college or university in the United States. But unlike the University of Chicago to the south or Northwestern University to the north, we had fox squirrels instead of grey squirrels. Furthermore, my backyard and neighborhood in Oak Park just west of Chicago shared the same fox squirrels as my university. Not unlike the distribution of baseball fans cheering for one or the other of Chicago's two pro teams (the Cubs and the White Sox), Chicagoland has fox squirrel neighborhoods and grey squirrel neighborhoods, and many places with both. And just like the diverse and changing milieu of Chicago's neighborhoods, UIC has changed, too, from fox squirrels to grey squirrels. How could I not study these squirrels?

With eight members of the squirrel family Sciuridae, the Chicago metropolitan area is a squirrel biodiversity hot spot, with grey squirrels and fox squirrels as the undisputed stars! For me, a student of biodiversity and how species coexist (or not), the mystery of how two such similar species divide and conquer Chicago was irresistible. Plus, even better, these were rodents, and like other squirrels I had known in California, they seemed to adopt us and thrive in our human-dominated landscapes. In coming to Chicago, I was a scientist in search of wildlife to study. And the squirrels of Chicago were quite possibly in search of a researcher—within a wide radius beyond Chicago, they were nobody's research animal.

Like any good relationship, ours has deepened over time in ways previously unimaginable. I conducted "basic" research into the squirrels' ecologies and habits—pretty much the bread-and-butter of naturalists. Next, they provided a valuable "model" system. My lab team and I could try things out on the squirrels that later we applied to conservation work on black rhinoceros in Kenya, springbok in South Africa, and even snow leopards in Nepal. Throughout, we aimed to see our world and habitats through the eyes of the squirrels.

We invited all of Chicago to join this endeavor. With Wendy Jackson as

originator and collaborator, we started "Project Squirrel," a web-based citizen science project. Thousands have spoken, and thanks to them we know much about our squirrel neighbors and especially how urban grey and fox squirrels coexist here.

For example, we have received some great comments that reflect insightful observations and reveal the range of people's attitudes toward squirrels. "Fox squirrels are like country folk, while the grey ones are like city folk," suggested one respondent. "I've hated squirrels for the last thirty or so years, they are rats with furry tails," opined a second. "Gray squirrels are more aggressive to get food, and will try to scare or chase away the red [fox squirrels] ones," observed a third.

Squirrels, then, provide opportunities for both education and engagement. When I first began teaching ecology to undergraduates, I would regale them with personal examples of working with mountain lions in Idaho, rattlesnakes in Arizona, sambar deer in Malaysia, or Amani sunbirds in the Arabuko Sokoke forest. During the lecture I could captivate students with exotic places and exciting animals. Some students flattered me with a gaze reserved for Indiana Jones. But like Indiana Jones and other adventure scientists from fiction, I, too, was not truly real. With the end of class, the students disengaged from my National Geographic special and returned to the real world, the urban world, their world. Could they really apply the very cool and important concepts of ecology and evolution from examples that few of them would ever deeply experience?

So I started weaving squirrels into my courses, supplanting the exotic beasts with more familiar creatures from their parks, neighborhoods, and backyards. Two things happened. First, I became much less cool. With the allure of strange lands gone, I was just one of several balding, bearded professors at UIC. But now my invitation to engage with ecology left the classroom and entered their dinner table conversations, their observations, and their interpretations of the city. They could see the concepts of ecology in action; they could see the relevance of the formerly abstract discussion of adaptations in the very characteristics and behaviors of the squirrels around them.

"My dad, he's a car mechanic, and he says you're wrong. Fox squirrels don't . . ." declared one student. Her demeanor suggested she wanted a resolution to this debate. Was I right or was he? I didn't care. This was great on so many levels. She was engaged enough in the class to share the goings-on in the classroom with her family. Her dad, regardless of background, had enough observations and knowledge of squirrels to form strong opinions and hypotheses. He was now contributing even more to his daughter's education. And both of them demonstrated an appreciation for the wildlife inhabiting our urban game park.

Native wildlife in the city may captivate, intrigue, and entertain us, while at the same time harming our gardens and homes and posing threats, real or imagined. Our relationship with such animals can be nuanced and contradictory.

Many realize that we have hijacked their habitat, yet a person may wonder, *Do I really want a squirrel in my attic, a raccoon spreading garbage, or an opossum startling me as I arrive home after dark?* This fascinating tension in our perceptions and reactions to urban wildlife creates a strange "mythology." We conclude that these animals are somehow displaced. Wouldn't they rather be in the "wild" and live in a more natural state?

The grey and fox squirrels disavow us of these urban wildlife myths. These are not displaced species; they have colonized and moved into our neighborhoods. Their fortunes ebb and flow with us and our socioeconomics. The squirrels of Oak Park tell this story beautifully.

To thrive, any species must have food, shelter, and safety. For urban squirrels like those of Oak Park, food can be a mix of intentional or unintentional human handouts as well as nature's bounty of acorns, nuts, and fruit. Many backyard wildlife enthusiasts are often dismayed to see the waste as squirrels pick unripe fruit, take a bite or two, and drop the rest to rot. "Why don't they just wait until the fruit is ripe?" asks many a squirrel watcher. The answer: since they share their home range with other squirrels and wildlife, squirrels do not patiently wait for what they may not be able to harvest later.

"How do I get them out of my attic?" is a frequent question of Oak Parkers. Attics and tree hollows provide winter homes for squirrels. Mom will raise her first litter of babies there. Live-trapping, relocation, and pest control provide options. But I prefer telling such folks to wait until summer when the squirrels will voluntarily move from their winter homes into their dreys (leaf nests), which are their summer homes. When vacant in the winter, these dreys can be easily observed as basketball-size balls of leaves at the end of branches, generally quite high in mature trees. During the summer, they are quite invisible among the fresh growth of leaves. Depending on conditions, some females raise a second litter in their drey.

I enjoy taking college students on "squirrel labs" in any season. During the summer, the students in their short sleeves enjoy throwing peanuts to the not-as-eager-as-you-might-think park squirrels. The students watch to determine whether they opt to bury the nuts or climb a tree, from which the squirrels will sometimes hang upside down by their hind feet as they eat and handle the nuts with their forepaws. Summertime squirrels live bountifully. They nibble on the ample green growth, thwart bird feeders, and gobble up human leftovers.

But during the winter, amidst the cold and snow of Oak Park, students bundle up and toss peanuts less eagerly to squirrels, who, unlike the students, are extremely eager, almost desperate. In fact, there is no worse time to be a Chicago squirrel than during the winter. In the city, as compared to forests, the squirrel population is higher and the density of nut-bearing trees such as oaks is lower. City squirrels have fewer nuts and acorns for their scatterhoards. Unlike their forest brethren, city squirrels live paycheck to paycheck. In the winter, garbage cans offer less, people leave fewer scraps about, and bird feeders may go empty. In the end, however, city squirrel populations remain remarkably stable from year to year as spring and fall recruits replace those that do not survive the winter. A severe winter invites higher survival of next spring's

young, while a mild winter brings more adult survivors that suppress the success of the year's young.

The entire squirrel population turns over about every two years. As a resident of Oak Park for over twenty years, I have witnessed ten generations of squirrels come and go. This often comes as a surprise to many. A person sees similar squirrels year after year and assumes they must be the same ones. "Where did 'Stub' go?" (Stub being that inevitable neighborhood squirrel who has lost a tail to a predator, pet, or another squirrel.) Then that person happily reports the return of Stub. In fact, it is likely a new squirrel, its tail recently bobbed from the vagaries of survival in the urban game park. The relative constancy of the observable squirrel population belies rapid dynamics of feeding, breeding, and dying.

This apparent constancy gives way to longer-term trends. In the last 150 years, Oak Park has seen three major squirrel transitions. Originally, the two-by-three-and-a-half-mile community would have been a mix of wetlands, prairie, and savanna with patches of oak trees. As is typical for natural areas, grey squirrels would have lived in the denser clumps of woods while fox squirrels would have occupied the wood margins. With European settlement, the landscape changed to orchards, croplands, and pastures.

By 1900, as Oak Park rapidly developed into a suburb of Chicago, there would have been no squirrels left. Folks in and around Oak Park were lethal predators. Firearms could be legally discharged, trapping and snaring would have been practiced, and backyards contained other species in the form of domestic chickens, rabbits, horses, and even some cows and pigs. Squirrels would have been seen as good eating, and they would have been a threat to backyard gardens. Such gardens would have been more extensive. Gardening then was about income substitution, not wholesomeness. By harvesting squirrels, the family gained twice—the squirrel substituted for other sources of meat, and the removal of a garden pest saved vegetables and fruits. Thus ended the first period of transition for Oak Park's squirrels.

Following World War II, fox squirrels would have been widespread and growing in numbers. Backyards became less important for livestock and produce, and more valued for recreation and lawns. Fewer people were inclined to eat squirrel, and even fewer knew how to kill and prepare squirrel for dinner. By the 1960s, bird feeding and wildlife watching increased in popularity with the rise of the environmental movement. A huge transition was under way for urban squirrels as we went from being the squirrel's deadliest predator to its greatest benefactor. The second transition was complete.

My lab began paying serious attention to Oak Park's squirrels in 1990. From then until the present, there has been a remarkably stable population. However, the composition of this squirrel population has undergone a third transition. In 1990 fox squirrels comprised upward of 80 percent of the squirrels. The remainder were grey squirrels. But in the last twenty years, the pattern has reversed, with greys comprising over 80 percent of Oak Park's squirrels.

We have studied this transition and have learned that the coexistence of fox squirrels and grey squirrels comes down to food and safety. Fox squirrels excel

at avoiding and managing risk from natural predators such as foxes and hawks, and from our domestic cats and dogs. Yet grey squirrels excel as competitors in the absence of high predation risk. They are the behavioral dominant of the two species. Greys manage survival in dense squirrel populations better than fox squirrels. In 1996 we found that the distribution of fox squirrels and grey squirrels correlated perfectly with the number of cats and dogs in the neighborhoods. Furthermore, since 1996, when Oak Park enacted leash laws, dogs have become fewer and smaller, and most compassionate cat owners have gone from letting their cats run free to keeping them safely indoors. Through the squirrels' eyes, Oak Park has become safer. Fewer predators favored the third transition from fox squirrels to grey squirrels.

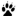

The history of squirrels in Oak Park is a reflection of us and our changing social norms and economic circumstances. These squirrels provide an enduring, enjoyable, and educational experience of wildlife right in our neighborhoods. Whether you love them or hate them, their agility as they run up tree trunks or leap from branch to branch is quite spectacular. Who cannot marvel at their perseverance and ingenuity when overcoming "squirrel-proofed" bird feeders or gardens? Who cannot admire their tenacity as they seek food on a snowy wintry day? Who can't be charmed by frisky chases during their breeding seasons? Who has not noticed how they seem to watch us even as we watch them? No wonder we all have a squirrel story. What's yours?

Recommended Resources

Books, Articles, and Film

Adler, Bill, Jr. *Outwitting Squirrels: 101 Cunning Stratagems to Reduce Dramatically the Egregious Misappropriation of Seed from Your Birdfeeder by Squirrels.* 2nd ed. Chicago: Chicago Review Press, 1996.

Benson, Etienne. "The Urbanization of the Eastern Gray Squirrel in the United States." *Journal of American History* 100, no. 3 (December 2013): 691–710.

Downie, Mark, dir. "Nuts about Squirrels," episode of television series *The Nature of Things with David Suzuki.* Canadian Broadcasting Corporation, 2012.

Steele, Michael A., and John L. Koprowski. *North American Tree Squirrels.* Washington, DC: Smithsonian Institution Press, 2001.

Thorington, Richard W., Jr., and Katie Ferrell. *Squirrels: The Animal Answer Guide.* Baltimore: Johns Hopkins University Press, 2006.

Website

Project Squirrel: www.projectsquirrel.org

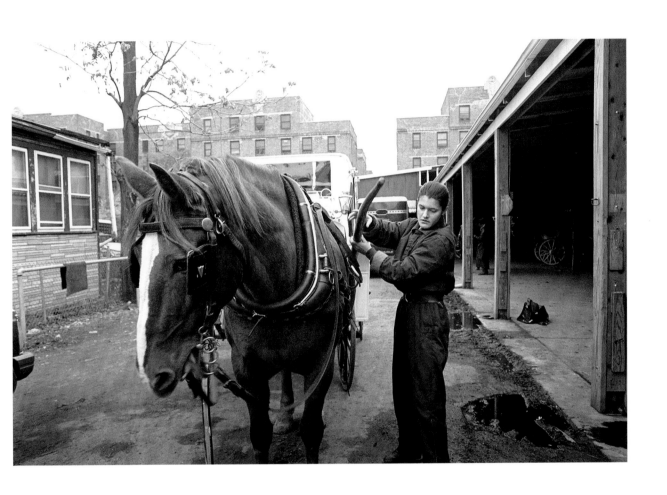

BROOKE COLLINS, *Noble Horse Stables*

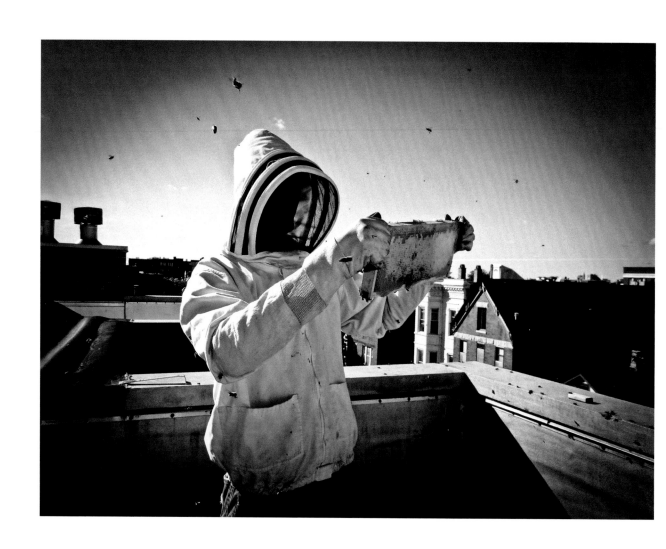

KYLE GATI, *Rooftop Beekeeping*

Pigeons

DAVID HERNANDEZ

Pigeons are the spicks of Birdland.
 They are survivors of blood, fire, and stone.
 They can't afford to fly south
 Or a Florida winter home.
Most everybody passing up a pigeon pack
Tries to break it up because they move funny
And seem to be dancing like young street thugs
To hip-hop music from a 10-speaker car radio
Parked on the street by the bus stop.
 Pigeons have feathers of a different color.
 They are too bright to be dull
 And too dull to be bright
 So nobody likes them.
Nobody wants to give pigeons a job.
Parakeets, canaries, and parrots
Have the market sewn up as far as that goes.
They live in fancy cages, get 3 meals a day
For a song-and-dance routine.
 When was the last time you saw a pigeon
 In someone's home?
 Unless they bleach their feathers white
 And try to pass off as doves
 You will never see pet pigeons.
 Besides, their accent gives them away
 When they start cooing.
Once in a while, some creature will treat them decently.
They are known as pigeon ladies, renegades, or
Bleeding-heart Liberals.

What they do is build these wooden cages
On rooftops that look like huge
Pigeon housing projects
Where they freeze during the winters
And get their little claws stuck in tar
On hot summer days.
No wonder they're pigeon-toed!
I tell you,
Pigeons are the spicks of Birdland.

CAMILO CUMPIAN, *DH + BH*

Civitas Canis lupus familiaris

MICHAEL S. HOGUE

The repair of democracy requires more democracy, as John Dewey and other early twentieth-century progressives were fond of saying. I would like to add to this idea that more democracy, or deeper democracy, can be facilitated by more (and better) dog companioning and dog parks. I mean this in all sincerity. After all, companioning dogs—walking and playing with them, socializing them, and being socialized by them—forces us to get out of our homes and into our neighborhoods, into civic space. Caring for a dog entails learning to be empathic, sensing and feeling and responding to another's needs. And getting out, getting involved, and learning to be more empathic and collaborative are critical democratic practices.

Yet while these practices are critical, they are also in crisis. For while *the world* is increasingly interconnected in some ways—economically and technologically, for example—*we* remain as divided from one another as ever in other ways. We are also always on the move, transitioning more frequently from job to job, commuting over ever-greater distances, existing as late modern variants of the nomad. In relation to these patterns, our participation in voluntary associations (e.g., religious groups, labor organizations, neighborhood clubs, and other civic groups) has sharply declined over the past few decades. This is bad news for democracy insofar as these forms of associations have historically served as the primary sites through which democratic habits have been cultivated.

It is with this in mind that I say that dog companioning and dog parks, which create unique urban civic and associational spaces by bringing diverse people into relationship with one another, are essential to the repair and the deepening of democracy. My experience as a dog-loving democrat in Chicago—the great midwestern "dog-friendly" metropolis, world-renowned for its political graft and its racial, ethnic, and socioeconomic divisions (as well as its "Bean," its versions of pizza, and the hot dog)—provides me with particular insights on the contributions that dogs can make to democracy by bringing people together and helping them to relate despite their differences.

There have been many dogs in my life, but no dog had as much influence on me as Birch. When I first met Birch in 1999, I was a graduate student in a difficult marriage. Though my partner was definitely not a "dog person," I eventually convinced her to allow me to "rescue" a greyhound. So after a couple of trips from Chicago out to a rescue agency in southern Wisconsin, I brought Birch to her new home in the Hyde Park neighborhood of Chicago. Birch was a gangly, golden, bizarrely neurotic dog. The rescue folks told me that she had been mistreated by her handlers during her brief racing career. But she eventually warmed up to me and began to trust me. We bonded on long walks through the neighborhood, the campus of the University of Chicago, and along the lakefront.

About a year later, my wife and I had a baby boy. And since babies demand a lot of attention, my daily habits with Birch changed. We didn't go out for walks nearly as often. As weeks turned into months and as the months went by, Birch became depressed. Between parenting, working, and studying, it became harder for me to give Birch the time and affection she needed and deserved.

After a lot of anguished reflection, I decided I needed to "return" Birch to the rescue agency with the hope that she could be provided the home and the family she deserved. It was a painful decision since I felt that "returning" Birch would wound her already-fragile spirit. She was innocent. I was the one who had done wrong. By bringing her into a situation that I knew was falling apart, I had prioritized my self-interest, my desire for a dog companion, over what was best for her.

The trip back up to Wisconsin was miserable. I had my son with me. Birch, as usual, was throwing up in the backseat. When we finally arrived, the woman from the rescue agency scolded me, as she was right to do. I was ashamed. I knew I was wounding Birch. She had known almost nothing but rejection in her life. I knew I was doing possibly irreparable harm to an already-scarred dog. But I was also trying to do everything I could to save a marriage. I desperately wanted my son to have a whole family. I didn't want my son to grow up unable to trust the people he loved. So I put Birch into that position instead. I sacrificed innocent Birch as a last-ditch effort to save a dysfunctional marriage for my innocent son. I will never forget that day. Birch's sad brown eyes, her lowered head, and her flattened, drawn-back ears are permanently seared into my heart. The animal in me forsook the animal in her.

The marriage did not last much longer. After it ended, one of the first things that my son and I did together, even before I found an apartment, was to go out to one of the city animal shelters to find ourselves a dog. I was determined to begin to make things right, as much as I could, for my son and for a dog who needed a home. I needed a second chance. On our first visit, we fell for the gentlest, fuzziest dog at the shelter, a two-year-old shepherd-chow mix, Flora. We found a pet-friendly apartment and slowly began to make ourselves into a new family—a father, a son, a dog, and a dissertation.

About a year later, I was adjunct teaching. The students covered the spectrum of ages, interests, learning styles, and abilities. At the end of the class, I

offered to write a positive recommendation for one of the standout students if she ever decided to go to graduate school. Six or seven months later, soon after I finished my dissertation, I received an e-mail. I couldn't place the name at first, but her message helped me to remember. She told me she had decided to go to graduate school and that she was hoping to take me up on my offer to write a recommendation on her behalf. Since she had only taken one class with me, I suggested we should meet so I could learn more about what she wanted to do and why.

A few days later, I met Sara near my office in Hyde Park and we went out for coffee. We talked about her plans for an hour or so. As we finished our conversation about her future, we shifted into light talk about the present. She told me a bit about her family. She was a fervent South Sider who came from a family that was religiously fanatical about the White Sox. At some point, she began to tell me about her dog, a greyhound that she and her mom had rescued a few years back. She told me how silly and neurotic and sweet she was and how she hadn't barked for the first few years she lived with them but that she had recently found her voice and now loved to bark with the other dogs in the neighborhood. She told me again about how neurotic she was and that she had a very bad habit of gnawing on her back.

My curiosity was piqued. I told Sara that I, too, had once rescued a greyhound but had to return her for some unfortunate family reasons. I asked which rescue agency she and her mom had gone to. Sara told me they had picked the dog up in Wisconsin. She said that the folks at the agency had told them that the dog had been previously adopted, but that the family who adopted her had to return her and that she desperately needed a new family to love her. I asked her about her dog's coloring. She said she was golden. I asked her how long ago they had adopted her. She thought it had been about four years or so. I asked her what her dog's name was and she said, "Birch."

At first she didn't believe me. Who would? But then she began to test me with very specific questions about Birch, her strange behaviors, her nervous tics, her distinctive features. We were speechless, eyes wide and mouths agape facing each other on the sidewalk.

A few days later, I went to visit Birch. It may only have been my wishful thinking, but it seemed as if Birch remembered me from years before. Though normally very shy around new people, she greeted me with a couple of sniffs and, as if offering her forgiveness, she leaned against me and allowed me to pet her.

As things sometimes do, especially given circumstances such as those that brought us together, one thing led to another, and Sara and I got married. We rather quickly made ourselves into a pack. In addition to my son, we now have two young daughters and two rescued shelter mutts.

Through this uncanny sequence of events, I was given a second chance to love Birch and Birch gave me a second chance at love. She lived for several more years, long enough for my son and our oldest daughter also to love her. The love, the loss, and the love again for Birch have been the wages of my adult life as husband, father, and lover again. Birch's innocence, her wounded and

healing soul, remembered the wounding and wounded animal in me. In loving and being loved by dogs, I've learned to live my life in relationship. I've learned from a life with dogs how thin the spaces can be between failure and forgiveness, commonality and difference.

As unlikely as my story about Birch may seem, the reality is that dogs have been bringing people together for millennia. In terms of evolutionary history, dogs have played a central role in the refining of human sociality. In fact, humans and dogs can be thought of as a co-evolutionary dyad. Dogs have had a great deal to do with the emergence of human civilization and the birth of cities, and thus also of politics. The depths of our shared history with dogs may have important modern-day implications in cities like Chicago.

Chicago is a city of over 3 million people densely packed like sardines into buildings likewise packed together liked sardines, commuting on buses and trains jammed full of other commuters. As we commute, we tend to keep our ears plugged with headphones and our eyes glued to our screens. We hustle shoulder to shoulder along our busy sidewalks, making sure not to make eye contact. In short, we spend inordinate amounts of time being alone together on the go or trying to avoid one another. This urban solipsism may not be unique to Chicago, but it is uniquely compounded by the fact that though Chicago is a multicultural city, it is also one of the most racially and economically segregated cities in the country. As documented by a Northwestern University study, more than half of the population in 68 of Chicago's 77 formally defined community areas identifies with a single racial or ethnic group. In 1950, 85 percent of the population identified as white and only 14 percent as black. But in 2009, in a massive reversal, only 33 percent of the population identified as white, while 67 percent of the population identified as racial minorities: 33 percent African American, 27 percent Hispanic, and 5 percent Asian or Pacific Islander (see www.chicagohealth77.org).

Chicago is also a city of "sides," the North Side and the South Side, and the divisions between these sides are determined by more than their differing loyalties to either the White Sox (South Side) or the Cubs (North Side). The South Side is predominantly African American, while the North Side is predominantly white; the South Side is comprised primarily of middle- and working-class people as well as the growing permanent underclass, while the North Side is disproportionately more affluent. The South Side receives less funding for parks, playgrounds, and other public recreational amenities; its schools are much less well funded and more crowded; its public transit system is less extensive; and it has experienced more frequent power outages.

But from a dog's point of view, these inequalities are nothing compared to the disparities in canine amenities between the North and South Sides. Despite being ranked as one of the Top 10 Dog-Friendly Cities in North America by DogFriendly.com, the degree of dog-friendliness depends on where in Chicago

you happen to live. Chicago's 22 official dog parks, its 32 self-identified dog-friendly stores, and its 44 self-identified dog-friendly cafés, pubs, and restaurants are all on the North Side.

Chicago's canine inequality, of course, has nothing to do with the number of dogs in these areas. Instead, it has something to do with the general imbalance of wealth and political influence between South and North Siders. Even more, it's possible that the canine inequalities and the wealth and political imbalances reinforce one another. After all, where there are dog parks, people from all walks of life will discover one another, and then they will begin talking, and then they may even get around to organizing themselves, and if they get organized, they may seek to take action together to address their challenges and to redress the inequities that contribute to them.

In about 2006, Sara and I, my son, and our dogs moved into a condominium in Woodlawn, just south of the University of Chicago and west of the Museum of Science and Industry. Two other young couples in our condo building also had dogs. Eventually, we all started running into each other at an empty lot across the street. We'd let our dogs off leash so they could run and play. Someone always had a gooey old tennis ball or a gnarled stick to toss. As the dogs chased and played, getting to know each other in their way, we humans also got to know one another. Short trips across the street to let the dogs pee would turn into hour-long conversations about work, the neighborhood, whatever. It didn't take long for a bunch of other folks to start showing up from nearby buildings. Before and after work, no matter the season, there was always a group of folks out with their dogs.

We were as motley a bunch of people as our dogs were muttly. We were black and white and brown, working and professional class, employed and unemployed, atheist, agnostic, and religious; we were professors, computer programmers, striving artists, musicians, and perpetual grad students; we were youngish and oldish. We were as different from one another as could be. But we loved our dogs and we claimed the same vacant lot as our unofficial dog park.

The dog park became for us a kind of *axis mundi*, a strong center or a vital pathway in our otherwise spinning, disconnected worlds. It provided a place of refuge and friendship in the midst of a larger world that many of us were experiencing as frenetic, chaotic, and unpredictable. Friendships came to life through our common love for our dogs, our morning and evening ritual gatherings, and the peculiar ways that our life stories began to intersect.

While our dogs continued to socialize us at the dog park, we eventually became more involved as a group with neighborhood and local issues. We lived in an area of Chicago where there was a (much) higher than average crime rate. We shared with each other what we knew and what we had experienced and some of us began attending CAPS (Chicago Alternative Policing Strategy) meetings together. We participated in neighborhood meetings and anti-violence protests.

We also helped each other out by dog-sitting and house-sitting for one another. We attended one another's art shows and music gigs and contributed to each other's various fund-raisers. We helped one another to find work and consoled each other when we couldn't. We accompanied each other through the anxiety of tenure reviews and qualifying exams, health crises, real estate disasters, and blizzards.

If not for our dogs and the dog park, we would likely never have met one another. But because caring for our dogs led us out of our private spaces into the public, and because the dog park became a civic site, we not only got to know one another, but we also got engaged in neighborhood issues. None of this was revolutionary, at least not on a large scale. But one might say that a number of micro-revolutions were launched—a changed mind here, an opened mind there; one relationship born, another repaired; a neighborhood that became a little more neighborly.

And yet the dog park, as I mentioned, was a claimed rather than a given space. We were guerrilla dog-parkers. Though we got organized and met with and lobbied our local city officials on numerous occasions, the South Side of Chicago continues to be a home to many dogs and their families but not to an official dog park. This is a sad thing, obviously for the dogs, but also for the civic culture of the South Side and for Chicago more broadly. Dog parks are unique civic spaces that bring diverse people together in ways that make it easy for them to get to know one another. As I discovered firsthand, dog parks catalyze new relationships and diversified forms of civic association.

Dog companioning strikes me as good training for democracy and dog parks as crucial democratic spaces. To be a worthy companion to a dog requires learning to empathize across some rather significant species differences. These skills are directly transferable to democratic life in a pluralistic society. Learning to empathize with our dogs in order to anticipate and respond to their needs is great practice for the hard work of actively listening to and empathizing with those whose politics, or racial or ethnic experience, can seem so alien to our own, in spite of our common species nature. Dog companioning forms us for life in a pluralistic society.

One would think we might have made some of these connections by now. After all, dogs and humans have lived together for millennia. In fact, we lived and worked together long before cities even existed. The direct biological descendants of wolves (*Canis lupus*), dogs (*Canis lupus familiaris*) branched into their own species between 35,000 and 15,000 years ago (the debate on dates is ongoing). That's several thousand years prior to the Agricultural Revolution that began about 10,000 years ago. Across these many millennia, humans have worked with dogs for diverse purposes: for security; for help with hunting, tracking, and herding; and for the load-bearing labors of carrying and pulling. Dogs were the first domesticated animals and have even been ascribed

something like "personhood," as suggested by evidence of dog burials in formal human cemeteries that date back to 14,000 years ago.

In comparison to the ancient history of dog-human relations, the histories of the city and of politics are still very much in their youth (even in dog years). As mentioned earlier, there are some scholars who think that human-dog relations were a causal factor in the birth of civilization and cities. For example, Duke University dog cognition researcher Brian Hare argues that the security provided by dogs and their labor freed our ancestors from certain tasks and allowed them to pursue others. In other words, human-dog relations may have had something to do with the specialization of human roles, and thus the division of labor, in early human groups. Role specialization and the division of labor made it possible for these early human groups to become more productive, to build up surpluses of resources, and thus to transition from a nomadic foraging lifestyle to place-based settlement, the transition that gave rise to more sophisticated agricultural practices and thus to human cities. In other words, interspecies social bonding between humans and dogs preceded by a few millennia the development of intraspecies social bonding among humans in town and city life.

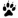

Being modern urban nomads, many members of the guerrilla dog park group have moved away from Woodlawn. But we stay connected. We meet at least a couple of times every year to share a meal and to tell our various dog tales. Though the dog park no longer physically exists, it continues to have a reality as a vector of *communitas*. According to anthropologist Victor Turner, who coined the term, *communitas* is a form of solidarity or community spirit that emerges in unstructured, liminal, or transitional communal spaces. I wouldn't be stretching the truth to say that the *communitas* that emerged in the formally unstructured space of our dog park, illicitly claimed rather than officially granted, saved some of us. It's too easy in a big city to isolate, to become anonymous. It's too easy to forget that the natural world grounds and sustains our human-built environments and to ignore the animality we share with other creatures. Our dogs and the dog park saved us from this amnesia by bringing us out of our isolation and into a sense of mutual belonging, into a little city within the larger city, the *civitas Canis lupus familiaris*.

I believe that dog companioning and dog parks can be critical to the renewal and deepening of democracy, on the South Side or anywhere else. They provide occasion and sites for relearning the arts of civic friendship, democratic dialogue, and political action. Just as many thousands of years ago dogs helped us to form the first cities and learn to work collectively in new ways, perhaps even now they can help us to rebuild our cities in ways that bridge our differences, encourage social engagement and dialogue, and thus bring to life a more participatory democratic world. Such a world might more truly be suited to a dog's kind of life.

Recommended Resources

Books

Grandin, Temple. *Animals in Translation: Using the Mysteries of Autism to Decode Animal Behavior*. New York: Scribner, 2005.

Grandin, Temple, and Catherine Johnson. *Animals Make Us Human: Creating the Best Life for Animals*. Orlando, FL: Houghton Mifflin, 2009.

Haraway, Donna. *The Companion Species Manifesto: Dogs, People, and Significant Otherness*. Chicago: Prickly Paradigm Press, 2003.

Hare, Brian, and Vanessa Woods. *The Genius of Dogs: How Dogs Are Smarter than You Think*. New York: Penguin, 2013.

Hobgood-Oster, Laura. *A Dog's History of the World: Canines and the Domestication of Humans*. Waco, TX: Baylor University Press, 2014.

Homans, John. *What's a Dog For?: The Surprising History, Science, Philosophy, and Politics of Man's Best Friend*. New York: Penguin, 2012.

Kotler, Steven. *A Small Furry Prayer: Dog Rescue and the Meaning of Life*. New York: Bloomsbury, 2010.

Littman, Margaret. *The Dog Lover's Companion to Chicago: The Inside Scoop on Where to Take Your Dog*. 2nd ed. Berkeley, CA: Avalon, 2006.

Milliken, Sue. *Dogs in the City*. Murdoch, WA: GlobeVista, 2012. Kindle edition.

Turner, Edith. *Communitas: The Anthropology of Collective Joy*. New York: Palgrave Macmillan, 2012.

Turner, Victor. *The Ritual Process: Structure and Anti-Structure*. 1969. Reprint, Piscataway, NJ: Transaction, 1995.

Waldau, Paul, and Kimberley Patton, eds. *A Communion of Subjects: Animals in Religion, Science, and Ethics*. New York: Columbia University Press, 2006.

Walsh, Julie M. *Unleashed Fury: The Political Struggle for Dog-Friendly Parks*. Purdue, IN: Purdue University Press, 2011.

Websites

Best Dog Parks in Chicago from Yelp: www.yelp.com/c/chicago/dog_parks

Dognition: Find the Genius in Your Dog: www.dognition.com

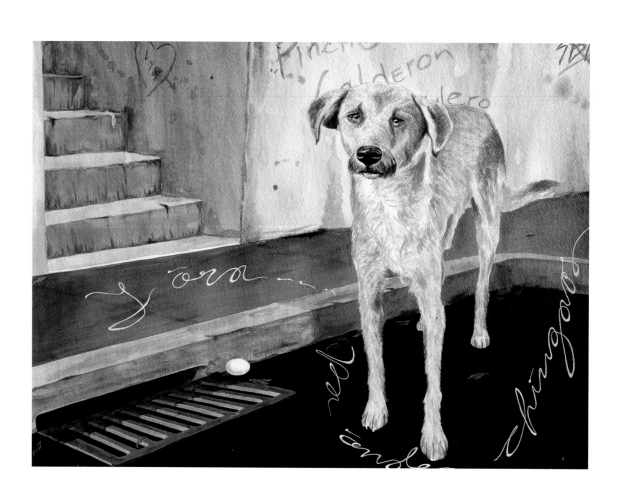

ALMA DOMÍNGUEZ, *Y ora pa onde chingaos*

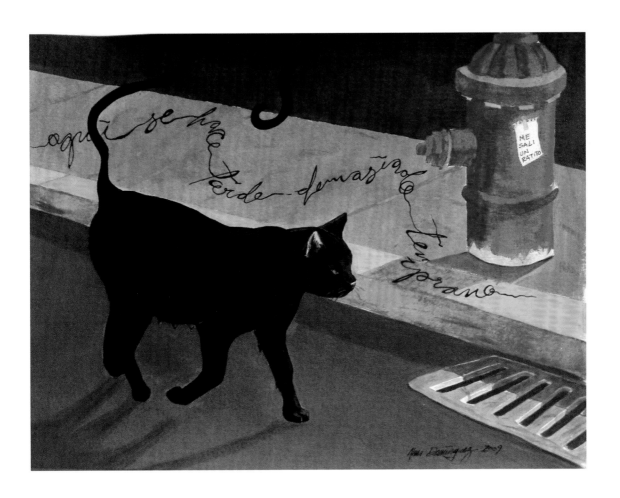

ALMA DOMÍNGUEZ, *Aquí se hace tarde demasiado temprano*

Wanting Was an Alley Cat

SUSAN HAHN

At five her freedom's thin
membrane stretched beyond
the patch of apartment grass
into the alley—a pulsing place—
where she sat on bumpy dirt ground
and wrapped herself in moving fur.

Garden of rubble grew
a child nourished
by the licks of strays,
defaced only by parental fears
she'd grow up a weed
leaning on an unclean building.

But wanting was an alley cat
by the time they moved away
and while suburban windows smiled
on a monotone of lawn,
the girl in her carried on
about that space—
about the soft and stony place.

ROA, *Ferrets*

Kiskinwahamâtowin
(Learning Together)

Outdoor Classrooms and Prairie Restoration at the American Indian Center of Chicago*

ELI SUZUKOVICH III

Prairie restoration is not something most would think of as happening within a city neighborhood, but in 2003, along Wilson Avenue on Chicago's North Side, 3,000 square feet of building frontage was restored to a savanna prairie ecosystem. The purpose of the garden was not necessarily for restoration, but instead to create a space within the city where members of Chicago's American Indian community could gather and learn about traditional medicinal, ceremonial, and edible plants. Through the years, the garden has evolved into a restoration garden, both in the sense that it has restored a piece of the neighborhood's pre-development ecosystem and that it is a place that has restored and helped revitalize the relationships among Native languages, cultures, and community in Chicago.

It was, and is, the primary space for youth participating in ecology programming, a place where youth and community members adopt plants and help establish them in the garden as part of learning about the plants and their roles in the ecosystem, including what these plants offer in terms of shelter for wildlife, soil stabilization, and food. In the process of building a prairie ecosystem, however, we found that the classroom was not just for people. Many birds, rodents, and rabbits found the garden to be an ideal place to rear and educate their young—interestingly, this education was also about plants.

Working in the garden, we soon found that there is much more to be revealed within the processes of prairie creation than just installing plants and running soil tests. Most importantly, our experience with the garden has provided a deeper insight into the mechanics of prairie ecosystems and the roles different organisms play. The garden was, and still is, a co-creation by local wildlife, humans, and the natural forces of rain, wind, and sun; it opens a window into the processes that prairie ecosystems undergo on a daily and yearly basis.

We learned prairie ecology from an interspecies perspective through hands-on work in the garden, and by observing and learning from other animals about

*The Native language used within this chapter is *Nehiyawewin* (Cree).

how they utilized this garden and other green spaces in the city to teach their young how to find food, communicate, and read their environment. These creatures taught us how all animals of the prairie, including humans, work together in their own ways to create and maintain these ecosystems.

From a Nehiya'w (Cree) perspective, this is not an earth-shattering concept. I grew up with traditional stories of the systematic relations between various animals, plants, peoples, and unseen worlds. In many ways, I developed an understanding of complex systems through learning about Nehiya'w culture. Others who were involved in the creation of these programs also came from similar backgrounds.

The concept of "Native science," as Gregory Cajete has called it—or simply the science of interrelated and connected systems—was and remains a major pillar of the youth and ecology programming at the American Indian Center of Chicago. While many of the designers and facilitators of the programs come from diverse tribes, it is this concept of all life being interconnected that helped us create a Native-based ecology curriculum that taught both Native cultural values and science, demonstrating to youth that science and culture are intertwined.

The Classroom Emerges

The front of the American Indian Center's (AIC) current building at 1630 W. Wilson Avenue has gone through several major ecological changes since 1860. Originally Wilson Avenue was a creek with a riparian and sand prairie ecosystem. In 1868 the Ravenswood Land Company purchased 194 acres of farm and wooded land eight miles north of Chicago. In the 1870s the site of the current AIC building was the pasture of a gentleman farmer, and the creek was piped for irrigation. In 1923 the Ravenswood Masonic Lodge built a four-story Masonic temple on the site, which was given to the American Indian community in 1966.

Members of the Chicago American Indian community founded the American Indian Center of Chicago in 1953 to provide a place where Chicago's Native American community could gather, find support, sustain cultural practices, and maintain tribal values. The AIC was also created to help Native peoples arriving in Chicago from various reservations throughout North America as part of the Relocation Program. The Relocation Program was an attempt to assimilate Native Americans through urbanization and separate them from their traditional land bases. While the plan of the program was to erode tribal and Native identity, the AIC and other urban Indian organizations in Chicago provided places and spaces for Native peoples from various tribes to maintain their identity by having a place within the city to freely exercise their cultures, beliefs, and familial and community ties.

In 2003 two Native community members required medicinal plants but could not find them in Chicago. In response to this, a group of women from the community came together and began planting medicinal plants in front of the AIC. From this grew the idea of having a community garden in front of the

Center to teach and help reestablish relationships between Native youth and plants. Five founding women and youth from the AIC's after-school and summer program began growing a Three Sisters garden (a traditional assemblage of squash, corn, and beans) for the youth in the community. This in turn became one of the impetuses for creating a Native youth ecology program, which became Urban Explorers and the AIC Urban Ecology Program, and grew from a National Science Foundation–supported research grant on engaging Native youth in science and mathematics (the research was a partnership between the AIC, Northwestern University, and the Menominee Language and Culture Commission).

By 2007 the garden needed redesigning. The front of the AIC was comprised of various plants representing different ecosystems without a site-appropriate focus, and had limited access for youth and community members to cultivate and harvest plants. Our top two priorities were to ensure that culturally significant plants—such as prairie sagewort, sweetgrass, and northern white cedar used for *wihkimâkasikan* (incense) in various ceremonies—were available to community members, and to make the garden functional as an outdoor classroom. It took about six weeks to remove sick trees and stumps, build planting beds, create berms and swales, and lay out paths. Community members and youth assisted with the redesign. In retrospect, this is when youth from the community learned their first lessons about their relationships to culturally significant plants and began seeing Chicago as Indian land.

Kiskinowâpahwâw (They Learn by Observation): Fledglings and Youth

The bulk of the redesign work was completed in July 2007, just in time for the Urban Explorers Program to start. We took the participants, ages ten to eighteen, out in the garden every day to learn about the plants, soil, and the ecology of the surrounding neighborhood. As youth and teachers were out in the garden, we observed and discussed the various insects, mammals, and birds we encountered.

Storytelling became a regular part of the curriculum and a way for Native youth to meet and learn about other community members, past and present. The stories ranged from parts of origin narratives that were associated with particular plants and their uses to remembrances of experiences in wild places and contemporary stories of animals, people, plants, and landscapes interacting with one another. The stories also focused on our four sacred medicines—cedar, tobacco, sage, and sweetgrass—and other culturally important plants such as corn, wild rice, strawberries, wild ginger, echinacea, and bee balm. We told the youth Anishinaabe (Ojibwe/Pottawatomie), Nehiya'w, Dakota, Lakota, Hoĉąk (Winnebago), Miami, Oneida, Chahta, Mohawk, and Diné (Navajo) stories about how these plants came to be utilized and their significance to the landscapes and ecosystems in which they are found. The stories represent the tribal background of the instructors and guest speakers and provide a space for youth

to learn about the multiple tribal perspectives and traditions that exist within the community.

Some stories, however, came from participants' experiences in the garden itself. Of the many wildlife and botanical encounters that occurred in the garden, there were several that especially highlighted the garden's role as an interspecies classroom. The following is one such story.

Just after the redesign work was nearing completion in July, a diverse number of birds began to inhabit the garden. As the area became more open and provided a wider variety of plants for food and cover, we began to see more songbirds such as purple finches, fox sparrows, robins, chickadees, red-crested kinglets, woodpeckers, and goldfinches. The local hawks also took notice of the open areas and the songbird activity, and our work in the garden that summer usually took place under the watchful eyes of a pair of kestrels, a Cooper's hawk, a young goshawk, and a peregrine falcon, waiting for us to startle and flush out the songbirds as we worked.

The birds, young and old, became accustomed to the youth in the garden, which allowed the youth to observe them hunt for insects, hide from predators, and learn their songs and how they communicate with one another. The birds became informal teachers about life in a savanna prairie, and the youth often found the fledglings watching back, observing their human neighbors.

In late June, we noticed that two male American goldfinches had been flying around the garden—randomly, it seemed. We found that they had come to check on the giant yellow hyssop growing in the garden. The hyssop was a volunteer, growing from seeds laid down some hundred years prior by stands of hyssop that existed in the area prior to development, waiting for the right conditions to reemerge. The goldfinches had not been seen in front of the AIC until this summer, and we soon learned that giant yellow hyssop and goldfinches have a mutual relationship: the hyssop provides a favorite food source for the finches, and the finches help spread its seeds as they voraciously feed on them.

On a typical morning that July during Urban Explorers, one would find the youth discussing the plants they were observing as they monitored their growth, the animal activity around them, and their flowers. Meanwhile, the goldfinches were visiting the hyssop, checking on the flowers, and tasting to see when the first seeds would be ready. Both finches and youth were so intent on their plant monitoring and observations that they often passed one another almost unseen. As July turned into August, the spires of tiny pale flowers of the giant yellow hyssop transformed into rich seed heads. It was then that the goldfinches changed their behavior and their use of the garden.

As the youth went out into the garden one Monday in early August to make their daily garden observations, they were met with a flurrying mass of golden twittering birds swooping and diving in and out of the garden. We all stopped and watched the goldfinches, not quite sure what they were doing at first. But as we watched, we noticed that the brightly colored male finches were leading the fledglings through the garden, twisting and swooping in a syncopated dance. It was quite a sight for all of us, but what were they doing? This question

led the youth and adults to watch, and as they did, a few kids saw *pipikesis* (kestrel) scanning the garden from atop the adjacent buildings. The male finches, we found, were teaching the fledglings how to evade capture from hawks or other predators. This predator evasion "class" went on for about thirty minutes.

Afterward, the female goldfinches arrived and began to show the fledglings how to identify food plants. Each female took her brood from one plant to another, demonstrating the best ways to get seeds from each species. They started with what seemed to be the easy plants, such as echinacea and black-eyed Susan, and then moved on to the trickier plants, such as bee balm and the hyssops (anise and giant yellow). When the finches got to the hyssops, the females and males worked together on teaching the fledglings how to sit on the plants and harvest the seeds. We watched the young finches disappear as they perched on the stems, learning how to blend into their surroundings as they ate.

Peyakwan-itohtêwin kekâc
(Similar Goals of a Journey)

For Native youth participating in Urban Explorers that summer, the prairie ecosystem of Chicago's past and present became visible. While the youth learned about traditional and contemporary uses of plants in the garden from adult humans, the birds and small mammals also taught them about life in the prairie and savanna from their perspective, sharing the knowledge they pass on to their own young. This experience prompted many youth to recall stories in which Bear taught humans how to find medicines (Anishinaabe) or Raccoon taught people how to gather eggs from birds' nests (Abenaki). By observing the goldfinches and other animals in the garden, they learned the basis of some Native stories and the complex relationships between different species covered in other stories and narratives (traditional, historical, and personal).

As the goldfinches conducted their daily learning activities in the garden, so did we. The AIC garden became a shared learning space for both humans and goldfinches, along with other animals living in the garden. We found that rabbits, squirrels, voles, and white-footed mice also taught their young and utilized the garden as a nursery in the spring. Along with the goldfinches, other birds brought their young to the garden. Fledgling hawks and owls would practice their hunting techniques on unsuspecting songbirds.

Our efforts to teach and connect Native youth with the land and to learn about culturally significant plants were really no different than what the goldfinches were teaching their fledglings. Both of us taught plant identification and use, as well as about the other animals living in the garden. Fledglings and human youth would learn side by side in the garden about plants and their significance to their daily lives, whether as food, medicine, or to their cultural identity. Native youth learned about plant medicines and foods such as sage, cedar, purple coneflower, sunchokes, June berry, bee balm, yarrow, and sweetgrass. The fledglings learned the importance of giant yellow hyssop as a vital food, along with how to find other foods, avoid predators, and the general ins-and-outs of the garden (similar to human youth learning about their neighborhood).

Both the youth and fledglings also made important connections to land and place through their interactions with the plants and other organisms and their continual return to the garden. By the end of the summer, many youth became protective of the garden and truly claimed it as their space educationally, culturally, and spiritually.

As teachers and facilitators, we would ask the youth about the day and what they observed, learned, or had thoughts about. In the early days of the program and research, our questions usually elicited very little response. For a while, it seemed as though we were not adequately reaching the youth, and we considered whether or not we needed a whole new teaching strategy.

But then we began to hear feedback from parents. They told us the stories their children shared with them about the plants they had learned about and the amount of wildlife that lived in the city that they had never previously noticed. More importantly, the youth began teaching their parents and siblings about which plants were medicinal and how to use them, or which ones were edible. They would introduce their families to the plants in the garden and the different animals that called it home.

One parent mentioned to me that her child never knew that it was possible to be close to birds, insects, and rabbits without scaring them away. Our youth found that many of the garden's residents had become familiar with them and felt safe, knowing none of the kids were going to eat them. For the fledglings that year, it seemed all of us were just another group of animals who occupied the garden. The fledglings learned who we were, as we learned who they were.

Tohkapinanki (Our Eyes Were Opened)

This experience caused me to think more deeply about how ecosystems develop, especially the relationships among their inhabitants. It was fascinating to start with an area stripped of vegetation—replanted and rearranged, with little biodiversity in the spring—and work toward an increase in plant and animal species, and then witness how all of these species seemed to find their place by the fall of the same year. True, this was just a 3,000-square-foot prairie restoration garden, but even so it provided a perfect opportunity to see the process of ecosystem development and how animals arrive in and make an ecosystem or habitat their home. I found it rewarding to be a part of the relationships between species and the roles they play in creating and shaping a habitat. Such relationships are probably going on all around us in the city all the time, but they may not be very apparent until we know to look for them.

However, these relationships are not all that unfamiliar to Native peoples. Many of our stories speak about these relationships. Traditional and current narratives of tribal origins, of how landscapes came into being, of personal experiences while hunting or at war, and of learning about foods and medicines were, and still are, important teaching tools for us. It is these stories that guide our endeavors.

We teach our youth in the American Indian community that Chicago is and always has been Native land, regardless of treaties that ceded territories and

policies that forcibly removed tribal peoples from the region. The connection to land has always been there, and Native peoples have always been included as part of, and active members within, the prairie and oak savanna ecosystems of the Chicago area. The youth and others who have helped in the garden between 2006 and the present learned about the significance of prairies and forests, both ecologically and culturally, through the hands-on experiences of actively participating in the garden space, whether through planting, collecting seeds, recounting stories, and teaching others, or simply being a part of its creation and maintenance.

Prairies and forests are not necessarily nouns, objects sitting stagnant; they are better understood as verbs that speak of process, time, and succession, with each organism from the tiniest bacterium to the tallest tree playing an important role in creating, shaping, and maintaining the landscape. They are also active places of learning. Restored gardens or accidental prairies do not always begin as learning environments, but nevertheless can become places where young animals (both nonhuman and human) learn about the world and their cultures.

What the goldfinches taught us, or at least opened our eyes to, was that prairie gardens and urban green spaces create environments of learning that are multidisciplinary and multigenerational. Unlike a formal classroom setting that has a controlled and planned environment, prairie ecosystems lend an air of unpredictability from which science and cultural learning opportunities emerge that cannot be reproduced indoors. The days our youth spent observing goldfinches and life in the prairie garden taught them more about systematic theories of science, interrelational mechanics of an ecosystem, and pride in their tribal identity and heritage through making meaningful connections to land than years of classroom education could have. Prairie ecosystems and outdoor classrooms are by nature dynamic and unpredictable, and can be frustrating to someone trained for the conventional indoor classroom. However, it is these very attributes that allow teachers and students, youth and adults, to gain a wider comprehension of, and access to, the physical, biological, and cultural forces that affect the daily lives of humans and other animals that call the urban ecosystem home.

Recommended Resources

Books

American Indian Center of Chicago, Nora Lloyd, and Jane Stevens. *Chicago's 50 Years of Powwows*. Charleston, SC: Arcadia Publishing, 2004.

Cajete, Gregory. *Native Science: Natural Laws of Interdependence*. Santa Fe, NM: Clear Light Publishers, 1999.

LaDuke, Winona. *Recovering the Sacred: The Power of Naming and Claiming*. Cambridge, MA: South End Press, 2005.

LaGrand, James B. *Indian Metropolis: Native Americans in Chicago, 1945–75*. Urbana: University of Illinois Press, 2005.

Straus, Terry, ed. *Native Chicago*. 2nd ed. Brooklyn: Albatross Press, 2002.

Toupal, Rebecca S. *An Ethnobotany of Indiana Dunes National Lakeshore: A Baseline Study Emphasizing Plant Relationships of the Miami and Potawatomi Peoples.* 3 vols. Tucson: Bureau of Applied Research in Anthropology, University of Arizona, 2006. (Available online at www.csu.edu/cerc/researchreports/indunes.htm.)

Websites

American Indian Center of Chicago: www.aic-chicago.org
Great Lakes Indian Fish and Wildlife Consortium: www.glifwc.org

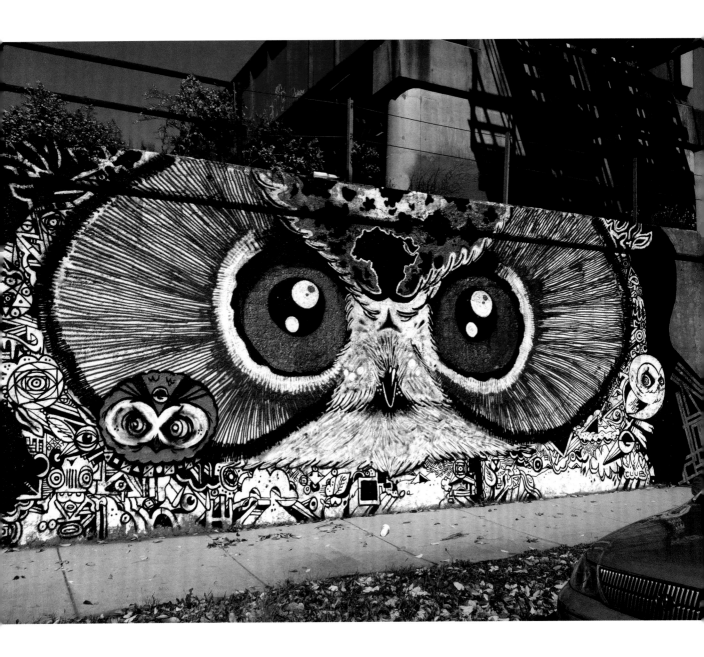

BROOKS BLAIR GOLDEN, *Owl*

The Red Fox Who Toys with the Dead

BRENDA CÁRDENAS

Carrying a sunset on his back,
the funeral home fox circles
an empty hearse where the dead pause
between rides. Perched atop
its shiny black hood, they pore
over maps of Mictlán, Valhalla,
Elysium, Bardo. Some toss dice, take bets.

I watch from the kitchen window
wondering who among them might play
Fox's game, chase the ball of fire he flips
off his tail into the arms of our old ash.
One specter so mourns her lost light,
she scales the tree's icy trunk, stretching
to rescue their dying day. A branch cracks,
falls through the windless sky, catching
a glint from the moon's sickle. In a blink,
la muertita abandons Fox's red globe,
grasping for brighter beams.

Fox snarls, barks, nips at her toes,
finally turns to other shadows
until he corners one strong enough to pass
through cellar doors, slim enough to slip
between hairline cracks in the brick.
Beneath our basement stairs cluttered
with wrenches and rusty hinges, crowbars
and paint cans, the wraith finds a rope
for Fox to whirl to the ash's crown,
snag the girl, bring her and his ball back
down to earth where all belong.

I hear their clinks, their clanks,
the rope dragging itself across the walk.
But *la muertita* has long sailed beyond
its reach, beyond the dimmest stars,
galaxies farther than the red fox's radiance
heaped in a crow's nest ablaze with black
cackles. Gray as a grandfather, he drops
his ears, tail; watches the hearse slink
away; retreats in his own tracks
slowly filling with snow.

Remaking Our Covenants of Life and Death on the Dunes Commons

J. RONALD ENGEL

> *For the hunter-forager, this Me in a non-Me world is the most penetrating and powerful realization in life. The mature person in such a culture is not concerned with blunting that dreadful reality but with establishing lines of connectedness or relationship. Formal culture is shaped by the elaboration of covenants and negotiations with the Other.*
>
> PAUL SHEPARD, *The Only World We've Got*

I

I did not expect when we moved to the Indiana Dunes that someday I would be constructing a seven-foot-high deer fence around the perimeter of our property. Nor did I anticipate, as my friend Xhela Mehmeti and I set about driving in the metal posts and attaching the black plastic netting, that the issue of how we should live in right relationship to deer would raise far-reaching questions of war, hunting, predation, and ecology, and lead our community to remake its covenants of life and death on the Dunes commons.

While building the house in 1992, my wife and I had felt nothing but delight when we ran with the carpenters to the window to see the doe and two fawns cautiously making their way through the black oak savanna on which our foundation was set. When the house was ready, we ceremoniously hung on the wall our large brown etching of a coy doe with big seductive eyes by Chicago artist Bronislaw Bak. The deer were all of a piece with our tufted titmouse, trillium, and wild grape vines.

But in 2002, 14 thin and hungry deer were bedded down on our ancient dune ridge. Garlic mustard spread by their hooves had replaced the wildflowers, the understory was cleared up to the browse line (the limit deer can reach when feeding), and birds were scarce. An aerial survey showed 121 deer in the one square mile of the town of Beverly Shores where we lived. Wildlife experts told us that at most 15 to 20 were sustainable.

We were not the only ones who felt under siege. Embraced on all sides by the Indiana Dunes National Lakeshore, Beverly Shores is truly a blessed community. In 2001, however, when it was clear that the superintendent of the

lakeshore was not going to take action on the deer issue, residents petitioned the town council to authorize sharpshooters to make a deer cull. Immediately, in what is now a typical narrative according to Jim Sterba's well-titled book *Nature Wars*, all hell broke loose. Two groups were formed, one in favor and one opposed. So much acrimony was generated that, one night, in a desperate attempt to find a compromise, the town council voted both to permit residents to shoot deer on their own property and to allow a group of "animal rights advocates and others" to surgically sterilize 75 male deer! Afterward, a member of the pro-cull faction exclaimed: "Is this going to be Beirut on the lake in Indiana?" A representative of the anti-cull faction chimed in: "You people are crazy. Absolutely crazy."

To understand what was happening in those years, we need a long view of the history of the Dunes commons and the roles that both war and the desire to overcome the violence of war have played in the formation of its underlying covenants.

II

The blessing of the Indiana Dunes National Lakeshore and other parks and protected areas that make up the Dunes commons did not come easily.

In the early 1900s, the "Dune Country"—a crescent of beaches, dune ridges, bogs, and lakes—stretched unbroken for fifteen miles along the southern coast of Lake Michigan between Gary and Michigan City, Indiana. Graced by an extraordinarily diverse flora and fauna, from predacious bog plants to native prairie grasses and from towering white pines to rare algal species, it was celebrated by outdoor enthusiasts, artists, and naturalists as a place apart, a commons, that in vernacular experience, if not in legal title, belonged to everyone.

Over the course of the following century, as powerful business interests sought to industrialize the region, several generations of citizens wrestled the gods of "progress" and preserved remnants of the Dunes landscape. Their efforts began in 1916 when a coalition of civic organizations launched a movement to establish a "Sand Dunes National Park." On Memorial Day, 1917, 25,000 people ringed a large dunes blowout to witness a thousand costumed actors enact the "Historical Pageant and Masque of the Sand Dunes of Indiana," billed as the largest outdoor drama in American history. In the culminating episode, in response to entreaties by the spirits of the dunes to "Grant us these haunts of beauty, Heart of Pan, Heart of Man," the Dunes commons was consecrated by the ritual of the calumet to "Peace, Love and the Fireside." The movement to "Save the Dunes" over the succeeding century owed its successes to the fact that a sizable band of citizens from the four-state Chicago region so covenanted with one another in 1917.

By the opening years of the twenty-first century, however, that covenant was in disarray. The promise to defend the Dunes commons "untouched and undefiled" from incursions from without had not matured into a covenant of shared public responsibility for the ecology of the commons. It was a covenant of *sanctuary* for the Dunes but not a covenant sufficient to *sustain* the Dunes

community itself. Most of the Dunes commons was owned by governmental and private conservation bodies that were largely impervious to citizen influence. When none of these entities, with the notable exception of the Indiana Dunes State Park, took measures to address the impact of deer overpopulation on the health of the commons, it was inevitable that the issue would become rife with frustration and controversy.

<h1 style="text-align:center">III</h1>

The vision of the Dunes as a sanctuary for all life drew deeply from many cultural sources, including the notion that a Peaceable Kingdom will come when humans tame their willful egos and spread the Light of loving-kindness to embrace all creatures of the world. In 1913 the Chicago dramatist Kenneth Goodman wrote a masque, "The Beauty of the World," which climaxed in an exchange of vows between a "friend of the Native Landscape" and a fawn. The friend pledges everlasting protection of the fawn's home and the fawn in reply pledges:

> These woods are mine and thine. Thy children's children
> Shall find me always here to welcome them.
> I pledge to thee and them ever lasting calm,
> A refuge from the fret of roaring streets,
> Silence and Beauty, Peace and leafy shade . . .

In 2001 an imaginative story by the Pressley family appeared in the Michigan City *Post-Dispatch*. It told how a doe named "Beauty" refused an apple when she learned that the town of Beverly Shores might undertake a deer cull. Although it is unlikely the Pressley family ever heard of the Goodman masque, which was last performed in the Dunes in 1948, they were obviously fearful that harming deer would somehow break a personal vow.

One effect of this interpretation of "peace" was to encourage the domestication of the deer. Some residents regularly fed the deer and opposed any legal ban on feeding. Each morning in the winter of 2002, someone dumped a bushel of apples on the side of the street in front of our house. Even more telling were the proposals, encouraged by Dr. Allen Rutberg of the Humane Society of the United States, to inject contraceptives in does—in effect treating the deer as human patients in need of mandatory planned parenthood. The burgeoning deer population was leading some to advance powerfully intrusive disruptions of the reproductive behavior and natural satisfactions of deer. Our town and the rest of the Dunes commons were being turned into a deer park.

<h1 style="text-align:center">IV</h1>

But as the deer debate raged on, the opposition to a deer cull proved to have deeper motives, motives that I could well appreciate. Underlying the assumption that a peaceful and reverent relationship between humans and nature

prohibited hunting was the largely unspoken belief that such action was tantamount to waging war.

In fact, the dialectic between war and peace is everywhere in the Dunes story. The Dunes Pageant was held in 1917 as the nation marched off to war, and it expressed an inchoate appeal by Chicago progressives such as Jane Addams to find an alternative path to world peace. In the 1960s, Illinois senator Paul Douglas led his "campaign" for the Dunes by capitalizing on his war record as a marine and attending rallies in a military jeep.

Perhaps, then, it is unsurprising that the proposal for culling would also be framed as a choice between war and peace. At the height of the deer controversy, a series of letters in the local community newsletter described the prospect of a deer cull in terms of an invading army and Beverly Shores as a potential "killing fields":

> What if a pet is killed? What if a bedroom window is shot out? And what if a child catches a stray bullet through that bedroom window? ... [T]here will be ten weeks of gunfire, blocked roads, sight of dead animals being carted thru town, loss of personal safety; they will kill pregnant females, fetuses will suffocate in their wombs.

The conflation of hunting and war runs deep in American imagination and history. The massacre of buffalo on the American frontier was encouraged by the U.S. government as a strategy to conquer the Plains Indians. The massacre of deer, birds, and other wildlife in the great Kankakee marsh by Chicago hunters in the late nineteenth century was in effect a scorched-earth military campaign. A similar wholesale slaughter of wildlife occurred a short distance north in the Dune Country. And who can forget how in the film *The Deer Hunter* "one-shot" Sergeant Mike Vronsky (played by Robert De Niro), returning from Vietnam, refuses to pull the trigger of his rifle and kill a magnificent buck?

Opponents of hunting are often derided as "Bambi lovers." It is hard not to feel deep sympathy for Bambi's mother, who does everything possible to shield her son from the terrors inflicted on the forest creatures by the two-legged Hunter god they call "Him." But as Matt Cartmill explains in *A View to a Death in the Morning: Hunting and Nature through History*, few readers are aware that the picture of "Hunter" that is presented in Felix Salten's 1924 novel was inspired by his reaction to the "senseless slaughter of WWI" (181) and that it was this long-standing association of hunting and war that led Salten to make the hunter the symbol of violent aggression.

V

Perhaps the greatest obstacle to our community's ability to ethically confront the issue of deer overpopulation was the broader cultural confusion regarding the relationships among war, hunting, and predation. We have seen the way in which hunting can be conflated with war. The same is true with predation and war. The metaphor is everywhere: General Atomics' MQ-1 Predator is an

unmanned aerial vehicle (drone) used today by the U.S. Air Force and Central Intelligence Agency.

The Dunes history shows that in our efforts to find alternatives to war, we are tempted to embrace covenants that promise emancipation from the evolutionary necessities of predation. Yet the dance of predator and prey, a biological dance of life and death, involving species whose physiology and behavior have evolved codependently, differs fundamentally from human warfare. And among traditional hunting peoples such as the Inuit, as Barry Lopez documents in *Of Wolves and Men*, good hunting comes as close to mimicking the natural relationships of predator and prey as possible. When Lopez asks a Native Nunamiut hunter in northern Canada, "Who knows more about the land, an old man or an old wolf?" the Nunamiut elder replies, "The same, they know the same."

Predator and prey rely on one another for life. Where one exists without the other, it is a species out of place, robbed of its necessary evolutionary partners. Since we humans have removed other predators from the Dunes ecosystem, we have become the *de facto* top predator, with all the responsibilities that such a position entails. We are not going to restore mountain lions and wolves to the Dunes commons anytime soon, so it is up to us to fulfill their roles.

Everything finally rests on whether we extend the covenants of life and death by which we live to include other creatures, or restrict them to humans alone. In covenants we commit ourselves to the well-being of Others in their freedom and individuality and to the relationships between us that have the power to sustain us as a community over the generations. Inclusive covenants involve different obligations to different Others within a common obligation of respect and care for all. Just as our covenantal obligations to different persons—to friends, marriage partners, colleagues, and fellow citizens—differ, so do our obligations to other species. This is something we have only begun to sort out and understand. If we are to take responsibility for deer, to accord them rights, or to feel obligated in some sense as stewards of their welfare, we must include them in a comprehensive covenant that not only respects and cares for them as individuals but also accords with the ecological and evolutionary processes on which their individual and species well-being depends.

VI

If anyone had reason to think of the Dunes as a prelapsarian Eden, it was Bob Beglin. He and his family discovered the town of Beverly Shores by driving up a remote lane one hot August afternoon in 1971 in search of a place where they could change their clothes and take a swim. At the end of the lane, they surprised a couple making love in the woods. Then and there, as Bob liked to tell the story, he knew this was the place where he wanted to live.

Bob loved wildflowers. In the 1990s he became alarmed as he noticed flowers disappearing, and he began to correspond with university experts on the impact of deer overpopulation on natural habitat. In 1999 Bob convened a series of educational meetings for the community that enabled us to see how the well-

being of the deer population depended upon the well-being of the total tro-phic or ecological pyramid of the Dunes commons, and therefore how impor-tant it was to maintain or restore the integrity of the food chains (including the predator-prey relationships) that link the life and death of soil organisms, plants, herbivores, and carnivores throughout the ecosystem. He also made sure that all sides on the question of how to address deer overpopulation were expressed. There were presentations by representatives of the National Lake-shore, the Indiana Department of Natural Resources, and by local conserva-tion, veterinary, and animal welfare and rights groups.

By 2001, however, civil discourse was no longer possible at town meetings, and a series of legal suits and countersuits usurped the public space. In spite of the acrimony, Bob did not give up. He went on to organize a not-for-profit orga-nization, the Environmental Restoration Group, which was dedicated to fund-ing the legal expenses of cull advocates, pursuing research and education on the impact of deer overpopulation on human and deer health, and doing what-ever it could—pulling garlic mustard became a favorite pastime—to restore the native plant communities at the base of the commons ecosystem. After seem-ingly endless debate and a new town election, the group successfully made the case to the town council that a series of annual deer culls by skilled bow hunt-ers could effectively and safely reduce the deer population to sustainable levels.

It was at this point that the deer fence Xhela and I were building took on a much more positive meaning. In effect we were creating an experimental plot. A few seasons after it was erected, the biologist with the Indiana Department of Natural Resources used our property to demonstrate the difference between healthy protected vegetation and vegetation exposed to excessive deer browse.

By casting the deer issue as a matter that needed to be addressed within the context of the restoration of the full range of ecological interdependencies of the Dunes landscape, the Environmental Restoration Group changed the dynamics of our community and opened the doors to healing. The question became *How might we in our current circumstances show gratitude for the bless-ings of living in this place, comparable to what the first Dunes enthusiasts showed a century earlier?* This meant both reaffirming the covenant that had inspired several generations to protect the Dunes (a common aim of pro- and anti-cull advocates alike) and remaking the covenant so as to responsibly embrace the roles of top predator and steward of ecosystem integrity that history and evolu-tion had thrust upon us.

But the Dunes were not the only gift that needed to be stewarded for the fu-ture. We had also received the gift of living in a democratic society, where sci-entific facts could be publicized, alternative courses of action tested, differing moral judgments debated, and the rule of law prevail. In the final analysis, the conflicts we suffered over the deer issue were not something to deplore, but a sign of democracy alive! The deer issue was not a tragedy but an opportunity for us to better learn our place in nature and exercise our covenantal obligations for the health of the political as well as natural commons.

VII

Bob became acquainted with a local bow hunter, Don Dolph, who had intimate knowledge of the terrain of Beverly Shores. Bob and his wife, Arlene, spent many hours sitting at their kitchen table with Don talking about deer. They were astounded by what Don knew about them, almost down to each individual deer family—where they bedded down; when, why, and where they moved; the trails they frequented; their life cycle; when a buck will stand its ground; and just how dangerous a kick by a hoof can be.

Some years later, in conversation with Tom Lane, the current coordinator of the Beverly Shores deer cull, I also learned just how attentive bow hunters are to the lifeways of deer in the local ecology and how challenging the discipline of bow-hunting is. Tom recruits around ten people each year from the Deep River Bowman Club and runs each through a demanding proficiency test at his home. What he is most watching for, he says, is not only how many times they can place a broad-head arrow in a two-inch circle at twenty yards, or how readily they can leverage a seventy-pound draw on their bow, but how much respect they give to what they are doing.

The heart of the hunt is the heightened awareness of nature it calls forth. My wife and I can relate to this as birders, but only so far. The hunt begins well before daybreak and ends at nightfall, and throughout the entire intervening time the hunter must sit or stand as immobile as possible. Sometimes squirrels will scamper within inches and birds perch only feet away.

"When a deer finally appears," Tom told me, "I can feel my heart pound and almost believe it is pounding in rhythm with the heart of the deer. Then I must wait until the deer offers a clear, straight shot to its heart or lungs, a vital zone no larger than eight inches in diameter. Sometimes the buck of a lifetime walks away if you don't have a good, straight shot." The actual killing of the deer is over in fifteen to twenty seconds. The deer may run a few yards, but it will soon slump down on the ground and expire. "The worst thing is to wound an animal that then gets away," Tom said. "It doesn't happen often. When it does, we do everything possible to track the deer and end its life swiftly." The Beverly Shores bow hunters examine the internal organs of the deer they shoot in order to judge their health. They pay for the deer to be dressed and made available to a local food pantry. The flesh of the deer must be shared for the hunt to be judged successful.

VIII

In 2012, almost a century after the founding covenant to preserve the Dunes commons was made by those who witnessed the "Historical Pageant and Masque of the Sand Dunes of Indiana," another commemorative ceremony was held. This time it was a memorial service for Bob Beglin, who helped teach us how that covenant must be remade if its original intention is to be fulfilled.

From 2012 to 2013, Tom's team of bow hunters took twenty-nine deer in Beverly Shores. Deer culls by bow hunting in Beverly Shores is now a model for other communities in Indiana.

In March 2013, fifteen years since alarms were first raised by local residents regarding the degrading impact of deer overpopulation on the Dunes commons, U.S. government sharpshooters conducted their first deer cull within the National Lakeshore and killed eighty-four deer.

We still have our deer fence. We look forward to the time when the deer numbers finally reach sustainable levels and we can take it down. One fall during rutting season, a doe sprang over the fence, leaving the buck who was chasing her standing outside, head cocked sideways, as if saying to himself, *Now I have seen everything!* She then leapt back out with graceful ease.

Such adventures are no substitute for what we have lost. We no longer peer from the window in anticipation of a burst of white bounding off through the woods. The forest is no longer so mysterious. It no longer harbors in its shadows creatures whose visage was somehow burned into our subconscious over millennia, creatures our ancestors drew with obvious delight on the walls of caves, bearers of vitalities beyond our ken, who call forth all our senses of alerted sight, hearing, tensed muscles, and patience, our hearts in our throats.

We need the deer and we need them wild. They are an irreplaceable part of the plenitude of being that constitutes our natural and mental worlds. The deer also need us, but they need us to be the ethically responsible, environmentally attuned, and politically self-governing creatures we have the potential to be. These two needs can only be met if we remake our covenants of life and death on the Dunes commons so that war is abolished and ways are found for predation and the full ecological pyramid of life to be sustained.

Recommended Resources

Books and Film

Cartmill, Matt. *A View to a Death in the Morning: Hunting and Nature through History.* Cambridge, MA: Harvard University Press, 1993.

Engel, J. Ronald. *Sacred Sands: The Struggle for Community in the Indiana Dunes.* Middletown, CT: Wesleyan University Press, 1983.

Lopez, Barry. *Of Wolves and Men.* New York: Scribner, 1978.

Manes, Jeff, Brian Kallies, and Tom Desch. *Everglades of the North: The Story of the Grand Kankakee Marsh.* DVD. Wheeler, IN: For Goodness Sake Productions, 2012.

Nelson, Richard. *Heart and Blood: Living with Deer in America.* New York: Knopf, 1997.

Shepard, Paul. *The Others: How Animals Made Us Human.* Washington, DC: Island Press, 1996.

Sterba, Jim. *Nature Wars: The Incredible Story of How Wildlife Comebacks Turned Backyards into Battlegrounds.* New York: Crown, 2011.

Websites

Indiana Dunes National Lakeshore: www.nps.gov/indu/index.htm
Indiana Dunes State Park: www.in.gov/dnr/parklake/2980.htm

XAVIER NUEZ, *Nikki: (hiphop) dancing queen*

Crickets

JILL SPEALMAN

On summer Wednesdays I teach clarinet lessons
in the damp church basement.
Here a cricket chorus congregates,
masking the racket of traffic above.
When I start down the stairs they stop,
clipped in mid-melody,
only to chime in again when they confirm that it's me.

Like shiny black beans, they're scattered over the cool cement,
but I corral them under the choir robe closet,
where their chirps soothe the squeaks of the students.
On hot days they crawl back out,
tentative antennae twitching toward us
creeping the girls and challenging the boys.
At day's end we leave them to convene until next week.

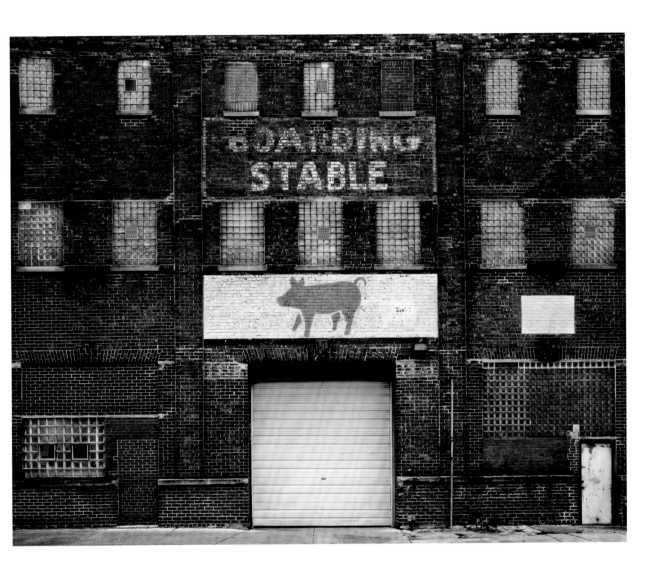

JOSEPH KAYNE, *The Boarding Stable*

※ **3** ※

ANIMALS ON DISPLAY

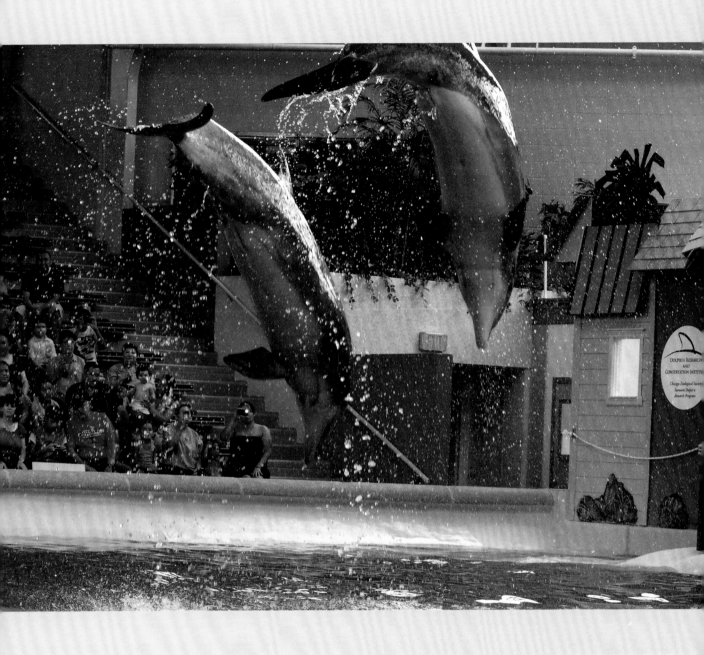

GREGORY J. AUBERRY, *Dolphins at Play*

Train to the Zoo

JOAN GIBB ENGEL

The train is in the station
It's going to the zoo

Mark and Kirsten, six and three, are galloping through the living and dining rooms, knocking over chairs, falling into each other, playing "Train to the Zoo" at top volume:

Choo, choo, choo, choo
Chugga, chugga, chugga, chugga
Train to the zoo.

To their minds, the song is about Chicago's Lincoln Park Zoo, the only zoo they know, a place they go to each time my parents visit. When Mark is eight, his grandfather will write a humorous short story about taking him there.

"Safari" by Walter M. Gibb, published in the *Atlantic* in November 1966, begins with the grandfather trying to interest Mark in marbles or a jigsaw puzzle. When that fails, he goes back to coloring one of Mark's picture books, "staying always within the lines and choosing colors which are an improvement upon nature. It was," he tells us, "while crayoning a particularly handsome amethyst elephant that I proposed our trip to the zoo."

They go to the zoo, but the animals don't interest Mark either, and he declares himself too old to ride the miniature zoo train. So the disappointed grandfather absentmindedly gets on the train himself, not waking up to what he has done "until we reached the rock pile of the aoudads, which is about halfway." The story ends with a child staring "rather strangely" at his grandfather as the train pulls into the depot.

I am older now than my father was then, and Mark is a physician with grown sons, but the *toot-toot*s of that diminutive diesel live on. Today, a blustery cold day in early November, it is I who am taking a train to the Lincoln Park Zoo—the South Shore electric from Indiana to Millennium Station. From there to this most central of Chicago's zoos is but a short bus ride.

It's full of little boys and girls
But there's still room for you

Is there?

In 1969 Desmond Morris said that zoos were symbols of the alienation of urban life, and it has since become a cliché to announce, "It's a zoo out there," in response to cars switching lanes on the Dan Ryan or the frustration of finding a parking space in a downtown garage. What we mean by this cliché is that the traffic is "wild," with cars not "staying always within the lines," or we are venting our repressed ferocity at handicapped-only spaces, our desire to escape to the rock pile of the aoudads, free ourselves from the limitations of family and social conditioning, and be as bellowing and trumpeting as lions and elephants. But more than expressing our inner psychology, "zoo" designates the repository, in the form of warm, living bodies, of a vanishing wilderness. "Zoo" is Wild Incorporated.

Yet, paradoxically, zoos are the very opposite of wild; they are places where wild is penned, disgraced, and tricked into submission.

Rather universally, I believe, zoos therefore elicit conflicting feelings. I remember as a child tossing peanuts to an elephant who vacuumed the concrete floor with his trunk in an increasingly listless manner before abandoning the effort. I remember the horrible smell of the monkey house and closing my ears to the echoing roars in the lion house. Yet I accompanied our children to the Lincoln Park Zoo, and in the past six years I have taken our granddaughter Helene several times to Tucson's Reid Park Zoo and once to San Diego's Wild Animal Park, where we rode the train around to see giraffes and lions in more "natural" settings.

I've read books that praise zoos for their care and that vouch for the happiness of their residents; books—the great majority—that argue persuasively for the value of zoos as holding pens for species that would otherwise follow the passenger pigeon into extinction; and books that chronicle the cruelty of zoos in convincing detail. Films such as *Free Willy* reinforce anti-zoo feelings, while the popularity of *I Bought a Zoo* does the opposite.

As the train picks up passengers at Hegewisch, and as the bus careens up Michigan Avenue, the zoo train song is in my head and I am awash in dilemma.

Chugga, chugga, chugga, chugga
All out! The Zoo!

Lincoln Park is the oldest free public zoo in the United States. I stop by an outdoor map and read that the zoo is accredited by the Association of Zoos and Aquariums (AZA), participates in the Species Survival Plan, and employs scientists who travel the globe "and bring species back from the brink." I know from their website that Lincoln Park Zoo scientists partner with the Jane Goodall Institute in Tanzania to study chimpanzee health in the wild; vaccinate domestic dogs against rabies and distemper in the Serengeti; document the effects of logging operations on ape populations in the Congo; assist in the recovery

of black rhinos in South Africa's Addo Elephant National Park; and have, all-around, an impressive résumé of global conservation work. Plus they are active on the home front, having established the Urban Wildlife Institute in order to collaborate with nature/conservation groups to tackle very local problems, such as how to ethically manage free-roaming cats, research what happens to pesky animals like groundhogs after they are relocated, and tag vegetable-nibbling rabbits to better learn their foraging patterns. Surely, such work weights the zoo dilemma in a positive direction.

Turning back to the map, I see there's an asterisk by the zoo train, indicating that it's closed for the season. Too cold.

Too lonely.

For my first feeling is one of loneliness. It seems wrong to visit a zoo without a child, to have no one to tie balloons to, no one to lift above the crowds or introduce to the zebra of "Z," the aardvark of "A." The first time I went to the zoo in Tucson, I was with Helene. We rode the zoo train. She was thrilled. The second time we happened to arrive at "feed the giraffe" time. Although she was three then and she has just turned eight, I remember it like yesterday:

We pay a special fee, and she is handed a rectangular biscuit. She holds the biscuit in her hand excitedly as we move to the front of the line. When it's her turn, the creature lowers its head and extends a twenty-inch blue-black tongue. My granddaughter turns away. "Come on, Helene," I say, as startled as she is. "The giraffe won't hurt you." But she refuses and I do the job.

No picture book prepared us for that tongue, for its wonder and strangeness. I have since checked out a Ready-to-Read book, *Eloise Visits the Zoo*. The giraffe who licks little Eloise's hand in that text does so with an ordinary, human-size, pink tongue.

So, in spite of loneliness, I'm game for a new revelation. Straight ahead is the Kovler Sea Lion Pool. I picture icebergs and rocky canyons.

In the water on their bellies
Smooth seals slip and slide

A troop of children race down the stairs ahead of me and stand in the dark underground viewing area facing a glassed-in pool, a flat concrete floor, and unadorned concrete pillars. I am reminded more of a flooded basement than an ocean paradise. The basement seems utterly empty at first, but periodically a ghostlike speckled torpedo sails into view, and the children break into reverberating barks, chasing around the ramp fruitlessly as the torpedo swims out of sight. When the original version of this pool was built in 1889, its eighteen sea lions escaped and staged an Occupy Clark Street Restaurant—at least that's the story on the zoo's website. I'd like to see a photo of those guys lining up for fish tacos. All but one were recaptured, though a few years later a second breakout occurred and a single sea lion waddled all the way to Lake Michigan, where it swam free for a year before washing up dead on a beach in Michigan. The gray seals I'm watching today are less adept on land than those sea lions. Still, if I were confined to circling this sterile pool, I'd give escape a try.

In his passionate anti-zoo book, *Thought to Exist in the Wild*, Derrick Jensen writes: "We see a sea lion in a concrete pool and believe that we're still seeing a sea lion." But we are not, for

> a sea lion is her habitat. She is the school of fish she chases. . . . She is the waves that strike the rocks on which she sleeps, and she is the rocks. She is the constant calling back and forth between members of her family. . . . She is the shark who eventually ends her life. . . . (86–87)

Outside, in the sunlight, I retreat to a bench, all too aware that I and the seals and the children have been handed a bill of goods. Fortunately, a child toddles over to my bench in pursuit of an English sparrow, utterly fascinated with a creature her mother need not have brought her so far to see.

My spirits lifted, I unbutton my by now too-warm coat and walk on, soon finding myself peering through a window at the end of an alcove. It's like looking into an old-fashioned candy egg, except that inside, instead of bunnies and flowers, a regal lion poses atop a pile of rocks, head erect, mane waving, his gaze focused on a tawny lioness who sleeps inches from the window, thus revealing the perfection of her body, her firm, square chin, the long black hairs of a tapered tail. An African American man enters the alcove with a group of children. "It's a beautiful animal," the man says. I can't help but hear pride for his ancestral home—and mine—in that resonant voice. What do the children see? Is this a ferocious man-eating beast from the Roman arena? Or do they see Simba, the lion who feels guilt for drawing outside the lines? What story holds them so rapt?

> *Oh when you clap, clap, clap your hands*
> *The monkey claps, claps, claps his hands.*

I pass by a few swinging monkeys to enter the Regenstein Center for African Apes. It was here that Benjamin Hale got the idea for his 2011 novel, *The Evolution of Bruno Littlemore*. If my revelation in Tucson was of the glorious wild Otherness of the animal kingdom, Hale fast-forwards *The Descent of Man* to give us Bruno, a chimp who wants to climb down from the tree, who gets a nose job, acquires language, and plays Caliban in *The Tempest*. "I'm a Chicago boy, Gwen," Bruno tells his amanuensis. Without mercy, he lets us see ourselves as we "ooglie-mooglie" the miserable caged animals, astonished by "how *human*, how eerily strikingly *human*," they look.

> *Monkey see and monkey do,*
> *The monkey does the same as you.*

Inside the Regenstein Center, a huge hairy gorilla presses his back against the glass. And he does look miserable. He could be, probably is, the gorilla Hale describes:

A magisterial old silverback male … in various attitudes of languor so bored, so hopeless that they could have only arisen from a feeling of humiliation so complete as to reduce his life of confinement and public display to a flat stretch of days full of nothing but a dull yen for the only remaining passage of escape still availed him in the bittersweet promise of death. (26)

Other visitors are looking at a mother with a baby in her arms, but I don't feel right standing there, and am glad to exit and be outdoors again.

> *Sleepy bear lies in his cage*
> *Curls up like a ball*

The bear is asleep all right, stretched out on his back like a mattress ad, but I keep walking, my mind on the gorilla and his astounding lack of privacy. I wanted to say "excuse me." I wanted to hang a curtain.

As I walk, I realize one of the things that I have been hiding from myself in Helene's turning away from the giraffe. She was frightened, of course, and it didn't help that the grown-ups around her laughed. But what the gorilla has helped me see is that she knew, in that instant when the giraffe lowered his head, that placing a rectangular biscuit on this stranger's tongue was a disrespectful act, that it was, using a word not yet in her vocabulary, a blasphemy, a making of the awesome into a pet.

Yet I wanted her to feed the giraffe. Jensen writes, "As we have overpopulated the planet, we have become the observers, changed from *experiencing* its mysteries, its openings, to *observing* its workings like a god." I think of Damien Hirst's artwork *A Thousand Years*, with its transparent vitrine, its maggots hatching from a cow's head and becoming flies that are drawn to the blue lights of an Insect-O-Cutor. If you stand looking long enough—like God (?)—whatever you are observing will die.

We have journeyed rather far from happy zoo-train days. Yet—

> *We mustn't go home without seeing the biggest,*
> *The very biggest animal in the zoo.*
> *You know which animal I mean.*

But elephant-less we shall go. There are no elephants in the Lincoln Park Zoo, haven't been since 2005 when an ailing Wankie was shipped out and died in freezing weather en route to another zoo, so soon after Tatima and Peaches died, having been in Chicago a mere two winters. The three were acquired from sunny San Diego, farmed out to make room for wild-caught, younger elephants. Not a proud chapter in Lincoln Park Zoo's history, but then the story of elephant capture and containment is not something you would want to replace *Goodnight Moon* with, either.

In the past, the elephant collector went to Africa, where he had to kill the mother to grab a baby. Now babies are produced in U.S. zoos by "assisted

reproduction," necessitating lots of rectal and vaginal probings and manual massage of the bull. Still, Lincoln Park will not have an elephant, unless it can find room for three (in line with 2011 AZA standards, because a lone adult elephant is nothing like Horton). Safari parks are the place to go for charismatic megafauna. Trouble is, and I can vouch for it, you can ride a zoo train around a safari park and see only a few ostrich eggs. Charles Siebert laments:

> They've passed so quickly from being curiosities to being scattered sympathies; from being the captive representatives in crude cages of an extant, flourishing wilderness to being the living memories of themselves in our artful re-creations of a vastly diminished one. (15)

The designers of safari parks build them to emphasize the web of life. As beautiful as that metaphor is—the sea lion as fish, waves, rocks, and shark—it has its limitations, as any metaphor does. The reality of difference—the giraffe's blue-black tongue, the lion's gaze, the hugeness of a gorilla—are hidden within its seamless tapestry. Yet wildness feels no more present in those living carousels, endlessly circled by canopied trains.

The ark—that old, old metaphor of the zoo with its two by twos, the one Lincoln Park is modeled on—may be off the mark in many ways, but you can still see the animals you mourn for, still get some sense that they are feeling creatures. Up close, you are rewarded with a sense of the fabulous. When my father tried to get Mark enthused about the zoo, he pointed to the camels. "Isn't it a singular privilege," he asked, "to gaze upon a camel whose ancestors the Wise Men rode to Bethlehem?"

The least I can do is acknowledge the privilege. But am I wrong to perpetuate the spectacle? I seem to have needed Helene on this adventure. Did she ever need the zoo? Putting aside the question of the necessity or not of perpetuating zoos for the sustainability of species, are we right to bring our children to zoos?

Aware of the ethical dubiousness of my answer, I nevertheless say yes. Yes, let sink into their virtual-reality-infused consciousness the awesome fact that such creatures as lions and giraffes exist in real time. Let our children see that their storybook friends are made of flesh and blood, that they eat and drink and defecate, that they move slowly and speak in strange tongues. And, I tell myself, for in the past I have treated the zoo outing as a picnic, a time when unmitigated happiness is in order, let surface expressions of the children's empathy, their desire to free the animals from imprisoning bars. Hopefully, zoos, all zoos, will one day be places where animals can live comfortable lives in natural settings. Such is not the case today, and it is wrong to paper their injustices with popcorn.

But the point is they are here. Lincoln Park Zoo, like zoos across the nation and the world, is home to wondrous animals, allegorical beasts who are also real, suffering individuals. For better or for worse, these messengers of a primal wildness reside in our city, and they are not about to leave. Not anytime soon. Strange as it is, on workdays as well as Saturdays, in winter and in summer, they are here. Today, right this minute, there is a jaguar in Chicago just as sure as

there's a butcher trimming steaks at Gepperth's Meat Market. Today and yesterday, a gibbon does handstands as we ride the escalator at Water Tower Place.

They are here, and we need to reroute our psychic and real-time journeys to include them. We need to acknowledge their presence, ponder their meanings, condemn their suffering, be aware of the mysteries they represent.

Let's climb back on the zoo train
And we'll be on our way
We're glad that we have been there
It was a lovely day

Recommended Resources

Books and Music

Baratay, Eric, and Elisabeth Hardouin-Fugier. *Zoo: A History of Zoological Gardens in the West*. Translated by Oliver Welsh. London: Reaktion Books, 2002.

Hale, Benjamin. *The Evolution of Bruno Littlemore*. New York: Twelve Hatchett Book Group, 2011.

Hancocks, David. *A Different Nature: The Paradoxical World of Zoos and Their Uncertain Future*. Berkeley: University of California Press, 2001.

Jensen, Derrick. *Thought to Exist in the Wild: Awakening from the Nightmare of Zoos*. With photographs by Karen Tweedy-Holmes. Santa Cruz, CA: No Voice Unheard, 2007.

McClatchy, Lisa. *Eloise Visits the Zoo*. Illustrated by Tammie Lyon; based on Kay Thompson's *Eloise* and the art of Hilary Knight. New York: Aladdin, 2009.

Rothfels, Nigel. *Savages and Beasts: The Birth of the Modern Zoo*. Baltimore: Johns Hopkins University Press, 2002.

Siebert, Charles. "Where Have All the Animals Gone?: The Lamentable Extinction of Zoos." In *City Wilds: Essays and Stories about Urban Nature*, edited by Terrell F. Dixon, 13–27. Athens: University of Georgia Press, 2002.

"Train to the Zoo." Lyrics by Judith Sidorsky and Ray Abrastiken, ca. 1957, recorded by the Eugene Lowell Singers; Norman Rose, narrator. The Children's Record Guild CRG-1001, n.d.

Websites

Lincoln Park Zoo, Conservation & Science: www.lpzoo.org/conservation-science

Lincoln Park Zoo Timeline: www.lpzoo.org/interactives/int_timeline.html

Lincoln Park Zoo, Urban Wildlife Institute: www.lpzoo.org/conservation-science /science-centers/urban-wildlife-institute

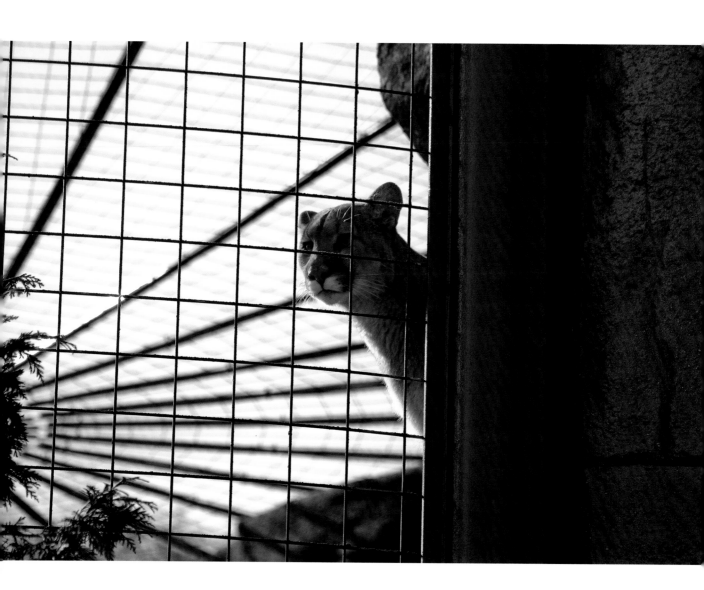

CARLOS ERNESTO URIBE CARDOZO, *Puma*

Bridging the Divide

Pondering Humanity at the Zoo

ANDREA FRIEDERICI ROSS

I get obsessed easily, particularly with puzzles. I can spend hours wrestling with a knotty crossword puzzle, until I have every single square filled in correctly. A riddle without a ready answer will drive me crazy, my brain spinning on puns until I get a reasonable solution. When I drag a jigsaw puzzle out of the closet, my kids know they will be benignly neglected for the next few days. It's not healthy, I know. But it's the way my mind works.

My current obsession is a person. A long-since deceased person, thankfully, or else it would be stalking.

For the past few years, I have been researching Edith Rockefeller McCormick. She was the daughter of the oil titan John D. Rockefeller, and she married Harold McCormick, son of the inventor of the reaper, Cyrus McCormick. Think money—lots of money. But she was fascinating beyond the wealth. She studied with a then barely known Carl Jung for eight years, supported James Joyce as he wrote *Ulysses*, and funded research that helped develop a vaccine for scarlet fever. She was incredibly well-read, uncompromisingly opinionated, and, for the men in her life, rather a headache. It is rumored that when she died, her brother and ex-husband burned her diaries and correspondence. Just for the record, I can't prove that—and I hate wrong answers—but I do believe it to be true. Hence, learning about Edith has been a scavenger hunt.

Ah, scavenger hunts. Even better than jigsaw puzzles. Solve, solve, solve.

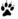

One of the mysteries about Edith concerns Brookfield Zoo. In 1919, while in Zurich under Jung's tutelage, Edith suddenly, unexpectedly, donated eighty-three acres of land to the Cook County Forest Preserve District for the express purpose of building a zoo. A zoo? Why? Nowhere else in her scattered materials is there any indication she had an interest in animals or nature. Edith died before the zoo opened and furthermore, since she was agoraphobic (frightened of travel and prone to panic attacks in unfamiliar places), likely never ventured as far west as Brookfield to see the land. Suffice it to say the zoo was not front and center in her heart.

Some speculated that the gift of land was merely to relieve Edith from the tax burden that the land had become. She had subdivided the land into lots, but the plots weren't selling and she was left to deal with the annual property taxes. A tidy gift to the Forest Preserve District took care of that problem, as well as improving her public image. A pretty smart move, some would argue.

But there's this line, this quote from Edith concerning the founding of the zoo, a quote that rings true to Edith: "When we can make scientific deductions of the actions and reactions of animals, we will find ourselves in a position to reach the human being. We must get nearer animals to reach the human soul." She said this a few years after the gift, at a speech at the Union League Club on January 25, 1923.

This woman was all about "reaching the human soul." She spent eight years—no, actually a lifetime—grappling with her own. Carl Jung had introduced her to the new notions of the conscious and the unconscious, and surely she struggled with whether this was a uniquely human trait. Was consciousness what set humans apart from animals? Edith would have wanted to get to the bottom of it. I suspect, like me, Edith needed to solve the puzzles in her life.

At the time, her comment was pretty "out there." Studying animals in order to reach the human soul? Combined with her announcement the previous year, during the excavations at Luxor, that she was the reincarnation of King Tut's child bride, it likely produced mainly shaking heads and rolled eyes. But now, not quite a century later, it seems perhaps she was just ahead of her time.

We don't know what she meant, exactly. The rest of the speech provides no further clues. And that, of course, bugs me.

I was employed by Brookfield Zoo for many years, I wrote a history of the zoo, and I've been a visitor with kids in tow more times than I can count. So I ask myself: *Does a visit to the zoo have an effect on my soul?*

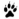

I know all the arguments against zoos. And, despite my fairly long association with one, I share some of those concerns about whether it is truly just to keep these magnificent creatures in enclosures. At the same time, there is a moment of magic that happens when a young child sees a certain creature for the first time. Elephants on television, in picture books, or on the computer screen just don't pack the same punch as one standing before you. If I had the proverbial nickel for every time I've heard, "They're so *big*," I could actually make a meaningful contribution to elephant conservation. Or that moment where the seal imitates a child's movement on the other side of the underwater viewing glass. It's magical. Truly. The divide is crossed. And we all—child, mom, keeper, casual observer—wonder what exactly that connection is between that seal and that child. Or a wolf balefully watching me as I watch him: what exactly is going on here?

Standing there, watching the wolf, the monologue in my head goes something like this:

Is it fair to keep him enclosed? In the wild he'd have much more room.

Does he want to be free? Is he silently pleading with me to help him?

Does he think in the same way I do? I bet he can't do calculus. Ah, neither can I. He probably just thinks I'd be tasty.

Is he more primal somehow? Less theoretical, more practical?

Is he sad?

Does he feel? Truly? Yes. Surely … right? But all of my same emotions? Jealousy? Empathy? Ambition?

Can a wolf be ambitious?

It probably takes less than a minute for that personal conversation to run through my head. Frankly, if I'm not focusing on a puzzle, my mind darts around at frightening, lightning speed. But regardless of my attentional shortcomings, those are some pretty meaty questions.

I'm not the only one with these sorts of thoughts. I hear them in conversations around me, and in questions from children to adults, who don't always know how to answer. Sometimes I wish the parents would ask the children instead. I suspect their answers may be more insightful. Over 150 million people will visit a zoo this year—how many of them will ponder some of these questions?

My monologue starts up again at the gorillas. It's always the primates that get me. And those gorillas: they look at me with eyes not so different from my own, with a face that demonstrates intelligence, partly because it looks so close to human.

What's she thinking? Is it okay to say that animals think or is that anthropomorphic? Obviously, she's thinking. You can see it.

Maybe she can read my mind. Sometimes my dog does that. I have no doubt cats can. Maybe animals can see brainwaves and decipher them.

Now I'm clearly nuts. Good thing the people around me can't hear my thoughts. They don't have animal superpowers.

Can she tell I'm a momma? Can she feel that commonality? Does it show in my aura? What, exactly, is an aura?

And, ultimately, always, after all the mental gyrations and recriminations, I land on the following questions: *What type of person do I want to be in respect to this creature? What is my responsibility toward her? Does responsibility toward imply superiority over, which doesn't seem right? Should I step up my conservation efforts? Become an animal activist? Are zoos really the best place for these animals?* I hate that I don't have an answer I'm comfortable with.

These questions hover dangerously close to issues of soul. I'm uncomfortable with the term "soul" to begin with; it's too vague and means different things to different people. But surely these questions—well, some of them—address aspects of what it means to be human. In seeking to better define how humans are different from other animals, we necessarily ponder our own place in this

world. And notice how, in Edith's quote, she refers to animals and humans as separate groups, though we know humans are animals as well. Did she? Well, Darwin had made his point, and I suspect she would have deferred to him. And she didn't have the religious belief that we were made in God's image: she had very deliberately abandoned the Baptist Church, in favor of deciding for herself what was true. For the sake of simplicity here, and to avoid having to say "animals other than humans" or the equally awkward "nonhuman animals," I will just refer to animals, though we know we are one of them (even if she didn't).

When Edith made her statement, it was generally believed that animals did not have consciousness in the same way as humans. Of course, since then it has been shown that animals do think, although scientists continue to argue about exactly how and to what extent. Calculus does seem unlikely. I cannot forget Jane Goodall's announcement in the 1960s that chimpanzees use tools, which shattered that convenient but inaccurate dividing line. And then she came forth with the news that chimpanzees engage in warfare, and another barrier fell. Finally, her images of an apparently heartbroken young chimpanzee showed us that our human high horse had serious flaws. You could fill an entire bookstore with the recent publications about animal intelligence, emotion, and, lately, morality. Some zoos are now engaging in "emotional enrichment" programs for the animals in their care. For those of us without the belief that we are God's chosen ones, the dividing line between humans and other animals is getting flimsier with each new scientific study.

We make assumptions about what animals want, or what they would do in certain circumstances. And then they surprise us. Years ago, at home, I inadvertently left the garden gate open. We were always hypervigilant about this, since we didn't want our dog to run away. On the one day I left that gate ajar, I went to check on the dog and there she was, sitting right in the middle of the open gate, as if to show me I'd forgotten. She had no interest in running away.

In 1969 a sudden downpour flooded the moats in front of the old polar bear exhibit at Brookfield Zoo. They swam out. Freedom! When zoo staff discovered this calamity, they found all seven bears near their exhibit, raiding the marshmallow stand. For years, the bears had watched people purchasing the sweet confections there and tossing them into the exhibit. Apparently unlimited marshmallows was a greater pull than freedom. Who'd have thought?

And then there was Binti Jua. A gorilla, of course: it's always the primates. In 1996 a young boy climbed over a safety fence and fell some twenty feet into the gorilla exhibit in Tropic World. Landing on the hard floor knocked him out, and he lay motionless. Onlooking visitors feared the worst. Binti Jua, with her daughter riding piggyback, hurried over to the unconscious boy and picked him up (imagine the horror of the boy's family), and—here's the surprise—carried him to the keeper door. She laid him down gently and stood guard, apparently protecting him from the other gorillas until keepers safely retrieved

him. Aside from pure relief, imagine the emotions and deep questions this incident aroused in those onlookers.

Despite our hunches and our observations, we don't really know what animals think. How they think. What/how they feel. And that—that riveting unknown—is the fascination.

So close to us. Yet so far away? Or maybe not?

Ah, the human soul.

From the very beginning, from the establishment of the Chicago Zoological Society that runs Brookfield Zoo, the four cornerstones of the zoo's mission have not changed: education, recreation, research, and conservation. Maybe Edith meant the research part? After all, she talks about "scientific deductions of the actions and reactions of animals." Brookfield Zoo was one of the first zoos in the world to hire a full-time curator of research. Since the inception of its formal research program in 1956, Brookfield scientists have published an impressive collection of research in areas including nutrition, breeding, small population management, and numerous other aspects of animal care. The number of research projects supported by the zoo over the years runs into the thousands.

The behavioral research conducted by the zoo perhaps provides the closest link to the type of scientific information Edith was hoping for. Observational studies on baboon interactions provided critical information about the community of those primates; a dolphin study that has now lasted over thirty years continues to generate knowledge about dolphin behaviors and interactions; and observations of mother-infant relationships among the Brookfield okapi (a relative of the giraffe) showed dramatic similarities to human parental bonds. Brookfield even developed a program called Ethotrak, which standardizes behavioral monitoring of animals and is now used at multiple zoos. Across town, the Lincoln Park Zoo is currently conducting fascinating research on the great apes, using touch-screen technology to measure their capacity for numerical understanding. All valuable information, which is helping us better understand animals.

And then there's the new field of conservation psychology. Conservation psychology, which Brookfield has nurtured since its creation about a decade ago, is the scientific study of the reciprocal relationships between humans and the rest of nature. Conservation psychology wrestles with issues such as developing empathy and an ecological identity, and with motivating people to engage in eco-friendly behaviors. This is not a direct link to the human soul, perhaps, but critical in determining our relationship with the rest of the natural world. As humans, what is our role in nature? What is our responsibility?

George Rabb, who was both that first curator of research in the 1950s and then director of the zoo for over twenty-five years, believes that "better understanding of our love of other creatures, our love of place, and our love for our own kind will result in more caring behavior, the essential element of

conservation." I think Edith would have liked that, as well as the viewpoint of Brookfield's current director, Stuart Strahl: "Sure, zoos are about animals. But at this zoo, it's about people and making that connection to nature and changing their lives."

Are zoos really more about people than animals? In considering animals, in caring for them, in learning about them, in becoming responsible for them, we must, necessarily, become more aware of our humanness.

Sadly, despite all the knowledge gained through scientific studies conducted at all the world's zoos, and all the educational efforts to increase awareness of environmental issues, human destruction of wildlife has more than tripled since Edith's 1923 statement. Much as they try—and they do try hard—it does not appear that zoos are being tremendously successful in significantly changing visitors' behaviors. The role of zoos must continue to evolve in order to help people adopt truly caring attitudes toward all of nature.

Applying a twenty-first-century mind-set to Edith's quote has its pitfalls. Consider this other quote from her—one of the only other times she spoke publicly about the zoo, as reported on March 12, 1931, by the *Chicago Daily News*:

"The plant grows but does not move, the animal grows and moves, while the human being grows, moves and thinks. Perhaps you have seen the animal picture now at one of the loop theaters, showing an ape dipping a piece of hard bread into the deep end of water in one of those flat pans? That animal may have a kind of thought process. It is quite reasonable to believe that instinct may lead to individual thought. The animals in Africa, for instance, may have felt cold, cold, cold for so many years that at last cold transfers itself to the thought. They can do nothing about it because they cannot think. A dog may walk along a road and turn out for a tree. He may not know why he turns out, he may not know if he turns right or left, but he turns out. Man goes along the same road, sees the tree, thinks and then turns out."

"Oh, was it your interest in animals that gave you the idea of turning over that tract of land to the city for a zoological garden?" we ask Mrs. McCormick eagerly.

"That would make a good story if it were true," she answered with a sense of humor, "but it isn't. I had the tract of land and, having seen the zoological gardens of other lands, I thought that it would help Chicago culturally to have such a garden, also. I thought, too, that it would be a place for the thousands of school children to study and observe."

So she had given some thought to that mysterious dividing line, though we now know more than they did then. No mention of research. No mention of the human soul. Educational for children, merely. Alas, maybe it really was for the real estate tax break. Who knows? All I know for certain is that, for me, the zoo raises many important—if sometimes fleeting—questions about what

truly makes us human. I don't have the answers. But I'll continue to roll those questions around in my brain. And then I'll go home and finish that crossword puzzle. Maybe the dog can help?

Recommended Resources

Books

Bekoff, Marc. *Minding Animals: Awareness, Emotions, and Heart*. New York: Oxford University Press, 2002.

Clayton, Susan D., ed. *The Oxford Handbook of Environmental and Conservation Psychology*. New York: Oxford University Press, 2012.

De Waal, Frans. *The Age of Empathy: Nature's Lessons for a Kinder Society*. New York: Harmony Books, 2009.

Hancocks, David. *A Different Nature: The Paradoxical World of Zoos and Their Uncertain Future*. Berkeley: University of California Press, 2003.

Ross, Andrea Friederici. *Let the Lions Roar!: The Evolution of Brookfield Zoo*. Chicago: Chicago Zoological Society, 1997.

Websites

Brookfield Zoo: www.brookfieldzoo.org

Conservation Psychology: www.conservationpsychology.org

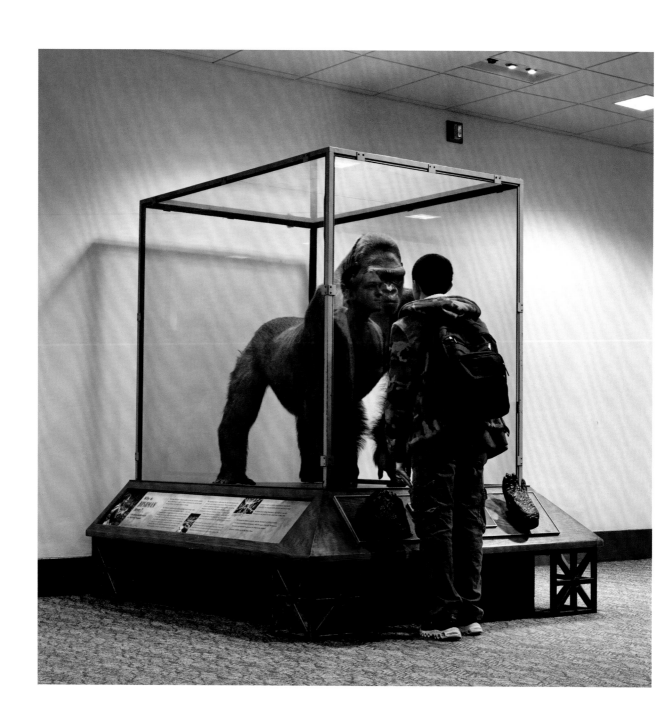

COLLEEN PLUMB, *Bushman, Field Museum*

Nature on Pause

PEGGY MACNAMARA

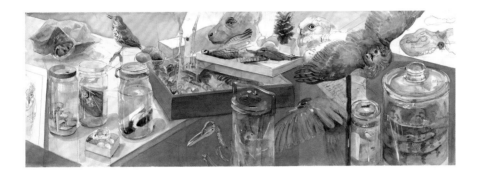

City creatures hide out in the winter, so that is the perfect time to step inside and up close to them in zoos, museums, and aquariums. While most of these institutions have been founded to support education, conservation, and habitat preservation, my own work has led me to believe that they can also offer a form of communion. Once inside one of these institutions, I begin not only to warm up, but also to gain a greater understanding of creatures I may have passed by outside without noticing. Here they hold still and encourage study.

For thirty years or so, I have drawn in museums, mainly natural history museums. But I also frequent zoos, aquariums, and other human-made animal habitats.

One morning while I was sitting in front of a mounted snowy owl at Chicago's Field Museum and drawing its subtle form, a group of schoolchildren surrounded me and silently watched my process. One little girl stared right at me rather than my paper. Finally she said to me, "I want to be you!" Who wouldn't! It is a great gig. As the Artist in Residence at the Field, I spend my days with insect collections, bird and mammal mounts that are over one hundred years old, and skeletons that defy imagination.

When I first visited the Field in 1980, I only meant to stay a few months and draw the Hoffmann statues, which are scattered throughout the Halls. Malvina Hoffmann created these life-size bronze statues in the 1930s. She traveled the world making clay studies from people of all known races. My interest

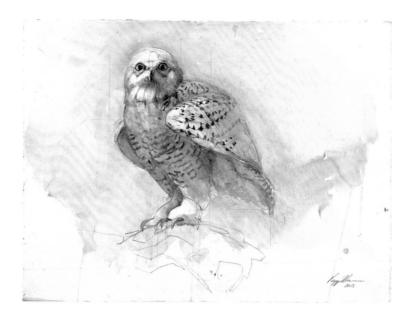

in Hoffman and her work got me to the museum on a daily basis and then led me to move through various exhibits, allowing me to become more intimate with the rich variety of museum collections.

Initially, I knew no one at the museum, and no one asked me to paint there; I went because the collections provided a fresh, fantastic subject and I loved the quiet and seclusion. (Maybe I particularly appreciated the peace the Field offered because I had five kids under five at the time.) So I began to treat the place like my studio. At the time, since I was teaching at a college in Lake Forest, I also benefited from free admission. Parking was also free on a first-come, first-served basis in a small lot just north of the museum.

After spending about a year on the Hoffmann statues, I began painting on the east mezzanine, which was filled with Chinese pots and other artifacts. During my "Chinese Period," which lasted about five years, I began to incorporate the museum's classical architecture in these 30-by-40-inch watercolors. I was never bothered by visitors who stopped to engage me as I worked and actually enjoyed the brief interactions.

Museum officials seemed largely unaware of my presence for the first ten years. It wasn't until 1990 that I was approached by someone in the Exhibits Department, a person who later became a vice president at the museum. She had seen me painting in the bird halls on the first floor, loved the work, and thought it might enhance the new bird exhibit that was being planned. When the bird hall opened in 1990, five of my large paintings were part of the new exhibit, and I began to be referred to as the Field's Artist in Residence.

On a cold winter day, I would walk into the hall of birds at the Field Museum and feel like it was summer. I'd be surrounded by hundreds of creatures posing and hear recordings of birds chirping while I stepped right up to a glorious diorama with re-created habitat. The Great Blue Heron case, just on the right as one enters the hall, is one with which I am particularly familiar—a scene that

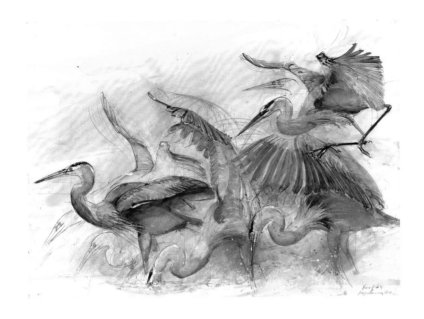

feels like a summer moment, full of butterflies and other insects, with herons posed at the water's edge. I've done many paintings from this case. Anyone who brings a chair and supplies can sit down in front of this case and draw herons and habitat for as long as they need to, bringing city creatures within reach and study. This applies to any number of animals: I find there is no better way to learn to distinguish the different warblers (often called "little brown birds," rather than by their individual species names, because of their notorious similarities in plumage) that make their way through Chicago in the spring than to draw them, or to study a grey fox up close while comparing its features with its relatives in the mammal hall.

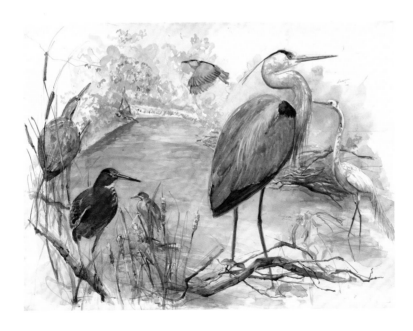

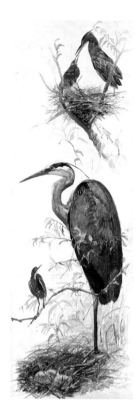

I have noticed over the years that studying these creatures at the Field Museum has helped me to recognize them in their outdoor habitats. When the leaves have fallen and the trees are actual skeletons, bird nests are revealed. Some birds like the barn swallow will return to their nesting sites every spring, so once I locate their nests in the winter, I am ready when spring comes to observe their mating and nest behavior.

Drawing has always provided a *way in*. Scientists often use drawings (E. O. Wilson, for example) to learn the intricacies of a species. When we glance at a heron fishing (and you rarely get within fifty yards of such a scene in the wild), you may be able to make out the species but not identify any of its finer details. But by drawing the species from a mounted specimen, you can learn about size and individual markings that are lost on the casual viewer. Also, many artists use nature to learn how form and color can be put together.

Many of the bird cases show the specimen with a nest, which has helped me learn from these tiny architects. First and foremost, I have come to appreciate how many species of birds are skilled recyclers. And they share. Several bird nests become co-ops, and once the original builder has left, another species is allowed to move in. They also sublet; for example, the beautiful wood duck will nest in the home left by the woodpecker. These homes are ingenious and worthy of study. Because of my artistic practice, I have learned that robins always use clay in addition to sticks and other plant materials. I have seen how tiny the hummingbird's nest is, discovered that barn swallows in Chicago always line their nests with white gull feathers like lovely linens, and that the kiwi (shown below) produces the largest egg in relation to its body size.

My time at the museum has also led me to develop a particular fascination with eggs, including how to spot them and recognize what species is about to emerge. The sizes and colors of eggs that are common among Chicago's local species quickly became embedded in my memory. Being able to identify these eggs has led me to fascinating stories about particular bird behaviors, like that of the cowbird, who leaves her eggs in another species' nest, often the vireo's. Later the vireo may build another nest layer over the cowbird's eggs. There are dozens of nests and eggs in the exhibits at the Field, and they are thorough in their details, offering a clearer understanding of the complexity of the housing issues our local city creatures face.

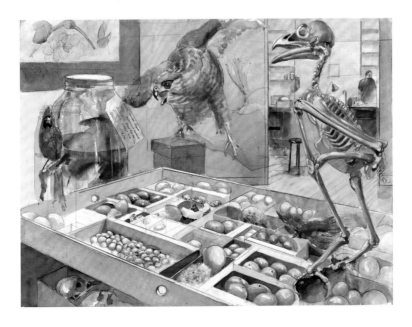

But in regard to housing issues, there are no creatures as adept as insects. They recycle available materials, create space for hundreds of their offspring, and do so without unduly damaging their environment. Mourning cloak butterflies squeeze into the crevices of bark and hide out for the winter. And while many butterflies build chrysalises, others literally hibernate right before our eyes. Indeed, insect ingenuity helps them survive life in the city. There is much to be learned from the creativity of insects, and their mimicry skills might even be understood as a form of performance art. Moths appear to have big eyes and therefore seem larger than they are. Beetles have patterns on their backs that help them blend into the earth. And some butterflies disguise themselves as leaves, which makes them extremely difficult to recognize in their native habitats. Insects also recycle. They keep the forest floor, and therefore our parks and open spaces, clear of rotting wood. They get rid of garbage and keep the earth inhabitable. When I take long walks now, I slow down so as not to miss the insects, and pay homage to them rather than just swat them away. A lot of insect nests are on display at the Field, and getting up close and personal to these bits of amazing architecture has changed my notion of these creatures that are so often dismissed as simply "bugs."

City creatures, birds, and bugs are not the only creatures I have learned from while painting at the Field Museum. The company of other humans who are devoted to nature has been its own kind of education, too. Every weekend scientists are available to the visitors in Stanley Field Hall. I recall one memorable weekend when Jim Louderman from the Insect Division displayed live tarantulas and other specimens, ready to meet the willing visitor and change his or her relationship with the world of arachnids and insects. Jim encouraged visitors to hold the insects, and these creatures put up with hundreds of eager adults and children that day.

For the past five years or so, I have been hanging out behind the scenes, familiarizing myself with the museum's vast collections. These collections are about

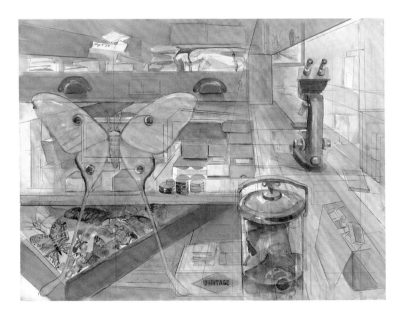

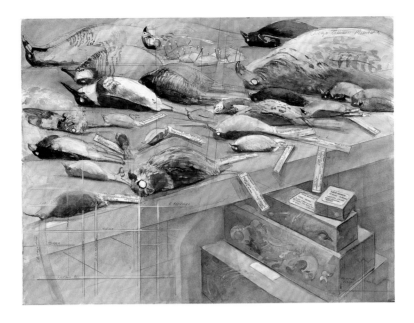

looking and learning. They are a testament to humanity's accomplishments and ingenuity. The paintings I am producing explore creatures of all kinds, including birds that have died from hitting Chicago's tall buildings, and which are carefully collected, preserved, and cataloged for further study.

Amphibians are another slippery group of city creatures with which I have spent a great deal of time at the Field Museum. They are reproduced as models, stored in alcohol, and available on display for insights and comparisons. The image included here features a jar of one hundred frogs from the CRC (Collection and Research Center), an underground storage area in the museum that is used for research by visiting scientists and staff.

The Field Museum has become a second home for my work and me. But

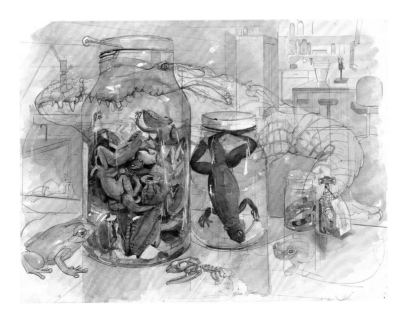

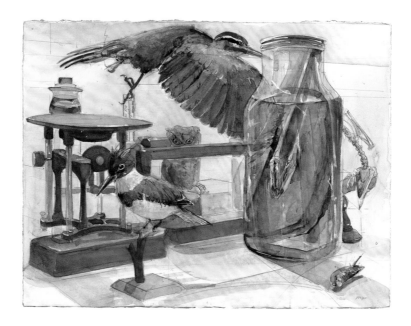

other institutions such as the Lincoln Park Zoo and the Shedd Aquarium are also valuable places in the midst of the city that allow for similar experiences—places not only to commune with local creatures but also to learn about the biology that makes them tick. These places are welcome sites of exploration for painters, photographers, poets, students, and indeed anyone with a desire to become more familiar with the intricacies of the natural world. You do not need permission to draw or paint at most zoos, natural history museums, and aquariums. The only concern these museums have is for the flow of visitors, so choose your spot so as not to block the enjoyment of others, and take your time to connect on an artistic level with these magnificent creatures.

Recommended Resources

Books

Macnamara, Peggy. With contributions by John Bates and James H. Boone. *Architecture by Birds and Insects: A Natural Art*. Chicago: University of Chicago Press, 2008.

Macnamara, Peggy. With contributions by James H. Boone. *Illinois Insects and Spiders*. Chicago: University of Chicago Press, 2005.

Macnamara, Peggy, John Bates, and James H. Boone. *The Art of Migration: Birds, Insects, and the Changing Seasons in Chicagoland*. Chicago: University of Chicago Press, 2013.

Macnamara, Peggy, and Marlene Hill Donnelley. *Painting Wildlife in Watercolor*. New York: Watson-Guptil Publications, 2003.

Ward, J. Logan. *An Explorer's Guide to the Field Museum*. Chicago: Field Museum of Natural History, 1998.

Website

The Field Museum: http://fieldmuseum.org

A Museum of Change in Illinois

JAMES BALLOWE

… all that we observe about us, and ourselves also,
may be so many passing forms of a permanent substance.
(George Santayana)

To capture change of the glacial kind requires
science, art, and a fund of imagination
if we are to understand a tropical Illinois
alive with undulating lilies and feathery stars,
those crinoids that compel our comprehension,
and the giant *Dunkleosteus* that plied the sea,
distant galaxies of emergent land fostering
forest millipedes and weeds like trees,
mysteries of lumbering reptiles, of mammals extinguished
by glacial and interglacial freeze and thaw
evoking the tortoise, colossus of forest and prairie,
and, upon the forest-tundra, the short-faced bear,
muskox, and Ice Age mastodont
that only yesterday were lost to earth's warming
and to the coming into the forest and the prairie, *us*,
forebears of this land that we know as Illinois,
that now here in what we call its Museum
holds the puzzle's pieces, the connections,
the clues to the flora, fauna, bones, and fossils,
in a virtual world that reveals the meaning of change
in our past, our present, and our future selves.

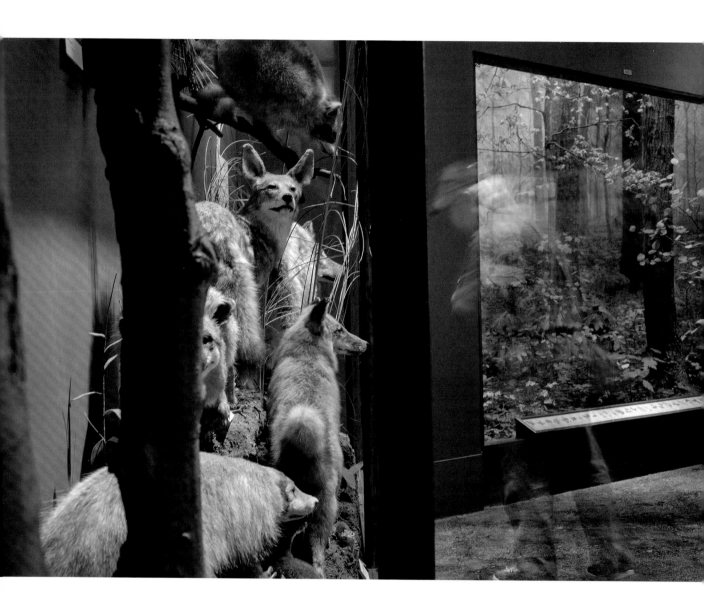

COLLEEN PLUMB, *Chicago Mammals, Field Museum*

A Living Taxidermy

REBECCA BEACHY

Taxidermists work to preserve the hide that holds the potential for an animal's image to be reconstructed, to tell a story. The peculiar stillness of an animal corpse makes tactile study and observation possible, shareable. The feathery skins, culled from those birds that fall into a taxidermist's hands, are lifeless—barring the slight smell of decay and their quaking in the gentlest breeze.

I am not a scientist. I generalize with what sometimes amounts to a crudeness. I could not justify calling myself a birder, not like the ones who devote their lives to chasing the movement in the trees, who memorize names and types and birdsong variations. I see "bird" and feel connotations of flight, air, fragile immediacy. The specifics are varied and distant. What I am is one who observes these dead. The simple observer in me wants to get closer, touch the animal of lightest disposition, absent of motion—creatures light enough for rising, never fully still.

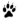

Ordinarily, a taxidermist's work is done privately, in part because it is a messy job. The Beecher Lab of the Peggy Notebaert Nature Museum (the public face of the Chicago Academy of Sciences) participates in the art of calling attention to natural systems so simple and local that they're often overlooked. To display the dead, in every stage of decay and preservation, enhances the possibility of actually seeing—of witnessing death and life in palpable conversation. Public taxidermy demonstration does just this.

Bird remains have an undeniable attractive power; they can imbue a meditative state through handling. The smell, open to attentive faces, transmits. In public performance, human bodies tend to accumulate as individual bird pieces divide. Kids try to reach out and touch the work. Observers choose to be present, participating voluntarily, asking questions. I've witnessed a wide array of responses (curiosity, shock, revelation . . .) during my involvement in the regular living performances of taxidermy at the Nature Museum. With no glass barriers between the audience, the taxidermist, and the animal under dissection

(usually, a small migratory bird), the art of preservation takes place under the banner of science but outside of the enclosed, inert display vitrine.

On all sides of the taxidermist, clear display cases protect century-old specimens, setting a stage rooted in the history of naturalism and "curiosities." Inside of these vitrines, both "display mounts" and simple, drawer-intended varieties known as "study skins" provide a sense of Chicago's local ecological history. Small data tags hang from the feet of individual specimens. These precise, handwritten tags bear the script of individuals once involved in the same voluntary naturalism—who used similar materials and tools over a century ago to produce specimens for the research of the Chicago Academy of Sciences. Each tag marks the date of the animal's death, when it was collected, its key body measurements—all relevant for scientists who use such ornithological data for research. When these nineteenth-century tags were written, attraction to these birds for food or ornament was so fierce that bird-lovers risked annihilating them. The forces of public legality responded, in turn, with a multi-nation prohibition against collecting any part of a wild migratory bird—the Migratory Bird Treaty Act of 1918.

Usually anonymous when we meet them in the wild, scientifically classified birds come to us with no individual name; they are nature in species form, organized into various categories as scientific strategy. A white lab coat is often used metonymically to describe the necessary non-description of the scientist—at the museum, I wear an institutional apron. I become a live human subject with a parsed bird. I notice human qualities when noting differences between birds. I identify features. Thankfully, a bird species will never be an accumulation of anatomical parts or the scientific name ascribed—any species defies domination by a simple persistence of presence.

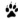

Dead bodies of any kind can awaken discomfort and longing. In contemporary daily life, the dirty work of tending corpses has become increasingly mechanized and separate from regular experience. Convenience meat and mass food production create distances between a living thing, a corpse, and the human hand. The taxidermy process, when shared, seems to shorten the expanse between abstract and embodied awareness of these basic, necessary intimacies. Revealing the unseen parts of an animal under dissection is integral.

Seeing animal viscera sometimes generates horror, feelings of threat, melancholy. I have repeatedly experienced how the interior of a body, opened up, produces affect; the confrontation of viscera can be exhausting. Learning the parts of the animal lends objectivity and a degree of emotional distance to a potentially overwhelming procedure. When the affect can be tolerated, to be shown, to touch, to identify and inspect through dissection can be both revelatory and calming, reconnecting the one looking to his or her own organic animal nature. Although I don't know the name of each and every bone and feather type, categorization and routine provides some armor. After years of learning, my fingers have become trained to handle bird skin regardless of affect. My hands

FIGURE 1. Ringneck pheasant. Video still by Marianna Milhorat.

quickly find the place where the flesh and the skin meet and can be separated. My nails know how gently to scrape along the tissue, my muscles know how hard they can pull before the fine skin begins to break. This is a bodily knowledge, acquired through practice. I follow mental notes derived from training and experience:

Make a clean incision with the scalpel from the cloaca up to the lower ribs. The legs should be amputated (while still inside the skin) and tendons cut at the knee. The skin may then be separated (gently) from the spine and the musculature of the back. Peeled, the skin should be pushed against itself, rather than stretched (high risk of tearing). The wings (the bones at the shoulder) must be clipped so that the thin skin of the bird can be nudged over the head, inside out (like a turtleneck sweater). This reveals the skull, still attached to the skin at the beak. Opening the back of the skull bone with the scalpel, the tongue (with tongue cartilage) can be pulled straight out of the bird's mouth with a pair of forceps. Whether whole (cohered in a sack nearly as thin as a soap-bubble membrane) or broken (gooey and mucus-like), the pink matter that makes up the brain must be coaxed out with tweezers and a small round of cotton. Following this step is the extraction of the eyes: deep blue iridescent sacks beneath the ultra-fine eye rings (akin to small blueberries: dried out, or plump and leaky). The optic nerves should be cut and cleared, and then the residual muscles around the face plucked out. The wing and leg meat can be removed with scissors and tweezers, trimming close to the bone at the tendon. The glands at the base of the tail should be popped, scraped, or scooped away lest they contaminate the skin and later attract insects. The skin can be washed lightly or fully submerged and lathered with dish soap. Turned right-side out and blow-dried, the bird becomes plump and lively with attached feathers ruffled and volumetric.

"Is it real? Is it dead?" are common *non-specific* responses to the silent and open bird body. Noticing the unexpected limpness of the bird's posture, the bits of blood and flesh peppering the counter, the fine mark of deep red blood lining the crevice of the beak, a lapse in perception sometimes takes place in the viewer. It's a nervous system, the body. Most insides are not transparent. The motionless birds possess no response and no argument; their bodies might become instructive, sparing their stunning beauty, made complicated in a dead state.

These complicated aspects are heightened by the sensitive requirements of such a delicate surgical process. The birds do not want to be mangled. The work to get the skin clean and ready for the tiny mannequin is substantial. The first bird specimens that result from taxidermy training always evoke Frankenstein—the "educational" specimen cabinet at the Beecher is full of first tries that the children are allowed to handle: most are a mess of mottled feathers, strangely stretched and pulled over a stiff, inaccurate form on a wire or wooden stick. The birds look pained, like they *should* be burned to spare humiliation of a second life in a mangled state. The more well-shaped the form beneath the skin, and the more accurately the skin and feathers align on top of the model, the more the bird survives to live a second life. And if it fails, the taxidermist is left with the responsibility of knowing the bird has been killed twice.

Though it can be a shock, it is my job to share the confrontation with anyone who happens to walk past. To hide it hides the essential stuff of bodies. The work is not always easy to do or to talk about. The taxidermist must embrace the gore itself as an act of care. In panic or disgust, mistakes are made. Removing the innards becomes a necessary step to a respectful end. The beauty of the complete bird body, before cutting, is enough to shake the hand that carries the scalpel: "Ugly specimens do not survive," says the Nature Museum's urban ecologist, Steve Sullivan. Some extinct species, such as the dodo bird, have been lost to history because of shabby taxidermy. Regarding the specimen drawers, the ugly birds, no matter how rare, have been hard to keep.

Posture, anatomy, attitude, movement—the particularities of species: a specimen preparer must become an acute observer. What happens to a wild bird is based on a web of interdependent factors and ecological particularities. As a non-scientist, I do not have precise knowledge of these interactions. When I look down at the viscera in front of me, I make stark observations (the bird becomes, for me, too, an object of curiosity):

A kingfisher has two outer finger-like webbed toes on short and stalky legs.
 A yellow-billed cuckoo has unusually long, skinny legs with exceptionally
 elegant feathers.
Warblers in the fall can be difficult to identify due to subtle differences in
 coloring of bill or eye rings.
The superciliary feature, directly above the eye of the hawk, is what makes the
 hawk look supercilious.

FIGURE 2. Ringneck pheasant being skinned. Video still by Marianna Milhorat.

Animal dissection is a curiosity and a revelation, but reconstruction is the key to taxidermy—taxidermists must make a mold and properly position and sew up the animal's skin around it. This has been called an act of *stuffing*. The statement is frustrating in its inaccuracy—the physical act of "stuffing" birds. To "stuff" is to cram, "to cram into a cavity," says the dictionary. Is taxidermy a stuffing? If preparing a turkey dinner, yes. A chicken dinner? Sometimes, yes. But the small birds' wet, paper-thin skins could never survive being "stuffed." Amid public attentiveness to extraordinary migratory birds, the non-specific chicken regains some worth: "I bet you *touched* a dead bird earlier this week," I sometimes say, as a response to expressions of disgust by those observing the counter.

Unlike a chicken breast, the deep red color of breast meat belonging to a flight bird at first resembles a human heart. Passersby ask when they see the carcass, with no wings, legs, neck, or beak, fully separated from the skin: "Is this the heart?"—no bones, no guts, no lungs, only one heart. Removed from the feathered mass on the specimen counter, the "heart" is in fact the flight muscles, the entire interior—the knowledge only comes with *specific* explanation I can provide at the taxidermy counter. I later imitate this heart shape in excelsior (a wood-wool fiber, used by taxidermists to make mannequins), and it becomes the new interior for the bird—the artificial organ that gives the bird skin structure. Giving the birds a *specific* voice requires distinction. The specimens must embody care, be identified, measured, and labeled in order to survive as more than a general heart.

Most birds handled by museum taxidermists come directly into their hands via the local architecture. The migratory bird falls due to urban architectural illusions: window collisions are a common fatality. Migratory birds are intermediaries—they journey between wild habitats and abstracted, industrialized cities biannually during spring and fall migration. Ornithological research suggests that some 70 percent of migratory birds pass through major cities during migration. Many of these birds will not make it—caught in the illusions of glass, they collide with the full force of flight.

FLAP (Toronto), the Chicago Bird Collision Monitors, Lights Out Chicago, and Project Safe Flight (New York) are all examples of projects that have been organized in the past several decades to increase awareness of urban bird collisions and to persuade architects and building managers to take simple steps to reduce the number of bird deaths resulting from lights and windows. It wasn't until the 1970s that these issues began to get the attention of researchers; this was when the Field Museum of Chicago decided to systematically begin collecting the dead migratory birds found around the perimeters of the McCormick Place Convention Center. From 1978 to 2001, the Field Museum study collected nearly thirty thousand birds from this site, finding, in a follow-up study, that simply turning off the lights that shine through the windows at night can reduce these deaths by up to 88 percent. The Field Museum and the grassroots bird rescue organization Chicago Bird Collision Monitors were able to use these data to pressure the city of Chicago to begin its "Lights Out Chicago" initiative in 2003, which turned Chicago into the first U.S. city to dim the lights from tall buildings at night after 11:00 p.m. in order to reduce traveling wildlife casualties.

Whether it is reflective or transparent, birds cannot distinguish glass as a barrier—the surface, rather than a clear passage, becomes a place of abrupt density. A feather-dust print from a bird that has smashed against the pane recalls a criminal chalk outline. For birds' limited visual perceptive abilities, glass is a completely surprising invisible force field. They are not capable of what Colin Rowe and Robert Slutzky explain as "the simultaneous perception of different spatial locations" (45). The impact on the bird population is substantial. In Rowe and Slutzky's study on the nature of the relationship between content and form in architecture, "Transparency," they write that "the transparent ceases to be that which is perfectly clear and becomes instead that which is clearly ambiguous" (45). In an essay titled "The Picture Window: The Problem of Viewing Nature through Glass," Kent Bloomer argues that beyond the provision of shelter, windows and glass encasements suggest that we are enjoying, a bit too much, "our dominion over and thus our secure distantiation from the 'prickle' of nature" (254).

Through glass, the world can be observed with a haptically disengaged presence. Physical collision in birds happens due to optic confusion regarding dense containers/barriers. This misidentification occurs through illusions of transparency and/or reflectivity, engraved by the bird crashing into a perceived vanishing point in the glass, where the picturesque urban skyline might only bounce

the oncoming flying body. This phenomenon begs a deconstruction of the optically oriented/optically privileged habitat in which both birds and people live.

"Taxidermy exists because of life's inevitable trudge towards dissolution," writes Rachel Poliquin in *The Breathless Zoo*. Small insects leave bones and nothing more for scientists to trace and document over time—the skin of an animal inevitably cracks, rots, tears, sheds, and becomes lost to history. While I am not a scientist, I have been taught that to be studied and protected, these migratory birds must be made into stable, preserved objects. With well-made taxidermy specimens, specific examples can be noted and compared by specialists committed to the long-term well-being of wild birds. Sharing the process of taxidermy contextualizes the process of specimen collection, giving it life. Skinning and reconstructing a bird on a counter without a glass barrier invites any person to haptically experience a process that can bring present, breathing bodies and ordinary, contemporary issues (as basic as meat and leather) back into the "breathless zoo" of the natural history museum.

Whether a leather boot or a preserved warbler, a dead body that doesn't smell of decay is still a dead body. When I stand to clean the taxidermy counter, the space must be cleared of all messy debris. Speckles of borax, feathers, and feather dust are washed down the drain from cleaning the sponge. Isopropyl alcohol helps to sanitize unseen bacteria. Medicinal fumes rise up and absorb into a sinus cavity that I carry back into my city life, surrounded by concrete, cutting open a thin, clear, and clean skin of plastic to access dinner, peering through rectangles of light to see what might be flying around in the open sky.

Recommended Resources

Books and Articles

Alberti, Samuel J. M. M. *The Afterlives of Animals: A Museum Menagerie*. Charlottesville: University of Virginia Press, 2011.

Augé, Marc. *Non-Places: Introduction to an Anthropology of Supermodernity*. London: Verso, 1995.

Bloomer, Kent. "The Picture Window: The Problem of Viewing Nature through Glass." In *Biophilic Design: The Theory, Science, and Practice of Bringing Buildings to Life*, edited by Stephen R. Kellert, Judith H. Heerwagen, and Martin L. Mador, 253–61. Hoboken, NJ: John Wiley & Sons, 2008.

Olalquiaga, Celeste. *Artificial Kingdom: A Treasury of the Kitsch Experience*. Minneapolis: University of Minnesota Press, 2002.

Poliquin, Rachel. *The Breathless Zoo: Taxidermy and the Cultures of Longing*. University Park: Penn State University Press, 2012.

Rowe, Colin, and Robert Slutzky. "Transparency: Literal and Phenomenal." *Perspecta* 8 (1963): 45–54.

Wilson, E. O. *Biophilia*. Cambridge, MA: Harvard University Press, 1986.

Websites

Birds and Buildings Forum: www.birdsandbuildings.org

Chicago Bird Collision Monitors: www.birdmonitors.net

Fatal Light Awareness Program: www.flap.org

Lights Out Chicago: http://www.cityofchicago.org/city/en/progs/env/lights_out
_chicago.html

Peggy Notebaert Nature Museum: www.naturemuseum.org

Ravishing Beasts: Taxidermy: www.ravishingbeasts.com

SONNET L. SCHULZ, *Happy Birthday*

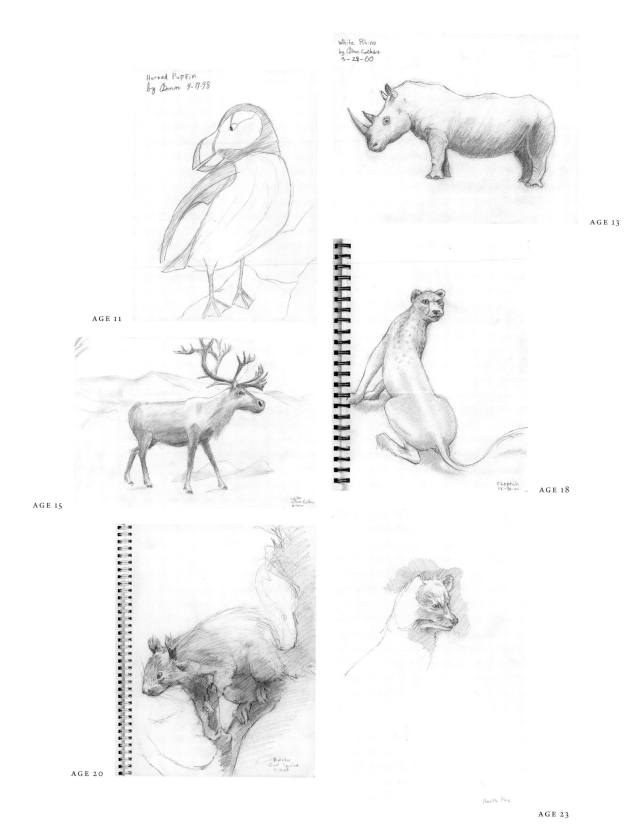

Horned Puffin
by Benn 9-17-98

White Rhino
by Benn Colker
3-28-00

AGE 13

AGE 11

AGE 15

Cheetah
12-30-04

AGE 18

AGE 20

Arctic Fox

AGE 23

BENN COLKER, *Six Sketches at the Field Museum* (1998–2010)

JULIE MERIDIAN: The light is dim and the halls are quiet, nearly deserted. My young son and I breathe slowly and enter the stillness.

We are unsettled, spooked, surrounded by death. In the shadows we can feel their eyes staring, almost hear them rustling, swishing, snorting, nuzzling, pawing, flapping, chirping, crying. We walk slowly, alert for signs, listening for the ones that seem to call to us, the ones that know our names. We have come to capture their spirits, to feel their presence, to learn the lay of their fur, the fall of their feathers, the arch of their necks. We want to own them, know them, become them, in the way that only artists can—by taking time, quiet and alone. Time to see.

He chooses the sharp edge of an ear. I choose the elegant curve of a back. Then we begin. Slowly our eyes move, following every detail of contour, every gesture of limb. Slowly our hands move, following our eyes, capturing the lines on the page. Sometimes the lines are good. Sometimes the lines stray and we begin again. But no matter—the lines are always magic. It is the act of drawing that makes us see. And it is the act of drawing that makes us remember. This is my zebra, my wild turkey, my crow. This is his rhinoceros, his antelope, his cheetah. We return again and again, throughout the years. The animals are always there, waiting for us to turn the page.

They are ours now, alive in us.

And we are theirs.

BENN COLKER: This is everything. This is where it all began. This is where my eye, hand, head, and heart fell in love with one another.

It is where my mother taught me to see and how to make what I see my own.

It is the birthplace of the line—my line—where I watched in astonishment as my hand found a voice beyond my control.

It is where these animals—these involuntary, yet gracious, participants—let me get close enough to feed my fascination. It is where these animals became my friends and where they stand now, eternally waiting for my return.

It is where, through seeing and drawing, I have been able to hold the wondrous and mysterious forces of life, for a moment, in the palm of my hand.

It is where I became myself—where I became an artist.

It is a gift for which I am grateful.

Playing for Life

Learning to Care about Nature at the Hamill Family Play Zoo

DAVID BECKER

It is a summer Saturday afternoon. Children and families from around the Chicagoland area, as well as tourists from other states and even other countries, are strolling through Brookfield Zoo. For some families, coming here has been a tradition since the Chicago Zoological Society first opened the zoo in 1934. I know some parents bringing their children on this day have photos at home of themselves as children visiting the zoo with their own grandparents. The pictures taken today will add to multiple generations of zoo photos.

In the southeast corner of the zoo, children have stopped to listen to an announcement. "Good afternoon, Hamill Family Play Zoo guests. My name is Danielle and I have one thousand ladybugs that need your help finding homes in our backyard. If you would like to help me find homes for our ladybugs, meet me in the backyard in five minutes." Hamill Family Play Zoo is 15,000 square feet of indoor exhibit space, much akin to a hands-on museum, and is surrounded by two acres of lush gardens designed for play and exploration, affectionately referred to as the "backyard."

Children gather around a young woman carrying a small container that says "Ladybug Hotel," and they follow her out the door as one excited mob. She reaches in and brings out a handful of live ladybugs, sprinkling them into their small outstretched hands. One little boy watches cautiously from behind his father's leg. A young girl squeals with delight, "It's tickling me!" With insects in and on their hands, the children scatter, then carefully sprinkle their ladybugs onto plants throughout the yard. Amidst the flurry of running children and flying ladybugs, Danielle patiently carries on conversations about these ladybugs and how they will benefit the plants. The scene is reminiscent of the writings of the scientist Rachel Carson. In her book *The Sense of Wonder*, she lovingly described her time in the woods with her three-year-old grandnephew Roger. She encouraged other adults to do likewise: "If a child is to keep alive his inborn sense of wonder ... he needs the companionship of at least one adult who can share it, rediscovering with him the joy, excitement and mystery of the world we live in" (45).

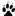

Over the past decade, the relationship between zoos and children has been undergoing a transformation. Granted, there has always been a strong relationship between children and zoos. Walk through any bookstore and you will find shelf after shelf of children's picture books about zoos and zoo animals, such as *Put Me in a Zoo, If I Ran the Zoo,* or *Goodnight Gorilla*—the list goes on and on. While zoos have long been a favorite place of children and families, it is only more recently that we in the zoo community have begun to ask ourselves, *What is our responsibility to children? Who are we in the lives of children?* This is a natural extension of the ongoing evolution of zoos and aquariums, which have steadfastly been moving beyond simply being collections of animals to becoming contemporary centers of conservation with active education, research, and field conservation programs. Over the past forty years, the science and ethics of animal care has grown in giant leaps, followed by increasing attention to the experiences and learning of zoo visitors, families, and children.

Children need places to explore and discover nature—safe and accessible green spaces, places to play hide and seek among the trees, boulders to climb, forts to build, and a chance to roll over a log and discover the amazing universe of pill bugs, worms, and slugs living underneath. These experiences fuel children's imaginations and are vital to their physical, social, emotional, intellectual, and even spiritual growth. I grew up in a midsize farming community in Michigan and spent hours in the woods climbing trees, building forts, catching frogs, and getting as dirty as possible. I didn't know how valuable these experiences were until I became a parent. For my own children to have any of these experiences, I had to help make them happen because their opportunities for near-at-hand experiences of nature were more restricted than my own—part of a broader cultural shift that is well documented by Richard Louv in the bestseller *Last Child in the Woods.*

Where does nature play happen in today's increasingly urban world? Where *can* it happen? I believe that modern zoological parks—with their landscapes, gardens, and animals in their care, as well as the birds, bugs, and local wildlife that inhabit and make more informal use of its ecosystems—can be an important place where childhood adventures occur and nature play thrives. I believe that in our modern world, we need conservation leaders who focus on children and childhood in the same way that we need conservation leaders who focus on polar bears.

I began working for the Chicago Zoological Society (CZS) in 2001, shortly after the Hamill Family Play Zoo opened at Brookfield Zoo. CZS operates Brookfield Zoo and also directs national and international programs in animal care, education, and conservation. The Hamill Family Play Zoo (HFPZ) is a groundbreaking zoo exhibit that was designed using principles of early childhood learning and development, an understanding of childhood play, and applied theories from the emerging field of conservation psychology. HFPZ has both indoor and outdoor hands-on learning opportunities where children can

explore nature through direct experiences of playing in the woods, gardening, building forts, making mud pies, pretending to be animals, and other vital nature play experiences. I was recruited from the world of children's museums to manage and develop CZS's newly formed interdisciplinary educational team, the Play Partners, made up of artists, science educators, and early childhood educators who are dedicated to providing increased opportunities for nature play, exploration, and inquiry. Play Partners provide daily walk-in programming for over 300,000 young children and families per year, as well as a wide range of classes for children and families, nature play and science exploration programs in the Chicagoland community, and professional development training for early childhood educators in both formal and informal settings locally, nationally, and internationally.

In the past twelve years, the programming initiated at HFPZ has grown into a comprehensive early childhood initiative, called NatureStart, which reflects CZS's long-standing commitment to engaging and involving people in caring for the natural world around us. CZS's organizational mission is decidedly people-centered: "To inspire conservation leadership by connecting people with wildlife and nature."

Even though I am pursuing graduate-level education in Learning Sciences research, it is often difficult for me to maintain an objective perspective on the Hamill Family Play Zoo, since it has become such a significant part of my own life and the life of my family. My seventeen-year-old daughter, Kara, was five when I began working at HFPZ and my thirteen-year-old son, Joshua, was one. In my office there is a photo of the two of them as young children in one of their favorite settings, the HFPZ's Animal Hospital. Joshua is on the operating table, wearing a lemur costume, his face painted with whiskers, while his big sister, dressed as a zoo vet, prepares to begin surgery. Kara has a love of snakes that was fed and fostered by her many hours in HFPZ. She would often patiently wait for a chance to pet the corn snake, which is one of the animals regularly used for hands-on educational purposes. It was an added bonus if the person holding the snake was a young woman, another female who shared her love of snakes. Today Kara is a seventeen-year-old young woman who still loves snakes and is passionate about environmental issues, sharing her love of animals and nature with others through a variety of volunteer organizations, including Brookfield Zoo.

Picture another group of children gathered around an operating table in HFPZ's Animal Hospital. This is a special day, because Dr. Tom of the Zoo's Veterinary Services has come for a visit. First up on the table is a border collie named Pete. Dr. Tom provides a routine physical, carefully explaining each step of the exam. Children gather and watch wide-eyed. Each child has an opportunity to listen to Pete's heart through a stethoscope. Next up is a guinea pig. Again, Dr. Tom explains each step of the exam, and again children listen to the guinea pig's heartbeat.

The HFPZ's Animal Hospital is modeled after Brookfield Zoo's Animal Hospital, with an eye toward authenticity. While Dr. Tom is not always there with live animals, children still have an opportunity to imagine themselves becoming veterinarians, operating on plush tigers, wolves, penguins, and other zoo animals. Every week Zachary, a regular visitor, would wheel in a four-foot plush alligator he brought from home, carefully buckled in a baby stroller, with a new ailment each week that he alone could cure.

Throughout HFPZ, the real world and the world of pretend play blend together as children take care of animals and become animals, sometimes through active participation and other times through imaginative play. Both are equally important in a child's world and in her or his development of empathy for other living beings.

Gene Myers of Western Washington University, one of the founders of the field of conservation psychology, has conducted extensive research into the relationship between children and animals. He has determined that children's animal play—when children pretend to be animals—has a significant role in social and emotional development, particularly in the development of empathy. During the concept development and design of HFPZ, Gene spent many hours talking to children at Brookfield Zoo, determining their perceptions of animal care needs in a zoo setting, as well as working closely with the design team. According to Myers, when children are pretending to be animals, they are exploring what it is like to be that animal and thinking about what that animal eats, where it lives, how it moves, and what it needs to survive. I am always reminded of this as I walk by a group of children, some dressed as lemurs and others dressed as zookeepers, re-creating through their play the actions they have observed in the nearby lemur exhibit.

Now picture a beautiful fall day. Children gather in a small woodland grove of trees, the Woody Knoll, which is part of the two acres of play gardens surrounding the Family Play Zoo building. One young boy fashions a small home out of clay, leaves, twine, sticks, and rocks in the base of a tree. He tells an elaborate story about the woodland trolls that live in his construction: "This is the ladder that they use to get inside their tree house. They have to be very careful that people don't see them." A young girl, captivated by a black-capped chickadee that flits around the backyard, builds a home in the branches of the tree. "Mine is a bird house," she explains.

In 1994 Louise Chawla—then of Kentucky State University and currently of the University of Colorado's Children, Youth and Environments Center—conducted open-ended interviews comparing the life-span experiences of fifty-six environmentalists who worked on a broad variety of issues ranging from wilderness protection to urban planning. Thirty of the environmentalists were from Kentucky and twenty-six lived in Norway, with the group as a whole fairly evenly divided in terms of the participants' gender. They were asked, "How would you explain the sources of your commitment to environmental

protection? What personal experiences have turned you in this direction and inspired you to pursue it?" These interviews were then transcribed and coded, and common themes were highlighted.

In 77 percent of the cases, free time exploring in wild and semi-wild spaces as children were described as formative experiences. The researchers found that these wild play spaces did not have to be in large landscapes, such as a forest—they could be a weedy ditch. Like Gene Myers, Louise Chawla became an active participant in the development and formation of HFPZ, helping to forward the notion that these wild play spaces could even take place in the landscape of a zoo.

Chawla's research also points to the importance of children sharing their love of nature with interested and enthusiastic adults. Along these lines, perhaps one of the most remarkable features of the Family Play Zoo is the relationship between the staff and visitors. In my first tour of HFPZ, as a then prospective manager of Play Programming, I was taken through Nature Swap. Nature Swap is a space to which children can bring either items that they have found in nature or drawings, photos, stories, or journal entries about their experiences in nature. The Nature Swapper sits with a Play Partner and has that staff person's undivided attention while discussing the items brought in on that day's visit. A Nature Swapper receives points for what she or he brings in, as well as knowledge points and story points, and then is able to trade these points for other items in the room. A child may earn enough points for a set of binoculars, a journal, or even a bison skull.

The Nature Swap room is filled with pinecones, fossils, driftwood, animal bones, and other natural items that children have collected, along with poems, journals, photos, and artwork, some with amazing attention to scientific detail, others with a sense of fantasy and imaginative adventure. Andrea Rivera, a Play Partner, was the person who walked me through Nature Swap for my tour. Andrea could pick up any item and tell me about the child who brought it in and the story that the child told to go with it. I was so captivated—Nature Swap is a room filled with stories within stories.

Just around the corner from Nature Swap is another small nook filled with the written voices of children. In pencil and in crayon, on plain sheets of white paper, children create memorials to pets who have died. Each is painfully earnest and profound in its simplicity. Among the tributes to dogs and cats, I found a note scrawled in the distinctive handwriting of a child learning to print that read: "goodbye wormy wormy. you were a good worm." This memorial testament is illustrated with a lovingly drawn picture of a single, solitary worm.

It might be tempting to view the Hamill Family Play Zoo as an anomaly, a Camelot-like place that rarely happens and can only be repeated through the luck and good fortune of a chosen few. Nothing could be further from the truth. It builds upon and extends a global network of growing awareness that children need quality time with plants, animals, wildlife, and nature. Robin Moore,

whose work in design and research of childhood nature play spaces began in the 1960s, was central to the design and development of HFPZ and has remained actively involved with the development of NatureStart. In the past decade, Robin, together with educational psychologist Nilda Cosco, founded the Natural Learning Initiative at North Carolina State University. Also in the past decade, the University of Denver began a new doctoral program focusing on research and design of environments for children and youth. Richard Louv launched the Children and Nature Network. The World Forum Foundation began their Nature Action Collaborative for Children. New opportunities for childhood nature play and exploration are being created in zoos and in neighborhoods, in cities and in classrooms, in backyards and apartment buildings, by adults who have become conservation leaders through sharing their sense of wonder for the natural world.

While the Hamill Family Play Zoo was the first zoo exhibit of its kind when it opened, it has sparked a trend of child-centered places and approaches in zoos and aquariums around the country and in other parts of the world, from the exhibit "Nature's Neighborhood" in Toledo, Ohio, to the NatureStart Initiative in Temaikèn, Argentina. Zoos in the twenty-first century are still a place for children, as they always have been, but new understandings about inspiring care and concern are transforming the programs and spaces that zoos provide for young children and their families.

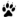

Imagine an August evening. Brookfield Zoo has closed for the day, but a group of parents, grandparents, and caregivers have arrived with the children in their lives for their favorite class, "Life on the Pond." They hike with Play Partners and CZS Animal Care staff to a far corner of Brookfield Zoo, then continue to walk past the sidewalks, onto an unpaved road used only by the CZS Grounds Crew, onto a trail, deep into the woods, until they can no longer see the zoo. They walk until they arrive at a small pond. As the evening sun sets, they put on boots and waders, and use small fishing nets to find tadpoles, grasshoppers, water striders, a praying mantis, even a small garter snake. A five-year-old girl is wearing a safari vest that she brought from home and pulls a picture guide of insects from her pocket. As she flips through the pages, she proudly points out to her mom each of the insects she has spotted this evening. And as the children laugh and play, they are serenaded with frog songs.

Recommended Resources

Books and Articles

Association of Children's Museums. *Kids Dig Dirt! Green Paper*. Washington, DC: Association of Children's Museums, 2008. Available online at http://naturalearning.org/sites/default/files/KidsDigDirt.pdf.

Carson, Rachel. *The Sense of Wonder*. 1965. Reprint, New York: HarperCollins, 1998.

Chawla, Louise. "Children's Experiences Associated with Care for the Natural World: A Theoretical Framework for Empirical Results." *Children, Youth, and Environments* 17, no. 4 (2007): 144–70.

———. "Life Paths into Effective Environmental Action." *Journal of Environmental Education* 31, no. 1 (1999): 15–26.

Deuchler, Douglas, and Carla Owens. *Brookfield Zoo and the Chicago Zoological Society.* Chicago: Arcadia Publishing, 2009.

Kahn, Peter H., Jr., and Stephen R. Kellert, eds. *Children and Nature: Psychological, Sociocultural, and Evolutionary Investigations.* Cambridge, MA: MIT Press, 2002.

Louv, Richard. *Last Child in the Woods: Saving Our Children from Nature-Deficit Disorder.* Chapel Hill, NC: Algonquin Books, 2005.

Myers, Gene. *The Significance of Children and Animals: Social Development and Our Connections to Other Species.* 2nd ed. West Lafayette, IN: Purdue University Press, 2007.

Rabb, George, and Carol Saunders. "The Future of Zoos and Aquariums: Conservation and Caring." *International Zoo Yearbook* 39 (November 2005): 1–26.

Ross, Andrea Friederici. *Let the Lions Roar!: The Evolution of Brookfield Zoo.* Chicago: Chicago Zoological Society, 1997.

Websites

Association of Zoos and Aquariums: www.aza.org

Chicago Zoological Society: www.czs.org

Children and Nature Network: www.childrenandnature.org

Children, Youth and Environments—University of Colorado: http://www.colorado.edu/cye/home

Children's Environments Research Group: http://cergnyc.org

Conservation Psychology: http://conservationpsychology.org

Hamill Family Play Zoo: www.czs.org/czs/Educational-Programs/Hamill-Family-Play-Zoo

Hamill Family Play Zoo Celebrates 10 Years video: http://www.youtube.com/watch?v=MNhILsb9P_0

Natural Learning Initiative: www.naturalearning.org

World Forum Foundation: www.worldforumfoundation.org

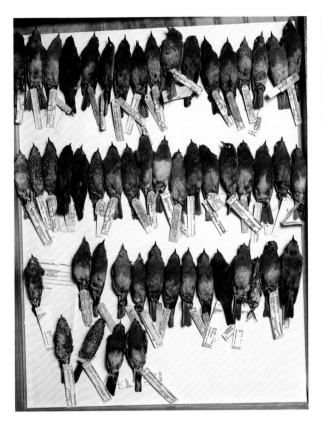

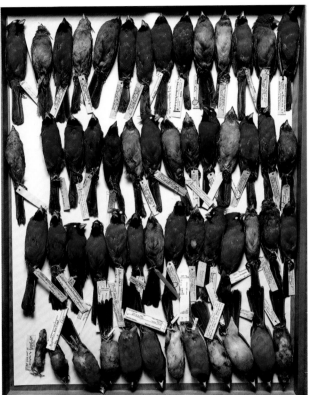

TERRY EVANS, *Field Museum, Drawer of Bluebirds*

TERRY EVANS, *Field Museum, Drawer of Cardinals*

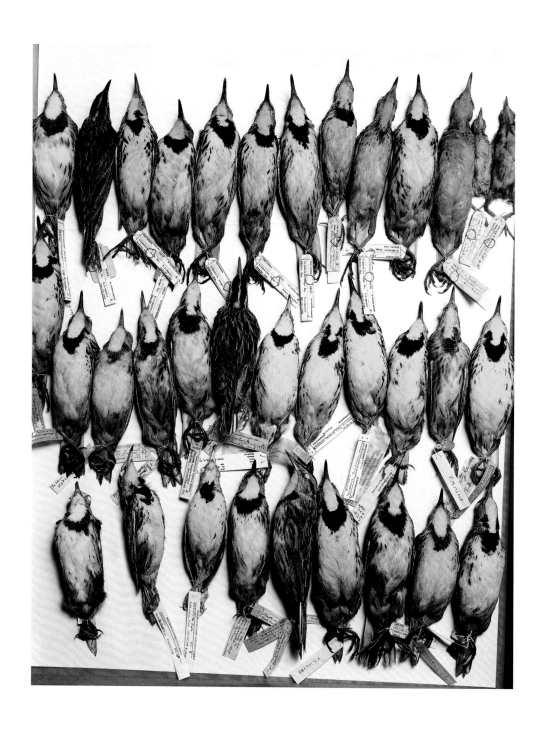

TERRY EVANS, *Field Museum, Drawer of Meadowlarks*

❊ 4 ❊

CONNECTING
THREADS

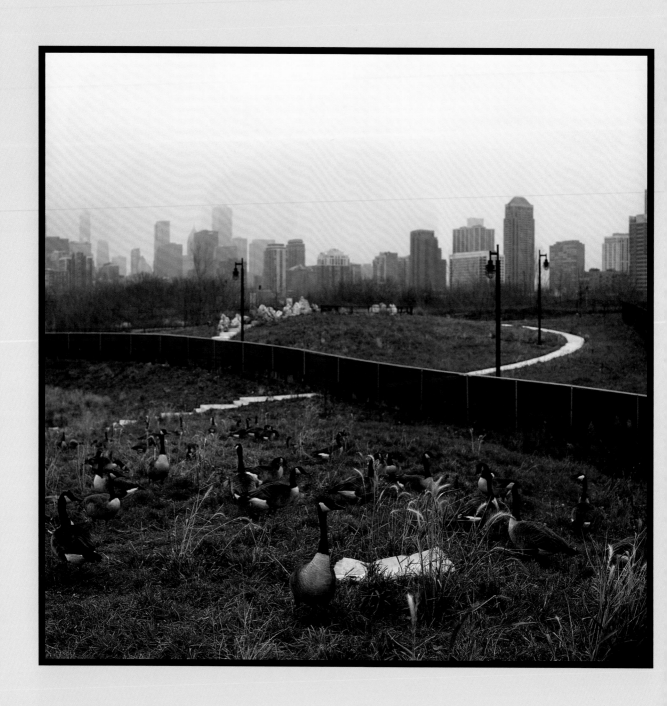

RYAN HODGSON-RIGSBEE, *Flock*

Migration

A Bird's and Birder's Eye View

JOEL GREENBERG

Even though I have been interested in animals all of my life, I didn't become a certifiable birder until middle school. A seventh-grade class on nature led me to conduct some research for a term paper (I wrote it on one of the area's rarest visitants, the Kirtland's warbler), which in turn revealed the existence of the Evanston North Shore Bird Club. I also made contact with Richard Horwitz, a high school senior at the time who has since enjoyed an enviable career at the Philadelphia Academy of Sciences. One Saturday morning in November 1966, he called and asked if I wanted to come birding with him. He showed me a roost of long-eared owls in the front yard of a house in Northbrook and I was hooked. Supportive adults, most especially my parents but also the then-dean of Chicago birders, Charley Clark, made it easy for me to pursue this growing passion. The Chicago region is a particularly good place to bird because it is adjacent to a large body of water, has many tens of thousands of acres of protected areas with diverse habitats, hosts legions of birders who scour the area for treasure, and lies along the migratory pathways of hundreds of species.

Gifted with wings, birds are endowed with powers of mobility surpassed among vertebrates only by *Homo sapiens*. Many have adapted migratory patterns that enable them to reap the seasonal bounty of different latitudes: they winter in hospitable environments to the south and spend their summers in areas where a surfeit of plants and animals provides ample nutrition to sustain new generations. The Arctic tern represents the extreme end of the migration continuum, traveling a remarkable 56,000 miles a year, moving from one pole to the other as it maximizes the daylight that enhances its ability to find tiny fish and crustaceans.

Bird migration graces Chicago with surges of biodiversity that ebb and flow throughout the year. (About three hundred species occur in the Chicago area every year.) Some of these migrants will spend months in the region while others merely pass through on their way to other destinations. And a few oddballs wind up here for no apparent reason. Appreciative humans have the

opportunity to revel in the beauty and spectacle of these feathered travelers without much change in their daily routines at all. For the birds, however, these peregrinations are more perilous than anything else they do, yet it is this aspect of their lives that people know the least about. In his book *Where Have All the Birds Gone?*, ornithologist John Terborgh describes migration as "a chain whose strength is its weakest link."

Consider the gray-cheeked thrush, a member of *Catharus*, a genus consisting locally of four small brown-backed species with varying amounts of dark markings on pale underparts. The gray-cheeked nests in the forests of Alaska and northern Canada, occupying areas of dense small shrubs with thick understory. The northern edge of their range ends where woody vegetation gives way to tundra. It is here in the perpetual northern light of June where the males seek mates and establish territories through the issuing of their plaintive song. Edward Nelson, writing almost 150 years ago, describes the sound this way: "The clear metallic notes rising clear and strong, filling the air with a sweet indescribable melody, and then dying away in measured cadence until the last notes are scarcely distinguishable" (192–93).

The same thrush may spend the winter in tropical forests on the border of Brazil and Bolivia, some 5,000 miles to the south. Life is easier there, since the sole task at hand is finding enough insects and fruit amidst the shaded understory to nourish one individual. Twice a year they travel between these two places. Flying mostly at night, gray-cheeked thrushes pass over an array of landscapes. When the morning sun terminates their nocturnal journey, they seek the habitat necessary to support them for the next day's flight. If morning dawns over agricultural deserts, they may have few choices and a tiny woodlot might have to do.

Over Chicago, various configurations of greenery exist, from the 15,000 acres of the Palos Forest Preserves of southwestern Cook County to the tiny lakefront patches of greenery at Montrose, Jackson Park, and the Hammond Bird Sanctuary (these small refugia are often referred to as "migrant traps"). Many migrating birds wind up in the foliage of backyards or even the concrete canyons of the city's center.

But surviving the obstacle course of a great city is a challenge beyond the capacity of many migrants. Many of the towering monuments to wealth that dominate downtown are plated with reflective glass and illuminated by lights that are beacons to the lost. But for birds and bats, these beacons lead to death. The American Bird Conservancy estimates that anywhere from 100 million to a billion birds suffer fatal collisions with buildings and glass every year in the United States. One authority believes that only habitat loss claims more birds. What makes this particularly troubling to me is that many of these deaths are so unnecessary—simply turning off lights during periods of heavy migration or pulling shades can reduce this mortality significantly.

Some Chicagoans help rescue collision victims. In fact, Chicago has not one, but two different groups of bird collision monitors, who, although not without their disagreements, are both committed to saving birds. One group is part of Flint Creek Wildlife Rehabilitation and the other is the Chicago Bird Collision

Monitors. Volunteers are assigned areas within the city to patrol in the early mornings of spring and fall. They collect all the dead and injured birds they find. The former go to the Field Museum for scientific study, and the latter go to wildlife rehabilitators.

The realization that this kind of after-the-fact conservation has it limits has prompted the groups to become advocates as well. "Lights Out," a program that encourages building managers to turn off lights during migration periods, started here but has been adopted in many other cities as well. With the support of the former mayor Richard Daley, widespread cooperation by the city's building operators resulted in the welcome darkening of the Chicago skyline.

Adverse weather is another force that has been killing migrating birds since their seasonal flights began. In 1820 Henry Schoolcraft noted that the shoreline of Lake Michigan was littered with "a great number of the skeletons and half consumed bodies of the [passenger] pigeon, which, in crossing the lake, is often overtaken by severe tempests, and compelled to alight upon the water and thus drowned in entire flocks" (381). In 1976 a storm left over 200,000 dead warblers, blue jays, and thrushes along one 50-mile section of beach on Lake Huron.

"Fallouts" is a term used to describe those weather-induced incidents when birds literally rain from the sky; it was immortalized in the movie *The Big Year*. I have witnessed them several times in the spring. A drop in temperatures and change in wind direction drive the birds earthward, where they struggle to find food. Under normal conditions, arboreal birds distribute themselves according to their favorite locations within a wooded area or adopt different methods of feeding. Cerulean and Tennessee warblers find sustenance among the branches of the canopy, while blue-winged and golden-winged warblers prefer shorter trees and shrubs. Black-and-white warblers work the trunks for their preferred insects, and ovenbirds and thrushes forage on the ground. They exploit all the food-rich spaces that a forest provides.

But when they arrive during unseasonably cold weather and before foliage has emerged, migrants find themselves competing for whatever can be found on the ground, which is more sheltered. During the spectacular fallout of May 10–12, 1996, observers in Indiana witnessed hundreds of warblers representing over twenty species feeding in flotsam rimming the flooded Little Calumet River and other inundated areas. This is great for birders, but tough on birds: on May 12 one birder encountered the corpses of twelve warbler species in one small section of Schiller Woods on the Des Plaines River.

In Chicago, the two premier lakefront migrant spots are the Montrose Harbor area, which is part of Lincoln Park on the North Side of the city, and Jackson Park on the city's South Side. They offer green oases next to the lake, and they are also scrutinized almost daily by varying numbers of birders. About 450 species of birds have been recorded in the greater Chicago region. Of that number, an astounding 335 have been seen at Montrose and 319 at Jackson Park. When the winds are from the west, the birds are forced against the lake and both places can be seething with birds. Jackson Park is larger and has more habitat, which makes its bird population at least slightly less affected by winds than at Montrose.

Assuming everything appears copacetic for the visiting migrants, the question remains open as to whether the migrant traps like Montrose really do provide adequate resources for the birds. This is difficult to answer and only recently has it begun to receive much attention. Elizabeth Condon, a graduate student at the University of Minnesota (Duluth), says that "measures of diversity on spring migration may fail to capture the overall energetic cost of migration. As more migration stopover sites are urbanized, research is needed to determine our conservation priorities for stopover sites in large cities." Over the course of their migration, birds tend to spend more time on foraging than actually traveling. "Stopover habitat quality may influence the total length as well as the energetic cost of migration, and these in turn affect a bird's ability to successfully reach nesting grounds and reproduce, ultimately having impacts at the population level," she writes.

Birders are on occasion able to witness what happens when birds are forced into inadequate habitat and close proximity to inhospitable neighbors. My two favorite examples involve American bitterns. One morning a group of us arrived at Montrose, and one of the first birds that we came across was an American bittern. This marsh-breeding heron has vertical brown markings that make it nearly invisible as it stands stock-still in the rank vegetation of a marsh. There it was, not moving one bit, secure that it blended in well with the surrounding grass. Here was the product of evolution being practiced in front of us. Unfortunately for the bird, though, the grass that was supposed to provide shelter had been freshly mowed and was only a few inches tall. In this case, the proximity of people forced the bird to rely on option two—flight—and presumably it then selected a less conspicuous location.

In another instance, reported by Kenai Hiryabashi, the bittern was well concealed. Kenai found the bird standing under the low trees that comprise the Magic Hedge, a row of trees that help make Montrose so appealing to birds. As she admired the bittern, she noticed a warbler pop into view off to the side. The warbler was a mourning, one of the less common and more secretive of the expected members of its group. They also have a relatively narrow window of migration through these parts that peaks between the third and fourth weeks of May. Her attention having shifted from the bittern, Kenai watched the strikingly colored male warbler, marked by a dark hood and yellow underparts, as it devoted itself to catching insects, unconcerned by any potential pitfalls. Its path brought it ever closer to the stationary bittern, until suddenly the larger bird extended its neck like a shot and grabbed the warbler. I sincerely doubt that these two species would come anywhere near each other at any other time of the year.

But from my narrow selfish interests as one who loves nature and birds, the aggregation of species in one place makes the migrant traps holy ground, where morale soars as high as the white pelican I saw coursing over Montrose a few years ago. Montrose is undoubtedly the most heavily birded place in Illinois. I did a point count survey once, walking a certain distance and then counting all the human voices I heard. My short transect yielded over fifty people.

One day a number of us were birding the hedge when word spread that a king rail had just been located on the beach, at the base of the pier, which was prob-

ably as far from where I was as any spot at Montrose. It was hilarious watching the swarms of people emerge from the shrubbery, some running, we portly types waddling, and still others limping as fast as they could to reach the rail. As most of them passed the halfway point, I mused about yelling out the presence of some even rarer bird. No doubt the crowd would have pivoted and raced in the other direction. A third shout in yet another location would have probably left many of us curled up in balls, weeping in indecision and despair. The reality was that the rail proved to be very cooperative and was well seen by everyone, a special treat given the increasing rarity of this species in the Midwest.

Fall birding provides its own unforgettable sights and challenges. Autumnal migration involves more individuals, since it includes the newest crop of youngsters not yet thinned by months of predation, collisions, starvation, and all the other factors that contribute to mortality. These immature birds sport subdued plumages, as do many of the molted adults, which makes identification difficult. The 1957 *Peterson Field Guide to the Eastern Birds* says that if you master the fall warblers after ten years of work, you are doing well. Pat Ware, an early birding mentor of mine, said she found solace in that quote up until the eleventh year.

The two autumnal activities I enjoy most are hawk watches and lake watches. Both are highly weather dependent. The ideal weather involves the passage of a front from the north or northwest that brings with it high winds. There is a local saying: "The more horrific the weather, the more terrific the birding." But even after years of studying weather trends, a promising day may yield surprisingly poor results. Still, everyone looks forward to those few days a season when the raptors move en masse.

Such was an early October Tuesday several years ago. From the end of August to the end of November, there will always be at least one avid Chicago birder ensconced at the hawk watch, eyes to the north, ready to count the raptors that fly over. On days of little promise, there may only be a couple of people, but when prospects look good, the observation area is brimming with people and scopes.

I showed up early that day, but pretty soon a full complement of watchers had arrived. More importantly, hawks that had been bottled up by stagnant winds arrived in droves. Of all the hawks, and perhaps one can even say this about the entire avian class, none have the aerial mastery of falcons. Peregrines can exceed 180 miles an hour in a dive. I once saw a peregrine seemingly toy with some kind of shore bird, forcing the prey higher and higher until they disappeared from sight. Merlins, the next size down among our local falcons, are both swift and maneuverable, inexorably chasing small birds by following every twist and turn as the target seeks to elude its pursuer.

Both of these species were once considered quite rare, since they were both vulnerable to widespread spraying of certain pesticides like DDT. Charley Clark had but a handful of merlin records (although it was not his style to sit in the same spot all day watching hawks). He would have been amazed at what

we saw that day: hundreds and hundreds of merlins barreled down from the north. Spotters looking into the distance rattled off numbers while low-flying birds popped over our heads. They were everywhere, and even with the large number of observers, we undoubtedly missed some. By the end of the day, we had an absolutely phenomenal total of 725 merlins and about 80 peregrines. Of North American hawk watches, only the one at Cape May, New Jersey, has ever had more.

Lake watches (and hawk watches) appeal to me so much because they offer more than just birds (as wonderful as birds are). They allow you to see migration for what it is—a primeval force, locked deep within the avian genome, enacted before your eyes. And Miller Beach, a section of Gary, Indiana, is an extraordinary place to witness this grand event. To understand what is so special about Miller, consider that Lake Michigan is the only Great Lake oriented on a north-south axis, and that the southernmost point of the lake is Miller. Any bird flying south over or along the shoreline of Lake Michigan literally runs out of water at Miller. I will never forget the flock of Bonaparte gulls happily winging their way south until just offshore when, realizing that the lake was about to end, they suddenly put on the brakes, as if to say, "Oh, s***, what do we do now?" In the case of the gulls, they milled around a bit, ascended high overhead, and headed straight south. Lake Michigan, as these gulls directly experienced, acts as a funnel.

Strong northerly winds were in the forecast for one Saturday lake watch in August 2009: perfect conditions for jaegers, the group of birds most sought after by the cognoscenti of Miller Beach. Related to gulls, jaegers are, in the words of Kenn Kaufman's *Lives of North American Birds*, "fast-flying seabirds, predatory and piratical." The three species breed on the tundra and spend the rest of the year at sea. Some of them, however, do wind up on the Great Lakes or on even smaller water bodies. (Miller is the best place in inland North America, however, to see jaegers.)

By far the most common species of jaeger on Lake Michigan is the parasitic, which can be seen from August through early December. The other two species are much rarer. Sightings of the long-tailed jaeger are concentrated in late August and early September (although we did see one in late October once), while the pomarine jaeger is a late-season bird, usually encountered in late October or November. Most of the time jaegers stay far offshore and identification as to species is often impossible, but even the chance of glimpsing birds that ought to be kiting over breaching whales is a powerful lure.

Northwest Indiana, where Miller Beach is located, is also the home of Ken Brock, a retired geology professor who leads a group of superb birders with particularly keen powers of sight and hearing. They cover the lakefront every Saturday, and weekdays if the weather is particularly promising. Everyone has a walkie-talkie, so even if separated from one another, they are constantly sharing their detailed observations, which Ken dutifully records on his clipboard. ("Juvie female redstart." "Copy that.")

After hearing me go on and on about Miller Beach and Ken's group, Sulli Gibson, then a middle school student, wanted to give it a try. Early in the sea-

son, birders usually gather atop a sand pile at Miller's Lake Street Beach because of the view; but when conditions are rough, they seek the shelter of the concession stand at Marquette Park. When Sulli and I arrived at Lake Street, it was clear that the swirling wind, and the sand in its grasp, promised a tough day of watching. This conclusion had already been reached by Ken and his squad, so they set up at Marquette. Fortunately for us, Ken came to retrieve us, only to learn from the others that while he was on his mission of mercy, a parasitic jaeger had been identified.

Many eyes focused toward the Chicago skyline as we scoped the horizon. At one point I spotted a bird at the limits of vision that looked like a jaeger. The problem was that as the bird headed west, it would move up and down—visible when against the sky only to disappear against the dark of the lake. A few minutes after I called attention to it, someone else picked it up and also thought it a jaeger. More people found the speck, by which time I lost it. The bird was joined by a second jaeger briefly but kept going west. Then the bird did something truly unexpected: it headed toward shore. People ran out to the beach to get a better view. I could not relocate it until I heard other birders shouting, "You can see it with your naked eye." And sure enough, heading right over us was a stunning adult long-tailed jaeger, with its streaming tail feathers still intact. Sulli gained the distinction of being the first person, among the many billions who have ever inhabited this planet, to have his first Indiana jaeger be a long-tailed. It was a bird he had never seen before, but even the veterans all agreed that this was the best view of such a magnificent example of this rare species that they ever had at Miller.

Rarities like these are the spices that keep many birders excited about their pursuit. But migration is of course much more than that, making the tame confines of a large city more wild by introducing throngs of creatures that are coming from far away and headed to equally remote destinations. There is beauty in their manner and appearance, and we get to glimpse these organisms performing at least some of the essential tasks of life. Whether it is a jaeger chasing gulls or a bittern grabbing the nearest protein, the incentives for close observation are many. Whatever your age or circumstance, migration presents all of this at your doorstep.

Acknowledgments

Some of this material originally appeared in a different form as posts on my birding blog at Birdzilla.com. I am grateful to Sam Crowe of Birdzilla.com for the opportunity to become a blogger and for allowing me to borrow from what I wrote there. I also want to thank Elizabeth Condon, who shared with me her two fascinating papers on bird migration. Ken Brock and Tom Schulenberg reviewed this article and their comments improved it greatly. Ken also shared his paper on the 1996 fallout.

Recommended Resources

Books

Carpenter, Lynne, and Joel Greenberg. *A Birder's Guide to the Chicago Region.* DeKalb: Northern Illinois University Press, 1999.

Greenberg, Joel. *A Natural History of the Chicago Region.* Chicago: University of Chicago Press, 2002.

Hughes, Janice M. *The Migration of Birds: Seasons on the Wing.* Richmond Hill, Ontario: Firefly Books, 2009.

Kaufman, Kenn. *Lives of North American Birds.* Boston: Houghton Mifflin Harcourt, 2001.

Kerlinger, Paul. *How Birds Migrate.* 2nd ed. Mechanicsburg, PA: Stackpole Books, 2009.

Nelson, Edward W. "Birds of Northeastern Illinois." *Bulletin of the Essex Institute* 8 (1876): 90–155.

Schoolcraft, Henry R. *Narrative Journal of Travels through the Northwestern Regions of the United States.* Albany, NY: E. & E. Hosford, 1821.

Terborgh, John. *Where Have All the Birds Gone?* Princeton, NJ: Princeton University Press, 1989.

Weidensaul, Scott. *Living on the Wind: Across the Hemisphere with Migratory Birds.* New York: North Point Press, 1999.

Websites

Chicago Bird Collision Monitors: www.birdmonitors.net
Flint Creek Wildlife Rehabilitation: www.flintcreekwildlife.org
Illinois Birders Exchanging Thoughts (IBET): http://birding.aba.org/maillist/IL
Illinois Birders' Forum: www.ilbirds.com

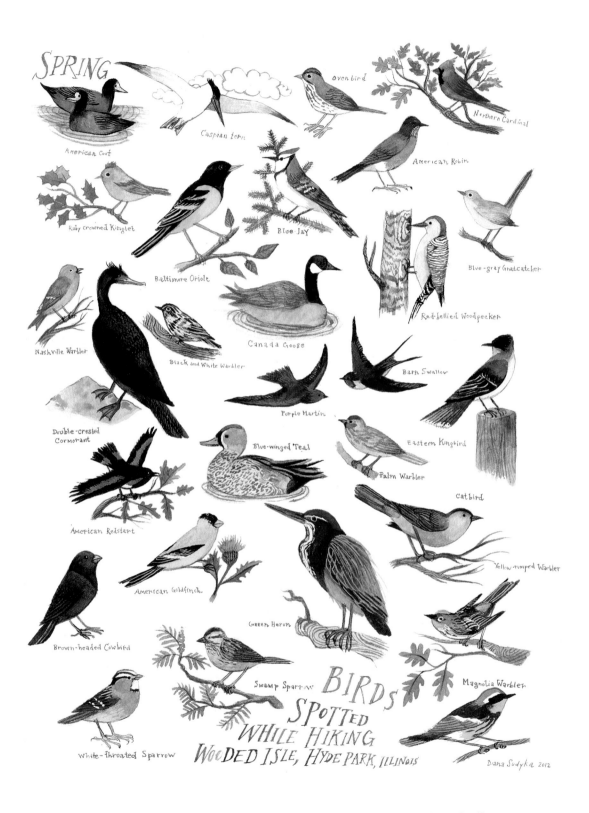

DIANA SUDYKA, *Birds Spotted While Hiking Wooded Isle, Hyde Park, Illinois*

The Song of
Northerly Island

WENDY J. PAULSON

It was a meadowlark that introduced me to Northerly Island. I was pedaling
south on the Lakefront Trail, passing the Burnham Boathouse on a borrowed
bike in early June 2007, when I was arrested by a clear, varied melody—the un-
mistakable notes of an eastern meadowlark. I knew the song well; meadowlarks
had nested for years in the meadows next to our longtime home in Barrington.
But here in Chicago? How could a bird of rural grasslands be singing in the city?

I stopped, turned around, and headed toward the song.

The only route toward the meadowlark led past the Field Museum and the
Shedd Aquarium and finally to a road that turned off just short of the Adler
Planetarium. A signpost read: "Northerly Island." Pedaling on southward, I was
surprised to find myself on a path that wound through an open field and grass-
land complex. I began to recognize prairie plants. The meadowlark sang again,
and I spotted it on the ground. Before long, I also had found a grasshopper spar-
row, savannah sparrows, and a kestrel—all birds of open grasslands.

At the southern end of the peninsula, I stopped, turned around, straddled
the bike, and gazed. The view of the city was a jaw-dropper. With the lake at my
back and spring prairie vegetation ahead, merging into that incomparable sky-
line, natural history and human history were fused into one grand sweep: lake,
prairie, Chicago. And here, in panoramic proximity to Soldier Field, the mu-
seum campus, and the city beyond, a meadowlark was singing.

It still was not clear to me, other than the obvious near-the-museums geog-
raphy, where I was. What was Northerly Island? Even though Barrington had
been our home since the early 1970s, Chicago was not so familiar to me, espe-
cially since we'd been away—in New York City and Washington, DC—for over
fourteen years. But surely I should have known of this place.

I headed north again, lost in thought, toward the apartment of our daughter
and her husband in Lakeview, where they awaited the imminent birth of their
first child. Gradually, it occurred to me: wasn't the site where the meadowlark
sang the former Meigs Field? I had never been there but had heard about the
small lakeside airport that Mayor Daley had ordered demolished under cover of
dark. I knew also of the mayor's championing of nature and parks. Hallelujah!
Not only had he traded tarmac for open space, but he also had initiated a prai-

rie restoration project on the site. And prairie birds, among the most precipitously declining species in the world—meadowlark populations, for example, had plummeted by as much as 87 percent since 1967—were responding.

Once back at my computer in the apartment, I shot off a brief message to Maggie Daley, the mayor's wife, whom I had come to know on her visits to New York and Washington during our eastern sojourn. "I discovered Northerly Island today. The song of an eastern meadowlark drew me there. Please thank the Mayor. He has done a wonderful thing for nature in the city—and for city dwellers' quality of life." In the months following, I spoke several times with Maggie about the potential of Northerly Island as an outdoor classroom and laboratory for Chicago students and citizens.

On subsequent visits to the city, the site invariably was on the itinerary, even during troubling times. I led my husband on a bike trek to Northerly at the brink of the 2007–8 financial crisis. He was preoccupied with the economy, but even on our short field trip, he found the encounter with prairie and prairie birds in the heart of the city captivating.

A cluster of friends from New York, members of a conservation book group we had started there ten years earlier, visited the next summer. We spent a day in the city before retreating to Barrington for prairie restoration work and book discussion. Our destination: Northerly Island. My friends gasped in wonder at the encounter with lake, prairie, and cityscape—not to mention the grassland birds. The meadowlark was missing, but we found grasshopper and savannah sparrows along with a kestrel.

It was entirely natural, then, when we came back to Illinois in 2010 and bought an apartment in the city near Millennium Park, that I get to know Northerly Island better. It was winter when I was finally able to visit the site. Someone had told me about possible short-eared owls and a northern shrike there. With our three-year-old granddaughter in tow, my husband and I headed to Northerly on a frigid, blustery Saturday morning. We leaned into the fierce wind and made our way southward. I spotted the shrike in a leafless sapling. Minutes later, crows mobbed a short-eared owl into flight. Once again I was plunged into utter astonishment and delight: how could anyone expect to find a northern shrike, the "butcher bird" of open fields (so named for its habit of killing and impaling prey on thorns), and a short-eared owl, a winter visitor to vast Midwest grasslands, in shouting distance of Soldier Field in Chicago?

I knew then that I wanted to start bird walks at Northerly Island.

Years before, the idea of leading bird walks in a city would have seemed to me preposterous. But what struck me before as improbable, if not impossible, no longer did. That was because of an eleven-year sojourn in the heart of New York City. From nearly daily outings to Central Park and bimonthly trips to Jamaica Bay, I had learned that birding in the city could yield as many encounters with birds, especially during migration, as outings in the country. In fact, the experiences often were more intense and diverse in the city settings, precisely because the concentration of birds was greater in these urban oases.

What's more, the city parks offered the best outdoor classrooms I ever experienced. I led walks for the Nature Conservancy in Central Park for eleven

years. While there were occasional slow days, as on any bird outing, never once did we leave without sighting something notable. It could be blackpoll and bay-breasted warblers on the same branch that gave us textbook comparisons of their confusing fall plumage. Or an airborne peregrine spotted through a gap in the tree canopy. Or a black-billed cuckoo that streaked out of a woodland. One morning, as our group stood atop a huge glacial boulder dubbed Sunbathers' Rock, we even watched a meadowlark fly overhead—the only time I saw that species in Central Park.

The unpredictable and serendipitous became almost commonplace.

For young students, the park was a vibrant aviary. With Audubon New York, I taught bird classes in urban schools for eight years. Each spring we took field trips to the park to test observation and listening skills developed in the students' classrooms and neighborhoods. With eyes newly alert to species other than the ubiquitous pigeons, sparrows, and starlings of city blocks, they marveled as iridescent grackles, just several feet away, tossed leaves in search of grubs. They stood motionless to watch ovenbirds tiptoe on the path before them and black-throated blue warblers perch on wire fences. Over lunch at the Model Boat Basin, they peered at Pale Male, the red-tailed hawk sire, and his mate in their large nest above a fancy window on Fifth Avenue. A teacher of birds could not design a better place for kids to learn about them.

Now back in Chicago, I did not know the parks well enough to know if they could—or did—offer the same opportunity for nature-rich encounters. I had heard and read about migration spectacles at the Magic Hedge at Montrose Harbor, and the good birding at Jackson Park and Washington Park, but had not yet been to any of those places. While I regarded Millennium Park as a fine urban achievement, it accentuated built structures, not natural ones, and it could hardly be considered the oasis for birds that Central Park is.

But the meadowlark's song at Northerly Island gave hope and promise that there was more to be discovered. That first winter I made several solo treks to the peninsula, one memorably on the day that the Green Bay Packers played the Bears at Soldier Field. I reveled in the solitude and stillness of the winter lakeside landscape, interrupted regularly by bursts of cheers from the stadium. I reveled also in the rafts of waterfowl gathered in Burnham Harbor and on the lake: mergansers, goldeneye, green-winged teal, canvasbacks, redheads. This place was special.

Under the sponsorship of Audubon Chicago Region, the Field Museum, and Openlands, I began to lead bird walks at Northerly Island in the spring of 2011. Sometimes we compile respectable lists of species sighted; other times we do not. But almost always we have experienced displays and encounters that leave us exhilarated and inspired for the day ahead.

In the glare of McCormick Place one spring morning, we discovered the nest of an eastern kingbird in a spindly oak on the west side of the island, and we could see the head of the incubating female just above the rim. The kingbird, *Tyrannus tyrannus*, had flown all the way from Colombia or Ecuador to build its nest and raise young in that oak. We marveled at this long-distance migrant that had chosen Northerly Island as its nursery. A year later, a kingbird (the

same one?) nested on the other side of the trunk in the same oak sapling. With only instinct and inner compass, it had navigated a 6,000-mile round-trip with neither map, motor, nor GPS.

Barn swallows demonstrated their mud-gathering techniques at the edge of mud puddles along the paths. One day someone noted it was not just barn swallows but cliff swallows, too, and we found their gourd-shaped nests of mud nestled in the electric light recesses in the outdoor canopy of the old airport terminal. Here were two master avian potters absorbed in their life's work as traffic choked Lake Shore Drive not a half mile away.

In late fall, horned grebes delighted viewers with extended close-range studies as we stood on the concrete platform at the southern end of Northerly. Lesser scaup, bufflehead, and common goldeneye swam and dove in the protected waters of Burnham Harbor. Offshore, we caught glimpses of red-breasted mergansers and green-winged teals. An occasional Cooper's hawk, in focused pursuit of a songbird or turning on a badgering crow, electrified the group. Kestrels were more regular visitors but no less appreciated by admiring viewers. One early spring day, a red-headed woodpecker surprised us. We had been counting brown thrashers, clearly in migration, when the woodpecker flew into a tree along the lakeshore. It is a species seldom seen even in rural habitats these days, and it thrilled us with its sudden appearance.

The company of wild, feathered creatures against an inanimate cityscape of concrete and steel and honking taxis was utterly magical. But there was more.

The winter of 2011–12 was remarkable for its warmth. It was also remarkable for the influx of snowy owls from the Arctic. Apparently the owls had experienced a bumper breeding season, and the overflow—mostly juveniles and females—headed farther south than usual for winter food. Ornithologists term such a phenomenon an "irruption."

Having spent many fruitless hours and days in search of a snowy owl over the years, I was desperate to see one. One morning in December, I received a call from my brother-in-law reporting a snowy owl at Montrose. I looked at my watch, figured I had about fifty-five minutes before a conference call, and sped up Lake Shore Drive to Montrose Harbor. A photographer emerging from his car offered to lead me to the owl, as I had no idea where it might be. In only a few minutes, I was staring at my first snowy owl cowering behind a fence on the breakwater. As other birders and photographers focused on the raptor from the Arctic, I felt a twinge of guilt for being part of a human phalanx backing the owl into a remote corner of the pier.

One month later I took a visiting friend, Gary, who is a fine birder, out to Northerly Island simply to see the place I had told him so much about. We were strolling up the footpath nearest the lake, and I could see that Gary was watching intently even while talking. Abruptly he announced in a reverent whisper, "Snowy owl!" He had been watching gulls climb and dive above the rocks that line the shore, and suddenly he realized what they were aiming at. We positioned ourselves for a better view, peering through the grasses and rocks, and there it was: a magnificent mass of ivory feathers etched with black, standing atop a cement slab, alone against the lake. We watched for a long time, chuckling when

we saw the bird hop—literally hop—presumably in pursuit of some rodent in the rock rubble. Gary stood vigil while I phoned my husband. He caught a cab to Northerly and saw his first-ever snowy owl.

In the middle of a workday crammed with phone calls, meetings, and e-mails, an encounter with a snowy owl on a remote edge of lakefront was something of a miracle.

It was not the only snowy at Northerly that winter. I saw several more—or at least had several more sightings, not knowing whether some of them might have been of the same bird. I chose not to report the encounters, preferring to give the magnificent creatures the dignity of solitude and freedom from aggressive birders and photographers.

The best experience with a snowy owl, however, was still ahead. On March 8 our regularly scheduled monthly walk started auspiciously with bluebirds migrating overhead. Soon an eastern meadowlark joined the northward parade, then another and another. Participants who had never even seen meadowlarks were soon identifying them by their silhouette and jerky flight pattern. A Cooper's hawk flew low over the open field. We swung around the south end and headed north on the east path, making occasional forays to the rock front to look for waterfowl. Mindful of earlier encounters with snowies, I kept scanning ahead.

And, suddenly, there it was. Another snowy owl, different from the darkly streaked one I had seen a couple weeks earlier but standing in almost precisely the same spot. Without revealing the object of focus, I positioned the telescope and directed the others, "Look." The gasps, as one by one each participant recognized the prize, were audible and sustained. It was as if we all were standing in a magical kingdom. Bluebirds, meadowlarks, and now a snowy owl—all on the same morning in a city by the lake.

It is precisely that dimension—the magical—that characterizes a place like Northerly Island. It offers suspension from the pace, noise, and mechanics of urban living. It opens the window of possibility to encounters with visitors from the Arctic, from the Amazon, who have chosen this place, even if only momentarily, for a segment of their life's journey. For many city-bound residents, it introduces—and awakens—them to species and migratory dramas they never knew or even dreamed of.

Lest we forget, Northerly Island is not a natural area. It is entirely human-made, part of Daniel Burnham's plan for a string of islands along the lakeshore for the Chicago World's Fair. With a land bridge built in 1938 that connected it to what is now Solidarity Drive, the island became a peninsula park and was converted to a small airport in 1947. It remained so, with rocky relations between the city and state about its operation, until 2003; in March of that year, Mayor Daley ordered it to be demolished and returned to parkland.

The genius of his decision is analogous to that of Frederick Law Olmsted when he designed Central Park in the mid-1800s. Olmsted knew that a majority of New Yorkers did not have the means or time to seek refuge from city noise and congestion in northeastern mountains and shores. Fundamental to his design of Central Park was the desire to bring the experience of nature—

the beauty, solitude, wonder that can be discovered in the natural world—to city dwellers. Mayor Daley developed a similar vision and sought to make a reality of Chicago's motto, *Urbs in Horto* (City in a Garden). The Millennium Park project, the miles of massive architectural planters on the city's avenues and along the sidewalks, the interpretive signs along the lakefront birding trail, the rooftop gardens, and now the decision to return the former lakeside park to its pre-airport character were bold steps in advancing a vision that would declare the city of Chicago green, aesthetically arresting, and inviting to both nature and people.

A city that includes a tapestry of parks and natural habitats—including native trees along its streets and roadways, and community and school gardens—is a city that honors nature, that recognizes the sense of inquiry and wonder that encounters with birds and butterflies and bats inspire. It promotes *wakefulness* (Did you see that yellow-bellied sapsucker drilling holes in the locust along Columbus Avenue?); *curiosity* (Why are there other birds feeding at the holes, too?); *gratitude* (What a gift to be able to watch sapsuckers and warblers on my walk to work this morning!).

Such a city honors its people, too. It recognizes the pleasure of learning, the delight in unexpected encounters, the pride in the beautiful. Initiating and maintaining parks, boulevards, and natural pockets make experiences in nature available, close, immediate, abundant—not to mention free. If we, as citizens of the planet, are to cherish and care for our natural heritage, we need to know it firsthand. Urban nature sanctuaries give us that opportunity.

As I write, Northerly Island is about to begin yet another chapter in its history. Fences will soon go up to cordon off the southern end for development of a wetland. It will be the first stage of a park plan designed by Jeanne Gang of the Studio Gang Architects. The good news for Chicago and nature lovers is that the Chicago Park District, the designer, and the regional conservation groups are unanimous in their commitment to a park for nature. The not-so-good news is that eastern meadowlarks—and the people who watch for them—may have to look elsewhere for stopovers until the project is completed.

Fortunately, the Park District continues to add parkland all along the lakefront, from Montrose Harbor in the north to Burnham Prairie to the South Shore Nature Sanctuary and Rainbow Beach Dunes. Surely the meadowlarks will find other spots to rest on migration, as will thrushes and owls and warblers headed for Colombia. Soon enough Northerly Island will again welcome nesting, migratory, and wintering birds. Chicagoans of every age will be able to walk there and watch and learn and marvel—and perhaps hear the song of the meadowlark, a song of the prairie in the shadow of the city.

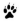

Author's note: Prior to publication, an unexpected development potentially darkened the bright prospects for Northerly Island. Instead of reducing the footprint of the Charter One Concert Pavilion, as recommended by Studio Gang and approved by the Park District, in March 2013 the District and city

abruptly announced plans to dramatically increase the concert area to accommodate a much larger stage and space for 30,000 concert-goers. The decision surprised and dismayed those expecting—and promised—a park for nature. It is unclear at present whether Northerly Island will become a park for loud music and massive crowds, or if it will continue to serve as a nature-based retreat from a noisy metropolis.

Recommended Resources

Books

Carpenter, Lynne, and Joel Greenberg. *Birder's Guide to the Chicago Region.* DeKalb: Northern Illinois University Press, 1999.

Kaufman, Kenn, and John Treadwell Nichols, eds. *City Birding: True Tales of Birds and Birdwatching in Unexpected Places.* Mechanicsburg, PA: Stackpole Books, 2003.

Rosen, Jonathan. *Life of the Skies: Birding at the End of Nature.* New York: Farrar, Straus and Giroux, 2008.

Smith, Carl. *The Plan of Chicago: Daniel Burnham and the Remaking of an American City.* Chicago: University of Chicago Press, 2006.

Wille, Lois. *Forever Open, Clear, and Free: The Struggle for Chicago's Lakefront.* 2nd ed. Chicago: University of Chicago Press, 1991.

Websites

Audubon Chicago Region: http://chicagoregion.audubon.org

Chicago Audubon Society: www.chicagoaudubon.org

Chicago Ornithological Society: http://chicagobirder.org/

Chicago Park District: Northerly Island: www.chicagoparkdistrict.com/parks /Northerly-Island/

Chicago Region Birding Trail Guide: www.bcnbirds.org/birdtrail/

MICHELLE KOGAN, *Wildlife Comes to Lake Shore Drive, Endangered Species*

A Siege of Herons

Nycticorax nycticorax

JAMES BALLOWE

The black-crowned
 night herons
 have left
the Calumet's phragmites
 and scrub
 for Lincoln Park's
linden and ash
 allée,
 the South Pond,
gulls, swans,
 wood ducks,
 the zoo,
Franklin, Lincoln,
 Grant,
 the North Beach.
Inelegantly elegant,
 these squat
 night ravens
squawk
 to disabuse those
 who thought them shy.

Crepuscular,
 they harvest
 the Lake shore's bounty
but a short
 commute
 from their posh address
where they bear their young
 and teach them
 to survive,

then get their bearings,
 go south for winter,
 abandoning
their pom-pom
 condos
 among naked limbs,
to which they will return,
 a siege
 of herons,
their *quocks* and *woc wocs*
 announcing
 they've come back.

Orchids and Their Animals

STEPHEN PACKARD

He lived in a particularly crime-ridden part of the Chicago neighborhood called Uptown. As a recent college grad, Rufino Osorio was searching around for what to do with his life. He had a job with the Latino Institute, where he worked on consciousness-raising, access to health care, and Hispanic economic opportunities. He believed in his work, but his inner heart of hearts gave itself to wild nature.

His grandmother in Puerto Rico was passionate about plants. Rufino took after her. He established a woodland garden in a shaded corner by his run-down apartment building. But he dreamed of wilderness—of prairies, dunes, savannas, and barrens. Somehow he heard that there was wild land at the end of the bus line. A person who lives in Chicago and dreams of wilderness can ride a cheap bus to a forest or prairie in an hour or less from even the roughest neighborhoods.

Schiller Woods Forest Preserve along the Des Plaines River was the last stop on the Montrose Avenue bus. It became an Eden to Rufino. He identified smooth phlox growing in a thicket. Could he have found a prairie remnant?

Sure enough, as the thicket opened into a little meadow, he saw big bluestem grass, wild bergamot, golden Alexanders, white false indigo. It was a little patch of ancient wilderness the size of a baseball diamond, hidden away in a thousand acres of brush. It seemed unreal. Suddenly he saw a specter that was beyond unreal—in full bloom, no less—the prairie white-fringed orchid. This species was nearly extinct on the planet. Could he really be finding it a stone's throw from the end of one of the busiest streets in Uptown?

He called the Audubon Society, and they put him through to me at the Illinois Nature Preserves Commission. I listened with excitement and skepticism. At that time, in the late 1970s, I was just starting my own career. Not so different from Rufino, I'd spent my post-college years doing my best to contribute to civil rights and peace. Now I was in an office in the Loop, trying to organize a network of people who cared about the plants and animals of nature.

I had to hurry. The prairie white-fringed orchid blooms for only a couple of weeks. Rufino gave me directions. I went there, found about twenty of them, and I was in love. Nor was it merely an abstracted kind of "love." Indeed, it

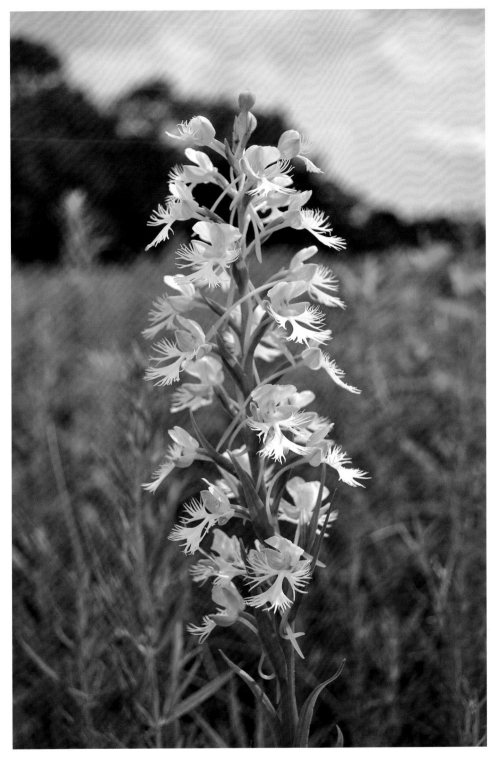

FIGURE 1. Prairie white-fringed orchid in a Cook County Forest Preserve. Because of the long "nectar spurs"—visible reaching back from each flower—this orchid is dependent on specialized hawk moths to reproduce. Photograph by Lisa Culp.

turned out that these orchids needed Rufino and me, and other animals, for their very survival.

The relationship started with a rush. Soon we were organizing volunteer expeditions to Schiller Woods to slay the brush before it snuffed out the whole prairie community. One time our group was detained by the Forest Preserve Police because the officers found it hard to believe that we had been authorized to saw down a lot of young trees. (We had indeed been authorized to clear invasive brush.) Many of us became passionate about our weekend mission to restore health to little prairie remnants. Rufino brought Puerto Rican treats for our shared lunches. Our prairies began to expand and thrive; but as the years passed, we noticed that at Schiller Woods our most beloved plant, the white orchid, rarely set seed and its numbers were dwindling.

Out of the blue, botanist Marlin Bowles, whom I knew slightly, dropped by my apartment with a prairie orchid sticking out of a 7-Up bottle. It had been broken off by accident, and he'd rescued it, sort of, for scientific purposes. Sure enough, it was destined for greatness, because he used it to teach me how the prairie orchid needs an animal pollinator, and how I could be that pollinator.

Sex and reproduction among the orchids is otherworldly. Only a few species of hawk moths can pollinate the white-fringed orchid. The pollinator needs a prodigious tongue, because the orchid plays hard-to-get with its nectar. There's a huge amount, but it's at the bottom of a nectar tube that is longer than the tongue of any bee or wasp or butterfly or hummingbird.

When the right moth finds this flower, it unrolls its hollow tongue, snakes it down to the bottom of the "nectar spur" (see fig. 1), drinks the energy-filled fluid, gets a pollen packet stuck to its head, and flies on to the next plant, where conception now occurs (for the plant) through a complex process that we had to learn. It's one of the impressive intimacies of nature.

Darwin wrote about how orchids and moth tongues co-evolved and interdepended on each other. If one went extinct, so would the other. Marlin knew why the Schiller Woods orchids produced little or no seed: hawk moths are few, back in the brush. Marlin taught me to mimic the moth with a toothpick (fig. 2). Once you have your pollen packet stuck to your toothpick, you go to another orchid and press pollen against the flower's stigma, a sticky patch just above the opening that leads to the nectar. When you do it right and pull back on the pick, the stem of the pollen packet stretches accordion-like until the pollen pops back from the sticky stigma, leaving thousands of pollen grains behind, ready to meet the ovaries of the next flower. It's hard to describe, but it's incredibly gooey, elegant, and sexy.

Rufino and I and our pals in the North Branch Prairie Project wanted seed so that the orchids could have a chance to reproduce in the many prairie patches where we were cutting brush and restoring prairie. We were part of a growing ecosystem restoration movement, first dozens of people, then hundreds, then thousands, who spent our weekends learning (and sometimes inventing) how to restore health to vanishing nature. We needed to develop a myriad of specialists. Some learned to be good at conducting controlled burns. Some studied the restoration of bird habitat—how to nurture the herbs, shrubs, and trees needed

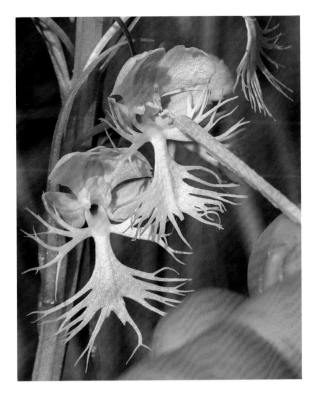

FIGURE 2. Person and toothpick act like a hawk moth. Here, as the toothpick is drawn back with one pollinium embedded in the orchid's stigma, that pollinium's stalk is stretched way out. The other pollinium on this toothpick (the yellow thing on the skinny stem), which didn't contact the stigma, shows what both pollinia looked like seconds before. Photograph by Carol Freeman.

for rare bird species. Some monitored amphibians, dragonflies, or rare grasses. All worked to become "ecosystem medics"—providing the best care possible as the infant science of restoration ecology developed.

I taught others to wield toothpicks and be hawk moths. Summer after summer we performed this sex work and scattered the resulting orchid seed in the prairies and oak savannas we were restoring. We ourselves were becoming creatures of our local landscape, with a valuable role in it.

Orchid conservation isn't for people who require instant gratification (at least beyond the sex part). Five years after we started planting, we still hadn't seen one orchid emerge and didn't know if we ever would. No one had ever done this. (Experts had tried to grow the species in greenhouses. It never worked.) In July 1985, I wasn't thinking much about orchids when I got a call from insect researcher Ron Panzer. He had entered the picture when, after years of prairie work, we started to realize that the oak savanna needed our help just as much as remnant prairies. Indeed, many of the rare animals that began to increase as we pampered the landscape were mostly associated with the trees and shrubs. An oak savanna specialist, the Edwards' hairstreak butterfly, which eats oak leaves as a caterpillar, was Panzer's biggest surprise on his return visit to Somme Prairie Grove after a few years of restoration there. He congratulated me that the Edwards' went from "unfindable" to "the commonest hairstreak on the site."

"Packard, you're a genius," he said. I was happy with the concept, but I asked for a little more detail. Panzer reminded me that he had initially thought that Somme Prairie Grove (where I had chosen to become volunteer steward) was so degraded that he considered it ecological junk—and a waste of time. But

now, a few years later, he was finding many rare insects like the silver-bordered fritillary butterfly and various katydids and walking sticks. But he especially congratulated me on the prairie white-fringed orchid.

Really?! He found one at Somme?! He assumed I knew they were there. I did not. I raced off, once again, to track down the orchids. Now comes the start of our next chapter—betrayal, evil, tragedy, and resistance.

There was no orchid where he directed me. With all its tall frilly whiteness, you can't miss it. Only one explanation was likely. Overpopulated white-tailed deer are known to eat (and in some cases completely wipe out) many endangered and threatened plant species. They especially seem to crave orchids.

The following year, I went again to the spot Ron had described, but this time a little earlier in the season. I found four orchids in bud. Oh, yes—my first view of orchid success! Then in 1987, I found three in the same place, and then more at other North Branch sites where we'd scattered Rufino's seeds. A successful restoration experiment?

At that point, the Volunteer Stewardship Network was thriving, and I had more than a hundred projects to shepherd. This orchid was just one species in one project. I divided my time between bobolinks, Blanding's turtles, prairie lady-slippers, short-eared owls, regal fritillaries, and more. A lack of notes in my restoration journal suggests that I didn't pollinate or later check whether the white-fringed orchid successfully escaped the deer, attracted moths, or set seed. In 1988 I searched at the time when they bloom and found zero. Okay, nature is unpredictable. But in 1989 and 1990, also zero. In 1991, blessedly, four plants bloomed. Then in 1992—another zero.

Finally I woke up. The day-by-day notes in my journal for 1993 reveal not a word about orchids on any summer date. But in the back, in the special species counts, under its scientific name, *Platanthera leucophaea*, next to 1993 I find the number "3" with an asterisk. And at the bottom of the page by the asterisk are the words "put in chicken-wire cage for protection from deer." It had finally gotten through my thick (or over-busy) head that overpopulated deer were seriously massacring many of our rarest plants. When I found three orchids, I caged them.

Had it come to this—plants from seed that had been hand-pollinated and hand-seeded now isolated in little wire prisons? Weren't we trying to restore nature? Yes, but we were also becoming knowledgeable creatures in the ecosystem, competing and interacting with other creatures.

Those cages were the beginning of a new commitment. The few orchids we found each year would get three different assists from us. First, the cages. Second, hand-pollination. And the third was the hardest: with many other people, we successfully worked for public recognition of the deer overpopulation problem; both the Village of Northbrook and the Forest Preserve District began culling to bring deer numbers into balance with the rest of the ecosystem.

At farther-away Schiller Woods, no one was caging the orchids, and deer numbers were even higher than on the North Branch. After 1986, we found no more orchids where Rufino had first found them. The Montrose bus doesn't take a person to as magical a place as it once did, though few knew.

Then we got an unexpected vote of confidence. The U.S. Fish & Wildlife Service began a program to protect our frilly endangered species. Fish & Wildlife monitors both plants and animals, and they know that the rare ones often depend on each other. Blanding's turtles need prairie marshes. Hines emerald dragonflies like clean, limey seepage springs with thriving wetland vegetation.

Fish & Wildlife folks have to set conservation priorities. On a global basis, they found the white-fringed orchid, as at Schiller, declining or dropping out completely. The new little North Branch sites where we volunteers were restoring health and helping orchids turned out to be an unusual bright spot. Fish & Wildlife teamed up with the Nature Conservancy (where by then I worked) to replicate this success at many sites in northern Illinois, the heart of the plant's range. The initiative started by Rufino and me was adopted as a model by the federal government! But I also looked at our rather feeble success data and whispered to myself under my breath, "I hope this is actually working."

From 1986 through 1997, we found no orchids in six of those years. In the other six years we found a few, with a twelve-year average of 1.8 orchids per year. (This may seem a pathetically small population for all this storytelling, but just you wait.)

The key fact was that the orchid demonstrated that it could grow in this restored savanna ecosystem, and each plant was making 50,000 to 100,000 seeds per year (once we'd caged them so the deer weren't eating them). In other words, a million or more tiny endangered seeds were floating through the air and landing in all kinds of places, some of which just might be right for another orchid. Millions of seeds but just 1.8 flowering plants per year—doesn't that sound suspiciously like failure?

Orchids are almost designed to be rare. They taste good and have little protection. (Most wild plants are bitter or poisonous or difficult to digest, or resprout readily when nibbled, or have prickles or some other protection.) Deer eat big orchid stands to the ground as soon as they find them, and many of the eaten plants just die. But in nature, deer don't bother walking long distances to find just one or two tasty plants. So the orchid developed plentiful nectar and heavenly aroma to recruit specialized pollinators that would take the trouble to find plants well separated from each other.

That's where the hawk moths come in. They're strong fliers, heavy, and need a lot of energy, which they get from nectar. They have a keen sense of smell, so they can find isolated orchids. We began planting the ground cherries and wild bergamots that their caterpillars need to eat. The caterpillars are as specialized as the adults.

Why not go somewhere and find hawk moths and bring them to Somme, as some suggested? First, they could be miles away one day after they're released. Second, they fly in and out of Somme themselves and would stay and lay eggs if the place appealed to them. Our job was to make it more appealing, if we only knew how.

We'd done that with birds, although not in the way we first imagined. We got no prairie birds—no bobolinks or meadowlarks, much less prairie chickens. Instead the ecosystem coming back to health under our care gradually revealed

itself to be not a prairie, but a bur oak savanna. Gradually understanding this "grassland with trees" better, we found ourselves protecting and seeding shrubs and trees we once might have cut as "brush." An Illinois threatened species, the black-billed cuckoo, returned to breed in our diverse thickets of hazel, plum, and dogwood. (Cuckoos like to eat hairy caterpillars who like to eat shrub leaves.) Red-headed woodpeckers, said to be the fastest-declining bird in North America, like our scattered oaks and elms. (Well, really they relish the beetle larvae that they peck out of the dead trees.) They raised their first fat, healthy baby red-head at Somme in 2012.

Our job was to facilitate increasing ecosystem health, not try to command the details of it. To do this right, we needed more understanding than control. Consider how our orchid's seeds work. As in most of its relatives, the white-fringed has seeds so small that they're barely visible to the naked eye. There is no seed coat, no "germ," no structures of any kind—just a few undifferentiated cells. Tininess has the advantage that the plant can make huge numbers of seeds, and such seeds are so light they can float long distances on the wind. But when the wind drops one into the dirt, the inner resources to start a new plant are minimal. Thus, another drama unfolds. A specialized fungus must infect that seed particle, as if to devour a piece of soil detritus. The orchid seems not to resist the assault—but it uses judo. Soon the fungus finds that, instead of gaining nourishment, it is losing it. The orchid is eating the fungus.

No one understands quite how this works. Experts are studying it. We don't even know if the fungus gets some reciprocal benefit (a symbiotic relationship?) or if the orchid is a parasite of the fungus. In any case, each orchid initially lives for years entirely underground, only vaguely remembering its green parent plant soaking up the sun with photosynthesis. The orchid then consists of fungus and root only. But it's a root that grows bigger each summer. It builds up resources until, three or more summers later, it decides to come out of hiding and put up a green leaf to start competing with the regular plants.

Now that we were hand-pollinating and spreading seed throughout the preserve every year, we noticed results. During the ten years from 1998 through 2007, we found orchids every year, with an average of 8.2 per year. These included three new sub-populations in three open grassland parts of the preserve. Each year, ten or so plants broadcast about 1 million seeds. (To put our growing numbers in perspective, in 2006 the U.S. Fish & Wildlife Service found a total of only 109 plants spread over more than thirty sites in northern Illinois.)

Some orchids live a long time. Not this one. Most white-fringed orchids glory in two to four years of knockout flowers and then fade back into oblivion. It's those hundreds of thousands of seeds that may live on. Or not.

If you're a rare species or a rare ecosystem, there are advantages and disadvantages to being located near Chicago. Some negatives are obvious: sprawl, pollution, big trampling boots, et cetera. But much more wild land survives in the metro area than in Illinois farm counties. Moreover, the forest preserves are much more likely to be managed by stewards and ecologists and have the benefits of controlled burns. Great expertise is concentrated here in urban universities and not-for-profit agencies. Tens of thousands of volunteers are available

to help worthy causes. The chances of a Marlin Bowles dropping by to teach orchid pollination are a lot higher in the metropolis.

Or consider Lisa Culp, a tennis pro who has won tournaments, coached winning teams, and generally lived tennis for most of her life. A grateful student dragged her out to see a natural prairie, and soon Lisa was a passionate photographer of flowers, birds, and bugs. From photographer to steward is an easy step. For the last few years, every spring Lisa Culp and I have raced the deer to find orchids. We pop a cage over every one that we find before they do.

Sometimes the U.S. Fish & Wildlife Service takes a bit of "our" seed or pollen to reinvigorate an existing population or try to start a new one, or they give us seed from some other northeastern Illinois site to build up ours. (Important note: it's seriously illegal to take seeds or otherwise mess with these rare plants without written approval from the Forest Preserve District of Cook County and the U.S. Fish & Wildlife Service.)

We the people of Somme have been working to restore biodiversity here for more than three decades. As the graph below suggests (fig. 3), success doesn't always come at the beginning.

After twenty years of just barely holding on, this population came into its own. We stewards too have been finding our place in the ecosystem. Humans are not aliens here. Native Americans have been part of our prairies and savannas ever since the last glacier receded. Our species is and has always been a part of this nature, although we came close to destroying it. Now we're like parents watching children and grandchildren recover from serious sickness or injury. We rejoice as we see returning spirit and health.

Why do some of us devote ourselves to rare orchids, woodcocks, and mushrooms? I suspect it's the same reason we help a needy child or create art. Requited love and generosity make the best feelings on the planet.

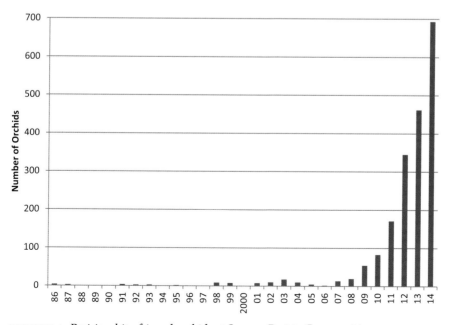

FIGURE 3. Prairie white-fringed orchids at Somme Prairie Grove, 1986–2013.

Our species can pillage and destroy, but we can also conserve and collaborate. The re-inhabitation of nature weaves human lives into the landscape. As we become intimate with our fellow species, we stewards are becoming natives of tallgrass Midwest nature. While selfishness pushes humans toward war and global climate change, generosity beckons us another way.

Acknowledgments

The Forest Preserve District of Cook County gets the fundamental credit: for buying the land, employing ecosystem managers, funding an intern program, and providing tools and guidance to the volunteers.

To check details and write this account, I tracked down Rufino Osorio in Florida, where he blogs at http://rufino-osorio.blogspot.com. Rufino wrote me that his "true love had always been, and still is to this day, the sun-loving wildflowers of prairies, dunes, savannas, and barrens."

Volunteers include Preston Spinks (carpenter), Jane Balaban (pharmacist), John McMartin (technical writer), Jeanne Dunning (university professor), Padmini Jyoti (computer professional), Jonathan Schlesinger (middle school teacher), Will Freyman (musician and computer consultant), but this list could go on forever. So could the list of sites and stewards who provide world leadership through what they do locally for ecosystems in the Chicago region. Deep thanks to all.

Special thanks to Lisa Culp for sharing her orchid photos. Lisa has also done or coordinated much of the orchid pollinating, caging, and monitoring since 2008.

Recommended Resources

Books

Packard, Stephen, and Cornelia F. Mutel, eds. *The Tallgrass Restoration Handbook: For Prairies, Savannas and Woodlands.* Washington, DC: Island Press, 1997.
Stevens, William K. *Miracle under the Oaks: The Revival of Nature in America.* New York: Pocket Books, 1995.

Websites

Friends of the Somme Preserves: www.sommepreserve.org
Illinois Natural History Survey: www.inhs.illinois.edu
Illinois Wildflowers (and the Insects that Visit Them): www.illinoiswildflowers.info
North Branch Restoration Project: www.northbranchrestoration.org
Steve Packard's Blogs (of Animal and Plant Stories and Ecological Restoration): http://vestalgrove.blogspot.com; http://woodsandprairie.blogspot.com
Volunteer Opportunities in the Chicago Wilderness: www.chicagowilderness.org /what-you-can-do/volunteer/

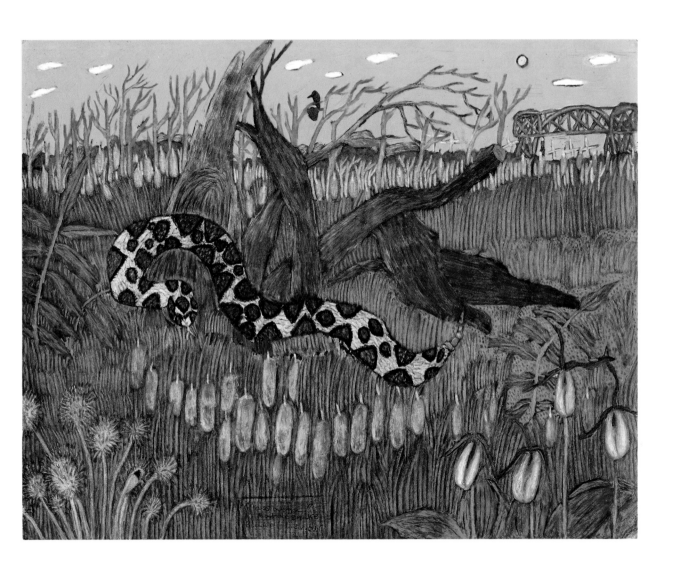

BLAKE LENOIR, *Massasauga Rattlesnake*

The Last Roundup

Observations on a Local Population of the Eastern Massasauga Rattlesnake

STEPHAN SWANSON

I kept a number of our prairie Massasaugas in a cage last summer. They were queer pets, but by no means uninteresting ones. Were it not for foolish prejudices, we might see much to admire in the rattlesnake. The Indian esteems and respects him.

Illinois naturalist ROBERT KENNICOTT,
letter to the Smithsonian Institution, 1854

The last known rattlesnakes still living in the Chicago area are being rounded up in an emergency species survival rescue effort.

Chicago Tribune, April 30, 2009

The year 2009 marked the end in the wild of a once-viable local population of massasauga rattlesnakes that existed in the northern part of Illinois since the glaciers retreated approximately 10,000 years ago. In this essay I will share my reflections from both a personal and historical perspective on the rapid decline and extirpation of this local population that once thrived along the Des Plaines River, from River Woods, Illinois, south to Glenview, Illinois.

What happened to the snakes? A diary excerpt penned by European-American settlers along the Des Plaines River in the 1830s provides a partial record of how the massasaugas have been lost: "From that time we waged war on snakes. It seems wonderful now that we could have killed them in the way we did, by putting a piece of timber, or even a foot upon their heads, and holding them down till someone could come and sever or bruise their bodies . . ." (Barker, 16).

For the next hundred years, the main challenges that massasaugas faced were habitat loss and individual snakes being killed by landowners, as well as predation by hawks, owls, raccoons, skunks, and foxes. But these pressures on the massasauga population paled in comparison to what was coming.

When I hike along the Des Plaines River corridor from Half Day Road south to Lake Avenue, a distance of nearly ten miles, I walk through prairie, oak savanna, floodplain forest, marshland, and old fields in the Forest Preserve. This is the only remaining habitat of our local population of the eastern massasauga. Forty years ago and during the snakes' active period from April to the end of September, I could have seen them in each and every one of these native com-

munities. As a boy, it was not uncommon for me to spot eight to ten snakes a day. Now almost two decades have passed since I have encountered more than two snakes in a whole season.

I have lived and worked along this same Des Plaines River corridor for more than fifty years, except when I attended Southern Illinois University. I chose this university and zoology as my major because of the abundance of snakes in the southern Illinois area, and, indeed, much of my life has been spent thinking and caring about snakes—and about one species of snake in particular, the eastern massasauga.

"Oh Such Snakes"

"Oh such Snakes," wrote Robert Kennicott in 1856 from the town of Anna in southern Illinois. My sentiments exactly!

I have had a fascination with snakes, and my mother a willing tolerance of them, ever since my parents moved to the Glenview area in 1958. When I was eight years old, I had the luck to turn over a wooden board in an adjacent prairie remnant. I can still see in my mind's eye those garter snakes racing out from under the board in every direction when I lifted it. Right then and there, I was hooked on snakes. I often returned to that prairie and lifted those boards, discarded smashed buckets, and pieces of sheet metal to discover a treasure trove of species after species of snakes, frogs and toads, mice and voles, worms and insects.

I frequently returned to that prairie remnant over the past thirty years until development overtook the native landscape. My friends and I searched for and moved as many as we could of the remaining garter snakes, brown snakes, and smooth green snakes to the adjacent forest preserve just before the bulldozers rolled in. Over these many years of visiting the prairie, I witnessed a decline in both the number of snakes and the kinds of snakes that could be found. Though I always held on to the hope that the populations of snakes could increase, the bulldozers did their work effectively. Apartments were built on the land, and the snakes lost their homes—permanently. I still pass the site daily and I never fail to recall what for me was a boyhood paradise, now lost to me as well as the snakes.

I first "discovered" the massasauga rattlesnake when I was nine years old riding my bike after school on the bridle path along the Des Plaines River. In this portion of the Cook County Forest Preserve, a trail junction was marked by a small sign with an arrow that read "Nature Center." I took that trail and discovered the River Trail Nature Center, located deep in a forest. The Nature Center displayed live snakes with a number of massasaugas in cages that were built into the walls. I was instantly in love with both the Nature Center and the massasauga. When I got back home, I excitedly described the massasauga to my parents. It was black and white, had rattles and a triangular head, and was poisonous. How cool was that!

I could not believe a magical place like this Nature Center existed. River Trail displayed both live and mounted specimens. There were rocks and fossils

to touch, and tanks held fish and turtles to watch. To enter the Nature Center, you passed through a one-room log cabin, where you were greeted by a naturalist. You then walked around a houseboat displaying native bluegill, largemouth bass, yellow and black bullhead, and many other fish from the area, and exited through a room that exhibited pioneer tools. On the outside of the building, large sections of the walls opened, exposing aquaria that held live turtles. I rode back the next day, the day after that, and each day throughout the following summer, fall, and winter. When I was in my teens, so strong was the allure of the place that I began volunteering there. I worked part-time while attending Glenbrook South High School, and then worked full-time when at Harper Junior College. Though I am now in my last years of working as director of the Grove National Historic Landmark, a facility of the Glenview Park District, I still harbor dreams of being the director of that magical center where I discovered nature and learned to be a naturalist.

Little did I know when I was a boy, however, the ways in which my life's journey would be shaped by and entwined with this local population of massasauga rattlesnakes.

Kennicott's Grove and the Massasauga

By virtue of my job and because of our mutual interests, I have come to know and appreciate the naturalist Robert Kennicott (1835–1866). Kennicott lived and studied at the Grove, the place I have worked for thirty-five years. More than 130 acres of Kennicott's ancestral homestead have been preserved at the Grove, including the Kennicott family home. The forest, prairie, and willow sloughs that served as early collection sites and places of childhood exploration for Robert can still be found on the site.

The Kennicott family arrived at the Grove on March 10, 1836, and settled in a cabin at the edge of forty acres of timber surrounded by sloughs and prairie. The forest was comprised of centuries-old oak, hickory, and walnut trees. Indian portage trails passed through the Grove, linking the Des Plaines River with the west fork of the North Branch of the Chicago River. The area teemed with wildlife. This was the country's western edge, an ideal place for a young explorer and collector like Robert.

Kennicott was a true field naturalist in the golden age of scientific discovery, collecting and classifying the flora and fauna of this region before the farmer and plow erased what was here. As a boy at the Grove, he discovered animals that were then completely unknown to science. His scientific observations were precise and many were also new to science. In front of the family house, Kennicott sometimes concealed himself under a bison skin to observe and describe the booming calls of prairie chickens, the mating dances of sandhill cranes, and garter snakes drinking water (herpetologists at that time thought they only absorbed water from the prey they ate). He collected copious amounts of natural history specimens, many of which were sent to the Chicago Academy of Sciences and the Smithsonian Institution, while also maintaining his own natural history museum inside the Kennicott House. As a young naturalist, he enlisted

friends, neighbors, and his brothers and sisters to collect the local insects, birds, frogs, turtles, and snakes.

But his lifelong passion was snakes. In his short life, Kennicott described and named thirty-seven new species of snakes, including four that inhabited Illinois and were previously unknown to scientists. He also named two new snake genera and one new variety. He knew snakes extremely well, and he made and recorded many important field observations. His notebooks, publications, and letters contain a treasure trove of natural history observations and personal opinions regarding the massasauga. For example:

Abundant. Is found throughout the state, except in heavily timbered districts of the south.
This species seems to belong to low marshy land on the prairie.
Rattlesnakes destroy immense numbers of mice. They are huge feeders and I never opened one that did not have the remains of mice in his stomach.
Why is it that no naturalist has ever defended the snakes? If I finally keep to my present opinion after more careful examination I shall try to write some articles on our snakes, taking up the cudgel in their defense to the best of my ability.

Kennicott described two separate species of massasauga occurring in this area, the prairie massasauga (*Crotalophorus tergeminus*) and the black massasauga (*Crotalophorus kirtlandii*). The black massasauga is a melanistic (dark-colored) version of the prairie massasauga. Eastern massasaugas were common in the Des Plaines River corridor when Kennicott made his observations and collected, and it is likely that the different species he described were simply color variations of the same species. In today's scientific nomenclature eastern massasaugas are *Sistrurus catenatus catenatus*. In the wild, massasauga coloration varies among different individuals, and an individual's color also varies as her or his skin ages prior to shedding.

Before the massasauga was scientifically described and classified by scientists, Native Americans knew it by various but similar names. The Chippewa called the massasauga "Great River Mouth," and the Mississauga Ojibwa referred to the massasauga as "It Has a Big Mouth." The local Potawatomi living at the south end of the Grove at the time the Kennicott family arrived in 1836 referred to the massasauga as *naatoweessiwak*, which means "little rattlesnakes."

The eastern massasauga is a shy and secretive snake. It is also so well camouflaged and can remain so motionless within its natural habitat that a person could be inches away and not see the snake. If someone does see the snake, he or she would observe classic Viperidae (viper family) features: a somewhat triangular head, elliptical eye pupils, infrared heat-detecting pits between the nostril and the eye, and, common to all rattlesnakes, the rattle. The massasauga's scientific name (*Sistrurus*) is derived from two Latin words: *sistrum*, meaning "a rattle," and *oura*, meaning "tail." This snake is so shy in the field that I have had difficulty getting it to rattle. It only does so when physically touched, and then it becomes highly agitated. The head of the massasauga has four distinct,

somewhat parallel black stripes. The body ranges from light brown to gray, while the snake's back has many light-edged blotches that are various shades of black and brown. Three rows of alternating dark blotches run along each of its sides. Yellow or white irregular markings on a black field mark the underside of the snake. Newborn massasaugas have a yellow band on the tip of the tail that darkens as the snake matures.

Due to his keen interest in snakes, Kennicott would likely have been familiar with all of these characteristics of the massasauga. Within twenty years of his family's arrival, however, Kennicott reported that most of the natural areas were gone and "replaced by well cultivated farms and fields." This heavy loss of habitat fragmented the massasauga population from a statewide species into smaller and smaller populations.

The First Rattlesnake Hunts

Shortly after the Cook County Forest Preserve was formed in 1914, Ransom Kennicott became its first chief forester. A nephew of Robert, his mission was to purchase large tracts of land along the Des Plaines River. This land included primary habitat for the massasauga and was home to thousands of snakes. Preserving their habitat should have been enough to sustain the species, but local commerce and prejudice continued the downward spiral of the massasauga population.

Even early conservation groups could not be counted on to come to the aid of snakes. The Izaak Walton League, for example, investigated the presence of massasauga rattlesnakes in the Wheeling, Illinois, area in the early 1930s. But they did so not to establish protections but because the snakes' presence was depressing berry picking and the home canning industry. Motivated by similar logic, an organized hunt to kill massasaugas was led by Cook County commissioners in 1933 in order to rid the forest preserves of snakes along the Des Plaines River. These annual hunts continued well into the late 1960s. They were advertised in the newspapers, and individuals and families could join the hunt.

My father's uncle, Edward Bellmore, a barber in Wheeling, Illinois, organized the most destructive yearly roundups of the localized population. I recall as a boy how fascinating it was to get a haircut at the barbershop. The shelves were lined with large glass jars filled with snakes preserved in alcohol, and the men often reminisced about the hunts. The provenance of those snakes lining the shelves is clear to me now: beginning in the 1950s and lasting almost twenty years, Ed organized hunts out of his barbershop, at times attracting more than seventy-five hunters to the cause. There were sixteen or seventeen yearly hunts, and the last one was held in 1968.

In 1965 there was a glimmer of hope for the snakes when the director at the River Trail Nature Center, Ray Schwarz, negotiated with my great-uncle to capture the snakes alive for "research at the Nature Center." I was a volunteer there when Schwarz struck this deal. I think enough time has passed that I can reveal a little secret about the "research at the Nature Center"—we released all the

captured massasaugas back into the areas where they were collected. Unfortunately this was too little, too late, to sustain the local population.

Even after all the hunts ended, the massasauga population continued to decline due to the combined impacts of habitat loss due to development, the killing of individual snakes by homeowners, road kills, collecting, and (in the absence of natural fire regimes or controlled burning) the encroachment of forests into prairie openings. It became clear to me in 2005, after twenty-six years of observations while working at the Grove, that the snake's numbers had dropped below those necessary to sustain a viable population along the Des Plaines corridor.

A New Kind of Rattlesnake Roundup

In 1856 Kennicott asked, "Why is it that no naturalist has ever defended the snakes?" I think he would be surprised to see the number of naturalists who today are defending the massasauga and other snakes.

Jointly conducted by the U.S. Fish & Wildlife Service, the Illinois Department of Natural Resources, and the Lincoln Park Zoo, a new roundup initiative is sending snakes to one of the zoo's captive breeding programs. Though it will likely take a decade or more to see substantial results, the idea is to breed the captive massasaugas back to a large and healthy-enough population so that they can be released back into their former habitat.

When John Rogner, then head of Fish & Wildlife's regional office, was asked, "How many rattlers would be a healthy population?" he responded, "You might want to shoot for several hundred." This prompted Mike Redmer, Habitat Restoration Coordinator with Fish & Wildlife, to add, "This is where you want to educate the public." Robert Kennicott may have been one of the first to advocate for an education process when he wrote to Spencer Baird at the Smithsonian in 1856, "I want if possible to write some articles on reptiles at our farmers! It is disgraceful that so much ignorance and prejudice exists on this subject among a community called intelligent!"—though his tone may not have won many followers to his cause.

It is now up to others. All of the naturalists and environmental educators I know want to see the massasauga recovery plan succeed and the massasauga reintroduced along the Des Plains River corridor. As of the 2011 collecting season, I believe all of the known snakes in the wild have been captured.

In my truly wonderful life and career spent along the Des Plaines River and its environs, River Trail Nature Center, and the Grove, the saddest event I have witnessed has been the loss of the massasauga in the wild. Many times over the years, after field excursions to look at the snakes, I thought about how nice it would be to retire before they were gone in the wild. The recovery plans give me long-term hope that I may still be able to fulfill that dream.

The Grove has been involved in environmental education for the last forty years in an effort to connect visitors with nature and to encourage them to think globally, particularly in understanding the importance of maintaining

biodiversity in our ecosystems. A concept that we emphasize at the Grove is that every animal and plant is connected to one another and to us. Extinction of even one species, locally or globally, should be viewed as tragic because it is not reversible and such a loss has profound effects on the ecosystems in which we live. When the world is diminished in this way, in my view, we as a species are also diminished.

I have read all of Kennicott's letters, publications, and journals, and when I reflect on his recorded observations, I am saddened by how much has been lost in this region … it is truly staggering. The vast flocks of passenger pigeons, cranes, prairie chickens, and wetlands teeming with snake, frog, and salamander populations that Kennicott frequently encountered and faithfully recorded are gone or reduced to next to nothing. A natural paradise lost. Yet the recovery plan for the massasauga reveals a shift in perspective, kindling a hope that my children's children (and me) will see massasaugas along the Des Plaines River once again. The new rattlesnake roundup and its goals represent how far we have come in caring for a species that was once so disdained.

Recommended Resources

Books

Barker, Frances Long. *From the Green Mountains to the Prairies.* Great Barrington, MA: Berkshire Courier Press, 1955.

Peattie, Donald Culross. *A Prairie Grove.* New York: Simon & Schuster, 1938.

Peattie, Louise Redfield. *American Acres.* New York: G. P. Putnam's Sons, 1936.

Phillips, Christopher A., Ronald A. Brandon, and Edward O. Moll. *Field Guide to Amphibians and Reptiles of Illinois.* Champaign: Illinois Natural History Survey, 1999.

Schlachtmeyer, Sandra Spatz. *A Death Decoded: Robert Kennicott and the Alaska Telegraph.* Alexandria, VA: Voyage Publishing, 2010.

Websites

The Grove: www.thegroveglenview.org

Massasauga Rattlesnake Stewardship Guide: http://www.torontozoo.com/adoptapond/snakeresources.asp

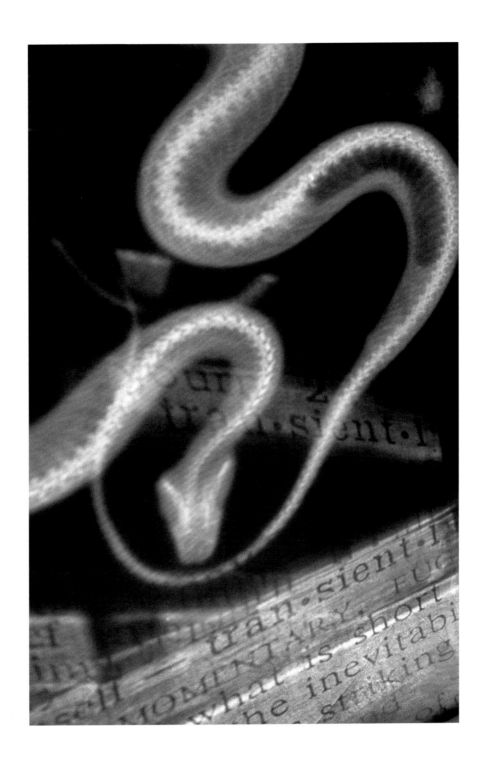

JULIE MERIDIAN, *Snake 2*

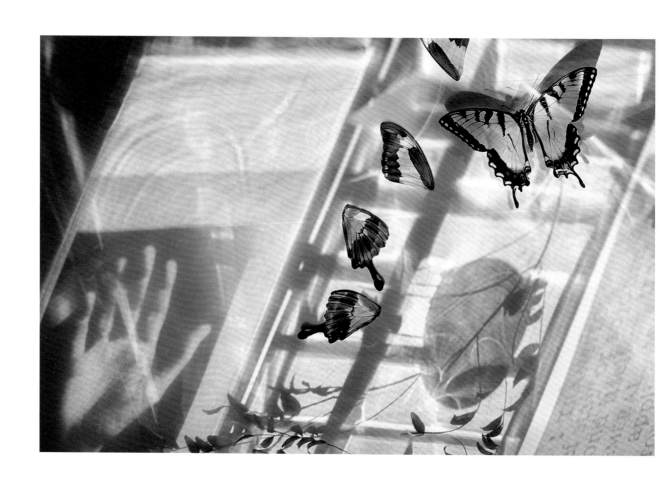

JULIE MERIDIAN, *Butterfly Collection*

Letting the City Bug You

The Artistic and Ecological Virtues
of Urban Insect Collecting

ANDREW S. YANG

It is an immense joy to set up house in the heart of the multitude, amid the ebb and flow of movement, in the midst of the fugitive and the infinite. To be away from home and yet to feel oneself everywhere at home; to see the world, to be at the center of the world, and yet to remain hidden from the world. . . . The spectator is a prince who everywhere rejoices in his incognito. The lover of life makes the whole world his family.

CHARLES BAUDELAIRE, *The Painter of Modern Life* (1863)

When the poet Baudelaire described this "lover of life" in the 1860s, he called him a *flâneur*, which can be translated as something like "stroller." This stroller embodied the ideal of a modern Parisian city dweller, someone who had a keen awareness of his or her surroundings, who could be in the middle of the mix without being completely mixed in. This is no small feat in the city. The urban experience invites, if not compels, us to lose ourselves in the endless variety of noises, voices, faces, goods, and places. The result? "The life of our city is rich in poetic and marvelous subjects," Baudelaire mused. "We are enveloped and steeped as though in an atmosphere of the marvelous, but we do not notice it" (119).

The strolling *flâneur* was also a modern model for artistic engagement. Rather than customary obedience to biblical narratives or Romantic pastoral scenes, the artist in the modern mode could draw upon the vital energy of daily urban life for themes. While urban life in an American metropolis today obviously differs from that of Paris in the 1800s, the idea of contemporary artists engaging the city with the sensibility of a *flâneur* (or the female *flâneuse*) remains a compelling one. It suggests a certain awareness in the way we observe the urban, and therefore presents novel possibilities for participating and intervening in its wider culture.

Today many artists are less interested in traditional notions of "beauty" regarding the work they make and more concerned with the possibility of creating situations that challenge typical expectations. The artistic opportunity is to orchestrate images, objects, and circumstances that can draw us into greater awareness of the ways we take our daily experiences for granted.

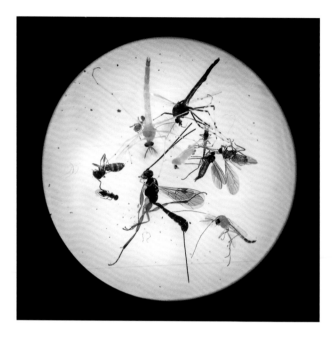

FIGURE 1. Insects caught in an overnight trap, Saugatuck, Michigan. Photograph by the author.

What might such art look like? In a city like Chicago, it might appear modestly, such as an anonymous bike rack that suddenly has a form-fitting, bright, woolen cozy knitted around it as an act of "yarn bombing" that various collectives have been weaving into the fabric of cities for the past few years. On the other hand, the art might be architectural in scale, such as Jessica Stockholder's *Color Jam*, the brightly colored makeover of the cityscape at the intersection at State and Adams. If a flash mob emerges from a crowd and performs a seemingly spontaneous musical dance piece, or the bronze statue of Columbus you usually walk by is now wearing a Hawaiian shirt or maybe is covered in fake blood, then you might have just witnessed some kind of contemporary art, vandalism, or both, depending on your point of view. Of course, given that spray paint is not even legal to sell in the city of Chicago, graffiti art can also run the fine line between public art and urban nuisance.

All these examples, however, involve artists riffing on what is human-made, and as such remain in the realm of the self-referential. If, as the artist and natural historian Mark Dion argues, "the job of the artist is to go against the grain of dominant culture, to challenge perception and convention," then it is worth asking what kind of artistic practice could help refocus our human-centered myopia. Usually we somehow manage to slip through the city without recognizing the nonhuman animal life that is around us. What opportunities to question the assumptions that we have about urban experience as an exclusively human domain are missing from the art, to say nothing of the everyday life, we practice?

The *flâneur* was just one among later Dadaist, Situationist, and other proposals for how the act of walking and looking in the city could be a form of artmaking. But the question still remains how an approach that prioritizes peripatetic experience over object-making might also confront the human-centered

way we view the city, as ecologically unrealistic as it is conventional. If we are to take seriously being present in "the heart of the multitude, amid the ebb and flow of movement," as Baudelaire put it, we need to update our notions of urban engagement, artistic or otherwise. To offer a more expansive view of urban diversity as well as challenge what it means to be a creature of the city, then, I would like to suggest we spend more time collecting insects.

A Philosophy of Looking with Bug Eyes

I used to be able to see flying insects in the air. I'd look ahead and see, not the row of hemlocks across the road, but the air in front of it. My eyes would focus along that column of air, picking out flying insects.

ANNIE DILLARD, *Pilgrim at Tinker Creek* (1974)

How might looking for insects be a portal to perceiving the city more vividly and in its fuller complexity? Insects are as ubiquitous as they are hard to discern. Their diminutive size strains our usual limits of attention despite their uncanny everywhereness—in the kitchen, on the windshield, or in our hair. We might notice the butterflies and dragonflies easily, or hear the pining choruses of cicadas in late summer along with the mosquito in our sleeping ear. More often, though, insects are the unacknowledged majority. While it is certain that the city-dweller Baudelaire had in mind was a human who could "see the world, to be at the center of the world, and yet to remain hidden from the world," he could just as well have been describing the insects who exist as proverbial and literal "flies on the wall" of the urban environment—seeing but rarely being seen.

By any empirical measure, insects are the center of the world. There are estimated to be about 8 million unique species, and anywhere from 200 million to 1 billion individual insects for every human on the planet. By weight, this is about 300 pounds of them for every pound of us. But just how many can there be in the city? No one knows for certain. With the millions of insects that researchers (thanks to radar) estimate must be flying and floating in the air above us on any given summer day, though, it is a guarantee that they have a sizable presence in most metropolises. For example, in 2002 a quick, daylong "bioblitz" of the Calumet area between Chicago and Gary uncovered 809 species of insects alone. These insects accounted for over a third of all the species found—plant, animal, or fungus—in an area known more for factories than forests.

Still, the proposition of collecting bugs in a city may sound silly and perhaps even childish to many people. An interest in insects seems like an odd mix of the quaint, the trivial, the gross, and certainly the uncultured. Much as young children might earnestly collect discarded bottle caps they find in the street, to pay attention to insects seems like the symptom of an unfettered curiosity that is acceptable in a kid but seems awkwardly deviant in an adult. But succumbing to such thinking is to lose sight of how collecting insects can be as pleasurable as it is difficult, as socially engaged as it is personally enlightening, and a form of tuning one's perception to the dynamic ecologies that we are enmeshed within.

FIGURE 2. Katydid collected (already dead) on a southbound Red Line "L" train. Photograph by the author.

Since a contemporary education in art and design explores the possibilities of reorienting both personal perception and cultural convention, it's perhaps no surprise that the entomology course I teach at the School of the Art Institute of Chicago tends to appeal to students. These art students are enthusiastic to peer into the face of the city's hidden diversity of butterflies, earwigs, and crickets. They look for what is not easy to see otherwise, navigating their daily lives and spaces in the city with new intention and attention to the ever present but unfamiliar: a sprawling field filled with praying mantises next to O'Hare Airport one day, a big shiny beetle crawling along the platform at the Damen "L" stop the next. Students come to recognize not only the lovely, but also the lowly—that bedbug hitchhiking on their winter coats or body louse discovered somewhere else (best not mentioned)—with a taxonomic eye as well as appropriate aversion.

In his seminal work *Art as Experience*, famed Chicago philosopher John Dewey observed that "the real work of art is the building up of an integral experience out of the interaction of organic and environmental conditions and energies" (67). This is an aesthetic dynamic of the living, the moving, the hiding, and the transient, and not simply of the pleasing. Walking through the tall grass along a park's edge and suddenly hearing the almost-inaudible keening of a tiny bug might evoke such an experience, but our urban interiors can also be a place of such encounters. Again, the engaged attention that the work of artist Mark Dion brings is relevant. In his project "Roundup: An Entomological Endeavor for the Smart Museum of Art" for their *Ecologies* exhibit in 2000, he and volunteers combed through the building to discover its resident insects. Dion set up a temporary lab space and display that documented the process, including the creatures that were found and the naturalist's accoutrements of nets, traps, and vials. The art museum with its "white cube" sensibility is often considered one of the quintessential human cultural domains, whereas "Roundup" pointed out the ecology that is uniquely present but often invisible to us in such spaces.

FIGURE 3. Shed exoskeleton of an emerging cicada, found clinging to a tree in Lincoln Park. Photograph by the author.

When I first moved to Chicago, I had a hard time connecting to a place that seemed defined by a landscape flatter than a perfect pancake. It was a giant city of buildings in every direction, seemingly so unnatural compared to my lifelong experience with rural edges. I began to look for urban insects not so much as a matter of personal refuge as an act of miniature rebellion. And yet as singular or even unsocial as seeking insects might seem at first, I have found that its public nature can lead to unexpected connection. Mobile and spontaneous, new social spaces have opened in surprising ways when our entomology class collects on early autumn days in Montrose or Humboldt Park, or as students prospect, nets in hand, along vacant lots. Passersby look twice, smile, squint, and just as often stop and ask what we are doing. They want to look at what we are looking at, and consequently they see something they wouldn't otherwise find.

Occasionally people have even spontaneously joined us to collect, borrowing nets or helping us bust open a log to see what is lurking inside. In the process I've come to see how the category of "stranger" in the city lies on just as fluid a continuum as the notions of "urban" and "natural." This kind of strolling for insects is therefore a fundamentally different and far more socially engaged experience than it would be for Baudelaire's incognito and detached *flâneur*. Searching for the diminutive majority in the city means making oneself uniquely visible within it. In this ecology of urban activity, our usual anonymity turns into the possibility for a collective sense of mystery, recognition, and curiosity. The nature of acquaintance and its possibilities open up.

If attuning oneself to insects lends some new dimensionality and immediacy to daily experience, then I suspect Rainer Maria Rilke would have made as good an urban entomologist as he was a poet:

If you will cling to Nature, to the simple in Nature, to the little things that hardly anyone sees, and that can so unexpectedly become big and beyond measuring; if you have this love of inconsiderable things and seek quite

FIGURE 4. Camel cricket collected in New Buffalo, Michigan. Photograph by the author.

simply, as one who serves, to win the confidence of what seems poor: then everything will become easier, more coherent and somehow more conciliatory for you, not in your intellect, perhaps, which lags marveling behind, but in your inmost consciousness, waking and cognizance. (33)

Insects are as considerable as they are inconsiderable, which makes them the perfect kind of paradox to bother to pay attention to. They are true wildlife in urban environments, places that many people believe are or should be committed to the domestication of all life. With their aesthetic of authenticity over artifice, insects are exactly who they are.

"The lover of life makes the whole world his family." If you find an insect in the city, try to say hello. You've stumbled into an intimacy with an Other that is all around you. Their six legs and faceted faces are inviting you to wrap your metropolitan mind around something else besides yourself, if only just for one moment.

Recommended Resources

Books

Berenbaum, May R. *Bugs in the System: Insects and Their Impact on Human Affairs*. New York: Basic Books, 1996.

Dewey, John. *Art as Experience*. 1934. Reprint, New York: Perigee Books, 1980.

Hoyt, Erich, and Ted Schultz, eds. *Insect Lives: Stories of Mystery and Romance from a Hidden World*. Cambridge, MA: Harvard University Press, 2002.

Macnamara, Peggy. *Illinois Insects and Spiders*. Chicago: University of Chicago Press, 2005.

Marshall, Stephen. *Insects: Their Natural History and Diversity: With a Photographic Guide to Insects of Eastern North America*. Cheektowaga, NY: Firefly Books, 2006.

Raffles, Hugh. *Insectopedia*. New York: Vintage, 2011.

Rilke, Rainer Maria. Translated with a foreword by Stephen Mitchell. *Letters to a Young Poet*. New York: Vintage, 1986.

Stewart, Amy. *Wicked Bugs: The Louse that Conquered Napoleon's Army and Other Diabolical Insects*. Chapel Hill, NC: Algonquin Press, 2011.

Websites

Art 21, "Mark Dion: Science & Aesthetics": www.art21.org/texts/mark-dion/interview-mark-dion-science-and-aesthetics

BugGuide.Net: www.bugguide.net

Calumet BioBlitz: http://fm2.fieldmuseum.org/scienceinaction/bioblitz/

Insectindentification.org, "Illinois Bugs and Insects": http://www.insectidentification.org/insects-by-state.asp?thisState=Illinois

Myrmecos (insect photography): http://myrmecos.net

The Smaller Majority (photo blog): http://thesmallermajority.com

University of Illinois Extension, "Let's Talk about Insects": http://urbanext.illinois.edu/insects/01.html

What's That Bug?: www.whatsthatbug.com

ARTHUR MELVILLE PEARSON, *Untitled*

Being Unseen

The Gift of Oppiella nova

LIAM HENEGHAN

I once received a Christmas present of a tin of baked beans. Perhaps I had specifically requested this humble gift, because I received them during my Thoreauvian years, when as a teenager under that great writer's spell, I felt compelled, as sometimes I still do, to attend only to pure necessities. A more unusual gift still was one I received many years later and that I also have come to think of in terms of necessity. This was the gift of mites.

When I first came to Chicago, the late Dr. John Lussenhop, an eminent soil ecologist working at the University of Illinois in Chicago, gave me, a soil ecologist of the generation behind him, a small population of *Oppiella nova. O. nova* is a free-living soil mite in the suborder Oribatida, a relative of ticks in evolutionary terms—though not sharing in the latter's unwholesome feeding habits—and more distantly related to spiders. *O. nova* may be one of the commonest animals in terrestrial environments and yet it is often overlooked, since it is both tiny (less than half a millimeter) and lives in the opaque medium of the soil. John presented me with a population of ten individuals or so in a small chamber not much larger than a pill box and also gave me a small quantity of brewer's yeast upon which these tiny animals could subsist. This urban colony grew over the years, and for that burgeoning population I constructed a set of small plastic chambers, each with a charcoaled plaster-of-paris floor and vented by small punctures in their ceilings. An entire condominium building of these homes fit prettily on a small shelf in my laboratory. Over the years with these mites as both companions and, indirectly, as subjects of that extended meditation that some of us call our research careers, I expanded my understanding of Thoreauvian necessity.

O. nova has been rather neglected by zoologists since it was named at the turn of the twentieth century by the Dutch systematist Anthonie Cornelis Oudemans. When I received John Lussenhop's gift of *Oppiella*, I became aware of the creature in a positive way for the first time. I had lingering misgivings about the species, having misspelled its name consistently throughout my dissertation and

consequently spending one of my last nights as a graduate student ferreting out each occurrence in the 300-page manuscript—not an easy task a couple of decades ago when my limited knowledge of computers meant simple search-and-replace functions were beyond me.

My first encounter with *O. nova* occurred two decades before receiving the gift, during a research project that involved examining the effects of acid rain on soil arthropods in a Sitka spruce forest in Kilkenny in southeast Ireland. Acid rain, a prevalent environmental problem; Sitka spruce, an ecologically unremarkable plantation tree; soil microarthropods, omnipresent litter-dwelling creatures. I studied the commonplace, though I did not see it that way at the time. The commonplace but, nevertheless, the vastly under-inspected. This work was based upon the insight that acid rain is accompanied by nutrient additions in the form of sulfur or nitrogen, chemicals that can modify the diverse communities of soil organisms in divergent ways, and that this, in turn, can modify crucial soil processes, such as nutrient cycling. *O. nova* was the dominant animal in the spruce litter in all our plots and was found in 98 percent of all my samples taken over a two-year period. It was so common, in fact, that paradoxically I virtually ignored it, as have many researchers before and after me. This was because *O. nova* was not especially troubled by the mild acid treatments we sprayed on the forest floor, and it simply was not rare enough to figure prominently in our analysis. My reevaluation of *O. nova*'s importance would have to wait until I was more intimate with both mites and Thoreau.

From Thoreau, environmentalists have inherited an inclination to inspect matters from the periphery—the perspective of cordial criticism—as Thoreau did from the vantage of Walden Pond on the outskirts of Concord. The environmental tradition has also inherited a regard for inquiring into necessities (an inquiry that has now arguably developed into the field of sustainability studies), a disposition toward minute inspections of the workings of nature, and an amplified sense of the affiliation between people and the wild, even if Thoreau had, at times, a tendency to view his neighbors with a jaundiced eye.

In other ways, though, the environmental tradition has veered from Thoreau's path of examining what is closest at hand. The pond beside which Thoreau would lay the foundations of his cabin was merely a walk away from home, from town, and from the neighbors. Greater attention to the ecology of the urban environment—that is, that which is most proximate to where most ecologists live—had to wait for well over a century to emerge, even though in some respects Thoreau's *Walden* is the first volume of suburban ecology. He provided, for example, detailed notes on a domestic cat who appeared quite at home in the woods. So though it is true that Thoreau famously walked out of town, finding, he declared, little of interest in an urban direction; nevertheless, Walden Pond was no glacial wilderness, though it is to wilderness that most environmental thought has subsequently been drawn.

Perhaps the most significant departure from Thoreau's legacy in modern

times, however, is our bewitchment with the ecologically exotic, the cultivation of uncommon experience, and the infatuation with the rare. Rarity, of course, is the appropriate focus for conservation biology, since rarity is an excellent predictor of vulnerability to extinction. That being said, Thoreau's genius for the ordinary may be worth emulating. In the "Brute Neighbors" chapter of *Walden,* he described a relentless battle between two species of ants, the sort of violent encounter that is infrequently observed and almost never recorded, though, presumably, such events occur all the time. What Thoreau's account suggests is that if we look closely enough, we will find that the rich dramas of nature are right at our feet, even if this place is not very ecologically distinguished. One does not need to peregrinate in remote parts to give witness to the marvelous.

I am not especially concerned with reinvigorating a Thoreauvian approach to ecology, though that, of course, would not be a bad thing. I simply want to suggest that right here, under our noses in the towns and cities where most of us live these days, there exist ordinary marvels, if we only know where and how to look for them. There is, let me suggest, another form of rarity that is not based on numbers alone—this could be called the rarity of experience, predicated on a poverty in our attention that may not be fatal but that is unfortunate and consequential. *O. nova* can serve as an emblem for this different form of rarity: it is common but unfamiliar. That most people have not seen it is by virtue of its cryptic nature forgivable; but that most people, I suspect, know little about this species, despite its ubiquity, needs to be rectified.

Mites are classified into three orders of Acari, a subclass of the Arachnida that also includes spiders, scorpions, harvestmen, and other eight-legged arthropods. The order to which *O. nova* belongs is Sarcoptiformes. Like other sarcoptiform mites, *O. nova,* for the most part, ingests solid food, though it may be a liquid feeder in its youth. The oribatid mites, the group to which this species belongs, contains over 10,000 species.

Structurally, all mites have essentially two major body compartments: a diminutive head-like region that contains complex mouthparts for feeding, and a usually rotund body in which the ambulatory, digestive, reproductive, and excretory functions are concentrated (see fig. 1 below). The body of oribatid mites tends to be heavily armored. Though this may confer a measure of protection against predators, there are some kinds of beetles who specialize in overcoming such natural fortifications to consume them. In one of the less charming ways known of dispatching a prey item, one specialist group of beetles flips mites over and, using their mandibles like a can opener, puncture the mites' anal valves and rip open their ventral shields.

Beetles are not, however, the mites' only foes. An ant specialist once boasted about his group eating my group, as if the latter were popcorn. Mites, on the other hand, have never been reported to be slave-makers, as many ants have been known to be (about 200 species of ants coerce the labor of other species).

Oribatid mites are part of a soil-dwelling animal community that is astonishingly species diverse on small spatial scales. Their diversity is so great that the soil zoologist Michael Usher has described these communities as being the "poor man's tropical rain forest." To give a sense of the diversity of soil critters in the U.S. Midwest, I offer the following calculation: in a typical walk along a woodland path, your feet tread upon the bodies of 270,000 protozoa, 135 mites, 3 springtails, and 1 or more large earthworms with each footfall. These are representative of 30 distinct soil species of which up to half may have not yet been described by taxonomists! Scaled up, there can be as many as 200 species of soil insects and 1,000 species of soil animals in every square meter of soil. Yet next to nothing is known about their habits.

Mites tend to be fairly generalist in their feeding: as long as the menu is fungus or bacteria, most will take whatever they are offered. Because of this similarity in their diets, the enormous diversity of mites has been described as enigmatic. How can they all coexist if they potentially compete over the same food sources? However, the soil environment is extremely complex—fractally complex, as some researchers have emphasized, meaning that the patterns reiterate on multiple spatial scales—and because of this the diversity of mites may be easier to understand than it might appear at first. Because the very structure of the soil is complex, there are plenty of places for a mite to go about its business unmolested by its competitors. A mite ensconced in a small soil pore munching on a fungal strand is functionally invisible to creatures operating at larger scales.

It is primarily through their feeding that soil animals influence ecological processes. Specifically, the processes they influence include the decomposition of dead organic matter and nutrient cycling. These processes are fueled by supplements from the living, but the living in their turn depend on them. Although in the kingdom of decay fungi and bacteria are royalty, directly breaking down the sloughed-off organics of plants and the carcasses of animals, soil fauna contribute by feeding upon the fungal and bacterial decomposers. Too much consumption by mites and decay decelerates for want of microbes; too little consumption and decay decelerates as microbial physiological processes slow down. *O. nova* and related species live largely in the ingestive sweet spot, where by their self-sustaining microbial consumption, they inadvertently turn the world.

O. nova is just one of legion—one mite among the dizzying array of species in any given area. While the more charismatic species such as lions, tigers, elephants, long-whiskered owlets, and so on that are often the object of conservation concern may be rare, we still know a fair deal about them. *O. nova*, in contrast, is common, though we know next to nothing about it. So common, and yet it does not even have a "common name." What little we do know I describe here.

The genus to which *O. nova* belongs contains nine species and several named subspecies. All members of the genus can be recognized by a particular form

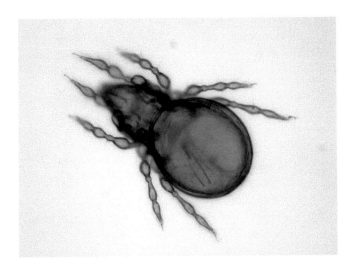

FIGURE 1. Photomicrograph of *Oppiella nova* showing its distinguishing traits. Photograph by the author and Claire Gilmore.

of ornamentation on their armored abdominal region (see fig. 1). The animal has, to be technical about it, S-shaped cristae on the notogaster—these appear as ridges on the exoskeleton when viewed through the microscope. In addition, rising up like little arches on the shoulders of *Oppiella*, there are distinct projections, the so-called humeral processes. The sensillus, a receptive organ, is distinctively fusiform or spindle-like shaped. If one were inclined to inspect the animal closely, one would observe that mites in the genus *Oppiella* have five pairs of genital setae. Though scrutinizing all such details is helpful when, as a youthful taxonomist, one is struggling to learn to identify these creatures, practically speaking, most soil ecologists just know one when they see it.

O. nova is reported in countless scientific papers because it is among the most common animals in samples of the upper layers of temperate soils. It comprises over 10 percent of the microarthropods collected at many sites. I will summarize a few of the ecological studies on soil animals to illustrate where *O. nova* has been found, under what circumstances, and how it responds to environmental perturbations to which it has been subjected.

Where Has *O. nova* Been Found?

O. nova has been reported from all continents. Some specific and delightful spots where it has shown up include the Galápagos; the Azores; Latvia; the Scots pine forests of the Bory Tucholskie National Park in Poland; in suspended arboreal soils of a coastal temperate rain forest in Vancouver Island, Canada; on downed logs in the Babia Góra National Park in the Western Carpathians; in a spruce plantation in Kilkenny, Ireland; and also at eighty temples of the Eighty-Eight Holy Places of Shikoku, Japan.

O. nova has also been found in inhospitable environments. For example, *O. nova* was one of ninety species of free-living mites found in a study of the tundra of northern Chukotka, in the former USSR. Another example of less-charming dwelling places for *O. nova* is the post-mining reclamation soils in Lancashire, where the mite was one of the two most prevalent species. At that reclamation

site, it comprised close to 90 percent of all mites. *O. nova* found limed soil at this site particularly congenial, where it maintained populations of over 2,700 individuals per square meter.

Under What Circumstances Has *O. nova* Been Found?

Typically when it is found, *O. nova* dominates the oribatid community. For example, in her large-scale study of litter-dwelling arthropods in an oak-dominated woodland in the Southern Appalachians, Randi Hansen extracted and counted almost 54,000 individual mites in the order Oribatida from a total of 151 species. Nearly a third of those individuals were *O. nova*.

Generally, *O. nova* has been found to favor humus—highly decomposed plant material—though on occasion it is found in slightly deeper layers of the soil ("deep," in this case, meaning below three centimeters). It has also shown up alive in a Russian study of birds' feathers, hinting at one of the ways in which it gets transported.

O. nova is only female, which one might think would be problematic. However, the animal is parthenogenic, a form of reproduction in which new individuals can develop from an unfertilized egg. In the temperate zone, eggs are developed during the spring and deposited during the summer. In the wild, *O. nova* has one generation a year, though in the warm, moist comforts of the laboratory, there can be as many as seven generations per year. Its populations aggregate—you rarely encounter a solitary mite.

How Does *O. nova* Respond to Human Perturbations?

Though most of the studies of oribatid mites generally, and our mites in particular, have been in areas remote from human activity, mites have long been cryptic companions of people. The long history of human-mite cohabitation can be picked up in the archaeological record. Since mites have hard exoskeletons, they can potentially fossilize. Fossilized mite communities can actually tell us where people were living in the past, because distinctive communities of mites are associated with the environmental conditions created by people. Indeed, mites have even been found in or on naturally desiccated mummies and associated with debris found in tombs.

Precisely because of the great adaptability of *O. nova*, as shown by the array of geographical locations in which it has been found, it might be expected to have survived the relatively recent (measured in evolutionary terms) and widespread human conversion of natural habitat to more urban conditions. There have been no comprehensive studies of urban *Oppiella*, however. One intriguing study was conducted by L. E. Ehler and Gordon W. Frankie in the 1970s that examined mites associated with the leaf litter of live oak along a fairly simple rural-to-urban gradient. They found that such communities are structurally similar, regardless of whether they are found in a natural stand of trees, in plantings at a suburban shopping plaza, or on the manicured campus of the

University of Texas at Austin. *O. nova* preferred stands of trees, but a single individual also showed up at the mall.

Because no such study exists, DePaul University undergraduate Amanda Henderson and I have initiated a census of *O. nova* across the city of Chicago. We are still in an early phase of this project, but initial samples from a small plot (five centimeters in diameter by five centimeters deep) near our laboratory in the Lincoln Park neighborhood of Chicago revealed *O. nova* individuals in all samples taken. In one sample, we found nine *O. nova* individuals. If this is representative, it gives a projected total of 46 million *O. nova* individuals per hectare. If Chicago's lakeside Lincoln Park supported a similar density, its total *O. nova* population would be 22 billion animals!

Although we expected *O. nova* to be present in the city, we also hypothesize that the populations of mites will be smaller in urban locations. One of the reasons why this might be the case is that there is less leaf litter in cities. Not only does the decomposition of dead organic matter occur faster in the city due to higher temperatures and elevated nitrogen inputs, but urbanites' fastidious gardening practices also rake and blow this habitat away, dispatching it to the landfill. Cities therefore represent a large zone that is relatively denuded of detritus but abundant with unintended consequences. In short, we are consigning one of the richest habitats to the garbage heap.

O. nova may be one of the most common animals in urban environments, even though the management of urban soils may have significant detrimental impacts on their populations. Is this necessarily a bad thing?

These days I understand "necessity" in a number of ways. Certainly I now have a broadened sense of what is essential. This is one of Thoreau's lessons for us. The vital ingredients that make up a life include our physical building blocks—what we eat, what shelters us—but not these only. In his journals Thoreau wrote, for instance, of the necessity, for him, of "deepening the stream" of his life, and in order to do so he needed to "cultivate privacy." Elsewhere Thoreau wrote of necessity in other ways. In one remarkable passage, he contemplated a snapping turtle that he hatched from an egg, writing: "When I behold this monster thus steadily advancing towards maturity. . . . I am convinced that there must be an irresistible necessity for mud turtles." Necessity means the needful, but it does not mean that only. The necessity of mud turtles is sensed but, in all his hundreds of thousands of words, even Thoreau cannot articulate precisely what this sort of necessity is. Perhaps he did not care to.

The etymology of "necessary" (from Latin *necessārius*) indicates that which is unavoidable, inevitable, indispensable, and requisite. It also points to intimate connection; in post-classical Latin, it denotes the rendering of services. When Thoreau went to Walden Pond to live at the edge of town for two years and two months, the exercise was not (just) to show that a man can live in solitude—perhaps he can, for a time at least—but more to show what this

isolation means in relation to the necessity of society. How does being part of a society serve us as individuals, and how do we, in turn, serve the social order? Thoreau, the author of "Civil Disobedience"—the essay that so influenced Mahatma Gandhi—knew well what these social obligations entailed: performing ethical duties is arduous. Thoreau's philosophy, ultimately, can be considered a sustained meditation on what is very broadly necessary in the life of a person; environmental thought, founded in part on Thoreau's approach, identifies the necessary links between us and the natural world, our ethical obligations to that world, and the services it, in turn, renders in order for creatures to be sustained at all.

O. nova is necessary in the sense that, like many other species, it provides a vital ecological service. However, if *O. nova* were to disappear or even diminish in urban environments, it is possible that humans might not notice the loss, since soil communities are both inconspicuous and tend to have high redundancy, with lots of different creatures attending to overlapping functions. However, the necessary is not always the useful; it can also be the beautiful, the fascinating, or even the troubling. That which is necessary is often ordinary but not noticed. We need a broad and generous, a Thoreauvian, concept of the necessary, one that demands of us a greater knowledge of our intimate connections—both those that provide service, and those whose presence enchants, delights, and mystifies. We can start this contemplation of necessity with that most common, most under-inspected of beings: let us start with the gift of *O. nova*.

Recommended Resources

Books

Coleman, David C., D. A. Crossley Jr., and Paul F. Hendrix. *Fundamentals of Soil Ecology*. 2nd ed. Burlington, MA: Elsevier Academic Press, 2004.

Nardi, James B. *Life in the Soil: A Guide for Naturalists and Gardeners*. Chicago: University of Chicago Press, 2007.

Thoreau, Henry D. *Walden, Civil Disobedience, and Other Writings*. Norton Critical Edition, 3rd ed. Edited by William Rossi. New York: Norton, 2008.

Websites

The Mites: Tree of Life Project: http://tolweb.org/Acari

Soil Mite Web Page from Dr. Maria Minor, Ecology Group, Massey University, New Zealand: http://www.massey.ac.nz/~maminor/mites.html

SHARON BLADHOLM, single bronze medallion from *Soil: Alive with Life* (2011); photograph by Gregg Woodward

SHARON BLADHOLM, *Soil: Alive with Life*, bronze-filled resin cast (2011);
photographs by Scott Becker and Gregg Woodward

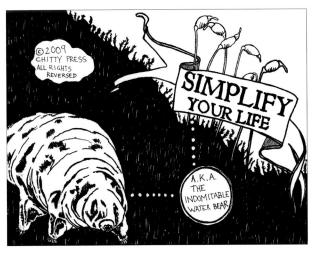

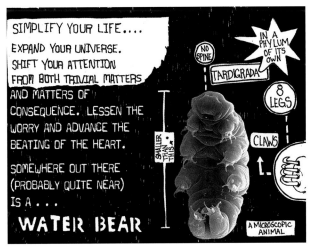

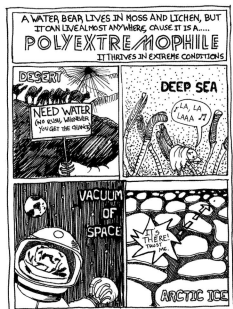

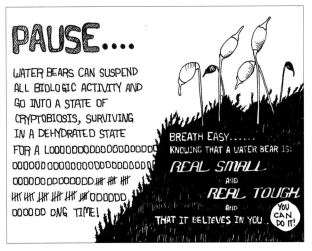

ALEX CHITTY, *The Indomitable Water Bear*

Burnham Centennial Prairie, Lake Shore Drive

MARTHA MODENA VERTREACE-DOODY

> *Physicists and mathematicians continued to debate*
> *whether it is better to walk or run in the rain.*
>
> (*Harper's*)

The cop's boots mud-caked from last night's rain;
twisted wheels like a dinosaur unearthed.
A dazed guy sways under a stack of clouds
while headlights crawl along the Drive.
A deer, you point, an antlered buck
as still as August trapped by two full moons.

No dented car. No blue moons
with prairie names. A rain-soaked
road is only part of it, the buck
as cold as whatever else Earth
leaves: raccoons, opossums, coyotes driven
from "amber waves" to bleak cloud

cover. "A full moon eats clouds,"
your almanac says for today, the galaxy moonlit.
You slow down, driving
through Hyde Park's rainstorm
to breakfast, "Earth
Angel" in radio static.
Behind the buck,

a stand of lindens, junk trees, the buck
indifferent to leaves, sweet twigs, clouds.
In the café, the waitress bussing earthenware
speaks of morning's moonlight,
of the coyote in front of her house as rain
ebbs when she drives

past him, driving
faster seeing the hare in his teeth. Two bucks
slide off her tray when she nods at the rain-smeared
window, her eyes cloudy
with tears. Someone whispers, "moonstruck,
trapped in a dream earthbound."

"Like the beasts that are destroyed," her dearth
of songs at each table, high minor tones driving
the psalm through the moonstruck
heartland as she pours coffee. Had the buck
lived, she sighs, he could have scattered clouds
with hoofprints, rain-streaked,

snorting at fast cars spinning under Earth's moon,
driving as if clouds drive. At the counter we tip
a few bucks, run through hard rain.

Visitations

ELISE PASCHEN

At the North Park Village Nature Preserve

I

DISAPPEARANCE

They're caught off-guard
as if once shot

in black and white
blindsided by

a flash. Mad dash
through goldenrod.

Antlers raised high
above tallgrass,

bone torches lit
to cut the path.

Could they predict
a dark outcome?

Still on the ground
two bucks, four does.

Bright intervals:
the interruption

of deer.

FLIGHT PATH

Butter-like bib
 headdress of wing

a common yellowthroat
 chattering rattle

skims across sedge
 flicks tail to shrub,

splashes and daubs
 while high above

planes scratch straight lines
 across slate.

DISPENSARY

Our family of four
drives past red brick buildings, one named
Dispensary, where patients,
at this once sanitarium,
were treated for TB. The strip
of park: a wall to stop disease.
Our kids, thirsty, demand Starbucks.
We do not stop. At night the gates
lock deer outside, and in, swing shut
their starving. Petitions to cull
circulate. Like patients, deer wait.
Sun-up. Cattails flat against dirt:
an impression of deer.

JIHA PARK, *Extinct Animal Series:*
Schomburgk's Deer, Golden Toad, and Pink-Headed Duck

✴ 5 ✴

WATER WORLDS

RYAN HODGSON-RIGSBEE, *Stroll*

Washed Up on the Shores of Lake Michigan

CURT MEINE

Lake Michigan is our *not-Chicago*. At its edge, our seemingly solid lives turn liquid, our streets must bend and end, and our busyness is watered down. For Chicago, the lake is the source of the rising sun. Then it is daytime's spread-out sheen of blue or slate or green. And finally it is nighttime's void, *just out there*, beyond the reach of city lights. It is dark matter, off the grid, the great pool of mystery amid our familiar.

Lake Michigan is the *not-city* that is the city's alternate being, its reason for being, and its reason for being *here*. It is the city's counterpart and counterpoint.

Lake Michigan is where the city repairs. It has that effect.

Lake Michigan is where we leave our conversations behind, our presence recedes, and we stop.

Lake Michigan is where we go to look back at ourselves. It is where we reflect, and are reflected.

I first saw Lake Michigan from the Indiana Toll Road and the Chicago Skyway, through the industrial vapors of the Indiana shore, early one evening in the summer of 1967. I was eight years old and our family was on the move. My father had taken a new job in Chicago. My mother, father, three older brothers, and I packed ourselves into the family car and left Maryland behind. After two long days of driving, we arrived at the nation's crossroads. I, at least, was utterly disoriented, unsure what to expect in terms of either our new geography or our future.

The scene was suffused in orange: the wide smear of sunset in the west, the flare stacks of the steel mills to the east. We craned our necks to see what we could of the big lake through the ruddy haze. We were a fishing and camping family. My brothers and I had vague notions of fantastic fishing opportunities; I'd learned about the Great Lakes, and the Midwest's freshwater oceans loomed large in my imagination. And I'd heard of Chicago; I'd begun (alas!)

to follow the Chicago Cubs the year before. But nothing prepared me for the dizzying entry into the city. It was all a blur of light, motion, traffic, smog, and skyscrapers.

For the first two weeks in our new environs, we camped out north of the city at Illinois Beach State Park. I'm not sure how that came about. Something about plans changing . . . a rental falling through . . . trouble finding another place. But we were veteran inhabitants of our big canvas tent and sidekick pup tent. We'd done this in the Pennsylvania forests, in the Appalachians, along the Carolina coast, in Florida scrublands. And so our family came to wash up on the shores of Lake Michigan.

We tried our hand at fishing there, but this was big water, and the gear and methods that worked on reservoirs and small streams back east were not very transferable. Besides, the beach was a rancid mess. There were dead fish everywhere, long drifted piles of them, stretching on and on and on along the shoreline.

Our campout ended and we moved temporarily into an apartment suite at the Evanston Inn, a dowdy old place, long since demolished, on Main Street in Evanston, a few blocks in from the lake. On slow afternoons that summer, we would wander over to one of the nearby lakeshore parks. Sometimes, though, the reek of rotting fish was so strong that we had to turn around. *What is wrong with this lake? Why are there so many dead fish everywhere?* Even on days with a strong west wind, the aroma wafted inland.

The rest of the summer was devoted to finding more stable housing, while orienting ourselves to the sights and sounds and (other) smells of Chicago. We attended the unveiling downtown of "the Picasso"—watched Mayor Daley pull the ripcord, dropping the draped pale blue veils and revealing . . . a monster baboon? A skulking Afghan hound? In various family combinations, we made the grand tour of the city's cultural stations: the Field Museum, the Museum of Science and Industry, the zoos and conservatories, the Adler Planetarium and the Art Institute. We visited the Shedd Aquarium, but I did not make any connection between the tanks inside and the lake outside, between the displays of exotic live fish and the myriad small dead ones afloat just outside in Monroe Harbor. In fact, I can hardly remember any of the fish I saw inside the aquarium. But I would never forget the opaque eyes of the fish, floating belly-sideways, outside.

After visiting all the major museums, we began to explore the less conspicuous ones. Toward the end of my mother's list that summer was the old building of the Chicago Academy of Sciences. After the commotion of the Lincoln Park Zoo's Farm-in-the-Zoo next door, it seemed a rather dusty and old-fashioned space. No live animals. No loud sounds. No knobs to turn or buttons to push. But the scale and all the *stuff* inside was just right, for me anyway. Immediately inside the entrance, straight ahead, was a small cave-like exhibit portraying the 300-some-million-year-old Carboniferous Period, with its tree ferns and giant horsetails and magnificent humongous dragonflies (that I'm sure a brother informed me could *eat your head!*).

On either side of the Carboniferous cave, two staircases led up to the natural history exhibits on the second floor. I loved the cave and reveled in the intricate exhibits upstairs, but two displays in the stairwells—part of a rather busy "Exhibit of the Great Lakes"—made an even more lasting impression. On the left: the historic fish community ("Original Lake Ecology") of an unsullied Lake Michigan. On the right: the contemporary fish community ("Disturbed Lake Ecology") of an altered Lake Michigan.

FIGURE 1. Overview of the Great Lakes exhibit in the stairwell of the Matthew Laflin Memorial Building, Chicago Academy of Sciences. From the collection of the Chicago Academy of Sciences and its Peggy Notebaert Nature Museum.

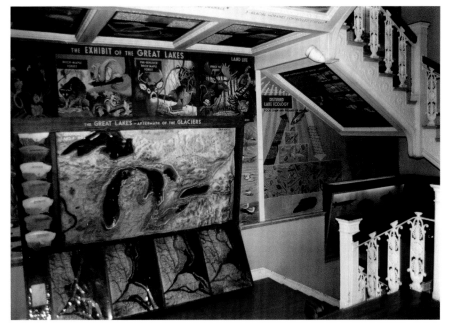

FIGURE 2. The Great Lakes exhibit, looking to right with panel on "Disturbed Lake Ecology," in the stairwell of the Matthew Laflin Memorial Building, Chicago Academy of Sciences. From the collection of the Chicago Academy of Sciences and its Peggy Notebaert Nature Museum.

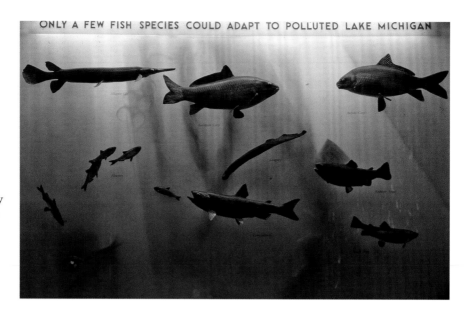

ONLY A FEW FISH SPECIES COULD ADAPT TO POLLUTED LAKE MICHIGAN

FIGURE 3. Display case of fish species that adapted to polluted waters of Lake Michigan as part of the Great Lakes exhibit in the stairwell of the Matthew Laflin Memorial Building, Chicago Academy of Sciences. From the collection of the Chicago Academy of Sciences and its Peggy Notebaert Nature Museum.

Walk back and forth between them, and compare. See the different food chains. See which fish we've lost, which remain, and which are newly arrived. See the lake sturgeon and cisco gone. See the sea lamprey and smelt come on the scene. Wonder who figured that out, and how many fish they had to catch to do so!

Have your eight-year-old mind blown, in a way that you did not understand at all. Look at that great big lake out there, and somehow see beneath its placid surface for the first time. Think about all the churning life below. Imagine yourself a fish. Come to know that the world is very old, and very new … that things change … that life changes … that nature has a history … that people came … and that people made a difference. The Carboniferous was too long ago, too weird, the horsetails and dragonflies too enormous, the people absent. The fish and the lake were here and now. I'd run along the shore of that lake, and I'd just seen and smelled the fish myself.

I would pass those two cramped displays many more times over the years, while hurrying up to the second floor. They always stopped me.

I learned the word "alewife" that first summer in Chicago. But I had only the vaguest sense of what it might mean.

My family's arrival in Chicago coincided with the high peak of the great alewife die-off of the mid-1960s. No one knows how many fish perished that spring and summer of 1967. Estimates ran into the hundreds of millions. On June 15 a federal official, conducting an aerial survey of sources of pollution in the lake, noticed incredible swaths of dead alewives on the water. One "great shimmering band," as the U.S. Federal Water Pollution Control Administration described it, ran fifty feet wide and forty miles long, from Muskegon to South Haven, Michigan. By June 19, a silver ribbon of expired alewives stretched out

along thirty miles of Chicago and suburban shoreline. Two days later a *Chicago Daily News* article pegged the total fish kill at 20 *billion*.

The July 7, 1967, edition of *Time* magazine told the tale to a national audience: "From the Chicago waterfront to the Mackinaw Bridge, the shores of Lake Michigan were taken over last month by dead alewives. The fish … washed ashore on every incoming wave, piling up on the beaches faster than bulldozers and tractors could clear them away. They filled the air with the odor of decay and drew swarms of mosquitoes and flies" (66). *Time*'s cover story that week was "The Hippies: Philosophy of a Subculture." The Summer of Love had commenced in San Francisco. A summer of blight had come to Chicago and its lake.

Death followed the fine line where the communities of the land and the lake met. It came as a consequence of dramatic changes in both that were a century and a half in the making. The astonishing transformation of Chicago and the Midwest as a human community happened for all the world to see and to marvel at. The revolution in the lake's biotic community happened mostly out of sight, beneath the waves—until it washed ashore in the form of putrid piles of dead alewives.

The alewife (as it exists in Lake Michigan) is six to seven inches long, with a brownish-bluish-green back, flashing silver sides and belly, a single dark spot behind its gills, and googly black eyes. It closely resembles its relative, the blueback herring of the Atlantic seaboard—hence its scientific name, *Alosa pseudoharengus* (a shad-like "false herring"). Its deep abdomen and large head are thought to account for its unbecoming common name, bestowed in tribute to plump female tavern keepers of Olde England.

Until the 1930s alewives occurred mainly along the Atlantic coast, from Newfoundland to South Carolina, coming inland to spawn in the freshwater streams. Their ability to survive in freshwater—to skip their time at sea if the opportunity arose—was the key to their destiny. The species may have been native as well to Lake Ontario, where it was first recorded in 1873. If the alewives did not exist there naturally, they were either intentionally introduced or followed their upstream yearnings through the Erie Canal and into the Great Lakes system. They made it above Niagara Falls to Lake Erie by 1931. Their great escape into the upper Great Lakes, though, came via the Welland Canal around the Falls between Lakes Ontario and Erie. The opening of the modern canal in 1932 hastened the alewife's spread into Lake Erie, to Lake Huron by 1933, to Lake Michigan by 1949, and finally to Lake Superior by 1954. As the little silvery fish worked its way upstream and inland, it bore global forces of environmental, cultural, and economic change into the Great Lakes basin, jolting and reconfiguring the food webs of the most extensive freshwater system on the face of the Earth.

It did not do so alone. Among the alewife's fellow travelers was the sea lamprey, scourge of the larger native fish of the Great Lakes (and of the fishers who pursue them). The lamprey took the same water trail into the Great Lakes as the alewife—but it did so, significantly, slightly beforehand. By the 1930s sea lampreys were common in Lakes Huron and Michigan, and by the 1940s in eastern Lake Superior. Aggressive parasites and predators, they quickly devastated

native fish populations in the lakes, including those of the large apex predators (especially lake trout and burbot), other key commercial and sport fish species (including lake whitefish, northern pike, and walleye), and smaller forage fish (such as the chub and lake herring).

Continuous overfishing of many species and unchecked industrial and agricultural pollution also contributed to the disruption of the native fish communities of the Great Lakes. The most profound ecological ripple effects were all but invisible. Three closely related endemic species of the lake's cold-water depths—the longjaw cisco, the blackfin cisco, and the deepwater cisco—swam straight into the vortex of extinction; they would vanish by the early 1960s. More conspicuous was the collapse of the lake trout population. The commercial catch of lake trout in Lake Michigan fell from 5.5 million pounds in 1946 to just 402 pounds seven years later.

Into the complex eddies of environmental change in Lake Michigan came the alewives. With the relentless advance of the lamprey, the wiping out of the lake's most important native large predator (the lake trout), and the suppression of populations of other predators and competitors, they entered an open ecological field. Although sensitive to colder water (which slowed its spread into Lake Superior), the alewife thrived prodigiously in its new landlocked environment.

Until it didn't. The alewife population burgeoned—and then it crashed. In a 1968 technical report, fisheries biologist Edward Brown described more formally what my family and I had seen and smelled upon our arrival in Chicago: "The classic population explosion, which crested in the southern and central basins of the lake in 1966, was accompanied by progressively heavier spring and summer die-offs and was climaxed by a massive mortality in June and early July 1967" (Becker, 268). In Lake Michigan, the alewife's arc from arrival to abundance to mass mortality took just seventeen years.

Several factors contributed to the 1960s die-offs (and to those that have occurred periodically since). Although able to survive in the lake, the alewife is physiologically stressed by life in fresh water. A shortage of food in the winter can weaken them. When moving to nearshore waters to spawn, they can experience rapid temperature change—a phenomenon they are not subject to in their home waters in the Atlantic—adding to the normal strain of reproduction. The alewife proved to be a phenomenally successful aquatic invader, but still a limited one.

The alewife's effect on life in the lake was and remains profound. Writing in 1983, Wisconsin biologist George Becker described the continuing consequences: "In Lake Michigan [the alewife] constitutes 70–90% of the fish weight. . . . [A]ll zones of the lake are dominated by vast swarms of alewives competing with and often eliminating the stocks of native fish" (265, 268). The alewife contributed to the loss of the native ciscoes, preying upon their eggs and larvae and outcompeting them as consumers of the lake's plankton reserves. It had similar, if less final, effects on the lake herring, yellow perch, and chubs. Stanford Smith, a fisheries biologist from Michigan, wrote in the aftermath of the big die-off that the alewife had "reduced or replaced all of the previously

very abundant species of the lake, and upset completely a very productive and stable multi-species balance that had existed since the glaciers retreated from the Great Lakes thousands of years ago" (12).

In 1966 the state of Michigan began to stock the lake with coho and chinook salmon imported from the Pacific in an effort to control the alewife hordes, creating in the process what has become a popular (if expensive and artificial) sport fishery. Wisconsin soon followed suit. Fisheries managers also stocked the lake with non-native steelhead, Atlantic salmon, and brown trout. But the sea lamprey preys upon these species as well, and so investments in lamprey control ratcheted up. Meanwhile, the beleaguered native lake trout struggled to regain its place in the food web.

That memorable summer of 1967, vacationers, resort operators, and land-owners inundated the Chicago office of the Federal Water Pollution Control Administration (the EPA would not exist for another two and a half years) with letters and phone calls. U.S. senators and representatives toured the sour beaches and drafted bills. Around the lake, people demanded that their local governments clean up the beaches. The fire department in Beverly Shores sprayed deodorant on the piles of dead alewives in an effort to squelch the stench.

Only slowly would the public and the policy makers come to see that they are part of a longer and larger and deeper story, one that has fish in it. It began 10,000 years ago, with a deluge: as the continent's ramparts of ice melted, the land lifted, the waters pooled, and fish swam in the great basin of cold-water lakes. Soon people came into the story from the north and west, living in ever-changing communities through the millennia. Then a different wave of people came from the east. They carved out a passage around Niagara Falls in the 1800s. Among the cascading consequences of that act: an invasive species (the lamprey) came into the waters and overwhelmed a native fish (the lake trout); another invasive species (the alewife) arrived and filled the ecological void; another suite of exotic species (the Pacific salmonids) were brought in to control the invasive alewife. Now we humans are moving mountains—or at least securing the Mississippi River/Lake Michigan watershed divide—to prevent other invasive species (Asian carp) from entering the lake and potentially harming the fish now in the lake (including especially the introduced salmon).

And so it goes—out there, under the waves, all the time.

"The Exhibit of the Great Lakes" at the Chicago Academy of Sciences is long gone. The quirky displays of the changing fish fauna are now themselves extinct. All that remains are a few faded fiberglass models, in storage and out of sight, of a lake trout and lake herring, red-horse and flat-headed catfish, paddlefish and gar. I see the displays vividly, though, in my own memory. And their fundamental message—that ecosystems are always changing, and that we humans are powerful agents of that change—is now widely appreciated among ecologists and conservationists, and increasingly in the popular imagination.

A lake, like any community of life, is a dynamic reality. The 150 or so fish species native to the Great Lakes have not existed as specimens in a fish tank, nor as mounted facsimiles in natural history museums. They have evolved together since the retreat of the ice. And people have been members of that community for a good part of that time. The "very productive and stable multi-species balance that had existed since the glaciers" will not return. Moreover, it is hard to gauge just how stable and balanced the Great Lakes community (or any other ecosystem on Earth) has ever been. In what ways? For how long? At what scale? The story is always more complicated than it seems on the surface.

A year before the big die-off, Stanford Smith had a remarkably clear view into the alewife moment in time and space. At a 1966 symposium on the over-exploited fisheries of the Great Lakes, he stated: "[A] succession of fish species would be expected during the natural aging process of the Great Lakes, but recent progressive changes in species composition have been rapid and obviously accelerated by influences of man, both from enrichment of the environment with wastes, and despoilment of the most abundant or preferred species of fish ... leading to the state of biological instability in the mid-1960s that is almost unparalleled in fishery science" (quoted in U.S. FWPCA 1967, 17).

The Great Lakes now host some 180 invasive algae, plants, invertebrates, and fish. In recent years, another species has arrived about once every eight months. Some, like the zebra and quagga mussels, we know mainly because they cause noticeable economic damage. (Recent estimates of the annual economic impact of invasive species in the Great Lakes run into the hundreds of millions of dollars.) Most, like the European frog-bit and Oriental mystery snail, we rarely hear or think about.

We are all part of a kaleidoscopic ecology—an ever-shifting pattern of pieces and processes, its parts constantly coming into the field of view, rearranging themselves, fading and falling, reappearing and recirculating anew. But now we are turning the kaleidoscope around ever more quickly. The rate, scope, and types of changes we have known in the last two centuries are unprecedented—at least at any meaningful human time scale. The causes of change are now predominantly human. Moreover, the arrival of new and potentially disruptive species is only one of many stressors coming to the Great Lakes. Pollution, sedimentation, dams, coastal development, and other factors—including the Big One: climate change—ensure that the story will grow only more complex, and the mingling of human and natural realities more conspicuous.

In that way, the lake continues to reflect our lives on the land. We have arrived at a new place, and a new time, in our relations with one another and with the place we live. How do we respond? Do we accept, combat, or accommodate the invasive species that come to our waters? Do we continue to see only the surface of Lake Michigan and to regard that water *out there* as something inert and apart? Do we persist in seeing the lake as only a commodity, lacking a relevant history, ours to reconstruct according to political and economic demands? Or do we care for the lake as a living community to which we belong?

We don't usually see it that way. In a city of neighborhoods, the neighborhood of the fish remains largely invisible. Would we regard the city or the lake

differently if we could see them through the living eyes of the lake sturgeon and burbot, or the lamprey and goby? Through the absent eyes of the coaster brook trout and lake trout and deepwater cisco? Through the fading eyes of a stressed alewife, nearing death, floating flat on its side, one eye gazing down into Lake Michigan's water, the other lifted toward the gleaming skyline of Chicago?

When I first saw alewives along the beaches of Lake Michigan, they were gross—and engrossing. They were not furry. They were furtive in life, obvious in death. They were mute animals, their species' experience and wisdom voiced not through howls or snarls or chirps, but through their mere being, surfacing, and expiring.

Now I see the alewife, for better or worse, as a companion animal, stranded in its multitudes on the shores of Lake Michigan, at the raw borders of past and future, light and dark, sound and silence, life and death, natural and human, land and water, city and lake. Now I see that, as I held my young nose against their stink, the alewives and I had come to the same place, the same fluid edge of our existence.

Acknowledgments

Thank you to Brian Ickes of the U.S. Geological Survey for inspiring, informing, and reviewing this essay, and to Paul Heltne and Amber King for guiding me into the historic exhibits of the Chicago Academy of Sciences.

Recommended Resources

Books and Articles

Becker, George C. *Fishes of Wisconsin*. Madison: University of Wisconsin Press, 1983.

Bogue, Margaret B. *Fishing the Great Lakes: An Environmental History, 1783–1933*. Madison: University of Wisconsin Press, 2000.

Brown, Edward H., Jr. "Population Biology of Alewives, *Alosa pseudoharengus*, in Lake Michigan, 1949–70." *Journal of the Fisheries Research Board of Canada* 29, no. 5 (1972): 477–500.

Eck, Gary W., and Larue Wells. "Recent Changes in Lake Michigan's Fish Community and Their Probable Causes, with Emphasis on the Role of the Alewife (*Alosa pseudoharengus*)." *Canadian Journal of Fisheries and Aquatic Sciences* 44, no. S2 (1987): s53–s60.

"Ecology: Alewife Explosion." *Time* 90, no. 1 (July 7, 1967): 66.

Greenberg, Joel. *A Natural History of the Chicago Region*. Chicago: University of Chicago Press, 2004.

Koonce, Joseph K. "Aquatic Community Health of the Great Lakes." EPA 905-R-95-012. Chicago, Illinois: Environment Canada and U.S. Environmental Protection Agency, 1995. Available at http://www.epa.gov/solec/archive/1994/1994_Aquatic _Community_Health_of_the_Great_Lakes.pdf.

Rothlisberger, John D., David C. Finnoff, Roger M. Cooke, and David M. Lodge. "Ship-borne Nonindigenous Species Diminish Great Lakes Ecosystem Services." *Ecosystems* 15, no. 3 (2012): 1–15.

Smith, Stanford H. "The Alewife." *Limnos* 1, no. 2 (1968): 12–20.

U.S. Federal Water Pollution Control Administration (FWPCA), Great Lakes Region. "The Alewife Explosion: The 1967 Die-Off in Lake Michigan." July 25, 1967. Available at http://nepis.epa.gov/Exe/ZyPURL.cgi?Dockey=2000UXW0.txt.

Woods, Loren P. "The Ale Wife." *Chicago Natural History Museum Bulletin* 31, no. 11 (1960): 5–8.

Websites

"Alewife" (species profile). United States National Agricultural Library, National Invasive Species Information Center (NISIC): www.invasivespeciesinfo.gov /aquatics/alewife.shtml

"*Alosa pseudoharengus*." United States Geological Survey, Nonindigenous Aquatic Species (NAS) website: http://nas.er.usgs.gov/queries/factsheet.aspx ?SpeciesID=490

Great Lakes Environmental Assessment and Mapping (GLEAM) Project: http://greatlakesmapping.org/

Great Lakes Fishery Commission: http://www.glfc.org/

"Invasive Species in the Great Lakes Region." Great Lakes Information Network: http://www.great-lakes.net/envt/flora-fauna/invasive/invasive.html

The Alewives

TODD DAVIS

die by the thousands, pitching themselves
onto the shore, now warmth has come back

into the water. Against the sand their sides
no longer glisten. Their bodies rot in the sun.

This great lake shaped like water pouring
from a pitcher scatters them where park-service

employees haul them away with front-end loaders.
How the world has opened to these fish

who long ago swam from the Atlantic
to this inland sea. How quickly they perish

far from home.

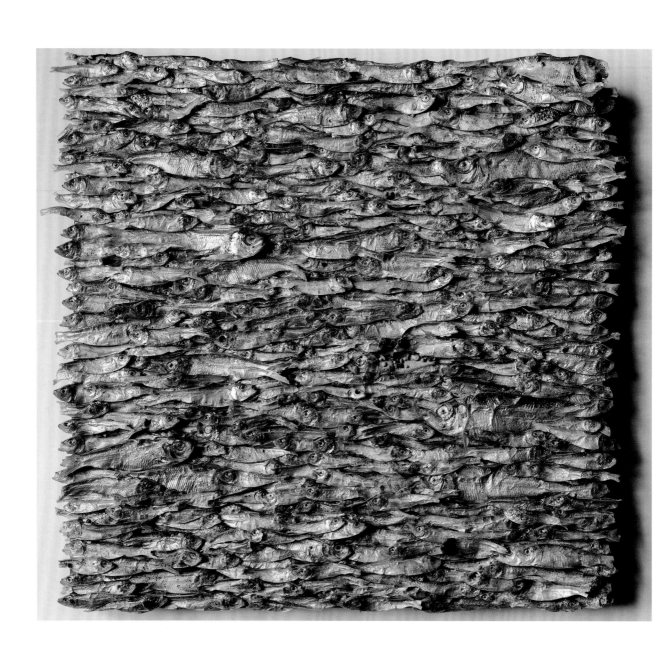

COLLEEN PLUMB, *Alewives*

The Fanciful Fairy Tale of Freezing Frogs

JILL RIDDELL

November. A cold air mass is rolling toward Chicago from the north, and local weather reporters chatter about possible ice storms. The mass churned over Ontario yesterday and gathered momentum this morning as it swept through Minnesota and Wisconsin, downing power lines and stripping the last leaves from deciduous trees.

By the time the front reaches Chicago, the afternoon rush hour sets in and temperatures drop thirty degrees. Those who wore light jackets to work stand at bus stops, hands folded in the pits of their arms, wishing for parkas.

When a freeze like this one sweeps in, humans are not alone in feeling its effects. Weeks ago, anticipating the freeze, adult insects laid the eggs that will succeed them. Birds migrated, or at least some did; so did the monarch butterflies and green darner dragonflies. Squirrels and raccoons had the good sense to fatten up and secure a hiding place for this very moment. For them, all will be well.

Tonight, as I head home to the South Side of Chicago to hot chocolate and chicken stir-fry, I wonder how frogs will confront the freeze. I wonder, with that thin, permeable skin of theirs, a skimpy organ that must offer about as much protection as a cheap paper towel, how can they make it? How on earth do they stay alive?

For the record, I'm not a fanatic. I possess no frogs as pets, own no frog T-shirts, collect no frog figurines. It's not as though in times of stress my thoughts continually turn to the question "What would amphibians do?"

But I think a lot about animals in general. When I consider the fate of frogs tonight, I imagine hundreds of thousands of them facing the freeze from the discomfort of dark, damp swales. It's fantastically bizarre to me that other living things are carrying out parallel lives, sometimes inches away from us, with concerns and strategies for survival completely alien to ours, braving habitats most of us drive by fast on highways or only read about.

I keep a number of wildlife books on the shelf, so once I made it home, I

pulled out Bernd Heinrich's *Winter World*. In the matter-of-fact prose of a biology professor, Heinrich spells out precisely what two of our local frog species—spring peepers and chorus frogs—are enduring on a night like tonight.

These frogs' method of protecting themselves from the freeze can't really be described as a survival "strategy," because unlike other animals, they do absolutely nothing to prepare for it. Their success or failure depends not on how well they perform at fattening themselves up or laying in provisions. Spring peepers and chorus frogs don't even bother to dig themselves down into the soil for protection, the way other amphibians might.

Basically, as the big freeze descends, our local frogs just lie there and take it. At some point today, the peepers and chorus frogs stopped moving. They hopped into wet leaves and clumps of sedges, or they stayed wherever they happened to be, and at some point, they just, well, hunkered down.

Maybe at some level, they knew their finely tuned chemistry would keep them alive. As soon as ice crystals start to form on a frog's skin, a message circulates through the frog's tiny nervous system that it should release adrenaline. This activates an enzyme that changes stores of glycogen into glucose. In frogs, glucose helps moderate the effects of freezing.

The antifreeze attributes of glucose, though, can't completely counteract the impact of tonight's freeze. Frogs are made mostly of water. If I went out looking for frogs tomorrow and picked one up, it would neither blink its eyes nor pee on my hand. Ice would have filled up its insides. It would be hard as a stone. It wouldn't be breathing, and its heart would no longer beat.

And here's the most amazing part: that unmoving frog in my hand would still be alive. The frog would be frozen, but it wouldn't be frozen to death. It marched down the hallway that leads to life's end, but the glucose managed to stop it just a hair's breadth short of death's final door.

Bear in mind, the individual frog did nothing to prepare for its stasis. In a period of mere hours, it went from actively hopping about and eating prey and avoiding predators to a state so resembling death that it's impossible for an observer to believe it isn't the real thing. In the spring, the frogs thaw out of this miraculous frozen condition prepared to eat and to mate. No harm has been done—they do it this way every single year.

The following March, I decide I don't want to miss the period when frogs return from the brink of death. After some phone calls, I hook up with three very cool individuals who monitor frog populations. Evalyn Campbell, Marlene Rosecrans, and Bob Mathieu work under the auspices of three different organizations: the DuPage County Forest Preserve District's amphibian monitoring program, Chicago Wilderness's Habitat Project, and Fermilab (the home of what was once the world's largest particle accelerator). Their job as volunteers is to go to marshes, listen for frog songs, and report what they're hearing. Marlene tells me that if I meet her and her associates in a parking lot at the Danada Forest Preserve, they'll let me tag along to listen to frogs sing.

Before arriving, I picture a pleasant hike to some beautiful place; probably we'll spread waterproof blankets over dried marsh grasses and sit for an hour listening to frogs. I imagine that in reverent whispers, the volunteers will share with me their love of frogs—a love so ferocious that it compels them to make this commitment to come to the wetland once every other week all through the spring, every spring. The data they collect helps the sponsoring agencies know more than just about the state of frog populations; they provide one important piece of the holistic view of how our ecosystems are faring.

I show up one evening in late March. As I climb out of my Toyota, I regretfully pull on my knit hat and a pair of gloves I keep in the trunk. It's chilly tonight. I wonder if the frogs will mind—from where I stand now, I can't hear them at all. Perhaps they're not fully defrosted.

I greet the volunteers and ask about their other lives—professions, hometowns, and so on. Evalyn Campbell and Marlene Rosecrans are both from Glen Ellyn and are retired schoolteachers. Bob, on the other hand, announces, "I'm a bricklayer. Retired eight years ago, live in Warrenville. Recently released from prison."

Evalyn's roll of the eyes and Marlene's laugh indicate Bob's account of himself may not be entirely factual, though neither he nor they bother to correct the record. They're busy putting the "Authorized Vehicle: Frog Monitor" sign inside the windshield and gathering up the tools they'll need tonight: hats, knee-high rubber boots, a clipboard, insect repellent, and, in honor of tonight's chill, down vests and gloves.

To my surprise, it turns out we aren't hiking anywhere. The team covers several different locations scattered throughout an 800-acre complex of interconnected prairies, savannas, and wetlands. They come here every other week to do this during the four months when the frogs are vocalizing. The only way to reach all the monitoring locations on a single night is to drive there on roads reserved for service vehicles. I climb into the backseat of Marlene's car and sit down next to Bob, the ex-offender.

Danada is just one forest preserve in the greenway that includes Herrick Lake, Blackwell Forest Preserve, the Morton Arboretum, and Fermilab National Laboratory. Immediately after leaving the parking lot, we're swallowed up in a grand landscape. Since the forest preserve is closed to the public at sundown, we're the only ones out here to watch the sun sink and night begin.

When we get out of the car five minutes later, we're surrounded by pure grassland, some lower and wetter, some higher and dryer. Tips of emerging grasses are blackened from a recent prairie fire, and the ground feels soggy from spring rain. Along a ridgeline far to the west, trees are darkly silhouetted against a pink sky.

The volunteers call this first wet spot "Location 1." Marlene briefs me on the monitoring protocol. First, Bob or Evalyn—this time it's Bob—drops a thermometer attached to a string into the pond to check the water temperature, and then he takes a reading of the air temperature. Tonight's water is thirteen degrees Celsius, and the air we're breathing is eight. (In Fahrenheit, that's fifty-five and forty-six degrees, respectively.) Marlene jots this down on her clipboard.

She's in charge of the team's record-keeping, reporting, and documentation. She also notes and records wind speed, cloud cover, precipitation, and whether there's any evidence of eggs having been laid yet. "We use paper in the field because we may get caught in the rain," Marlene explains. "Once I'm back home, I enter it into an online database with the Habitat Project and fill out a spreadsheet record for the DuPage Forest Preserve."

Each pond is divided into imaginary fourths, and each quadrant of the pond is assigned a number by the Forest Preserve District. The volunteers' job is to listen for frog calls and record the species of frogs and the approximate number of individuals heard in each quarter.

Frogs sing for sex, but I'm sure if they had another, quieter way to locate mates, they'd use it. Loud male voices may win over the ladies, but they also attract predators who skulk around ponds in search of a meal. Since frogs tend to shut up when they hear mammals like us tromping around, if we want to hear anything, we need to be quiet as we walk in. This is hard, since the trio jokes around a lot. Plus, now Marlene is passing around a plastic tub full of raspberry M&M's. (Surprisingly delicious, we all agree.)

The protocol requires volunteers to wait at each location for at least one full minute in absolute quiet before concluding that there's nothing there. Once we finally manage silence, we wait far longer than that. Mallard ducks fly overhead, quacking as they fly. In the distance I hear Canada geese and wind rustling the branches of trees—but no frogs.

"Actually, the rules for monitoring say that we shouldn't even bother doing the monitoring on a night when there's a strong enough wind to sway tree branches," Marlene says as we walk back toward the car. "Frogs don't like strong wind or cold temperatures. That's why we're not hearing any."

"I think they smell your breath," Bob suggests to Marlene.

"What, they don't like garlic?" she asks.

Their camaraderie and the casual way they share their M&M's—indeed, the very fact that they tote M&M's into the field with them—attest to the fact they have been working together for several years. They have the easy confidence of being old hands at this. As we drive to the next location, I learn that Bob is the eldest of the three, having just turned eighty. In the time he has been living in Warrenville—about fifty years—he has raised two crows, two red-tailed hawks, one opossum, one blue jay, and one red squirrel. Evalyn, it turns out, has explored Antarctica and skied to the North Pole. These days she's been trying to find hills to climb to prepare for an upcoming trip to Mount Kilimanjaro. Since the Chicago region is topographically challenged—that is, flat as pancake, thanks to the glaciers—Evalyn says the closest thing she can find to a mountain is an old landfill at the Blackwell Forest Preserve: "It's called Mount Hoy, but we call it Mount Trash."

At each location, we quickly jump out of the car, grab what we need, walk into the monitoring site, pause to conduct our assigned tasks, and hike back out. Some locations are close to the road; others are more distant. Often we have to push our way through dense vegetation to reach an open spot where we

can stand and observe. Frog monitoring, it turns out, is an athletic endeavor. (I'd hoped for a lot more sitting.)

Evalyn insists we observe hiking protocol, where an experienced hiker leads and another experienced hiker brings up the rear. This means that I, the novice, walk safely sandwiched in the middle. Early in the evening, this precaution strikes me as overly protective, but as night darkens, I grow grateful. I know it sounds strange: I'm in America's third largest metropolitan region, and yet I'm afraid of getting lost in the woods. But the truth is, it's possible. It's big country out here.

In spite of the wind, the frogs do sing at all of our other stops. We're hearing two of the species that are the earliest of the season. They happen to be the ones I read about, the chorus frog and spring peeper. The peeper's call is like the high-pitched "cheep-cheep" a chick would make. The sound of many peepers peeping at the same time—a whole wetland full of them—reminds some people of bells jingling. (We don't hear that, so I can't say.) The call of an individual chorus frog is described by naturalists as sounding like running a finger over the teeth of a comb. I'm fine with those official descriptions—they fit well enough—but mostly what the night in Danada sounds like to me is the generic, joyful clamor of spring. Unlike where I live in the city, in the suburbs these frog calls become ubiquitous. Within the next couple weeks, anyone who happens to live near a wet patch of earth might hear frogs croak as he or she picks up the kids or unloads groceries from a car.

We evaluate each quadrant by assigning it levels. Level 1 means we believe we are hearing as little as one individual frog in that area and no more than six. Level 2 means we're hearing six to twelve individual frogs. Level 3 is reserved for when we're hearing more than twelve.

Location 7 has a large pond of open water. We identify songs of chorus frogs as well as spring peepers, and when Bob shines his flashlight into the water to read the thermometer, the beam happens to shine directly into the eyes of a frog with a striped face. "Ah!" Marlene says. "A chorus frog. For that, we write down 'OBS' for 'observed'—we use that only when we actually see the frog."

"I wish we'd hear a screech owl," Bob says.

"Me, too," says Marlene.

"I do, too," says Evalyn. "That's why I started doing this. I want to be out in the forest preserves at night. I want to hear owls. Monitoring's the only way to do that."

"We hear woodcocks all the time," Marlene says. "One time in Location 7, we saw a sora rail. We spotted it with the flashlight."

Back in the car, Marlene explains that the calls we're hearing tonight from the frogs sound slower than normal. "They're making more of a stutter and less of a trill. That's because it's cold."

"Later in the season on a warm night, the frogs out here can be so loud you can hear them on Butterfield Road," Bob says. "I mean, you can be driving in your car with all the windows rolled up and still hear them."

By the time we make our final stop, it's completely black out. A half-moon is up in the east. The path to this last location is full of brambles, which Evalyn thoughtfully holds to one side for me to make my way easier. We all walk a little more slowly now, and it takes us a while to reach our destination.

We arrive at a large pool of open water with a mix of live and dead trees standing in it. Herons use the upper branches for building their nests, I'm told, and sure enough, as I lift my gaze, I can see the black outline of a great blue heron flying silently in for the night.

Perhaps because of the protection of the trees, the wind is less intense in the rookery than it was out on the prairie. In the still water, moonlight is reflected. Evalyn and Marlene diligently conduct their assignments: listening, counting, and recording. But I find my own thoughts have drifted away from frogs and over to the magic of this place.

Bob comes over to stand nearby.

"I think I see why you guys do this," I say.

"When you tell someone about it, the word 'nuts' comes up a lot," Bob says. "But one time I brought my two sisters and my uncle over here to the rookery. They thought this was beautiful."

I think of telling Bob what I learned about the frogs freezing and thawing, and the miracle of their singing. But I decide information will add nothing to this moment. This is good, hearing the frogs, seeing the herons.

Whether I'm indoors in the city or out here paying attention, the frogs do what they do. In these stretches of land unpopulated by any human being, frogs sing and mate. They eat food and excrete streams of sticky eggs. The eggs turn into tadpoles, and eventually the frogs freeze almost to death, and when spring comes, they live again.

In Illinois there are about twenty different species of frogs; none are endangered, though three are listed as threatened. The work of amphibian-monitoring volunteers helps provide important data on the status of frogs. People like Bob and Marlene and Evalyn are diligent observers of one kind of animal that shows us, once again, how many different ways there are to be alive.

Whether you and I decide to notice is up to us. I like imagining that sometime soon, on a warm night, some guy will be driving on Butterfield Road just the way Bob described. Maybe he'll be feeling a bit weary or preoccupied. But in the distance, he'll hear the muffled clamor of what sounds like a billion frogs. He'll roll down his windows to hear it even louder. If someone is with him, he'll say, "They're back! The frogs—they made it!"

Recommended Resources

Books

Heinrich, Bernd. *Winter World: The Ingenuity of Animal Survival*. New York: Ecco, 2003.

Phillips, Christopher A., Ronald A. Brandon, and Edward O. Moll. *Field Guide to Amphibians and Reptiles of Illinois*. Champaign: Illinois Natural History Survey, 1999.

Sleigh, Charlotte. *Frog*. London: Reaktion Books, 2012.

Websites

Chicago Herpetological Society: www.chicagoherp.org

Fermilab Natural Areas: www.fermilabnaturalareas.org

The home of what was once the world's largest particle accelerator, Fermilab is host to a high-quality natural area restoration.

Forest Preserve District of DuPage County: www.dupageforest.com.

The DuPage County Forest Preserve District has protected and manages 25,000 acres of open space where residents can bird, boat, camp, fish, picnic, bike, or listen to frogs. (Or do all of the above at once.) You can see Marlene describe frog monitoring on a video the Forest Preserve District has posted on YouTube: www.youtube.com /watch?v=POVQxH5UZYw&feature=youtu.be.

Habitat Project: www.habitatproject.org

The Habitat Project of Chicago Wilderness trains and supports Chicago region volunteers in monitoring all sorts of living things: birds, butterflies, and plants.

"The Search for Lost Frogs." Conservation International: http://sp10.conservation.org /campaigns/lost_frogs/Pages/search_for_lost_amphibians.aspx

Because frog populations are in decline all over the world, many organizations work on their protection. Conservation International runs "The Search for Lost Frogs," an international effort that searches for species not seen for years, to see if they still exist.

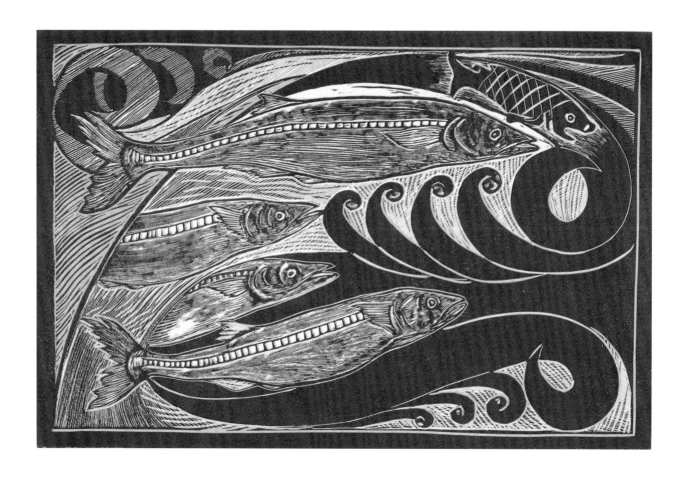

RENÉ H. ARCEO, *Pescado Blanco en Río Chicago*
(White Fish in Chicago River)

These *pescados blancos* (white fish) actually live in Mexico's Lake Pátzcuaro and are one of the features for which this area is known. The fish are regarded as a delicacy by locals and tourists alike, although in recent years overfishing and contamination have greatly reduced their use as a source of food. This woodcut relocates them into the Chicago River, bringing together two worlds inhabited by Chicago's large Mexican American community.

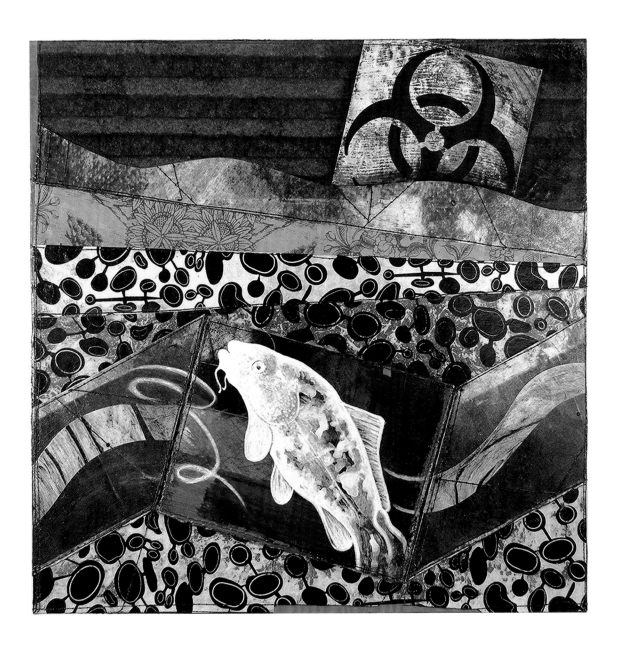

KIM LAUREL, *Heavy Water*

Canoeing through History

Wild Encounters on Bubbly Creek

MICHAEL A. BRYSON

It's hard for me to think of a waterway more forgotten or forlorn than the South Fork of the South Branch of the Chicago River. Such a convoluted name would seem to doom any stream to perpetual obscurity, and indeed the South Fork is very easy to overlook. Even though the South Fork is crossed by the Orange Line elevated train, Interstate 55, and some busy city streets in Chicago's Bridge-port neighborhood, travelers on the Southwest Side of Chicago might go years without ever taking more than a passing glance at this low-profile tributary of the city's namesake river. That's unfortunate, because the South Fork is one of the best places to think about nature in Chicago: what it is, how it's changed, why we should care about it, how we can make it better.

This industrialized and heavily polluted channel has another, much more evocative name: Bubbly Creek. That half-affectionate, half-insulting moniker bestowed upon it in the nineteenth century refers to the methane gas that bub-bles up from the anaerobic bacterial decomposition of organic wastes that now largely constitute the creek's sediments. Decade upon decade, from the mid-1800s onward, Bubbly Creek was the notorious dumping ground for the sprawl-ing animal processing factory known as the Chicago Union Stock Yards.

Waste products from the industrial deconstructions of cow, pig, and sheep carcasses were unceremoniously dumped into the headwaters of Bubbly Creek, a dredged-out channel of which ran along the Stock Yards' northern boundary. Every day obscene volumes of blood, offal, hair, and chemical waste from the meatpacking plants poured into the sluggish current of the creek, soon ren-dering it so befouled that any further objection to its continued pollution and abuse must have seemed pointless. Things became so bad that in 1911 a chicken was photographed walking across the sludgy surface of the river. Another photograph from around the same time shows a city inspector in a suit, top-coat, and bowler hat as he strode upon a fetid island of muck along one stretch of the creek, surveying the harrowing landscape as if he were picking his way through a disaster area.

The industrial desecration of Bubbly Creek was perpetrated in the patently false belief that the slow-moving current would simply wash the filth down-stream—an attitude that was applied with equal enthusiasm to the Chicago

River (and other urban waterways) in general. This once-meandering and biologically rich waterway thus became a de facto sewer for the residential, commercial, and industrial waste exuded from the metabolic activity of a fast-growing city. Although the Stock Yards have been closed since 1971—over forty years now—the legacy of environmental abuse is readily apparent in Bubbly Creek today, and visitors can still watch the water bubble up as methane and hydrogen sulfide escape from the dark brown depths of the otherwise mostly calm waters.

These gaseous emissions are only one indicator of the creek's compromised ecology. Here on Chicago's Near Southwest Side, where the frame houses and industrial buildings of the Bridgeport, McKinley Park, and Pilsen neighborhoods converge, the once-extensive wetlands that surrounded Bubbly Creek were long ago filled and paved over. The creek itself—which formerly teemed with all manner of plankton, invertebrates, fish, birds, and mammals—is now a dredged and channelized canal with harsh angles and sheer vertical embankments of broken concrete or rusted steel. Life here is difficult for just about any organism except the anaerobic bacteria that teem in the creek's long-polluted sediments. Except for one hardscrabble and graffiti-tagged city park at its mouth, the creek has no place along its banks that is fit for direct or pleasant human access to the water.

And yet I can't deny it: this is why I love Bubbly Creek. Its ugliness, its monumental bad luck, and its perpetual sickness from so long and intense a period of mistreatment have done more than earn my sympathies. They've convinced me that Bubbly Creek, and places like it, are also potential sites for contact with wildlife and renewal of spirit—especially for urban citizens who may be plagued by a fundamental disconnection from the nonhuman world around them. Healing nearly ruined landscapes like the watershed of Bubbly Creek involves the reconnection of city folks to water, land, and the organisms that call our urban waterways home.

The best way to start such a journey? A canoe trip on Bubbly Creek.

Setting Forth

My initial encounter with Bubbly Creek was also the first time I had traveled on the Chicago River in anything other than a large tour boat. I had long wanted an excuse to have a more intimate experience with these complicated waters; it just took a while to find the right time and place. The occasion turned out to be the capstone field trip of an experimental "Sustainable City" seminar I first taught in the spring semester of 2009 as a professor at Roosevelt University.

To pull off the complicated logistics of taking my Roosevelt students out on the river, I partnered with the environmental organization Friends of the Chicago River (and have done so ever since on subsequent trips). Formed in the late 1970s, the Friends promote river conservation, provide educational opportunities for K–12 students and teachers, and run canoe trips on various stretches of the river throughout and beyond the city limits. Their trained volunteer guides not only know the river's history and geography like the veins on

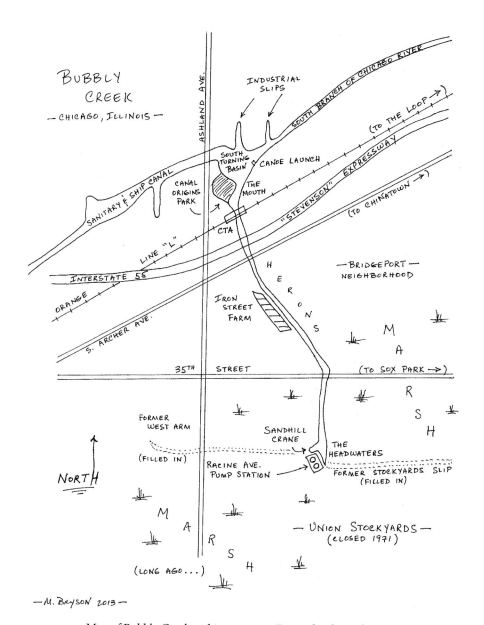

BUBBLY CREEK
— CHICAGO, ILLINOIS —

INDUSTRIAL SLIPS

SOUTH BRANCH OF CHICAGO RIVER

ASHLAND AVE.

SOUTH TURNING BASIN

CANOE LAUNCH

(TO THE LOOP →)

SANITARY & SHIP CANAL

CANAL ORIGINS PARK

THE MOUTH

"STEVENSON" EXPRESSWAY

(TO CHINATOWN →)

CTA

LINE "L"

INTERSTATE 55

ORANGE

S. ARCHER AVE.

IRON STREET FARM

H
E
R
O
N
S

— BRIDGEPORT —
NEIGHBORHOOD

M
A

35TH STREET

(TO SOX PARK →)

R
S
H

NORTH

FORMER WEST ARM

(FILLED IN)

SANDHILL CRANE

RACINE AVE. PUMP STATION

THE HEADWATERS

FORMER STOCKYARDS SLIP
(FILLED IN)

M
A
R
S
H

(LONG AGO...)

— UNION STOCKYARDS —
(CLOSED 1971)

— M. BRYSON 2013 —

FIGURE 1. Map of Bubbly Creek and its environs. Drawn by the author.

the backs of their hands, but also are skilled in coaching novice paddlers about proper technique and safety protocol.

Thus it was that my students, a few colleagues, and I met up with the Friends of the Chicago River on the first of May at the mouth of Bubbly Creek in Bridgeport (fig. 1). "We're really excited to be doing the creek again," enthused Dave, a veteran guide and our trip leader. "We haven't been on this part of the river for, what, ten years? Yeah, about that. Someone on that trip spotted a dead body in the water. That was kind of traumatic, as you might imagine. So it seems we haven't been back until now. Long time coming—this is a good stretch of the river to explore."

A speech like that was not necessarily a surefire way to inspire confidence in a gaggle of nervous paddlers, especially since several of them were middle-aged African American women who had never set foot in a canoe, let alone gotten within sniffing distance of the likes of Bubbly Creek. But Dave was funny as well as encouraging in his subsequent remarks on the art and pleasures of canoeing this historic stretch of river; and to the credit of my students, they proceeded with our plan, a bit nervous but undaunted. Thus fortified with paddles, life jackets, and newly acquired expertise, we divided up two per canoe, decided within our pairs who should take the stern and bow, and ventured forth on the water.

Our launch site was a small dock jutting out from the eastern shoreline of the South Turning Basin, one of two dredged-out and widened sections of the river that allow larger ships and barges to turn around and reverse course. This is the mouth of Bubbly Creek, where it meets the South Branch of the Chicago River that flows from the northeast. The conjoined streams become the aptly named Sanitary and Ship Canal, which continues southwest through and beyond the city. The open expanse of water here provided us with a panoramic view of the steel bridges, boat slips, warehouses, factories, smokestacks, houses, and churches of the Bridgeport and Pilsen neighborhoods. Most impressively, the Chicago skyline loomed large to the northeast of us, only three or so miles distant, reminding us that we were in the heart of a vast and sprawling metropolis.

Despite these visually compelling surroundings, though, our attention was immediately focused on the water and our canoes. The day was windy, and the breadth of the Turning Basin provided the west wind with sufficient fetch to raise a chop on the water. But once we settled into a quiet paddling rhythm, we began scanning the water and the shoreline for movement, trying to peer through the reflective glare of the water's surface to see into the depths below, and listening for the beating of wings overhead. At first the traffic noise from nearby Ashland Avenue and Interstate 55 made it challenging to hear such muted sounds. But as we ventured upstream and got out of the wind, the landscape quieted down. We began to hear the river as well as see it.

Encountering the Wild

The view from just above Bubbly Creek's waterline was one of arresting images and stark contrasts. Along some stretches, vegetation had reclaimed the industrial riverbank. Elsewhere, pipes stuck out from concrete or steel embankments, water from street-level drains trickling from their openings. We floated slowly and quietly under massive railroad and highway bridges, the dim roar of traffic far above us.

Visible evidence of pollution was everywhere—old plastic garbage bags hanging from trees; floating bottles and cans; the occasional used condom (nicknamed "Chicago River Whitefish" by jaded river veterans); and, yes, the infamous bubbles, still percolating up from the murky depths. At times the faint stench of sewage drifted over us—confirmation of the Combined Sewage

Overflow events that in times of sufficient precipitation release untreated sewage into Bubbly Creek from seven different outlets, all of which are gaping drain holes in the vertical concrete wall of the river. These are labeled with large, official, and somewhat ominous signs from the Metropolitan Water Reclamation District of Greater Chicagoland, a bureaucratic discourse warning that the river's water level can rise rapidly and substantially in the event of a sewage overflow. As it turns out, these happen several times a year.

Yet we also encountered abundant wildlife along the creek, especially birds—Canada geese, mallard ducks, a juvenile red-tailed hawk. Tree swallows swooped over the water, hunting for insects, and red-winged blackbirds and white-throated sparrows sang lustily from the brushy riverbanks. That first trip on Bubbly Creek featured what was for me a most gratifying avian trifecta, as my students and I spotted three charismatic heron species native to the Chicago region—the great blue heron, the green heron, and the black-crowned night heron. These birds were clearly at home here, flying along the concrete riverbanks, poking around the litter-strewn mud banks of one of the quasi-naturalized stretches south of the I-55 bridge, and hunting for fish in this long-channelized waterway whose sediments are laced with PCBs and layered with half-decomposed effluvia from Chicago's aging sewer system.

In my thirteen years of living in Chicago at that point, that was the first time I had ever seen all three of these beautiful herons in one place at the same time. Veteran birders have since disabused me of my shock. It turns out that these species are often spotted along the North and South Branches of the river, and other heron species (such as the great egret and least bittern) are seen less commonly, yet regularly. But at the time, it struck me as delightfully ironic that I had needed to come to Bubbly Creek, of all places, to see them for myself. More importantly, the herons teach us by their mere presence about the capacity of this forlorn and mostly forgotten section of the river to surprise and inspire its human visitors with quiet glimpses of the nonhuman wild. They also provided tangible evidence of the partial biological comeback of the river that began in the 1970s.

Although we didn't see any in our Bubbly Creek journey that day, beavers are known to be active in Chicago's waterways, despite their degraded and developed state. Chewed-upon trees along the riverbank on the North Branch and even here, on Bubbly Creek, testify to their presence. And below us undoubtedly swam many common carp (*Cyprinus carpio*), longtime invasive residents who are remarkably tolerant of pollution and muck about in the bottom sediments for food. Bubbly Creek's sediments, water column, and shoreline thus constitute a biologically challenging urban wilderness in which plants and animals eke out survival amidst toxic sediments, turbid waters, and ribbon-thin riparian zones. All species up and down the food chain, from the native herons to the invasive carp, share the fate of having heavy metals and PCBs bioaccumulate in their tissues.

But this doesn't stop people from fishing in the Chicago River, even on Bubbly Creek. Canal Origins Park, a small city green space located across from our canoe launch at the mouth of Bubbly Creek, is a popular fishing spot. Catch-

and-release is the officially sanctioned recreational activity here, for obvious health reasons. But many folks, particularly those struggling at the bottom of the socioeconomic food chain, eat what they catch, whether out of ecological ignorance or just plain disregard of the risks of doing so. This reality is a reminder of how hunger can trump caution, as well as how Chicago residents are an inextricable part of Bubbly Creek's ecosystem.

Reaching the Headwaters

It took us about an hour of quiet but steady paddling to travel Bubbly Creek's one-and-a-quarter-mile length. Along the way, my mind began to drift backward through time, slipping between the past and present. I found it exceedingly difficult to visualize what this part of the Chicago River's watershed once looked like. Technology, human ingenuity, and brute force have profoundly changed the relations here among water, land, and wildlife.

In its pre-industrial state, Bubbly Creek was a small and beautiful wetland stream that teemed with wildlife and moseyed through approximately five square miles of marshland and wet prairie. Early voyageurs would have encountered dozens of species of birds, mammals, fish, amphibians, and invertebrates in a journey through this wetland wilderness only a few miles downstream from the modest frontier outpost of Chicago.

The once-meandering channel of Bubbly Creek was long ago straightened and dredged. In the process, the wide riparian zone and marshy floodplain were replaced by an abrupt border of corrugated steel, concrete walls, and/or gravelly riprap. In some stretches, the riverbank is a sheer wall rising eight feet or more from the water's surface; in others, a pitifully narrow band of vegetation clings to the steep, erosion-prone slopes that lead upward to street level within the surrounding residential and industrial neighborhoods. Human access to the water is difficult, if not impossible. Willows, maples, trees of heaven, cottonwoods, and a scrappy miscellany of shrubs take root here, tenaciously providing a thin but welcome stretch of green along much of the creek's length.

This part of metropolitan Chicago has for decades been an endless grayscape of concrete, houses and apartments, factories and industrial sites. Under the streets—which were built initially at ground level and then raised in the mid-nineteenth century to make room for the city's sewer system—a sprawling and mind-bogglingly complex network of pipes collects street runoff and sewage from a vast thirty-square-mile area on Chicago's South Side. Where once rainwater filtered through the marshlands and fed the groundwater in Bubbly Creek's watershed, now it hits roofs and pavement before traveling through this man-made drainage system of pipes, most of which are invisible, but a few of which protrude abruptly from the banks of the creek.

Legs cramped, backs stiff, we stretched our limbs here at the halfway point of our voyage, taking care not to flip our canoes in the process. This is one of the best places to contemplate the profound physical changes imposed upon the Chicago River: the headwaters of Bubbly Creek—now a literal dead end at a massive piece of urban water infrastructure, the Racine Avenue Pumping

Station, an imposing concrete-and-steel edifice that dwarfs our canoes and intimidates first-time visitors. These huge pumps have operated since the 1930s, taking all the runoff that flows into Bubbly Creek and sending it a few miles southwest to the Reclamation District's gigantic 570-acre Stickney Wastewater Treatment Plant. In times of moderate to heavy rainfall, the pumps reverse, flushing storm-water runoff, untreated sewage, and trashy flotsam into the still waters of Bubbly Creek, temporarily raising its water level several feet.

In our canoes we felt small and vulnerable. Shying away from the five-foot-diameter intake/outflow pipes of the Pumping Station, we scraped the aluminum skins of our boats against the concrete embankment of the opposite bank. The collision inspired us to look up, and we noticed the waterline stains that testify to the upper reaches of Bubbly Creek's modern flow regime.

Here at the headwaters with my students, our Friends of the Chicago River guides "rafted up" our canoes so that we could discuss the relationship of wastewater—what we flush down our toilets and let flow down our sinks—to the biota and ecology of urban waterways. Such a topic packed a considerable punch while floating in the heavy shadow of the world's largest wastewater pumping station. Then we grabbed our paddles and headed back downstream, retracing our water pathway, seeking the river's mouth once more—but with a new perspective on the water flowing beneath our hulls.

Contemplating Cranes

It was at the outset of our return leg that we spotted a sandhill crane, wading slowly and silently through the shallows of a wide part of the river where the west arm of Bubbly Creek used to flow through a lush marshland of cattail and pickerel weed. Unlike the other bird species I've seen repeatedly along the creek in the last five years, I've encountered the sandhill just this once.

It stepped gingerly on long legs through the sediment . . . pausing . . . poking a dagger-like beak into the mud . . . then taking more slow steps. We floated for a long time in the non-current of the stream, murmuring low sounds of appreciation and awe, and scanning the sky in case other cranes were up and about. Most of my students had never before seen or heard a sandhill crane. They were, in a word, impressed.

Here in the middle of America's third-biggest city, the sight of a gray-winged, rusty-bellied sandhill fishing on the margins of Bubbly Creek is a link to the wild past of this once-wetland and a harbinger of its potential future as a restored urban stream. *Grus canadensis* stands over three feet tall and has a dazzling wingspan of up to seven feet; for me, its unmistakable bugling gargle of a call brings compelling memories of my childhood visits to the North Woods, where I first encountered these birds at Seney National Wildlife Refuge in Michigan's Upper Peninsula. The great writer and conservationist Aldo Leopold wrote in his *Sand County Almanac* that "our appreciation of the crane grows with the slow unraveling of earthly history. His tribe, we now know, stems out of the remote Eocene. . . . When we hear his call we hear no mere bird. We hear the trumpet in the orchestra of evolution. He is the symbol of our untamable past,

of that incredible sweep of millennia which underlies and conditions the daily affairs of birds and men" (96).

This kind of moment—one in which city dwellers can have an intimate encounter with a primeval species like the sandhill crane in a quiet urban wilderness, a place so foreign to the setting of our daily lives—bespeaks both the undeniable magic of the crane and the profound sense of hope I have for Bubbly Creek. As a site of ecological restoration, even the U.S. Army Corps of Engineers in their detailed studies of the creek admits its revitalization and recuperation are not technical impossibilities, but merely matters of sufficient time, money, and public will.

Until that day comes when sewage is no longer pumped into the river's channel and when wetlands once again line its margins, Bubbly Creek will remain a damaged yet still wondrous place to viscerally plumb the depths of Chicago's environmental history and make contact with a surprising cast of nonhuman city creatures. With birds of such great physical stature and symbolic import as sandhill cranes calling Bubbly Creek home, even if only briefly on their north-south migrations, what other marvels might we see if we remediate and restore these damaged riverscapes?

Recommended Resources

Books

Daniel, Eddee. *Urban Wilderness: Exploring a Metropolitan Watershed*. Chicago: University of Chicago Press, 2008.

Hill, Libby. *The Chicago River: A Natural and Unnatural History*. Chicago: Lake Claremont Press, 2000.

Leopold, Aldo. "Marshland Elegy." In *A Sand County Almanac and Sketches Here and There*, 95–101. New York: Oxford University Press, 1949.

Websites

Bryson, Michael A. "Paddling Bubbly Creek: Water, Food, and Urban Ecology," May 2, 2012: sites.roosevelt.edu/mbryson/2012/05/02/paddling-bubbly-creek-water-food -and-urban-ecology

Friends of the Chicago River: www.chicagoriver.org

Openlands: Northeastern Illinois Regional Water Trails: www.openlands.org /northeastern-illinois-regional-water-trails

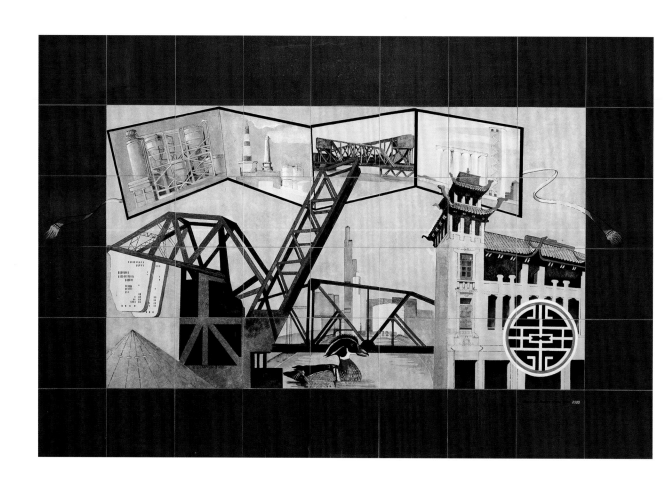

ELLEN LANYON, *Riverwalk Gateway, the South Branch of the River*

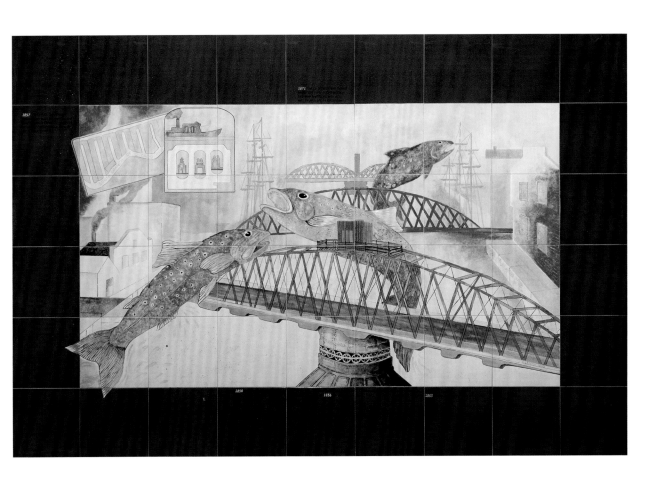

ELLEN LANYON, *Riverwalk Gateway*

The Fish in the Cage

TODD DAVIS

He kept his lines out all night—five poles stationed
in fittings made from discarded plumbing pipe.

At dawn he returned to the river, tugged at the lines,
made sure whatever he hooked in the darkness

of water hadn't come loose in the bluntness of light.
Then he turned the reel, dragged in a catfish or crappie—

if luck was with him, sweet flesh of pumpkinseed
or perch—put them in a wire box at the end of the dock.

When people stopped he showed them the fish
in the cage, hauled the box up on ropes thick as his wrist.

He told me the key—keep them in the river
until you're ready to eat. I watched as their bodies flailed

when they met the air, chicken wire holding them
from the current that moved like his hands

as he explained how the big one in the corner
put up a fight.

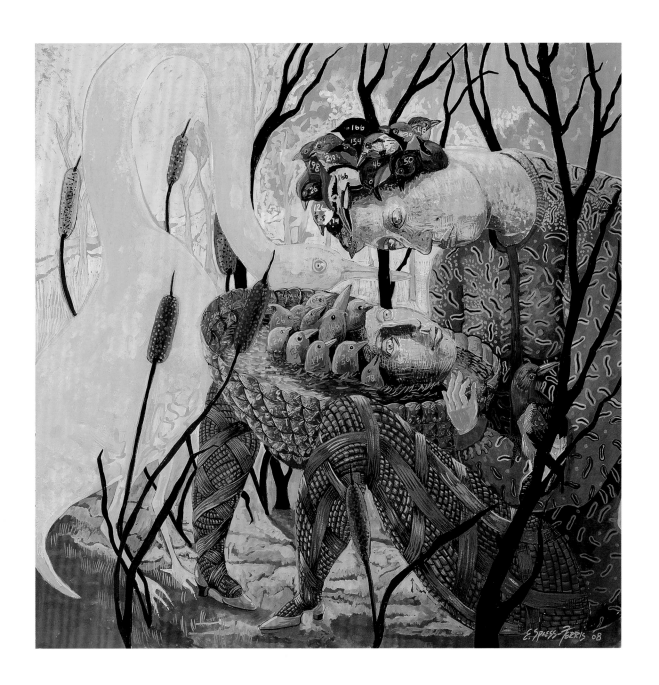

ELEANOR SPIESS-FERRIS, *Pond Reflection*

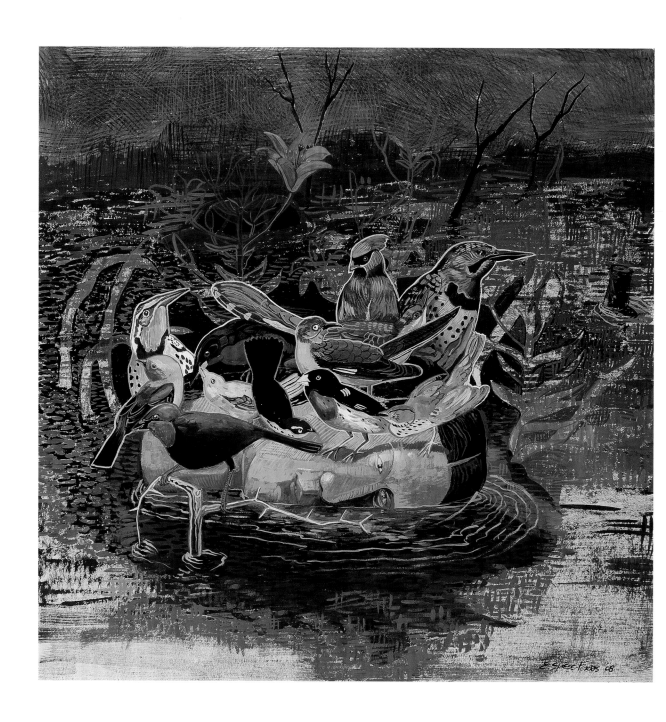

ELEANOR SPIESS-FERRIS, *Flood*

Calumet

Requiem or Rebirth?

JOHN ROGNER

The wildfowl was so incalculably numerous that it is scarcely possible to give you any adequate idea of their numbers.... The bay was literally filled with game, old and young, and they simultaneously rose, and at times absolutely obscured the sun from the beach over which they passed and around which they circled. As this cloud of game passed each officer fired....

 Then followed the picking up and collection of game. I dare not name the number we would then collect of a morning lest you might doubt the accuracy of my memory.... There were swan, pelican, geese, brandt, canvasbacks, redheads, mallards, teal of every variety, and ducks of every kind which breed upon this continent.

JAMES WATSON WEBB, officer stationed at Fort Dearborn in 1822,
describing a morning hunt in Lake Calumet (from Greenberg 2002, 233)

With this and other early descriptions of the pre-industrial Calumet landscape in mind, I occasionally rue my misfortune, considering the totality of human history, of having been born a mere two hundred years too late. I count myself among those who cannot live without wild things. I have visited some of the wildest places in North America. I also have spent many hours gazing out over corn and beans, imagining the original midwestern wilderness. This is common behavior among those who are students of big natural landscapes but who must be content working with remnants. In the prairie biome of North America, early accounts and imagination have to suffice. Today I look out over the sharply angled geometry of Lake Calumet with its bulldozed perimeter, abandoned boat slips, and riprapped shorelines, and lapse into the familiar fantasy. I dream of days gone by. I dream of a Calumet wilderness lost.

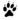

The name "Calumet" is considered a French corruption of the original Indian name for the river whose precise meaning is uncertain. Geologist and historian Kenneth Schoon suggests it may have alternately referred to the river's deep still waters or to the river's native reeds that were used as peace pipes. In addition to its river connection, the name now refers to a region bordering the south end

of Lake Michigan, anchored by Lake Calumet and its environs in Illinois on the west and Michigan City, Indiana, on the east. In between it spans the watersheds of the Little Calumet and Grand Calumet Rivers in Indiana. Most of the region is considered geologically to be part of the Lake Michigan lake plain because it was submerged by the waters of Lake Michigan after the glaciers began to recede roughly 13,000 years ago. My experience, and thus this narrative, is centered on the Illinois portion of Calumet in the city of Chicago and the immediate south suburbs.

What was left when the waters of Lake Michigan finally receded was a flat and poorly drained landscape. Had you walked directly away from the Lake Michigan shoreline 200 years ago, after scaling a series of perimeter dunes, you would have traversed a concentric succession of ancient beach ridges of sand prairie and black oak savanna, between which were long, broad swales of marsh and wet prairie. Two of these swales were occupied by the Little Calumet River, which followed a long westward track from Indiana into Illinois before almost completely looping back on itself and discharging into Lake Michigan. This was a lazy river that grew to a mile in width during flood stage, its waters as content moving sideways as downstream toward its terminus. Lake Calumet itself formed from a depression in Lake Michigan pinched off by southward-drifting sands as the big lake continued its retreat. Depending on where along the lakefront your walk began, you would have traveled five to ten miles across this ridge and swale topography before reaching the higher ground of the Valparaiso Moraine. It was a difficult terrain to traverse and to settle, but gloriously wild country. Early settlers describe a stunning landscape of clear and overflowing waters, dune ridges and wet swales, oak woods, marshes, flower-spangled prairies, and exceptional beauty. It teemed with fish and wildlife.

Potawatomi Indian travelers used the beach ridges as their foot trails. These later became wagon roads for European settlers and eventually highways for commuters. Railroads were less respecting of existing landforms, and they sliced through ridges and marshes on their way toward the hub of Chicago.

By the late 1800s, with a rail system already in place, "improvements" to the Calumet River and Harbor by the Army Corps of Engineers completed the transportation system necessary for development. Business promoters conspired with government to prepare the region for wholesale conversion. The river was dredged, deepened, and finally reversed. What moved in were steel mills, metal finishers, shipyards, paint and chemical manufacturers, grain handlers, breweries, and, later, landfills. Molten slag—a by-product of steel smelting—was poured indiscriminately into low marshy areas to expand land for industry and to eliminate swamp "miasmas" (miasmas were thought to be poisonous vapors from decomposing organic matter that caused illness).

Filth of all types was dumped into what was now a system of transportation and waste disposal canals, with predictable consequences for river life. In perhaps the earliest account of the Calumet region's fish communities, naturalist, ethnologist, and Field Museum associate E. W. Nelson described the steep decline in Calumet fish populations that had occurred by 1876. Just ten years ear-

lier, the Calumet River had large populations of northern pike and black bass and was a favorite destination for anglers; but in the subsequent five years, fish decreased so rapidly that a person might troll for several days without catching anything. The only areas that continued to support sizable populations of fish were the mouth of the river at Lake Michigan and the marshy Lake Calumet, which were more protected from the concentrations of pollutants in the main river channel. In the relatively isolated Lake Calumet of the time, when wild rice still thrived along its shores, it supported fish species such as eelpout (burbot), dogfish (bowfin), and lake sturgeon. All of these species have since vanished from the lake, and the lake sturgeon has become a species of conservation concern throughout the Great Lakes.

Today we would consider such a place an aquatic paradise, but at that time it was considered a useless wasteland by industry and government. Two lakes adjacent to Lake Calumet were filled in entirely. Wolf Lake was partially filled and carved into segments with dikes and roads. The wild rice beds of Lake Calumet were filled and converted into dry land. The northern third of Lake Calumet was turned into a dump and the remainder into a slip-filled port. Marshes and low prairies that were not completely destroyed were severely fragmented.

By the mid-twentieth century, the transformation was nearly complete. The Calumet wilderness had become one of the nation's mightiest industrial regions. A single, vast wilderness had been reduced to small vestiges tucked in between the mills, waste heaps, and subdivisions.

This was the Calumet that I first saw as a young boy in the early 1960s, traveling with my family between our new home in a small farm town in northern Illinois and family and friends in Michigan. The route took us through the city of Chicago and over the Skyway, through Gary, and past the steel mills of northern Indiana. Calumet was the singular highlight of our journey for me, bracketed between endless miles of familiar crop fields. To this small-town kid, seeing the smoke and flame of the steel mills seemed absolutely otherworldly. This was Calumet at its industrial apogee. I was always alert for Wolf Lake to come into view because, as carved up and hemmed in as it was, it seemed the sole natural feature that related the Calumet's world to mine. As eagerly as I anticipated traveling through this region, I also felt an urgency to get through this sulfurous smoke-and-steel landscape so I could finally exhale.

At that point the natural remnants' days were numbered. Had it not been for the environmental movement of the 1960s and the suite of land and water pollution laws that were put into place in the 1970s, the job would have been finished and I would likely have no cause to sit here and write these words today.

I entered the professional workforce in the early 1980s, ironically working for the Army Corps of Engineers in Chicago, administering the federal program that regulates filling in wetlands and other waters. My job immediately took me into Calumet. I remember once looking through mildewed permit files dating back to the origin of the Rivers and Harbors Act of 1898. The permit record perfectly chronicled the progressive transformation of Lake Calumet into a port until the passage of the National Environmental Policy Act in the 1960s

and later the Clean Water Act in the early 1970s. Then letters from the U.S. Environmental Protection Agency began to appear in the files. Both industry and government were forced to rethink what had seemed inevitable.

The second thing that put the brakes on runaway filling was the demise of the steel industry and a general recession in the 1980s. I remember seeing bustling mills become idle, turn into rusting hulks, and get dismantled. I saw once-proud neighborhoods go into decline. A century of manufacturing and uncontrolled waste-dumping had ended.

Great damage has been done. Wetlands and other waters have been reduced in size, fragmented, and biologically simplified. Human communities have also suffered. Long-lasting contaminants like PCBs, DDT, and mercury that are a legacy of Calumet's industrial past persist in its soil and sediments. There is evidence of higher rates of some forms of cancer in the region. In recent years I participated in several fish surveys of Lake Calumet and the Little Calumet River conducted by the Illinois Department of Natural Resources in search of Asian carp. I witnessed people regularly fishing in the Calumet River system and in Lake Calumet, likely both for sport and for food. Yet contaminants in fish flesh remain high enough that the state of Illinois recommends eating no more than one meal a month of common carp taken from Lake Calumet or Wolf Lake, and no consumption of carp over a foot long from the Calumet River system. In his excellent historical summary of industrial wastes in the Calumet region, geographer Craig Colten refers to it as a "landscape of dereliction." Yet amongst the steel and waste graveyards, the heart of the original wilderness beats on.

What remains is a mix of small, scattered remnants of natural areas, most of which are now permanently protected, and neglected marshes and adjacent waste areas that have redeveloped in response to massive land alterations. Lake Calumet and Wolf Lake still remain the most important fish and wildlife habitats in the region. A fish survey of Lake Calumet in 1982 showed that the lake's fish fauna, although missing a few species that were historically present, still retained a relatively diverse population of twenty-six species, including the popular sport fish largemouth bass, yellow perch, channel catfish, and black crappie. More recent fish surveys of the Calumet River system and Lake Calumet confirm that fish populations have rebounded significantly since the 1960s due to controls on industrial discharges and improved wastewater treatment spurred by Clean Water Act requirements. State-endangered and threatened plants and animals hang on in these fragments. The region still harbors the most significant bird habitats and bird populations of the entire Chicago region—indeed, Calumet remains a regional hot spot of biodiversity. The land is nothing if not resilient.

The region raises an eyebrow and asks, "What now?" What now for wildlife and what now for people?

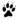

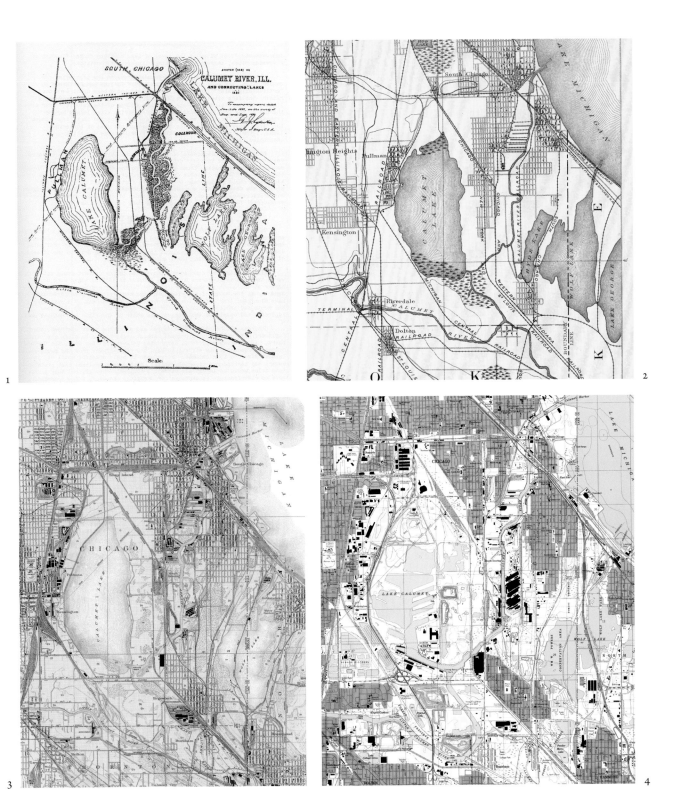

FIGURE 1. Calumet region, 1881, Army Corps of Engineers. Courtesy of Southeast Chicago Historical Society.

FIGURE 2. Calumet region, 1892, U.S. Geological Survey.

FIGURE 3. Calumet region, 1939, U.S. Geological Survey.

FIGURE 4. Calumet region, 1997, U.S. Geological Survey.

I am floating by canoe down an Arctic river in northern Canada's Northwest Territories accompanied by my wife and four friends. For one who lives in— and is acutely aware of living in—a landscape dominated by the physical and cultural footprint of *Homo sapiens*, to spend three weeks in a place where the visible imprint of people is undetectable is to be a time traveler. To be somewhere that cartographers label a "Territory" adds to that feeling. This gently undulating, treeless tundra even hints at the prairies of the early Illinois Territory of 1816. This is as remote as it gets outside of actual polar regions. We are paddling down 250 miles of river toward our endpoint at the Arctic Ocean. There is not a human habitation, field, factory, business, domesticated animal, or camp to be seen along the entire length. Every day we encounter Arctic char and grayling, grizzlies and wolves, muskoxen and caribou. Continuous daylight adds to the stark contrast between where I am and where I came from. We float on.

I look up and see two hawks chasing a third. Through binoculars I can see that it is two merlins after a gyrfalcon. Pure unadulterated wilderness … check. Calumet cannot be a more extreme opposite.

At each inside bend of the river is a protruding gravel bar. An Arctic tern occasionally rises from one of these to protest our passage. But the birds that really make their presence known are lesser yellowlegs. This graceful but otherwise unremarkable shorebird pipes at us from every gravel bar. Their piping becomes the theme music for the entire wilderness trip.

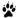

Three weeks after returning from the Arctic, after the glow had worn off and I was fully reintegrated into the parallel and opposite Chicago universe, I found myself on business, standing on the shores of Lake Calumet. All the familiar and characteristic sights and smells were there—the Cargill grain elevator in front of me, the abandoned shell of Wisconsin Steel to the left of me, the closed city of Chicago landfill behind me, a bouquet of landfill gas and industrial odors surrounding me. It was the same old "landscape of dereliction" that I had come to know so well.

But then I heard the familiar piping, and there, probing in the cindery waste of a beach, was a small flock of yellowlegs refueling on their way south. Where I had seen them three weeks earlier was clearly wilderness and this place was clearly not. But the distinction seemed not so clear for the yellowlegs.

Of course, there are many examples like this. When we speak of the global importance to biodiversity conservation of the Chicago region, it is partly in recognition of the unity of cities and formal wilderness. In this sense, Calumet can be branded as "wilderness close to home."

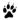

Yellowlegs aren't the only birds of significance in Calumet. In the Chicago region, the presence of yellow-headed blackbirds signals a very special place, and Big Marsh is one of the few places they can be found in Illinois. At nearly three

hundred acres, Big Marsh is the largest wetland in the Calumet region and perhaps the single most important wildlife habitat outside of Lake Calumet and Wolf Lake.

It is also one of the most highly regarded regional destinations among birders. Referred to as "deep marsh" or "hemi-marsh," the habitat is a nearly even mix of open water interspersed with robust emergent vegetation such as cattails. In this region, hemi-marsh supports an entire suite of marsh-nesting birds of which the yellow-headed blackbird is perhaps the most prominent: least bitterns, American bitterns, Virginia rails, sora rails, black terns, marsh wrens, pied-billed grebes, and a variety of ducks. In Illinois, hemi-marsh areas have become sufficiently uncommon that many of their typical species are listed as endangered or threatened. While perhaps the most celebrated and visited by bird-watchers, Big Marsh is only one of a half dozen or more places in Calumet that are regular destinations for a sizable cadre of wildlife watchers. For resident ecotourists, these uncommon habitats represent the identity—the very purpose—of Calumet.

In May 1988 I was part of a group at Big Marsh that recorded 762 black-crowned night heron nests, containing 538 chicks and 1,701 eggs yet to hatch. The remarkable thing is that the deep marsh we saw that day in 1988 was in one important respect accidental. The site of Big Marsh has been completely transformed from its pre-European settlement condition. Big Marsh is hemmed in by abandoned industry, a landfill, a road, and slag deposits. The earliest aerial photographs available from 1938 show the future Big Marsh as a low prairie that was too wet to farm, but that clearly contrasts with the cattail marshes of Lake Calumet. Land filling altered the drainage to create a deep marsh that eventually supported birds found in few places in Illinois.

This marshy bird paradise did not persist. Further alterations and prolonged high water levels eventually led to a shallow lake with no vegetation, and the birds moved on. The night herons at first moved into the adjoining Indian Ridge Marsh, where they flourished for a decade. In recent years they abandoned that location, and a new colony established itself in Lincoln Park, almost in the shadow of downtown Chicago. These may be the descendants of the birds we counted that day in 1988.

What Big Marsh had become in the 1980s—and what it can become again—hints at one of those pivot points to Calumet's future. Wild places in Calumet now consist of a relatively few "true" natural areas—those remnant lake plain wet prairies, dunes, and beach ridge savannas that persist with much the same biodiversity as they had when James Watson Webb roamed the region in the 1820s. These are globally rare museum pieces that demand our most careful and expert curating. More abundant are the accidental habitats that appear when you push around water with landfills, roads, slag, and dikes. There are many of these, and they are all design targets for the maturing fields of habitat restoration and creation. We can build this raw material into a cornerstone for a new vision for Calumet. And if you build it, they will come—both wildlife and people.

Even now, what is happening with Calumet's natural open spaces represents some of the most forward-looking enterprises for the region. Hegewisch

Marsh, which sits atop a former meander of the original Little Calumet River, was rebuilt with a marsh, adjacent savanna, and a public trail system. Water will be managed with pumps drawing from today's Little Calumet. Indian Ridge Marsh, long ago a spoil site for river dredging, is in the latter stages of habitat and trail reconstruction. Big Marsh itself, recently acquired by the Chicago Park District, is undergoing design work and will sometime in the near future once again host marsh-nesting birds and people to watch them.

It becomes easier now to see how natural areas could become a foundation for Calumet's future. With further expansion, these habitats can serve as the core areas for the region's green infrastructure. Land and water trails will further link them into a complementary human infrastructure, allowing people to better envision it as a destination for recreation. Because natural areas require active and creative human intervention, volunteer restorationists and citizen scientists have already come together to conduct habitat management and monitoring, thus strengthening both natural and human communities. The existing Calumet Stewardship Initiative provides the nucleus for this effort. Community gardens, perhaps developed on topsoil-dressed slag, could also provide a complementary connection with the earth.

When rapid transit is expanded into the region, it will be easier for Chicago and suburban residents to experience the wilds of Chicago. As the region's image changes, businesses may begin to see it as a place for the future and start to reinvest. Calumet can then be marketed not just for its historic ties to things like industry and the labor movement, but also as a place featuring world-class nature in the city of Chicago.

Wetland restoration work and this kind of vision for Calumet's future have been anticipated for some time. Almost thirty years ago, the Lake Calumet Study Committee proposed a 2,500-acre wetland ecological park and associated open-space recreation area in the Lake Calumet vicinity. The Calumet Ecological Park Association was later formed to promote this idea. Momentum continued to build, and in 1998 the National Park Service released a final "Calumet Ecological Park Feasibility Study" that better defined opportunities and challenges. The "2001 Calumet Area Land Use Plan" and "2005 Calumet Open Space Reserve," both initiatives of the city of Chicago, further defined how open space, natural areas, and redevelopment could be harmonized into a single vision for the region. Nature and wildlife in the city is a powerful concept, and urban conservation advocates continually look for the next opportunity to turn the concept into reality.

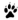

Calumet resembles the greater Chicago metropolitan area in the abundance of natural lands interwoven into the fabric of the city. This goes back to design parameters conceived by civic leaders in the early 1900s and accounts for several hundred thousand acres of nature built into the metropolitan area. Today we refer to this as the Chicago Wilderness.

In late 2011 Illinois governor Pat Quinn launched an initiative called Millennium Reserve, focused on the greater Calumet region. It features the open natural spaces of Calumet and proposes to expand and knit these together into a single reserve system with a unique identity. But it also acknowledges the interrelatedness of natural and human communities and the need for a holistic vision for Calumet. Nature will not do well if human communities do not do well, and the Millennium Reserve rests on a three-legged stool of environmental restoration and open space, economic revitalization, and community development. It is boldly ambitious, but the region is deserving of nothing less.

In our attempt to reimagine Calumet, its wildlife provides a thread of continuity across geographies and across time. Whether for scaup down from the prairie provinces, black-crowned night herons up from the Gulf Coast, or yellow-headed blackbirds from Mexico, Calumet offers breeding and stopover places for many species that still seem to retain the genetic memory of a place they have known for millennia. Despite its transformation, Calumet is still part of a planetary life-support continuum that includes both remote wilderness and intensively developed cities.

Calumet is the product of a bygone era of heavy manufacturing and waste disposal whose visible remnants still define the region and shape public perceptions. It is a landscape with a proud past but no obvious future. Is it possible to honor, even celebrate, the region's industrial past while looking for a pivot point into the future? Might its remaining wild places serve both as a historical anchor and a bridge to a new way of thinking about Calumet?

Wildlife helps us with the immediate and practical challenge of marketing Calumet as something other than an area of defunct industrial zones and waste places, and it also provides a constant around which to build a new human enterprise. Wildlife is part of our cultural memory of Calumet, whose identity through the years has always included its unique wild places and creatures. But as part of Calumet's rebirth, we now have the opportunity to preserve that memory forever by consciously and deliberately incorporating nature and wildlife into our newly imagined industry and community. And it just may be that by starting with a new vision of community that includes people, land, water, and wildlife, we will create a more durable and livable region. Caring for the land and caring for other people are mutually reinforcing, and both help create the foundation for a stable society.

Building nature and wildlife into the infrastructure of Calumet has implications beyond the region. The importance of urban wild places increases with every person who migrates from the farm or small town into the city. People's basic connection with and perception of nature will be formed in an urban context, and the ultimate fate of wildlife in both cities and remote wilderness areas will increasingly rest with an urban populace. There is no more important reason for providing refueling stations in the city of Chicago for yellowlegs down from the Arctic.

Recommended Resources

Books

Carpenter, Lynne, and Joel Greenberg. *A Birder's Guide to the Chicago Region*. DeKalb: Northern Illinois University Press, 1999.

Colten, Craig E. *Industrial Wastes in the Calumet Area, 1869–1970: An Historical Geography*. Champaign: Hazardous Waste Research and Information Center, Illinois Department of Energy and Natural Resources, 1985.

Greenberg, Joel. *A Natural History of the Chicago Region*. Chicago: University of Chicago Press, 2002.

Greenberg, Joel, ed. *Of Prairie, Woods, and Water: Two Centuries of Chicago Nature Writing*. Chicago: University of Chicago Press, 2008.

Greenfield, David W., and John D. Rogner. "An Assessment of the Fish Fauna of Lake Calumet and Its Adjacent Wetlands, Chicago, Illinois: Past, Present, and Future." *Transactions of the Illinois State Academy of Science* 77, nos. 1 & 2 (1984): 77–93.

Moore, Powell A. *The Calumet Region: Indiana's Last Frontier*. Indianapolis: Indiana Historical Bureau, 1959.

Nelson, E. W. "Fisheries of Chicago and Vicinity." In *Report of the Commissioner of Fish and Fisheries for 1875–76*, 783–800. Washington, DC: Government Printing Office, 1878.

Schoon, Kenneth J. *Calumet Beginnings*. Bloomington: Indiana University Press, 2003.

Walley, Christine J. *Exit Zero: Family and Class in Postindustrial Chicago*. Chicago: University of Chicago Press, 2013.

Websites

Chicago Wilderness: www.chicagowilderness.org

Illinois Fish Advisories: www.idph.state.il.us/envhealth/fishadvisory/index.htm

Millennium Reserve: Calumet Core Initiative: www2.illinois.gov/gov/millennium-reserve/Pages/default.aspx

RYAN HODGSON-RIGSBEE, *Bubbly Creek*

✳ 6 ✳

COMING HOME
TO THE CITY

MOLLY SCHAFER, *Untitled*

Great Migrations

Immigrants to the Indiana Dunes, from Grandparents to Great Blue Herons to People of Color and Conviction

GARY PAUL NABHAN

I.

I must have been three or four when I began listening to the waterfowl and wading birds migrating over our backyard, a sand dune slope just a half mile from the Lake Michigan shoreline. The dune sloughed off into a remnant wetland in the backwater village of Miller Station, a former fishing village, minor summer vacation haven for landlocked midwesterners, early laboratory for the emerging science of ecology, and refuge for Chicagoland socialists as well as blue-collar workers in steel mills and oil refineries. Miller Station was too sandy or swampy for agriculture or industry, but it eventually became absorbed into the melting-pot sprawl that reached from Gary, Indiana, to South Chicago, Illinois.

I turned four in 1956, as the city I was named for had reached its halfway mark toward becoming City of the Century (as it had prematurely proclaimed itself). Already its inhabitants of many ethnicities and colors wondered aloud how such a smoke-filled, toxin-dowsed mill town reeling with social strife would achieve such an illustrious status.

But I could not fathom such issues at that time. All I could do was ride on the shoulders of my Lebanese immigrant grandpa's shoulders, pointing up into the sky at migratory ducks, geese, and herons, squealing: "Papa, lo-look dere at der birds!"

"*Inshallah* . . . God willing, they'll make it home," he mumbled in his broken English, always mixed with Arabic in the same sentence. He was a migrant himself, an emigrant from a Sunni, Druse, Maronite, and Antiochian Catholic village in the Bekaa Valley, then part of Greater Syria, and a refugee escaping from the Ottoman War. For him, the lines and dashes and chevrons made by those buffleheads, Canada geese, common mergansers, and great blue herons high above us spelled freedom and flight. For me, they were sowing the seeds of wonder and awe in my little brain well before I could speak their names.

II.

Less than two decades later, as a high school dropout, I worked as a sludge sprayer in a sewage treatment plant at Midwest Steel, and then as a gandy dancer (a now-defunct profession of railroad workers who laid tracks and maintained rails by hand) for Elgin, Joliet, and Eastern emergency repair crews on industrial freight train lines running between U.S. Steel and Inland Steel. I was an unruly dissident, not quite drinking or voting age; I would do anything I could to keep from working indoors, and hoped to save enough money to buy myself a ticket out of the Rust Belt, for it was seething with interracial violence and police brutality in those years immediately following the assassination of Martin Luther King.

It must have been a spring that had followed a lingering winter, for the ice had recently broken on Lake Michigan and the cold weather had passed from the Indiana Dunes shoreline. I glanced up from driving a steel spike into a newly replaced railroad tie just in time to catch a half dozen great blue herons loping by above me, perhaps looking for a place to land.

I put down my spike mall and unbuttoned my blue jumpsuit, where I had a small set of field glasses tucked into my shirt. A biology teacher of mine in junior high school had given those binoculars to me, on the promise that I would learn to recognize at least ten new species of birds migrating through the dunes each year. He did not realize what he had triggered, for each spring and fall, I went truant from school, to spend the afternoons watching tens of thousands of migratory waterfowl land in Long Lake on the edge of Indiana Dunes National Lakeshore. Those birds simultaneously offered me a sense of peace and of adventure, and the seasonal ritual of watching them migrate became one of the few anchors that kept me sane and offered me a chance to gain some confidence in dealing with the world at large.

Since junior high, I had been playing hooky out on the edges of these intra-dunal marshlands, trying to identify birds with a *Peterson's Field Guide*, trees and wildflowers with Donald Culross Peattie's *Flora of the Indiana Dunes*, and occasionally foraging wild foods with Euell Gibbons's Stalking the Wild series. These were quaint and curious activities for a teenager in Greater Chicagoland during this era, when pot could be bought behind the school boiler room, Students for a Democratic Society activists clandestinely pulled fire alarms to empty classrooms, and Major Daley the First ordered Chicago cops to "shoot to maim" any youth out in the streets after curfew.

That particular spring day, those herons loomed as large in my mind's eye as if they were Jurassic pterodactyls. I can still see them flying low in the heavy, sulfur- and iron-oxide-laden air above the steel mills between the lake and downtown Gary: their deep wing beats and their hoarse squawks as they called to one another over the chemical and mechanical cacophony of blast furnaces, foundries, and finishing plants.

At first, I thought the herons were simply passing by the mills and railroad tracks as quickly as they could, for how would they see the pig iron piles, cinder-covered railroad yards, and polluted marshes as anything more than horrors

to pass by, to escape? But then I saw them circle, as if searching for some former habitat they had mapped in their racial memory, some intra-dunal pond where they could stop over, or one that once had a rookery that they had called *home.* A home that had called them back to another time, one that had offered them true sanctuary. At the same time, I wondered how first-flight immigrants born somewhere else came to identify this particular place as their potential home or, for that matter, how any of us recognize the place for which we are the best fit.

I tucked the field glasses back into my jumpsuit and zipped it up to the neck before my supervisor or any of my coworkers could notice what I had done. How, I thought, could I explain to them that those birds mattered to me enough to stop our communal work? What made me think that I deserved a rest while everyone else was driving down spikes, pushing creosote-covered railroad ties with digging bars, or running back to the truck for more tools?

My affection for these birds—one that I had felt since I was four—might need to remain a secret. It was kept between me, the herons, and my field glasses, under cover. But that brief experience became for me a turning point, a watershed moment. From then on, I began to hone my skills and gain purchase on more of the accoutrements of a bona fide (but still aspiring) naturalist. I imagined taking on a new career as a field biologist, instead of remaining a railroad worker. I did not realize until later on that this was not really a *new career*; the vocation of being a naturalist on one's home ground—whether that be in a wilderness, a village, or an industrial city—was truly the oldest profession in the world.

III.

Forty years after that spring day watching herons migrate over the dunes, I laugh at myself for assuming that my coworkers on that crew of railroad gandy dancers would have little empathy for other kinds of migrants. Half the crew members were African Americans who were born on the Mississippi Delta, and whose families participated in the Great Migration of 6 million rural southerners who left their homes between 1910 and 1970. Many of them had taken Highway 61 up the Mississippi floodplain to the cities of the Great Lakes, following almost the same routes that herons took in the spring.

Others on my gandy dancing crew were migrants from tropical Mexico, who had taken the same routes northward that ruby-throated hummingbirds and monarch butterflies take each spring. They spoke Spanish and shared their tacos with me each day at lunch; they would stay in the United States until their children had finished high school and had become legal U.S. citizens. They themselves had crossed the U.S./Mexico border undocumented, but of course, so had the hummingbirds and butterflies.

And there were others among us who had roamed the entire world before they landed in the dunes along Lake Michigan. Our foreman was a Greek immigrant who had worked for two decades as a sailor on cargo ships in fleets owned by Aristotle Onassis, the millionaire merchant who had been born in

the ancient seaport of Smyrna, Turkey. Like Onassis himself, our gandy dancer foreman seemed more like Homer's Odysseus than any supervisor we had ever known, for he spoke five languages and told tales of his adventures that almost seemed too surreal to be true. And yet he was a kind and understanding man who lived and breathed tolerance for the many races, faiths, and cultures that he had encountered over his multifaceted career. Why would he have wanted to chastise a boy enamored with waterbirds when he himself had spent hours at sea watching them, reading them for signs that land was near?

More than a half century after seeing my first migratory birds on the southern shores of Lake Michigan, I now realize that migrants, human or other than human, have been my guides and mentors my entire life. I can no longer watch them without thinking of how many of their homes and stopovers have been disrupted over the millennia, and how many times after being *displaced*, they must have worked at being *re-placed*. We too—all of us—remain hungry for home.

Recommended Resources

Books and Articles

Gregory, James N. "The Second Great Migration: A Historical Overview." In *African American Urban History since World War II*, edited by Kenneth L. Kusmer and Joe W. Trotter, 19–38. Chicago: University of Chicago Press, 2009.

———. *The Southern Diaspora: How the Great Migrations of Black and White Southerners Transformed America*. Chapel Hill: University of North Carolina Press, 2005.

Nabhan, Gary Paul. *Arab/American: Landscape, Culture, and Cuisine in Two Great Deserts*. Tucson: University of Arizona Press, 2008.

Nabhan, Gary Paul, and Stephen Trimble. *The Geography of Childhood: Why Children Need Wild Places*. Boston: Beacon Press, 1994.

Website

Indiana Dunes National Lakeshore: www.nps.gov/indu/index.htm

HECTOR DUARTE, *Desenredando Fronteras (Unraveling Borders)*

Monarch butterflies may not be year-round residents in Chicago, but they are regular seasonal migrants to the city. For muralist Hector Duarte, the butterflies symbolize migration and freedom and overcoming great odds—especially for Chicago's Mexican American community, many of whom hail from the very province to which these butterflies return every year, Michoacán.

TONY TASSET, *Eye and Cardinal*

"Hardy, Colorful, and Sometimes Annoyingly Loud"

The Hyde Park Parakeets

DAVE AFTANDILIAN

I'll never forget the first time I saw the Hyde Park parakeets. It was a chilly late fall day, with a biting wind. As I trudged along, I found my mood matching the day, gloomy and overcast. But suddenly a flock of bright green-and-yellow birds swooped over my head, cutting loose with a chorus of raucous squawks that sounded positively tropical. I could hardly believe my eyes and ears, but after pausing, shaking my head, and looking twice: yes, there they were again. Over the years I lived in Hyde Park, I saw these crazy birds on a number of occasions, and every time, as in our first encounter, they brought a smile to my face. As a Florida boy who had come to Chicago for graduate school, I often felt out of place; these birds helped me come to see Hyde Park as home, just as they had.

Outside Hyde Park, they go by a number of names, including monk parakeets, Quaker conures, and Quaker parrots. Scientists know them as *Myiopsitta monachus*. These names all refer to the cowl-like band of gray over the top of their heads, which some think resembles the plain and modest attire of Quakers. In her *Guide to the Quaker Parrot* (the usual name for this bird in the pet trade), Mattie Sue Athan points out that young birds also quake or "shiver" when feeding and begging. There is nothing plain or timid about these birds as adults, though, and their bright green backs and heads, olive-yellow abdomens, and blue wing tips (primary feathers) reveal them for what they are: relatives of other New World parrots such as conures and macaws.

From Argentina to Chicago and Beyond

No one knows for sure how these neotropical parrots ended up in Hyde Park, but the most likely explanation is that they were imported for the pet trade from South America and either escaped or were released by their owners. According to the U.S. Department of Agriculture, an average of 700,000 monk parakeets a year were imported during the 1980s, most of them wild-caught. After the passage of the Wild Bird Conservation Act in 1992, which prohibited their importation into the United States, most Quaker parrots sold as pets have been bred and raised in captivity, and do not do well on their own in the wild. But

wild-caught monk parakeets who escaped or were released have adapted handily to even the often-chilly climates of Chicago, New York, and other urban areas. Christmas Bird Count surveys sponsored by the National Audubon Society have found monk parakeets in at least fifteen states, and there are thriving breeding populations in Connecticut, Florida, New Jersey, and Texas, as well as Illinois. They've gone international, too, with naturalized breeding populations located in places as far-flung as Japan, Kenya, Mexico, and Spain.

Monk parakeets were first seen flying wild in Chicago in 1968, but according to well-known local birder Douglas Anderson and scientists such as Stephen Pruett-Jones, they first nested successfully in 1979 or 1980 in Hyde Park. By 1992, the year of the first scientific survey of their population, there were 64 monk parakeets living in Hyde Park. Their numbers expanded dramatically throughout the 1990s to 208 in 1997, and by 1999 the monks had become a well enough established species that the Illinois Ornithological Records Committee added them to its official state checklist of birds. The count grew to 316 in 2006. But by 2010 the Hyde Park population had shrunk to 84, likely because migrant monks had established territories elsewhere in Chicagoland. Today monk parakeets are seen regularly from Naperville to Gary. Drawing on reports from local residents starting in fall 2009, the Chicago Parakeet Project located 249 known nesting structures with 389 breeding pairs spread across 933 square kilometers.

It looks like the monk parakeets are here to stay in Chicago.

What's in a Nest?

At least until recently, monk parakeets adapted well to Hyde Park because of their flexible diets and colonial nesting habits. During the winter, they survive almost entirely on seed from backyard bird feeders. But for the rest of the year, they eat nearly any plant material that's in season, from dandelion and carpetweed flowers in the spring to crabapples and hawthorn berries in the summer and fall.

Like many other Hyde Parkers, the monks live colonially, building huge nests from thorny sticks and other materials, with each parakeet family occupying its own "apartment" of one or more rooms with a separate entrance (see fig. 1). These nests are impressive works of avian engineering, sprawling up to ten feet wide and four feet high. Monks are the only parrots who build their own freestanding nests, and they are one of few parrot species in which multiple pairs breed and raise young in the same nest. They maintain their nests throughout the year, patching the walls and adding insulating material, sometimes with sticks they have stolen from other monks' nests. By serving as windbreaks and trapping the heat of the resident birds, these nests help the monks survive Chicago winters.

Monk parakeets are also remarkably tolerant landlords. They have been known to share their nests not just with other monks, but also with other parrot species, storks, ospreys, squirrels, bats, geese, opossums, and even great horned owls.

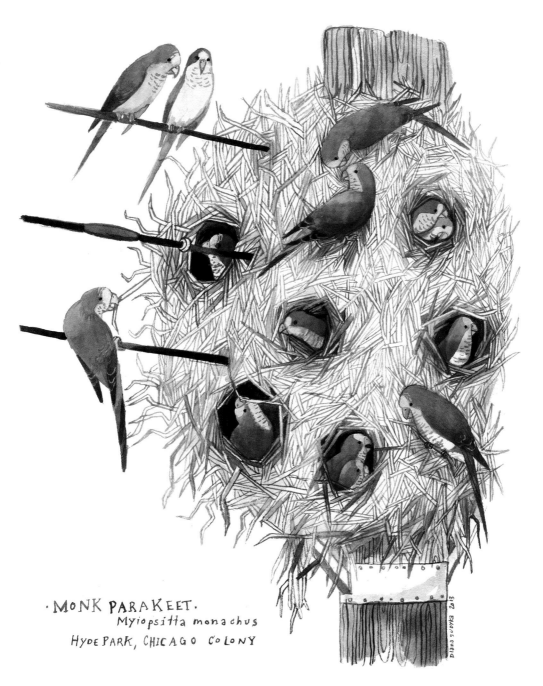

·MONK PARAKEET·
Myiopsitta monachus
HYDE PARK, CHICAGO COLONY

FIGURE 1. Monk parakeet colonial nest on utility pole in Hyde Park. Painting by Diana Sudyka, *Monk Parakeet Colony*

While some monks nest in tall trees, others find human-made equivalents more to their liking. Emily Minor and her colleagues in the Chicago Parakeet Project found that 42 percent of Chicago parakeets built their nests in trees, while 58 percent favored "railroad overpasses, telephone and light poles, satellite dishes, transmission towers, and structures associated with electrical

substations" (984). Walter Marcisz, who conducted an informal survey of Chicago monk parakeet nests in 2004, thinks the parakeets may be "leap-frogging across the city and suburbs via cell [phone] towers" (3).

This behavior has not gone over too well with utility companies, since the nests sometimes catch fire and damage the equipment to which they are attached. For example, in 1997 an electrical transformer in an alley behind St. Thomas the Apostle Catholic Church in Hyde Park overheated and caught fire, destroying the $15,000 transformer and leaving 150 residents without power. Since then, work crews from Commonwealth Edison (ComEd) have regularly removed parakeet nests from transformers to prevent similar incidents. Due to protests on the birds' behalf from local residents, ComEd now works with the Greater Chicago Cage Bird Club, which sends its members out while the nests are being removed to care for any parakeet hatchlings or unhatched eggs that are discovered.

This issue is even more serious in Florida, which has a much larger monk parakeet population than Illinois. In 2000 ornithologist Bill Pranty estimated that the Florida population was 10,000 birds, and it has likely grown since then; in comparison, the Chicago Parakeet Project estimated about 800 breeding birds in Chicagoland, which is where most of the Illinois population is concentrated. Michael Russello and his colleagues cite studies that found: "In 2001, an estimated 1,027 power outages in south Florida were attributed to monk parakeet activities at an approximate cost of $585,000. Moreover, the cost of nest removal alone in south Florida was estimated at $1.3 to $4.7 million" from 2003 to 2007 (2–3).

But trying to get rid of monk parakeets by removing their nests may be a waste of time and money. Jon-Mark Davey, JoAnn Davey, and Mattie Sue Athan, coauthors of a book about monk parakeets called *Parrots in the City*, argue that while tearing down nests might seem like the simplest solution to power companies, it's actually counterproductive, since rebuilding a nest—which the parrots do quite quickly and often in exactly the same spot—actually stimulates breeding. Instead they suggest that "trimming nests—reducing weight and bulk without stimulating a full-scale rebuilding process—may work better than removing them. This has been done with limited success with small colonies" (98).

Plucky or Pesty?

If you live in Hyde Park and have any interest in nature, it's hard to avoid hearing about the monk parakeets. No one seems to be neutral: people either love them or hate them. But nearly every long-term resident delights in talking about them, and many Hyde Parkers also see the parakeets as a key part of what makes the neighborhood so unique (for better or worse).

To get a better sense for what Hyde Parkers and other Chicagoans think of the monk parakeets, I recently read every article I could find about them in the online archives of the community's main newspaper, the weekly *Hyde Park Herald*, as well as the *Chicago Tribune*. On the statistical front, I learned that the

Herald first covered the parakeets on September 21, 1983, and published about them most recently on August 21, 2013. Over that nearly thirty-year span, the parakeets were front-page news in the *Herald* eight times and were also mentioned in nine letters to the editor; in total, they were mentioned in nearly thirty pieces. Although the *Tribune* beat the *Herald* to covering the parakeets by about a year and a half, first writing about them on February 1, 1981, it has published about them much less frequently overall.

I also found out that some locals don't like the parakeets because they're afraid they might become unstoppable invasive avian juggernauts like starlings or English sparrows. As one Hyde Parker put it in a letter to the *Herald* from April 13, 1988: "Incarcerate the parakeets. Put them in a zoo! Don't people ever learn from experience? Remember the man who wanted a little bit of old England in America, so he brought over the English sparrow?" (5). Reasonable worries like these, coupled with fears that the parakeets might become serious crop pests in Illinois—as some say they have become in parts of their South American homeland—led the U.S. Department of Agriculture (USDA) to propose a plan to eradicate the Hyde Park parakeets in 1988.

But the USDA didn't know what they were getting themselves into when they picked a fight over a bird that had become beloved to many local residents. As anyone who follows the history of Chicago politics knows, Hyde Parkers love a good scrap, especially if they see themselves standing up for the underdog (or underbird, in this case). So it made perfect sense to me when I read that local "parrot troopers" mobilized in the parakeets' defense, organizing petition drives, letter-writing campaigns, and demonstrations, as well as forming the Harold Washington Memorial Parrot Defense Fund and threatening legal action against the USDA. Faced with such staunch local opposition, the USDA dropped their eradication plan. This led the *Hyde Park Herald* to quip, "It appears that Hyde Park's colony of South American monk parakeets have successfully faced down the United States government" (May 11, 1988, 3).

So far, fears over the parakeets becoming the next starling have not come to pass. Even the USDA seems to have come around: in 2003 USDA biologist Michael Avery told *Chicago Wilderness* magazine, "There is no documentation of [monk parakeets] causing damage to cereal crops in the U.S., and no indication that they are displacing other birds. They are not cavity nesters, like starlings, which displace woodpeckers. Overall, there seems to be no competition for food or nest space." On the other hand, while parakeets may not feed on cereal crops in the United States, researchers have documented them eating exotic fruit crops in Florida. This led Pruett-Jones and his colleagues to predict that they may indeed become agricultural pests in Florida, where their winter survival is not limited to urban areas with a lot of backyard bird feeders, as it is in Illinois.

The two other biggest complaints that some Hyde Parkers lodged against the parakeets in the articles involved their messy nesting habits and their loquaciousness. Local resident Eugene Krell applauded ComEd for taking down parakeet nests, since one of the largest was located right over his garage. He told

the *Herald,* "I have to go out and clean up the alley every week" from the birds' droppings and nest debris (November 5, 1997, 2).

Others don't appreciate the parakeets' constant commentary. In their essay about the parakeets for *Birds of America Online,* Mark Spreyer and Enrique Bucher note that they "chatter incessantly," which might even be something of an understatement. And we're not talking about a pleasant undertone; a *Washington Post* article from 2006 about monk parakeets described one of their calls as sounding "like metal scraping metal," and having heard it, I'd say that's pretty accurate. Even Mattie Sue Athan, a real fan of captive Quakers, wrote in her *Guide to the Quaker Parrot*: "Wild Quaker sounds can be so repugnant that interlopers flee just so they don't have to hear the noise" (3).

In general, though, these articles convinced me that most Hyde Park residents like the parakeets. For one thing, they admire the parakeets' pluck and appreciate their beauty, especially in the wintertime. As a *Chicago Tribune* article put it, "The only thing that makes their tropical plumage more stunning is seeing it against a backdrop of snow" (November 2, 1997). Bosnian refugee and writer Aleksandar Hemon included the Hyde Park parakeets in his list of twenty "Reasons Why I Do Not Wish to Leave Chicago" from his 2013 *The Book of My Lives,* writing: "9. The Hyde Park parakeets, miraculously surviving brutal winters, a colorful example of life that adamantly refuses to perish, of the kind of instinct that has made Chicago harsh and great" (excerpted in *Chicago* magazine, April 2013).

I also found multiple examples of more ecohistorically minded Hyde Parkers who welcomed the parakeets as a replacement for the extinct native Carolina parakeets that once ranged across much of the central and eastern United States. For example, local birder Douglas Anderson told journalist Bil Gilbert, "I know it is a bit iconoclastic, given the feeling about imported species, but I enjoy seeing those birds in Hyde Park, and I hope they become established.... I like the idea of the [Carolina] parakeet niche being reoccupied in this country" (39–40).

Others remember beloved Hyde Parker and Chicago mayor Harold Washington when they see the parakeets and appreciate them because he did. At the time the parakeets first began nesting in an ash tree in East End Park, Mayor Washington lived in Hampton House across the street from the park. He often watched them through a telescope from his apartment windows and pointed them out to interviewers. As Douglas Anderson explained to the *Hyde Park Herald,* "There was a squad car parked under that tree 24 hours a day [when] Washington was the mayor. The joke that got started in the community . . . was that the police were there to protect the birds, not the mayor" (March 27, 2002, 2).

According to Sue Purrington, a friend of Mayor Washington's, "He had a love-hate relationship with those parakeets. He understood how . . . his location across the street from them protected them and helped them thrive, but there were those days, at 6:30 a.m. when they flew by his windows on their morning flights with their raucous voices, when he felt like opening his window and

screaming at them to go away. But he was proud of them in his own way and told me once they fit well in Hyde Park because of their loudness and their tenacity" (*Hyde Park Herald*, November 28, 2012, 6).

Washington also sympathized with the parakeets because they had to find a way to fit in so far from their native habitat. As the first African American mayor of Chicago, Washington often felt like an outsider in the political establishment himself. This may just be local folklore, but I heard from other Hyde Parkers that Washington said he sometimes felt about as comfortable in the Mayor's Office as he imagined the parakeets felt during a Chicago winter. In 1999 University of Chicago student Jason South wrote that Washington "compared [the parakeets'] experience to the plight of African-Americans in this city" (4).

Washington also believed the parakeets were good luck both for him and for the city in general. In a 1984 interview with *Sports Illustrated*, "Washington predicted he would never lose an election so long as the parakeets were cared for" (*Hyde Park Herald,* March 27, 2002, 2). He also praised the parakeets to journalist Bil Gilbert: "We are all pleased and grateful that these fine parrots have chosen to settle in the great city of Chicago. I think of them as an omen signifying better times ahead for the entire community. For me personally, they have been a good-luck talisman. On the South Side we all admire them for the way they face and stand up to The Hawk [biting winter wind along the lakefront]" (45–46).

For all these reasons, many Hyde Parkers are willing to go above and beyond for "their" parakeets. I often heard stories of locals picking up parakeet hatchlings who had fallen out of their nests and nursing them back to health. The following story provides a good example of how precious the parakeets are to many Hyde Parkers. On June 12, 2004, the ash tree in which the parakeets had first nested in Hyde Park toppled over from old age, taking a number of current parakeet nests and young with it. Located in Harold Washington Park (formerly East End Park, but renamed in the mayor's honor after he died in 1987), the tree had become a local pilgrimage destination, just as the parakeets had become local celebrities: people came from miles around to see them. When the tree fell, "It was loud. It tilted over and came fully down [with] a big boom. The birds started flying and screaming. . . . [They] were hysterical just like a human [would be] if his house was on fire and his children were trapped," said Brenda Cochran, who worked across the street at Hampton House (*Hyde Park Herald*, June 16, 2004, 1).

But what happened next really shows the lengths that locals will go to for their beloved parakeets. The *Herald*'s description of the parakeet rescue efforts is inspiring enough to quote at length:

> Workers from Animal Control, the Police Department, the Park District, Streets and Sanitation and even the Lincoln Park Zoo came to the birds' aid. . . . Czeropski and Glanos [of Animal Control] gathered a total of 50 young parakeets as their parents flew above the downed tree shrieking. . . . While the pair scouted a new nest location in the park, a Lincoln Park Zoo

bird expert and a veterinarian monitored the birds. A city tow truck moved cars to make room for a Chicago Park District work crew which cleared branches in search of more birds. Meanwhile a police officer tracked down extra terry cloth towels to keep the fledgling birds warm. A manager at Ace Hardware, 5420 S. Lake Park Avenue, re-opened the store so the officer could get the towels after hearing the birds' plight. (June 23, 2004, 1–2)

It's hard to imagine a similarly heroic and herculean parakeet rescue effort being mounted anywhere but Hyde Park.

Totem Parakeet?

Introduced species can be problematic, but the Hyde Park parakeets seem to be an exception. During their more than thirty years in Chicago, they don't seem to have done anything environmentally egregious, either to humans or other species. On the contrary, in Chicago and other urban areas, monk parakeets have actually done a lot of good. For one thing, "sightings of these attractive little birds surely lift the spirits of some city dwellers with few or no opportunities for viewing wildlife," as the authors of *Parrots in the City* argue (26). That certainly has been true for me, and it's a sentiment shared by many other Hyde Parkers. For example, in the *Chicago* magazine's staff blog, *The 312*, Whet Moser wrote that the monks were "one of the first things I saw in Chicago, and one of the things that helped me get through to spring" (entry for March 18, 2013).

Monk parakeets have also nurtured ecotourism in cities across the country. Just as people come from throughout Chicagoland to visit the Hyde Park parakeets, so, too, do New Yorkers flock to Brooklyn to see their resident parrots. Steve Baldwin, parakeet enthusiast and webmaster of BrooklynParrots .com, has been leading free "Wild Parrot Safaris" since 2005. Among other stops, Baldwin takes people to see the main colony area where the New York parakeets were first sighted in the 1970s, which he calls "the wild parrots' Ellis Island." Jon-Mark Davey has also run occasional "Parrot Safari" ecotours in Fort Lauderdale since 1999.

Scientists in both Hyde Park and Brooklyn have taken advantage of the research and teaching opportunities the parakeets provide. At the University of Chicago in Hyde Park, faculty teaching the undergraduate Environmental Ecology class, including Mathew Leibold and Trevor Price, have had students census the parakeet population as a laboratory exercise. And at Brooklyn College, whose campus also hosts a large parakeet population, psychology professor Frank Grasso sees the parakeets as a good model for studying the behaviors of adaptation and cooperation, which he and his students have been using the parakeets to do since 2000. He told the *Brooklyn College News*, "Their great organizational skill and cooperation with one another in nest construction and maintenance have helped them to survive and adapt to their new home. . . . They wouldn't be able to do this successfully without cooperating with one

another. That's what this study has to show us: the value of organization and the fundamentals of control that enable all of us to survive" ("Making It in a Strange Land").

Chicago biologist Mark Spreyer thinks the parakeets can also help rope in potential new naturalists and birders. He told *Audubon* magazine in 2005 that "there's an exotic appeal to these parakeets. It's not just a new species but a whole new category of bird" (Friederici).

Several artists have also been inspired by the monk parakeets. In a post entitled "Monk Refrains" on his blog *City of Living Garbage*, Austin, Texas-based artist Scott Webel writes of their nests: "The nests are constructed using the improvisational principles behind the Cathedral of Junk and the open-air rooms at Biosquat. They are composed by weaving things together; they are never finished being woven; they are all built of trash (especially Monk nests, given trash's etymology of 'fallen leaves and twigs'); they are all 'beyond control.' Like Austin junkitects, monk parrots build something out of nothing, and in the process, pull together communities through their semi-public homes." The members of the DUMBO Theatre eXchange in New York renamed themselves Monk Parrots, Inc., in 2007. They took the monks' name because they admired the birds' ability to "survive basically anywhere by working together and adjusting to unusual climates. They symbolize intelligence, endurance, adaptation, and collaboration," according to the group's website.

But to my mind, monk parakeets are most valuable as a new kind of totem animal, one especially appropriate for non-natives like me who, like the monks, have left their original homes to build new ones in Hyde Park, Brooklyn, and other urban spaces. Here I am using "totem" not in the narrow sense that nineteenth-century anthropologists once did, who misunderstood indigenous peoples' sense of shared fellowship with certain other animal or plant beings as a belief in direct lineal descent from those beings. Instead I'm drawing on Graham Harvey's more inclusive definition of the term in his book *Animism*, where he uses it to refer to not just the animals or plants in question, but also to the humans who feel closely connected with them, together as "groups of persons that cross species boundaries to embrace more inclusive communities and seek the flourishing of all" (168). By observing and empathizing with these bright green, cheeky little invaders, we can come to learn something about what it takes to become "native" to a place, and to make space for others to share that place with us, as the monks make space for others in their nests.

Many Hyde Parkers share this totemic impulse. The parakeets have become "a sort of winged metaphor for the community," as Steve Johnson put it in a profile of the neighborhood that he wrote for the *Chicago Tribune* (March 20, 1987). The title I borrowed for this essay from a *Hyde Park Herald* article (December 20, 2006, 2) alludes to this idea, since "hardy, colorful and sometimes annoyingly loud" could just as well describe many Hyde Parkers as their parakeets. In 2010 the Hyde Park Art Fair used an image of the monk parakeet in their official logo, describing the bird as "Hyde Park's avian mascot" (*Herald*, June 2, 2010, 1). And in 2002 the University of Chicago–Hyde Park Arts Fest

map of events listed three "monk parakeet nesting areas" on the map as major tourist attractions (*Herald*, May 29, 2002, 19).

I was also not the only student who felt a kinship with the parakeets. Jason South wrote that "University of Chicago students have also often seen the parakeet as representative of their status in Hyde Park, sometimes suggesting that the Monk Parakeet should become the school mascot" (4). And Chicago students aren't the only ones to make that suggestion: monk parakeets have become the unofficial mascot at Brooklyn College.

But perhaps the strongest argument for the monk parakeets being a fitting totem for Hyde Park, and also for Brooklyn, is their status as initially unwelcome immigrants who later went on to carve out a place for themselves in their new homes, diversifying their communities and showcasing the value of tenacity and adaptability for survival in the urban jungle. In Hyde Park, as Steve Johnson put it in the *Tribune*, "just as the exotic [parakeets] . . . broaden the city's pigeon-heavy ornithological profile, humans of many different feathers come together to make Hyde Park the operational definition of the American melting pot" (May 20, 1987). In this sense, "the parakeets match Hyde Park's self-image as a diverse and tolerant neighborhood," as Peter Friederici noted in *Audubon*.

Of course, image is one thing; the reality may be something else again. While Hyde Park is racially integrated to a greater degree than many Chicago neighborhoods, it still has its fair share of intolerance. A similar sort of intolerance seems to characterize some people's response to the monk parakeets. Bil Gilbert explained, "Another reason for the cold reception the monks received in some quarters is an almost reflexive bias against species that have been brought to this country recently and which then start living freely here. . . . However, this judgment is essentially an esthetic one, having less to do with science than with zoological snobbery and chauvinism" (40–41).

For my part, I think the monk parakeets have as much right to be in Chicago as we do. In fact, ethically speaking, they may well have *more* of a right, since we brought them here against their wishes in the first place as bird-napped victims of the international pet trade. We have a greater moral responsibility to care for species that we intentionally removed from their native habitat for our own purposes than for those that opportunistically chose to colonize a new habitat on their own.

Moreover, humans aren't exactly in the best position to point fingers at introduced species like the monks who have not yet caused any serious negative impacts in their new home. Humans, after all, are an introduced species in Chicago (or at least those of us who are not Native Americans are), and one that has done far more damage to the local ecosystem than monk parakeets have or ever could.

When I visited the South Side of Chicago recently and saw the familiar green blurs winging overhead, squawking me home in their own special way, I couldn't help but smile. I looked, and listened, and wondered what the future held for Hyde Park's totem parakeets. And I thought to myself that maybe if we

can learn to live with the monk parakeets, we can learn to live with other city creatures, too—including each other.

Acknowledgments

Thank you very much to Denis Bohm, recording secretary of the Illinois Ornithological Society, for help obtaining monk parakeet articles from their journal *Meadowlark*, and to the Hyde Park parakeets, for being there when I needed you.

Recommended Resources

Books and Articles

Athan, Mattie Sue. *Guide to the Quaker Parrot.* 2nd ed. Hauppage, NY: Barron's, 2008.

Bittner, Mark. *The Wild Parrots of Telegraph Hill: A Love Story . . . with Wings.* New York: Harmony Books, 2004.

Davey, Jon-Mark, JoAnn Davey, and Mattie Sue Athan. *Parrots in the City: One Bird's Struggle for a Place on the Planet.* Self-published under supervision of the Quaker Parakeet Society, 2004.

Friederici, Peter. "Loud, New Neighbors." *Audubon,* January 2005. http://archive .audubonmagazine.org/birds/birds0501.html.

Gilbert, Bil. "The Chicago Parrots." In *Our Nature,* 31–46. Lincoln: University of Nebraska Press, 1986.

Harvey, Graham. *Animism: Respecting the Living World.* New York: Columbia University Press, 2006.

Marcisz, Walter. "The Expanding Monk Parakeet: An Update on the Chicagoland Monk Parakeet Expansion, with Notes on Cell Tower Nests." *Meadowlark* 14, no. 1 (2005): 2–7.

Millett, Katherine. "Monk Parakeets: Urban Outsiders." *Chicago Wilderness Magazine,* Winter 2003. http://www.chicagowilderness.org/CW_Archives/issues/winter2003 /monkparakeets.html.

Minor, Emily S., Christopher W. Appelt, Sean Grabiner, Lorrie Ward, Alexandra Moreno, and Stephen Pruett-Jones. "Distribution of Exotic Monk Parakeets across an Urban Landscape." *Urban Ecosystems* 15, no. 4 (December 2012): 979–91.

Pruett-Jones, Stephen, Christopher W. Appelt, Anna Sarafty, Brandy Van Vossen, Mathew A. Leibold, and Emily S. Minor. "Urban Parakeets in Northern Illinois: A 40-Year Retrospective." *Urban Ecosystems* 15, no. 3 (September 2012): 709–19.

Russello, Michael A., Michael L. Avery, and Timothy F. Wright. "Genetic Evidence Links Invasive Monk Parakeet Populations in the United States to the International Pet Trade." *BMC Evolutionary Biology* 8, no. 217 (July 2008). http://www .biomedcentral.com/content/pdf/1471-2148-8-217.pdf.

South, Jason. "The Status of the Monk Parakeet in Illinois: With Comments on Its Native Habitat and Habits." *Meadowlark* 8, no. 1 (1999): 2–5.

Websites

The Birds of America Online, "Monk Parakeet": http://bna.birds.cornell.edu/bna/species/322

Brooklyn College News, "Making It in a Strange Land": http://www.brooklyn.cuny.edu/web/news/bcnews/bcnews_121015.php

Brooklyn Parrots: www.brooklynparrots.com

The City of Living Garbage, "Monk Refrains": http://cityoflivinggarbage.blogspot.com/2011/07/monk-refrains.html

Monk Parakeets in Hyde Park and Beyond: www.hydepark.org/parks/birds/monkparakeets.htm

QuakerParrots.com, "Quaker Parrot Information Site and Forum": www.quakerparrots.com

Stanley's QuakerVille: The Virtual Home for the Quaker Parrot and Their Companions: www.quakerville.net

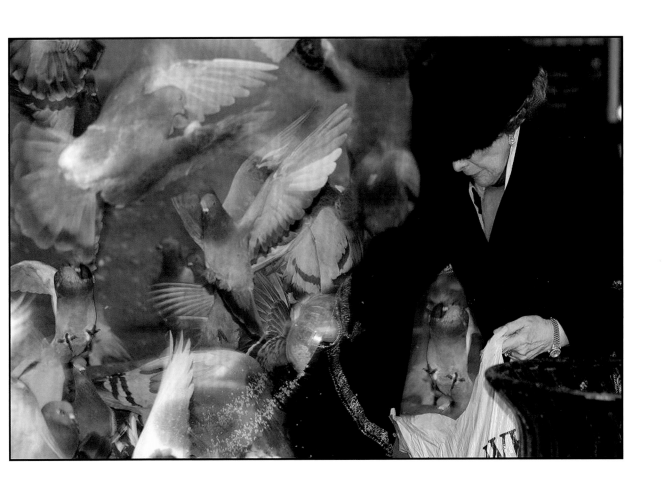

JYOTI SRIVASTAVA, *Flock of Pigeons*

Endangered Species

MARY CROSS

1.

Got a light? Change for a dollar?

He's pushing out,
breaking the shell with a shiny egg tooth, under the midday sun
on Western Avenue.

The pigeon man sits on a fire hydrant, embryonic,
wearing suspenders, blue work pants and matching shirt,
arms outstretched. Two grey pigeons land on a bicep.
A dove nudges his ear. A stray dog licks his shin, where just a shred of hair
 emerges off a bone.

Who is willing to be imprinted?

2.

Are these your birds?

He's surprised to hear me use words.

Upon impulse, he scoops up rice from a bucket,
sprinkles a load onto the sidewalk. And before he's finished,
pigeons line his arms, six at a time, two
on his lap, atop his head, uttering coo-

roo-c'too-coo, bobbing with joy.
Or finding the position of the sun.

Emotions are hard to prove.

3.

He sits from sunup until sundown.

A brown-speckled pigeon flies up in front of a bus,
clapping its wings behind its back,
as if carrying an ancestor's memory of a cliff
in Europe or Asia
thousands of years ago—

Strutting their 37 taste buds,
their 16 ounces, they fly 50 miles per hour
to eat from an old man with hunched spine. He bows
and preens and kisses their wings,
the iridescent sheen of their necks and
red-orange eyes.

Who is to say you cannot collect
love?

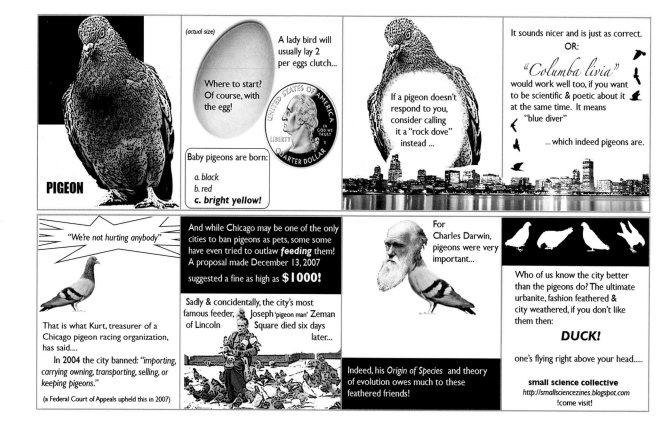

PIGEON

(actual size)

Where to start? Of course, with the egg!

A lady bird will usually lay 2 per eggs clutch...

Baby pigeons are born:

a. black
b. red
c. bright yellow!

If a pigeon doesn't respond to you, consider calling it a "rock dove" instead ...

It sounds nicer and is just as correct.

OR:

"Columba livia" would work well too, if you want to be scientific & poetic about it at the same time. It means "blue diver" ...which indeed pigeons are.

"We're not hurting anybody"

That is what Kurt, treasurer of a Chicago pigeon racing organization, has said....

In 2004 the city banned: *"importing, carrying owning, transporting, selling, or keeping pigeons."*

(a Federal Court of Appeals upheld this in 2007)

And while Chicago may be one of the only cities to ban pigeons as pets, some some have even tried to outlaw **feeding** them! A proposal made December 13, 2007 suggested a fine as high as **$1000!**

Sadly & concidentally, the city's most famous feeder, Joseph 'pigeon man' Zeman of Lincoln Square died six days later...

For Charles Darwin, pigeons were very important...

Indeed, his *Origin of Species* and theory of evolution owes much to these feathered friends!

Who of us know the city better than the pigeons do? The ultimate urbanite, fashion feathered & city weathered, if you don't like them then:

DUCK!

one's flying right above your head.....

small science collective
http://smallsciencezines.blogspot.com
!come visit!

ANDREW S. YANG AND THE SMALL SCIENCE COLLECTIVE, *Pigeon!*

Sheka'kwa and the Skunks of My Re-Rooting

MARYNIA KOLAK

Contact with a skunk can be a transformational experience. You're either sprayed and stink, or escape spraying and can't stop thinking about that fantastic fur and how you'll never be able to touch it. Skunks are fearless, yet careful. They instill dread without aggression. Some states allow skunks as pets, if their special stink glands are removed, but that's not the case in Illinois. I've looked into it.

My first skunk contact transpired one night when it was late enough for the buses to have stopped running and I had to walk home down Milwaukee Avenue from the Blue Line. On the far Northwest Side of Chicago, Milwaukee is wide and empty at night, with abandoned storefronts and occasional immigrant-saturated drinking establishments. You can hear the streetlights click from green to red, the air moving between the one-story buildings, and the sound of your own two feet rushing down the sidewalk, eager to get to your next destination.

It was only a flicker, a tiny sliver of movement that caught my eye—she was behind a chain-link fence in an empty lot, nosing a pile of weeds between two buildings. She was as startled as me, holding still, dark eyes locked with mine, unmoving. The amber streetlight shone just enough to reflect her brilliant black coat and white stripe. In the nanoseconds to follow, I stood stupefied and then contemplated how the texture of her fur would feel under my palm. The softened city slicker in me tangled with healthier instincts. She continued to stare, motionless and determined not to move from her location. With a flash of fear I began to retreat, then fled to the end of the block.

I was moved by her presence. I assume that she merely returned to her late-night foraging, yawning at the silly human who had bumbled across her path.

She seemed so sure, so confident, so rooted to her place—the same neighborhood I was living in, yet really had no knowledge of beyond my family memories and the network of streets and names of buildings. We were neighbors yet had never met before; had never introduced ourselves. She knew more about my expected reaction than I did, and she was an expert in the land and its complicated interactions.

After living in smaller towns that were closer to so-called nature, my skunk encounter on Milwaukee prompted me to connect to the city I now inhabited. Not to the Chicago as we local humans know it, post-1833 incorporation, but through deeper, longer-rooted connections involving the earth and soil and the feet of those that moved on it before my own.

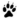

I don't have any stories about skunks from my heritage. Skunks didn't populate Poland at any time historically and still do not, unless a few Poles have recently adopted them as domestic pets. Perhaps this might be explained by their food preferences, since skunks aren't even interested in my Polish grandmother's typically Polish garden in Chicago's Portage Park. (Rabbits were until she found use for a cat I rescued in college.) I'm not even sure how to ask my *babcia* about skunks, and when I tried once, my broken Polish allowed me to string together only fragmented words and phrases: "black," "white," and "smelly animal." I still don't know how to translate "cute" effectively into Polish, and know that my *babcia* would look at such a skunk-related characterization with disdain.

The closest thing Europe has to skunks is a polecat, an unfriendly term around these parts. The term comes from the early fourteenth century, perhaps from the Anglo-French *pol* or Old French *poule* or Middle English *pullet*, referring to the fowl hunted by (pole)cats. Or it could come from Old French *pulent*, which means "stinking," because some of these animals stunk. European polecats look similar to skunks but are actually related to ferrets and minks; perhaps because of their smell, they often have not been held in high regard.

Striped skunks (*Mephitis mephitis*), the kind that I ran into that night on Milwaukee Avenue, can be found from northern Mexico through the United States and up to Canada. The oldest known ancestor of all skunks, based on fossil teeth, migrated to North and South America during the Late Miocene, between 12 and 5 million years ago. The earliest evidence of *Mephitis mephitis* is from the early Pleistocene (about 1.8 million years ago). By the Late Pleistocene (70,000 to 14,500 years ago), skunks were well distributed across the southern half of the United States.

During the Holocene (our own epoch), skunks migrated to the Midwest and Northwest with the retreat of the Wisconsin glacier between 10,000 and 4,500 years ago. They were surely seen by the first Native peoples to inhabit the Great Lakes region, who arrived between 12,000 and 8,000 years ago. The arrival of skunks in (what is now known as) Chicago thus coincided, plus or minus a few thousand years, with human settlement of the area.

One of the first English narratives about skunks was written by Charles Darwin. When his *Beagle* expedition arrived at Punta Ala in modern Argentina, he embarked on a fossil hunt in nearby mudflats, which he appreciatively described

as the "perfect catacomb for monsters of extinct races." That morning his team found fresh puma tracks, and they also saw "a couple of Zorillos, or skunks,— odious animals, which are far from common." Darwin compared the *zorillo* to the notorious European polecat, but noted that it was larger and thicker in size. He did not hide his conflicted admiration for *Mephitis*; the puma slinks, but the fearless *zorillo* swaggers:

> Conscious of its power, it roams by day about the open plain, and fears neither dog nor man. If a dog is urged to the attack, its courage is instantly checked by a few drops of the fetid oil, which brings on violent sickness and running at the nose. Whatever is once polluted by it, is for ever useless. Azara says the smell can be perceived at a league distant; more than once, when entering the harbour of Monte Video, the wind being off shore, we have perceived the odour on board the Beagle. Certain it is, that every animal most willingly makes room for the Zorillo. (*Voyage of the Beagle*, 82–83)

Prior to Darwin's voyage, the earliest citation of the skunk in English is most likely William Wood's *New-England's Prospect*, published in 1634, in which *Mephitis* is referred to as "squnck," later connected with the Abenaki word *segankw*. Cognate words for skunk in other Algonkian languages are similar, such as *sikak* in Cree and *shikag* in Chippewa (Ojibwe or Anishinaabe, in their own language). In the 1910 *Handbook of American Indians North of Mexico*, the skunk was defined as a "vile, mean, good-for-nothing, or low-down fellow," or as a verb meaning to "a) defeat utterly, without the other party scoring at all, b) get no votes in an election, or c) leave without paying one's bill."

The second skunk I met, alarming in its brilliant sheen of ebony and white, moved between two houses down the street from my apartment. I was returning home from class, enjoying the longer route on sidewalks rather than alleys, more vigilant and slow because of my pregnancy. My senses were sharpened; the air incredibly clear in the aftermath of a light spring shower. I stopped for a moment, glaring from afar.

The skunk didn't notice me, as it pushed aside leaves and grasses to uncover bugs for dinner. I watched as the skunk scampered between the buildings to get to the next yard. Again, I wasn't sprayed. I wasn't even noticed.

In 1950 Charles Hockett of Cornell wrote that Chicago was an Indian place-name for onion, perhaps Fox in origin (*seka-ko-hi*), derived from skunk or *seka-kwa*, another Algonkian cognate word. In the 1990s John Swenson looked at the city's naming from the perspective of French mappers who interacted with the Illinois tribe, claiming that the French *Chicagou* refers to a wild garlic plant, not an onion. Carefully preserved by ecological stewards as a native

species that blossoms gorgeously in the spring, wild garlic can still be found in Caldwell Woods and the adjacent forest preserve lands that extend through northwestern Chicago. When fur trappers visited the area in 1674, they reported that it was almost their entire source of food during the season and was commonly used for soup.

I was raised with neighborhood stories that Chicago took its name from onions or garlic, because the area used to stink of endemic wild onions or garlic, and because it smelled like a swamp. This place-name is often related as an "Indian" name, or sometimes more specifically from the Potawatomi tribe, most likely because of their dominance in Chicago at the turn of the eighteenth century.

Borrowed words are reshaped to fit the patterns of the borrowing language, and the original meaning is often lost. In Algonkian languages, which are spoken by many different Native peoples, names have multiple sources and are incredibly complex, further complicated by translations and (mis)interpretations over the past three centuries. For example, there are over 140 spellings of "Potawatomi." The meaning of the name "Potawatomi" is itself disputed and references multiple things—such as Neshnabek, meaning Peoples or Self, as well as the Fire People, the Keeper(s) of the Fire, the Eastern People, or one of the many contemporary nation tribes of Potawatomi. The meaning of Chicago as a place-name might not have a singular answer, considering its derivation from a pluralistic, sophisticated linguistic family such as Algonkian.

And so, things get complicated. Wild garlic was known as *cigag'wunj* by the Forest Potawatomi to the north, who also called it the "skunk plant." *Sheka'kwa* is a proto-Algonkian term, perhaps meaning "skunk." Skunk is pronounced as "zhigaag" in Ojibwa and "shkak" in Potawatomi. According to the English-Potawatomi dictionary, onion is *shakwesh*. Basically, some form of *sheka* in the proto-language accounts for a smelly substance, and a skunk may be at the root of it.

I like to think that it was the feisty skunk for which Chicago was actually named, interpreted through wafts of wild garlic or onions weaving through the swampy air.

The Latin term *mephitic*, which is used for the skunk's scientific name, *Mephitis mephitis*, means "noxious vapor." Mefitis was also an ancient goddess of the Campagna region of Italy who embodied the nasty-smelling gases and vapors emerging from swamps and volcanic fissures. A fissure emitting such gas remains in the region to this day. The cult of Mefitis Utiana near the city of Potentia was considered one of many localized, ancient religions integrated into the Roman Empire's cultural mélange. The importance of her sanctuary is indicated by multiple offerings that span centuries.

Did the ancient Campagnans think Mefitis took human form to exhale the gas, or did they consider Mefitis the gas itself, powerful and lethal yet rich with intrigue? Could I dare interpret the striped skunk, *Mephitis mephitis*, as a kind

of shamanic medium for the goddess, secreting her divine breath to combat the intrusive nature of nature, when a human or dog gets too close for comfort, reminding us to pay homage to the space and privacy of her medium's form? Is that why her genetic makeup is so difficult to wash out with tomato sauce or some other equally futile home remedy?

Urban ecologist Joel S. Brown, who specializes in the Chicago landscape, tells me that skunks prefer the Northwest Side of the city. I am eager to point out the forest preserves and wooded landscape as the primary reason, though Brown suggests the woods are only one component of the skunks' preference. Skunks also find ideal habitat in the expansive cemeteries on the Northwest Side, which sprawl for blocks between the city boundary and northwest suburbs. These are places where pools of water quietly collect and that contain rarely disturbed soil in which insects thrive. With the varying terrain of woods, savanna, and riparian areas nearby, there could be no more perfect place for the skunk in the Chicago urban wilderness. Within an area of a few miles, skunks can den, traverse, forage, and rarely be disturbed. Where there were once swampy lowlands and savannas, there are now cemeteries and forest preserves.

I know well the area that Brown spoke of: St. Adalbert Catholic Cemetery, the roads arching around the plots, the plots stretching farther than the eye can see, with showy granite monuments in some sections and small rectangular slabs set into the ground in others. It is the largest cemetery of the Archdiocese of Chicago, built in 1872 to serve the Catholic Poles on the North Side, named after the Apostle of Bohemia. You can always find a few older women walking across the cemetery by foot with fresh cuttings in hand. On November 1 the grounds glow with candles, and evergreen wreaths with crimson bows emerge from the snow in the winter. At the cemetery's entrance, a dramatic sculpture with a cross and deconstructed eagle wings commemorates the *Katyn* massacre. This monument has been continually filled with fresh flowers and Polish flags since it was built a few years ago. Wojciech Seweryn, the sculptor, was one of the ninety-seven people killed in the 2010 plane crash that also took the Polish president. The surrounding area is populated with Poles who emigrated during the Russian communist regime in the 1970s, and who are not eager to forget.

Yes, I know the area well. It is also where my grandfathers are buried, where the plots for others in my family have been purchased. It is likely where I will end up, too.

In the 1830s, when the fate of Chicago was being fought for, across the Atlantic Ocean Poland had been partitioned between Prussia, Austria, and Russia. My ancestors were peasants, one part in the Austrian partition, the other in the Prussian. In November 1830, the Polish army and noble class rose in revolt but were eventually subdued by Russian forces in late 1831, with crackdowns

on intellectual and religious customs to follow. Chopin and our other national heroes fled to France. When the peasants revolted about thirty years later without success, mass emigrations to the United States began. Some of my family would immigrate to the Midwest at the turn of the nineteenth century, building homes in a climate similar to the one they left. Poland wouldn't regain its statehood until 1918, with great cost and several decades of war and occupations to follow.

It is one of the strange stories of the Americas that immigrants fleeing oppressive states arrived on lands taken from others in violent, systematic oppression. In 1830 the U.S. Congress passed a law that essentially demanded the removal of all American Indian nations who lived east of the Mississippi River. After the unsuccessful Black Hawk resistance movement, the inevitable pushed many tribes to sell, broker, and negotiate for the best terms available. Some moved to the other side of the Mississippi, some fled to Canada, some stayed in Chicago, and others were forced to march in the "Trail of Tears" to the newly constituted Indian Territory in Oklahoma.

While online communities extol domesticated, de-scented skunks as sweet and loving creatures, as affectionate as cats and as loyal as dogs, local policies approach the skunk as a matter of quarantine and kill. The skunk is one of the few animals in Illinois that must be terminated if it is trapped or captured, for fear of spreading rabies. Hunting and trapping skunks is permitted seasonally in rural Illinois, though Chicago and urban residents are to report problems with skunks to Animal Control. Habitat management is not focused on skunks, though they benefit from soil conservation programs that enrich their food supply. Cars may be their greatest predators.

I've smelled skunks going down Caldwell Avenue with the forest preserve on one side and residential homes on the other, and I've smelled their crisp, almost refreshingly potent spray from afar on late nights when the air is saturated with cool droplets. When the air is damp, acetate derivatives of the sulfur-bearing thiols in the skunk spray release a faint but familiar stench, lingering long after the initial secretion has occurred.

The third and last skunk I've seen was roadkill, flattened perfectly across the road, fur still thick and solitary strands of its white stripe standing up. There was no moment of stillness, and no time for indifference. I held my breath and swallowed deeply, and kept on driving. I was a city slicker, after all, and had places to be.

As a contemporary American raised in a post-asphalt land, perhaps I am frustrated and even offended by the swagger, confidence, and great mystery of the skunk. I can review her diet, home, and habits, but those clinical observations can only disclose so much about the skunk, and I may never have the time or

tools to understand further. Yet, the skunk *knows*. She can smell my fear and fumbling when I am not conscious of it. She is connected in a way I am not, able to thrive on the land alone in a way most humans have forgotten. Her knowledge doesn't have to be written; it is transmitted through her lineage in ways we will never fully understand. And her scent is powerful enough to be sniffed dozens of miles away, instilling fear in human and nonhuman creatures alike.

My skunk encounters sparked a connection to unfamiliar parts of myself: my instinct turned on, my wandering mind turned off, and I remained in awe of the small and powerful creature, perhaps already aware that the connection transcended our respective lives.

Recommended Resources

Barton, Heather D., and Samantha M. Wisely. "Phylogeography of Striped Skunks (*Mephitis mephitis*) in North America: Pleistocene Dispersal and Contemporary Population Structure." *Journal of Mammalogy* 93, no. 1 (2012): 38–51.

Granacki, Victoria. *Chicago's Polish Downtown*. Charleston, SC: Arcadia, 2004.

Hodge, Frederick Webb, ed. *Handbook of American Indians North of Mexico*. 2 vols. Bureau of American Ethnology. 1907–10. Reprint, Washington, DC: Government Printing Office, 1959.

Low, John N. "Chicago's First Urban Indians—the Potawatomi." PhD diss., University of Michigan, 2011.

Tanner, Helen Hornbeck, ed. *The Settling of North America: The Atlas of the Great Migrations into North America from the Ice Age to the Present*. New York: Macmillan, 1995.

RYAN HODGSON-RIGSBEE, *Care Bare*

RYAN HODGSON-RIGSBEE, *Nature Calls*

Above All

My son's red mouth screams without gentleness
and I remind myself: *above all, gentleness.*

The deer at the lakeside cracked like a geode
spilling rubies of blood, each a fallen gentleness.

In November: five coyotes on the ice
trot through late fall's gentleness.

The deer is on the shoulder and my father is weeping.
The others on the hillside, too late, call, *gentleness!*

What the house of the knowing woman knows:
the thin and plaster walls of gentleness.

I am the robin caught in the garden net
and the hands that free it, a small gentleness.

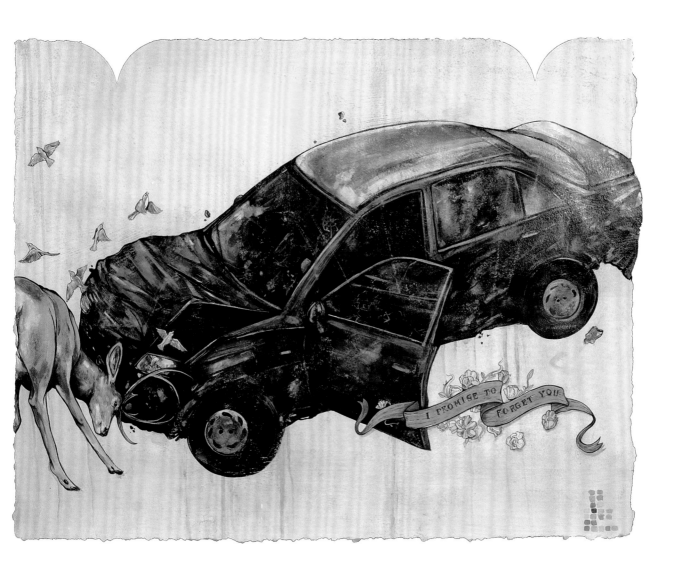

STEVE SEELEY, *Untitled (I Promise to Forget You)*

Coyotes

The Ghost Dogs of Chicago

STANLEY D. GEHRT

As the afternoon shadows lengthen and give way to the gray twilight, the coyote family begins to move. Clouds quickly roll across the Chicagoland sky, pushed along by uncommonly stiff winds, even for Chicago. Soon, the coyotes arrive, but we can't see them. They come closer, they are only yards away, but still we cannot see them. They are like ghosts . . .

We are sitting in a truck at the edge of a parking lot, facing a small field surrounded by a church, golf course, and houses. I know the coyotes are coming because the alpha pair (the dominant male and female) are radio-collared, and my team and I have been tracking them for the past decade. We know their movements very well. Using this technology, I can hear their signals getting stronger, revealing their approach, but still we cannot see them. It is too light, human activity still too great, and the strong, shifting winds undoubtedly make them uneasy. A reporter is with me in the truck, and she desperately wants to see our study animals. I quickly set up a "predator caller," a speaker with a long cord connected to a tape player with a recording of a rabbit distress call. It is designed to attract coyotes and other predators, but especially coyotes. I move back to the truck to turn it on, and we watch.

As the electronic rabbit squeals and the sun sets, two erect ears suddenly appear above the grass. They are a striking white in front and silhouetted by reddish fur on the back. Soon the ears transform into a head featuring a pointed muzzle framed by a white highlight around the lips and piercing yellow eyes. It is the alpha male of the group, and if we didn't have technology to betray his position, we would not have seen him. Somewhere nearby are his mate and their three grown pups, born the previous year, but they are hidden. After a long moment of remaining perfectly still, he cannot resist his instincts and he half sprints and half pounces toward his estimated location of the rabbit. The gusty wind works to our advantage here, as it shifts and confuses him. He looks about, listening, triangulating with his ears, his attention totally focused on the sound. He completely ignores us and the surrounding activities; his focus never wavers from the constantly shifting sounds. He repeats the sprint-pounce in a different direction—feet seemingly never touching the ground—and then stops, eyes

transfixed to the grass where the rabbit is supposed to be, even raising on his hind legs for a few seconds as he strains to visually confirm his hearing. This is repeated over and over, within ten yards of our truck. He puts on this amazing performance for nearly five minutes before giving up, or figuring out the deception, and disappearing. Even today, I cannot remember watching him leave, the direction or manner of his exit; he simply disappeared, like a ghost.

Still in awe of the performance we just witnessed, I walk in the grass to pick up the speaker, and suddenly I freeze: I have come face-to-face with the alpha female and the pups. Four pairs of eyes looking directly at me, all of us surprised and frozen in place, separated by no more than ten feet. Apparently the reporter and I were not the only ones watching the performance of the alpha male. My heart nearly stops with the adrenaline rush, because I have been following the alpha female for the past ten years, catching glimpses of her from time to time, struggling daily to learn more about her life, and here she is just a few feet away, motionless and looking directly into my eyes. She is a stunning animal, even at her advanced age, with a multi-hued coat of fur, a bushy, black-tipped tail, crimson accents around the face and legs, and large, luminous eyes that transfix me. As I stand there, she and the pups turn and silently move away, subtle gray shapes floating across the ground and quickly blending into the shadows as dusk turns to night.

In one of the more amazing wildlife stories in North America, the coyote has dramatically expanded its range across the continent within the past fifty years, despite tremendous persecution, including unrestricted hunting, bounties, and government-sponsored predator control. In response to our efforts to eliminate them, coyotes have not only increased in abundance, but, seemingly thumbing their noses at us (if they had thumbs), within the last fifteen years or so they have colonized most metropolitan areas across the continent. In other words, coyotes have responded to our attempts to eradicate them by becoming our hidden neighbors.

Coyotes emerged on the plains of North America about 1 million years ago. A medium-size member of the dog family (Canidae), they have historically occupied the predatorial niche in between the larger wolves and smaller foxes, in which they commonly hunt small prey (e.g., rodents or rabbits) or scavenge larger prey. However, they are extremely opportunistic and flexible in their diet, and they will at times hunt cooperatively for larger prey if necessary. Although coyotes were likely a part of the Illinois landscape at the time of European settlement, they were quickly eliminated from the Chicago region as it was developed, and people went to great efforts to keep them out. Thus, the Chicago area, as is typical of many modern cities, only shares a recent history with coyotes.

Over the past twelve years, I have supervised a large collaborative project involving many people and agencies focused on exploring the behavior and

ecology of coyotes around Chicago. We have captured and marked over six hundred coyotes, of which nearly four hundred have been radio-collared. We have followed these animals across the Chicagoland landscape in an attempt to learn their stories. Coyotes are so secretive that it is necessary to use many forms of technology—including radiotelemetry, satellite technology, genetics, serology (blood work), and pathology laboratories—to uncover the mysteries of this remarkable, but elusive, animal. Each time we are lucky enough to capture one of these ghosts, we try to open a window into their lives and read as much of their story as they will give us. For sure, we have seen highly varied stories: some short, some long, some with surprising plot twists, and others remaining as puzzling following collaring as they were before. However, one common theme has emerged from these different threads: all Americans are living with coyotes to varying degrees, whether we like it or not. We have also learned that, like ghosts, they are seemingly everywhere and nowhere.

Today coyotes can be found throughout the Chicago region, regardless of location, if you look hard enough. As they colonized the area, they eventually arranged themselves in discrete territories that resemble the patches of a quilt. Much like their human neighbors, ownership of these territories is a private affair, and they put up behavioral "fences" in the form of marking and howling. Unlike a typical quilt, these territorial "patches" are of different sizes and shapes (the average territory size is around two square miles), but they show little spatial overlap between groups and the boundaries are maintained consistently from year to year.

In each of those territories reside an alpha pair (the breeding pair), pups from the current year, and often a few adult offspring from previous years. Coyote social bonds are strong, even though they are rarely seen together. Occasionally they join together for howling bouts, which is used to strengthen pack bonds and to advertise to neighbors that the area is occupied. They are very picky as to who breeds (only the alpha pair in a pack) and membership (nonrelatives need not apply). All members of the pack help raise the litter each year, which may be up to twelve pups from a single alpha pair. Their "quilt" of territories extends across all parts of Chicagoland, even downtown areas, with the exception of airports (from which they are removed regularly) and possibly the most central part of the Loop. Layered on top of this highly organized territorial structure are the relatively chaotic movements of transient coyotes, those unfortunate individuals of both sexes that leave their packs in search of a territorial vacancy and oftentimes a mate. The transients, who account for up to a third of the Chicago population, travel over large home ranges (typically ranging from twelve to thirty-five square miles), and their movements overlap many established territories.

With adults ranging in weight between thirty-five and forty-five pounds, the coyote is the "top predator" in the Chicago area, with no natural predators to fear except humans. This "top predator" status has benefits, such as a wide range of prey items to choose from with little competition from other predators, but it also confers unique costs. The most obvious cost is that many people are afraid

of coyotes because they represent an element of risk, and therefore they can be deemed a "nuisance" by simply being seen at the wrong place and wrong time. The consequence of such a designation is usually lethal removal with traps or gun by professional wildlife control operators (approximately three hundred to four hundred so-called nuisance coyotes are lethally removed from the Chicago metropolitan area each year). Thus, more than any other urban wildlife species, success in the city for the coyote depends on their ability to carry out their lives largely hidden from us. This is a truly amazing challenge when one considers that there are over 9 million people living in the Chicago metropolitan area.

How do they accomplish this feat, in which they live among millions of people, yet avoid them at the same time? One adjustment they make is being active when we are least likely to see them: in the middle of the night. Coyotes in rural areas may be active at any time of the day or night, but urban coyotes are usually nocturnal. By restricting their activities to nighttime, coyotes are able to hide from us. As an example, let's return to the field where the reporter and I witnessed the pouncing male coyote. During the day, this field is used for games and recreation by children and adults from a nearby school. At night, use transfers from people to coyotes. This transfer of use is typical of hundreds of places across the Chicago region each night.

Another benefit of nocturnal activity is that coyotes are able to cross roads more easily in the middle of the night when traffic volume ebbs. This is a critical adaptation to urban areas, since many coyotes must cross dozens of roads each night to make their rounds, and vehicles are the biggest threat to their survival (about 70 percent of all coyote mortalities are due to cars).

Equally important to maintaining their unique relationship with us is the coyote's strong avoidance of using parts of the landscape that we use the most. Coyotes in the Chicago area typically focus their activities on green spaces, no matter how small or isolated the patches are, including areas such as cemeteries, golf courses, and managed parks. Even after fifteen years of studying coyotes around Chicago, I still marvel at their ability to find the smallest pieces of habitat, and to move among these pieces without coming into conflict with us. It is simply stunning that they can do this in virtually any part of the Chicagoland landscape. The family group described above regularly crossed some of the busiest roads every night (Roselle and Meachum in Schaumburg), often doing so multiple times in a single night. I don't think I'll ever completely grasp how they manage to do so safely. The only other wildlife species I know that can move about the Chicago area as easily as coyotes can are of the avian variety, who have the distinct advantage of being able to fly above the roads and buildings. Coyotes exhibit the same type of movements, such as moving long distances, crossing roads, and finding small, isolated, patches of suitable habitat, only they do it on the ground and must stay hidden from us while doing so.

Indeed, if the coyotes weren't telling us their stories (albeit through radio collars), I'm not sure anyone would be convinced about how successful they really are at using this landscape. Chicago is justifiably famous for the large amount of preserved open space sprinkled throughout its landscape, especially

the forest preserve system. Certainly these large, permanent habitat fragments were instrumental in allowing coyotes to get a foothold in the landscape, and the forest preserves probably continue to have the highest local densities of coyotes in the area.

But what I find remarkable is how the small patches of unused space that we pass by each day without a glance—such as water retention ponds, tollway easements, or a small stream crossing through a subdivision—may serve as the critical hub of a coyote territory. Coyotes have forced me to reevaluate what I consider to be "wildlife habitat" and to look at the landscape differently. Areas that I once considered completely developed and that seemed to have little to offer wildlife, I now know have numerous small nooks and crannies that often harbor coyotes. These small, isolated areas were always there, but it took coyotes to reveal them to me.

A year after my encounter with the alpha pair, the female died of natural causes. She and her mate lived in the downtown area of Schaumburg for over ten years, without an incident. Together they raised at least seven litters among the human residents, without the benefit of a single forest preserve to hide in. While their story is impressive, it is not unique, or even that special, among the Chicago coyote population. Other coyotes are doing this every day and night, in some areas much more challenging than downtown Schaumburg.

Currently, about 95 percent of the Chicagoland population of coyotes are ghosts, which the public only occasionally glimpse as we and they go about our daily lives. Unfortunately most people's only experience with coyotes is with the "five percenters," those coyotes that become habituated until they lose their fear of people and become more visible. Most of the "five percenters" are not aggressive, but some may eventually begin attacking dogs, and there is a small risk of attack on people, especially children. A common misperception, often reinforced by the media, is that the "five percenters" represent the norm for urban coyotes. Nevertheless, urban coyotes do represent some element of risk for people and pets. To determine how small of a risk, and whether it is changing over time or with successive generations of coyotes, is one reason why we continue our research.

Just after dawn one August morning, I decided to check in on the alpha male a few months after the death of his mate. He had remained in the territory he kept with his former mate, with the core of the territory only four blocks from the intersection of Roselle and Meachum. I slowly drove my truck through a church parking lot and eventually spotted him with his three offspring, sitting and lying on the ground behind a cemetery. Using the headstones as cover, I moved closer to watch them, a single father and his grown, but still dependent, children. This was a good reminder as to the level of care that both parents give their offspring, and that sometimes these relationships continue for years before the young disperse. The pups were his size now.

Despite my care, they soon picked up my scent and moved away. As I watched them disappear, I reflected on how little we know about coyotes, especially how we benefit from them. It is a sad fact that the funding for most predator research

in this country is driven by conflict between mammalian predators and ourselves, rather than the importance these animals may have for ecosystems and, by extension, how we may benefit from them. This is especially true for coyote research, even my own. We have, however, been able to devote small amounts of attention toward possible benefits, and have uncovered some surprising findings, such as coyotes' role as a biocontrol on urban Canada goose populations. They largely achieve this through the predation of geese nests, and these behaviors had remained largely hidden from us prior to closer monitoring. We have also found that coyotes may help control urban deer populations through fawn predation. Given their penchant for rodents and rabbits, they must also have some effect on these prey populations in the city, but to what extent remains a mystery.

But the most important value of urban coyotes is arguably not ecological at all. They may force us to consider what large predators are all about, what they mean to us, and to what extent we will allow them to live in our midst. For the first time, this larger discussion is occurring within urban centers across North America. The coyote is a great test case because they give us little choice, unlike the larger predators that are more susceptible to our efforts to control them. If we were able to completely exterminate coyotes, they wouldn't be in cities today. But we can't, and now they are. Consequently, people are beginning to grapple with the idea of sharing space with a large predator. I think the coyote is moving us toward a more holistic society, where we consider the many parts of the urban ecosystem, not just the parts that directly affect us, and see ourselves as participants in the environment rather than merely observers. Because of coyotes, people in the city can bear witness to an important part of nature's dynamics, which involves the killing and eating of animals. Urbanites may also learn firsthand that we can't always control nature, even in a highly altered, manicured urban ecosystem. Coyotes remind us that sometimes we are merely participants in ecological systems, even urban systems, like every other species. Coyotes humble us; they humble me every day.

The story of the urban coyote is a naturally occurring, unplanned experiment, one for which the final chapter has not yet been written. The irony is that this experiment is largely beyond the control of people in an urban landscape, the type of landscape that we have assumed we had complete control of since we created it. In Chicago, we had the audacity and technical skills to change the flow of the river coursing through the city, but we remain largely powerless to stem the flow of coyotes in the city. We do not possess ultimate control of this experiment, and we do not know how it will end. However, if recent history is any indication, coyotes are now a permanent, and prominent, fixture of the Chicago landscape. Ghost dogs will continue to appear and disappear before our eyes, to thrill, excite, and scare Chicago residents, whether we want them here or not.

Recommended Resources

Books

DeStefano, Stephen. *Coyote at the Kitchen Door: Living with Wildlife in Suburbia.* Cambridge, MA: Harvard University Press, 2010.

Gehrt, Stanley D., Seth P. D. Riley, and Brian L. Cypher, eds. *Urban Carnivores: Ecology, Conflict, and Conservation.* Baltimore: Johns Hopkins University Press, 2010.

Parker, G. R. *Eastern Coyote: The Story of Its Success.* Halifax, N.S.: Nimbus, 1995.

Websites

Calgary Urban Coyote Project: http://vet.ucalgary.ca/coyote/

The Edmonton Urban Coyote Project: www.edmontonurbancoyotes.ca

Urban Coyote Ecology and Management: The Cook County, Illinois Coyote Project: www.urbancoyoteresearch.com

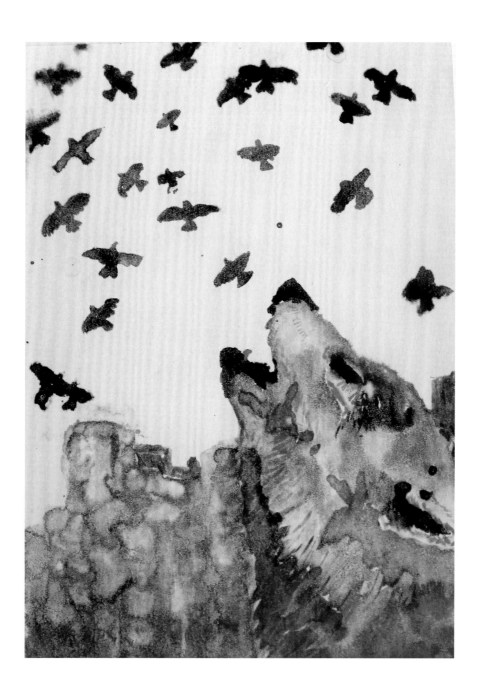

NIKKI JARECKI, *Wolf with Birds*

Ghost Species

BRENDA CÁRDENAS

Pockets of this city resist its grit, open
 portals that travel back-
wards to a wilder-land
 we can only imagine rewound

many decades north where dragonflies
 are the lone black points on the horizon
swallows of light skimming the lake—

where fireflies gather in small galaxies
 milky ways of bulbous bodies flashing on/
off like lit entrances to exotic dance strip-
 tease in a hidden acre of woods.

Pockets of this city shape-
 shift to meadow bracken pond wild arbor
summon their disappeared to a ghost dance

where fat raccoons tumble across midnight's front lawns,
deer scatter
 among abandoned bulldozers, dump trucks,

summoning geese to form blockades
in the street, stare drivers down.

 Concrete is not an object
 for chipmunks tearing fault lines in garage floors.

 Coyotes cross bicycle paths at dusk,
 slink into shadow,
 tear rabbits to shrieks on the patio
 beneath our bedroom window

while we dream of a crib long stored in the attic
 or sent away to a young mother grown old.

What can we do with this gathering of ghosts
 but welcome them home,
for they've returned all at once bright as a quintet of monarchs
 in milkweed flickering.

Tickling the Bellies
of the Buffalo

GAVIN VAN HORN

In metropolitan Chicago, it is difficult to imagine an unbounded, fenceless world of the kind that existed in this region a mere two hundred years ago. Prairie grasses that dominated and defined the area—with wispy stalks brushing the saddles of travelers on horseback, and roots extending ten to fifteen feet into the ground—are now scarce in this Prairie State. Remnants spangle the embankments of railroad right-of-ways, line the pockets of forgotten cemetery edges, and adorn larger forest patches and prairie savannas. Salvaged by accidents of history and the foresight of nineteenth-century Chicago planners, who envisioned an "emerald necklace" circling the city, these urban green spaces account for a great irony: more biodiversity exists in metropolitan Chicago than in rural Illinois, where the soils have largely been repurposed for corn and soybean monocultures—from fencerow to fencerow—to provide forage for livestock, fuel for automobiles, and food for hungry cities near and far.

Dividing up the tallgrass prairie of Illinois was very good for some species but not for others. I think particularly of two animals, bison and wolves, their stories entangled as predator and prey in the dance of the tallgrass prairie's evolution. Like the prairie flora that co-evolved in their presence, these large mammals were uprooted from places they inhabited for thousands of years.

And yet they have not vanished. They linger on the fringes of memory and in present-day enclosures, evoking future possibilities for a landscape undivided.

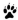

I pay homage to the defining habitat of Illinois by visiting a restored prairie near Batavia, to stand within shouting distance of one of its more imposing creatures: *Bison bison*. Most people know this shaggy-maned, one-ton behemoth more familiarly as the buffalo, and there is a small herd in Batavia, cropping the grass an hour's drive west of Chicago's Loop.

These bison are residents of the Fermi National Accelerator Laboratory (Fermilab), a high-energy physics facility. Bison and particle physics may seem an odd combination, but Fermilab's founding director Robert Wilson had a

vision for both. Underground would be the realm of quarks and neutrinos, as well as massive particle accelerators that are modern-day marvels of engineering. Aboveground would be still more marvels, but unlike subatomic particles, these could be seen with the naked eye.

Bison were brought to Fermi in 1969. Three years later, Wilson took things further. Persuaded by biologist Bob Betz (a man who described himself as a willing victim of "prairie fever"), Wilson was convinced that representing the indigenous landscape of Illinois was preferable to thousands of acres of suburban lawn. Betz got the green light to spread his prairie enthusiasm, beginning with ten acres above the Fermi accelerator ring. His determination soon attracted others to the cause, and the Fermi prairie restoration has since spread to over 1,200 acres that serve as a diverse mosaic of habitats for Chicagoland wildlife.

Fermilab's initial group of five bison also expanded over time, and the herd is now managed to hold steady at around twenty-five animals. Some suggestions have been made to join the bison with the prairie restoration. Thus far, however, these massive beasts function only as living symbols of a bygone era. A perimeter of double-fencing divides them from lands they once shaped so extensively, as much to protect the bison as the people who might mistake them for gentle giants.

The role of bison as landscape architects of the prairie is well documented. Among other things, they recycle nutrients, disperse seed, open up patchy areas of increased plant diversity through their grazing, and create wallows that hold water and provide resources and breeding grounds for other prairie species. Their influence on the variety and abundance of prairie species once loomed large. Could bison in Illinois again play such roles? It's an open question. There isn't much prairie left.

I lean into the fence and wrap my fingers around the cool metal, watching the Fermilab herd graze at their leisure. I wonder, do they ever sniff at the air in June, when the prairie is afire with colorful blooms, and feel their bodies straining to know what is on the other side of these fences?

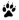

On weekday mornings, a train whisks me along its tracks and deposits me near the Chicago River. I begin my walk to work and stop at a spot where the North and South Branch of the river merge. At this confluence, the North Branch's western bank is occupied by some high-end condos known as Riverbend. I stare at the vertical human habitat and imagine the landscape before the skyscrapers and office buildings, before the river was forced to change directions in 1900 and flow into the Mississippi, before the infamous flames of 1871 jumped these waters and left 100,000 people homeless, and before Chicago was incorporated as a city in 1837, when it was a modest trading outpost and portage site. In 1832 a simple log-cabin watering hole stood here. The name of the place was Wolf Point Tavern.

In this city of 2.8 million, it is now hard to imagine wolves roaming the banks of the river. Yet they did, and not too long ago. According to historian William Cronon, author of *Nature's Metropolis*, a Chicagoan could still shoot a wolf "within earshot of city center during the 1830s" (30). By the latter decades of the 1800s, however, one would have been hard-pressed to hear a wolf howl in the state of Illinois. The extirpation of wolves conformed to a historical pattern of colonization. Waves of settlers disrupted dynamic relationships among native flora and fauna, homogenizing diverse ecological systems, oftentimes in favor of only a handful of species useful for livestock production and agricultural cultivation.

Chicago was a major catalyst for such upheavals. As the "gateway to the West," the city was a hub whose spokes reached widely across the continent's interior, connecting once-distant lands to Atlantic coast cities. The continental-scale decimation of wolves in the late nineteenth century was facilitated by the railroads that converged in Chicago, known at one time as the "Rail Capital" of the world. Evolutionary time scales were compressed, then crushed, by the commercial linkages created by trains, and wolves were unacceptable obstacles to the nation's efficient metabolization of natural resources into hard currency.

I listen to the screech of metal on metal as the elevated train passes over the river into the Loop. For a moment, I think I hear a sound just underneath the metallic squeal and rumble, something rippling over the surface of the river like a breathy wind, something like a howl.

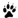

On a train to the city, I read a *Tribune* article about a wolf who recently wandered from Wisconsin to Illinois. Because I keep tabs on the topic, I know there have been twelve wolf sightings in Illinois since 2002. Nine were shot or killed by hunters; one wolf was struck by a car in Lake County in 2005; and in March 2010, near Aurora, a live wolf was photographed for the first time in Illinois. For now, there are no established packs in the state; the wolves that create minor headline material for newspapers are lone dispersers, likely probing the landscape for new territories.

The only place that wolves escaped eradication in the contiguous United States was northern Minnesota. Once the Endangered Species Act was passed in 1973, those wolves gained protections that allowed them to steadily repopulate not only Minnesota but also Wisconsin and the Upper Peninsula of Michigan. Wild wolf populations later reached sufficient sizes to allow their delisting as a threatened species in the Midwest. In 2012 state-issued hunting licenses for wolves were available for the first time in Michigan and Wisconsin, a reflection both of the population rebound of wolves and the limits of human tolerance.

The *Tribune* article presents an opposing viewpoint about these hunts from Mic Isham Jr., of the Lac Courte Oreilles Band of Lake Superior Chippewa. Isham offers a distinctive perspective about what the presence of wolves in the Midwest means: "The way we hold the wolf is like how the Catholics hold the

Holy Trinity—Father, Son, Holy Spirit.... The wolf is like one of those to us. It's a sacred, holy being. To us the wolf was put on Earth at the same time as man to walk together as brothers, and as one goes, so goes the other."

I fold the newspaper in my lap and linger on Isham's words. Most of the reasoning I see for ecological restoration, including the reintroduction or conservation of animals who rely on healthy lands and waters, is couched in scientific language (rare and threatened species, biogeochemical cycles, ecological dynamics, natural disturbance regimes, successional trajectories, biodiversity recovery, and so on). The language of science has appeal to the midwestern pragmatist—of course we should restore the prairie, for the land is a "living laboratory." But push a little further, and I think connecting and restoring the remnant prairies of Illinois is based on something more intimate, something that relies on a place-based wisdom of mutual healing, something that could be called sacred. As one goes, so goes the other.

There are still bison in the city of Chicago—long since expired, but present in their own manner. I seek them out on a visit to the Field Museum, one of Chicago's most outstanding refuges for natural history.

Through the "Nature Walk" section of the main level, I enter one of the museum's narrower hallways. Dioramas on opposite sides of the hall create the illusion of space, stretching nearly floor-to-ceiling with carefully painted backgrounds that mimic distant horizons from around the world. The foldout map in my hand tells me I am in a part of the museum called "Messages from the Wilderness."

I am drawn down the corridor to the diorama of American bison, and I take a seat on a simple wooden bench in front of the ten-foot-tall plate glass. A wind-whipped sky rolls over the upper half of a painted back wall. Atop a sandy wash, a gnarled juniper tree clings to an eroded bank. Bison are milling about, waiting to descend for a drink at a gently flowing stream. Directly behind the glass, five full-size bison and one calf are frozen in mid-stride. My gaze lingers, softening. It seems the small band of bison in the foreground might take their next step at any moment. I stare into the black, unblinking eye of a bull. I hear the thunder of hooves in the distance. My imagination tramples other competing sounds, other competing thoughts, transporting me to when I last taught environmental studies classes to undergraduates.

During one class session, I would take my students out to a nearby graveyard, adjacent to an underutilized campus golf course. This was not due to a fascination with morbidity. I wanted to highlight the essay "Prairie Birthday" from Aldo Leopold's *A Sand County Almanac*. In this short piece, Leopold tells of a country cemetery he visits where a single cut-leaf silphium (compass plant) dwells in a forgotten, unmowed corner. He speculates that this tenacious, sunflower-like prairie plant, disregarded as a weed by most people, might be the last remaining celebrant of the prairie's July blooms in the western half of Dane

County, Wisconsin. Between doses of good humor about the supposed progress of "mechanized man" who considers it an improvement to be rid of such plants, Leopold makes a profound statement about relationships: "We grieve only for what we know"—and so the prairie is dying. For him, the land told a story of deep interrelations whose pages were being torn out. Something precious was passing away, in the landscape and in the human ability to know and care for it. Leopold remarks, "What a thousand acres of Silphiums looked like when they tickled the bellies of the buffalo is a question never again to be answered, and perhaps not even asked."

Since I didn't have silphium conveniently on hand, I made use of a huge oak whose massive galls would seat a person with legs dangling. I asked the students to scan the horizon with their imaginations. They obliged, looking out across the cemetery at the unkempt golf course, a softball field, and a wisp of meandering creek threading its way into a distant culvert. The oak we sat under, I told them, has witnessed many changes. Perhaps honoring its age, perhaps by happenstance, the university spared the oak even while some of its kin were uprooted and replaced by Bermuda grass. But two hundred years ago, when there was not a single campus building, before this institution of higher learning was even conceived, the oak began to grow here, anchoring itself to the ground and extending fresh branches to catch the welcome warmth of summer light. When it was a sapling, all of the landscape was prairie and oak savanna. On that prairie were bison. Bison wallowing in clouds of dust, bison calves prancing between their mothers, bison bulls snorting warnings into the air. There may have been wolves nearby, surreptitiously skirting the margins of the herd. I asked the students: "What would a thousand acres of silphiums look like tickling the bellies of the buffalo?"

I drive my five-year-old son to Wolf Park, a seventy-five-acre facility in Battleground, Indiana, founded in the 1970s by animal behaviorist Erich Klinghammer and now home to ten wolves. My son, a prehistoric-life enthusiast, has more familiarity with dire wolves, but he gushed at the prospect of encountering their real, modern-day descendants. The strongest selling point was that since it was a Friday, there was a group howl session scheduled for the evening.

It would take a wolf on a single-minded mission four days to reach Wolf Park from Chicago. With the advantage of a car, it took us a little under two and a half hours.

The wolves at Wolf Park are socialized to humans and spend their lives in fenced enclosures. Until recently, Wolf Park also hosted a once-a-week, forty-minute demonstration of predator-prey dynamics, in which a select group of wolves was allowed to "test" the resident bison herd under controlled conditions. Problematic as that may sound, no major injuries occurred over the span of the thirty-year program (the bison actually dictated most of the engagement).

That night, the resident wolves gathered near the fence line of the main pack's seven-acre enclosure; they were restless, feigning aggression, reaffirming social order. Following an educational introduction about the purpose of howling, a park volunteer encouraged those of us seated in the viewing area to initiate the chorus. About forty people, some tilting their heads upward, began tentatively. My son stirred on my lap. He had been waiting for this. As the chorus thickened, I watched him make an O shape with his lips; he then quavered out the full-bodied howl of a five-year-old. He sounded remarkably like one particular wolf perched on a large boulder in the enclosure. Their alternating howls echoed in call-and-response. We howled again and again, the pitch of our voices rising and descending. In those moments, the visceral power of sound became more clear to me. Voices carry through fences, unmindful of chain-link barriers. The wolves and the humans were at least for that moment in unison, until all our voices faded into a full silence and the quiet again encircled us.

Maybe I brought my son to Wolf Park seeking a certain kind of knowledge, the kind discovered in participation. If we grieve only for what we know, as Leopold put it, then a corollary must also be true: we celebrate only what we know.

I am on my way to Fermilab again, thinking about bison and wolves. I pass by lands that are dissected by a tangle of physical boundaries (roadways, fences of all kinds, housing developments) and a still more confusing amalgamation of invisible barriers (private property, public lands, zoning ordinances). Given these obstacles, it seems fanciful to imagine a mutual restoration between cities and rural lands, people and prairie, and animals such as bison and wolves. But because of their need for large habitats and their key roles in shaping those habitats, large mammals like bison and wolves may point the way to such possibilities.

Twenty-five years ago, geographers Deborah and Frank Popper began earnestly pitching the idea of a Buffalo Commons, "the metaphor for a restoration-based future" (31) that would mobilize a long-term vision for the Great Plains region. It is an idea that has gained traction in many places. A full-blown "buffalo commons" is a mismatch for the climate and demography of the Chicagoland region, which has a more intensive history of agricultural settlement and hosts a much denser human population than the Great Plains. Still, it is striking that a nonhuman animal—and recognition of its key ecological and cultural roles—served to broadly define a commons area, a shared place with shared responsibilities to both human and nonhuman residents.

Over fifteen years ago, stirrings for a landscape-wide vision for Chicago coalesced around the phrase "Chicago Wilderness"—an arresting pairing of words. To me, the phrase signals that after a long and brutal legacy of presuming that humans and cities are incompatible with nature—that nature is a vast storehouse of goods fit only to be plundered—urban places are being reimagined as areas nested within a larger commons. This Chicago Wilderness

commons is a shared habitat, one in which the needs of other species should be carefully weighed, and the long-term well-being of the land is not merely a remnant of the historical past but an opportunity to forge new relationships.

The bison are starting to get a hearing. Places like Nachusa Grasslands, Midewin National Tallgrass Prairie, and Fermilab are all within the larger Chicago metropolitan reach, and all of them either have bison or plan to re-introduce bison to their restored prairies in the near future. Meanwhile, wolves are testing the landscape, fitfully making their way back to Illinois. The restoration of fragmented lands that could serve as primary habitats and corridors—both within the larger metropolitan area and outside of its official limits—may give these species an opportunity to once again engage in their prairie dance.

As I watch the bison at Fermilab, I am reminded that the recovery of such relationships is a process both dynamic and incremental. On another portion of Fermilab's property, on the edge of one of the site's restored tallgrass prairies, there is a boulder with an engraved plaque. The plaque honors the late Bob Betz, the man with "prairie fever" who was so instrumental in envisioning and then carrying forward Fermi's prairie restoration. In his book *The Prairie of the Illinois Country*, Betz recounts the story of his first meeting with Robert Wilson, Fermilab's director. When Betz pitched his prairie idea, Wilson wanted to know, "How long would it take to restore such a prairie?" Betz knew it would take decades, maybe hundreds of years, but he low-balled his answer: five, ten, maybe twenty years, he said. Wilson pondered this for a moment, and then replied, "If that's the case, I guess we should start this afternoon."

My eyes drift past the boulder with Betz's plaque to the bright colors of native plants spread across the horizon. The yellow-starred blooms of silphium dot the land like a constellation.

Recommended Resources

Books and Articles

Betz, Robert F. *The Prairie of the Illinois Country*. Westmont, IL: DPM Ink, 2011.

Cronon, William. *Nature's Metropolis: Chicago and the Great West*. New York: Norton, 1991.

Gates, C. Cormack, Curtis H. Freese, Peter J. P. Gogan, and Mandy Kotzman, eds. *American Bison: Status Survey and Conservation Guidelines 2010*. Gland, Switzerland: IUCN, 2010.

Hoffmeister, Donald F. *Mammals of Illinois*. Urbana: University of Illinois Press, 1989.

Lopez, Barry. *Of Wolves and Men*. 1978. Reprint, New York: Scribner Classics, 2004.

Matthews, Anne. *Where the Buffalo Roam: Restoring America's Great Plains,* 2nd ed. Chicago: University of Chicago Press, 2002.

Mech, L. David, and Luigi Boitani, eds. *Wolves: Behavior, Ecology, and Conservation*. Chicago: University of Chicago Press, 2003.

Popper, Deborah E., and Frank J. Popper. "The Onset of the Buffalo Commons." *Journal of the West* 45, no. 2 (2006): 29–34.

Fermilab Prairie: http://sustainability.fnal.gov/ecology/prairie/index.html

Great Plains Restoration Council: http://gprc.org/research/buffalo-commons/

Midewin National Tallgrass Prairie: http://www.fs.usda.gov/main/midewin/home

Nachusa Grasslands: http://www.nachusagrasslands.org/

Nature Conservancy, "Nachusa Grasslands": http://www.nature.org/ourinitiatives
/regions/northamerica/unitedstates/illinois/placesweprotect/nachusa-grasslands
.xml

U.S. Fish & Wildlife Service, "Wolf—Western Great Lakes": http://www.fws.gov
/midwest/wolf/

Wolf Park: www.wolfpark.org

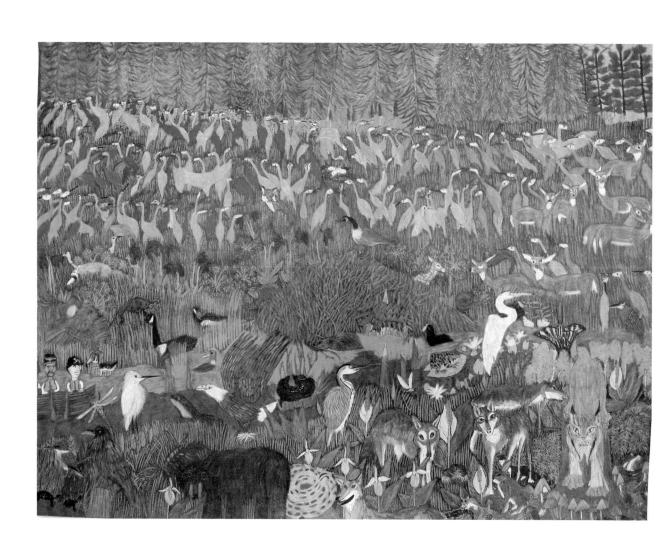

BLAKE LENOIR, *Indiana Dunes*

Recommended Resources

Rather than attempt to produce a comprehensive guide to the ever-expanding literature about the sorts of urban human-animal interactions discussed in *City Creatures,* we have instead provided some hopefully helpful points of entry in this appendix. Interested readers can browse through the sections below to learn more about animals in art, Chicago metropolitan nature, literary and popular works, nature encounter guides, philosophical and humanities perspectives on animals, social and natural sciences perspectives on urban animals, and blogs and websites on these and related topics. Happy reading!

Animals in Art

Aloi, Giovanni. *Art and Animals.* London: I. B. Tauris, 2012.

Baker, Steve. *Artist/Animal.* Minneapolis: University of Minnesota Press, 2013.

———. *Picturing the Beast: Animals, Identity, and Representation.* New ed. Urbana: University of Illinois Press, 2001.

———. *The Postmodern Animal.* London: Reaktion, 2000.

Berger, John. "Why Look at Animals?" In *About Looking,* 1–26. London: Writers and Readers, 1980.

Broglio, Ron. *Surface Encounters: Thinking with Animals and Art.* Minneapolis: University of Minnesota Press, 2011.

Clark, Kenneth. *Animals and Men: Their Relationship as Reflected in Western Art from Prehistory to the Present Day.* New York: W. Morrow, 1977.

Lucie-Smith, Edward. *Zoo: Animals in Art.* New York: Watson-Guptill, 1998.

Magee, Judith. *Art and Nature: Three Centuries of Natural History Art from around the World.* Vancouver: Greystone Books, 2009.

Morphy, Howard, ed. *Animals into Art.* London: Unwin Hyman, 1989.

Chicago Metropolitan Nature

Bryson, Michael A. "Empty Lots and Secret Places: Leonard Dubkin's Exploration of Urban Nature in Chicago." *Interdisciplinary Studies in Literature and Environment* 18, no. 1 (2011): 47–66.

Chicago Metropolitan Agency for Planning. *Refinement of the Chicago Wilderness Green Infrastructure Vision Final Report.* Chicago: Chicago Metropolitan Agency for Planning, 2012. Available online at http://www.cmap.illinois.gov/documents/10180

/11696/GIV20_FinalReport_2012-06.pdf/dd437709-214c-45d6-a036
-5d77244dcedb.

Chicago Region Biodiversity Council. *Biodiversity Recovery Plan*. Chicago:
Chicago Region Biodiversity Council, 1999. Available online at http://www
.chicagowilderness.org/resources/.

Chicago Wilderness Alliance. *Atlas of Biodiversity*, 2nd ed. Chicago: Chicago Region
Biodiversity Council, 2011. Available online at http://www.chicagowilderness.org/
resources/.

Cronon, William. *Nature's Metropolis: Chicago and the Great West*. New York: Norton,
1992.

Dubkin, Leonard. *My Secret Places: One Man's Love Affair with Nature in the City*.
Philadelphia: David McKay, 1972.

———. *The Natural History of a Yard*. Chicago: H. Regnery, 1955.

Greenberg, Joel. *A Natural History of the Chicago Region*. Chicago: University of
Chicago Press, 2004.

Greenberg, Joel, ed. *Of Prairie, Woods, and Water: Two Centuries of Chicago Nature
Writing*. Chicago: University of Chicago Press, 2008.

Hill, Libby. *The Chicago River: A Natural and Unnatural History*. Chicago: Lake Clare-
mont Press, 2000.

Jordan, William R., and George M. Lubick. *Making Nature Whole: A History of
Ecological Restoration*. Washington, DC: Island Press, 2011.

Macnamara, Peggy, John Bates, and James H. Boone. *The Art of Migration: Birds, Insects,
and the Changing Seasons in Chicagoland*. Chicago: University of Chicago Press, 2013.

Mayoral Nature and Wildlife Advisory Committee and the Department of Housing
and Economic Development. *Chicago Nature and Wildlife Plan Update: A Strategy
to Enhance Urban Ecosystems 2011-2016*. August 2011. Available online at http://
www.cityofchicago.org/content/dam/city/depts/zlup/Sustainable_Development/
Publications/Chicago_Nature_and_Wildlife_Plan/Nature_Wildlife_Update
_2MB.pdf.

Platt, Rutherford H., ed. *The Humane Metropolis: People and Nature in the Twenty-First
Century City*. Amherst: University of Massachusetts Press, 2006.

Shaw, Robert, and Jason Lindsey. *Windy City Wild: Chicago's Natural Wonders*. Chicago:
Chicago Review Press, 2000.

Smith, Carl. *The Plan of Chicago: Daniel Burnham and the Remaking of the American City*.
Chicago: University of Chicago Press, 2006.

Stevens, W. K. *Miracle under the Oaks: The Revival of Nature in America*. New York:
Pocket, 1996.

Sullivan, Jerry. 2004. *Hunting for Frogs on Elston: And Other Tales from Field and Street*.
Chicago: University of Chicago Press.

Wille, Lois. *Forever Open, Clear, and Free: The Struggle for Chicago's Lakefront*. 2nd ed.
Chicago: University of Chicago Press, 1991.

Literary and Popular Works

Barilla, James. *My Backyard Jungle: The Adventures of an Urban Wildlife Lover Who
Turned His Yard into Habitat and Learned to Live with It*. New Haven, CT: Yale
University Press, 2013.

Bosselaar, Laure-Anne, ed. *Urban Nature: Poems about Wildlife in the City*. Minneapolis:
Milkweed Editions, 2000.

Chiappone, Richard, et al. *City Fishing*. Mechanicsburg, PA: Stackpole Books, 2002.

Couturier, Lisa. *The Hopes of Snakes: And Other Tales from the Urban Landscape*. Boston:
Beacon Press, 2005.

Daniel, Eddee. *Urban Wilderness: Exploring a Metropolitan Watershed.* Chicago: Center for American Places, 2008.

DeStefano, Stephen. 2010. *Coyote at the Kitchen Door: Living with Wildlife in Suburbia.* Cambridge, MA: Harvard University Press.

Dixon, Terrell, ed. *City Wilds: Essays and Stories about Urban Nature.* Athens: University of Georgia Press, 2002.

Fate, Tom Montgomery. *Cabin Fever: A Suburban Father's Search for the Wild.* Boston: Beacon Press, 2011.

Fleischner, Thomas Lowe, ed. *The Way of Natural History.* San Antonio, TX: Trinity University Press, 2011.

Gillespie, Allison. *Hives in the City: Keeping Honey Bees Alive in an Urban World.* Silver Spring, MD: Croydon Hill, 2014.

Green, Chris, and Liam Heneghan, eds. *Brute Neighbors: Urban Nature Poetry, Prose and Photography.* Chicago: DePaul University Humanities Center, 2011.

Haupt, Lyanda Lynn. *The Urban Bestiary: Encountering the Everyday Wild.* New York: Little, Brown, 2013.

Kaufman, Kenn, and John Treadwell Nichols, eds. *City Birding: True Tales of Birds and Birdwatching in Unexpected Places.* Mechanicsburg, PA: Stackpole Books, 2003.

Matthews, Anne. *Wild Nights: Nature Returns to the City.* New York: North Point Press, 2001.

Mooallem, Jon. *Wild Ones: A Sometimes Dismaying, Weirdly Reassuring Story about Looking at People Looking at Animals in America.* New York: Penguin, 2013.

Pyle, Robert Michael. *The Thunder Tree: Lessons from an Urban Wildland.* Boston: Houghton Mifflin, 1993.

Rosen, Jonathan. *The Life of the Skies: Birding at the End of Nature.* New York: Macmillan, 2008.

Sterba, Jim. *Nature Wars: The Incredible Story of How Wildlife Comebacks Turned Backyards into Battlegrounds.* New York: Crown, 2012.

Sullivan, Robert. *The Meadowlands: Wilderness Adventures at the Edge of a City.* New York: Scribner, 1998.

Tallmadge, John. *The Cincinnati Arch: Learning from Nature in the City.* Athens: University of Georgia Press, 2004.

Winn, Marie. *Central Park in the Dark: More Mysteries of Urban Wildlife.* New York: Farrar, Straus & Giroux, 2008.

———. *Red-Tails in Love: A Wildlife Drama in Central Park.* New York: Pantheon Books, 1998.

Woolfson, Esther. *Field Notes from a Hidden City: An Urban Nature Diary.* London: Granta Books, 2013.

Nature Encounter Guides

Comstock, Anna Botsford. *Handbook of Nature Study.* 1939. Rev. ed. Ithaca, NY: Cornell University Press, 1986.

Cornell, Joseph. *Sharing Nature with Children: The Classic Parents' and Teachers' Awareness Guidebook.* 2nd ed. Nevada City, CA: Dawn Publications, 1998.

Feinstein, Julie. *Field Guide to Urban Wildlife: Common Animals of Cities and Suburbs— How They Adapt and Thrive.* Mechanicsburg, PA: Stackpole Books, 2011.

Garber, Steven D. *The Urban Naturalist.* 1987. Reprint, Mineola, NY: Dover, 1998.

Hadidian, John. *Wild Neighbors: The Humane Approach to Living with Wildlife.* 2nd ed. Washington, DC: Humane Society Press, 2007.

Lawrence, Gale. *A Field Guide to the Familiar: Learning to Observe the Natural World.* 1984. Reprint, Hanover, NH: University Press of New England, 1998.

Leslie, Clare Walker. *Keeping a Nature Journal: Discover a Whole New Way of Seeing the World around You.* 2nd ed. North Adams, MA: Storey Publishing, 2003.

———. *The Nature Connection: An Outdoor Workbook for Kids, Families, and Classrooms.* North Adams, MA: Storey Publishing, 2010.

Tornio, Stacy, and Ken Keffer. *The Kids' Outdoor Adventure Book: 448 Great Things to Do in Nature before You Grow Up.* Guilford, CT: Falcon Guides, 2013.

Philosophical and Humanities Perspectives on Animals

Abram, David. *The Spell of the Sensuous: Perception and Language in a More-Than-Human World.* New York: Vintage, 1997.

Aftandilian, Dave. "Animals Are People, Too: Ethical Lessons about Animals from Native American Sacred Stories." *Interdisciplinary Humanities* 27, no. 1 (2010): 79–98.

Aftandilian, Dave, Marion W. Copeland, and David Scofield Wilson, eds. *What Are the Animals to Us?: Approaches from Science, Religion, Folklore, Literature, and Art.* Knoxville: University of Tennessee Press, 2007.

Atkins, Peter, ed. *Animal Cities: Beastly Urban Histories.* Farnham, Surrey: Ashgate, 2012.

Biehler, Dawn. *Pests in the City: Flies, Bedbugs, Cockroaches, and Rats.* Seattle: University of Washington Press, 2013.

Brantz, Dorothee, ed. *Beastly Natures: Animals, Humans, and the Study of History.* Charlottesville: University of Virginia Press, 2010.

Cheney, Jim. "The Moral Epistemology of First Nations Stories." *Canadian Journal of Environmental Education* 7, no. 2 (2002): 88–100.

Cronon, William. "The Trouble with Wilderness: Or, Getting Back to the Wrong Nature." *Environmental History* 1, no. 1 (1996): 7–28.

Deane-Drummond, Celia, Rebecca Artinian-Kaiser, and David Clough, eds. *Animals as Religious Subjects: Transdisciplinary Perspectives.* London: Bloomsbury T&T Clark, 2013.

Deane-Drummond, Celia, and David Clough, eds. *Creaturely Theology: On God, Humans and Other Animals.* Norwich, UK: SCM Press, 2009.

Gross, Aaron. *The Question of the Animal and Religion: Theoretical Stakes, Practical Implications.* New York: Columbia University Press, 2014.

Gross, Aaron, and Anne Vallely, eds. *Animals and the Human Imagination: A Companion to Animal Studies.* New York: Columbia University Press, 2012.

Gruen, Lori. *Ethics and Animals: An Introduction.* Cambridge: Cambridge University Press, 2011.

Harvey, Graham. *Animism: Respecting the Living World.* New York: Columbia University Press, 2006.

Ingold, Tim. *The Perception of the Environment: Essays in Livelihood, Dwelling, and Skill.* London: Routledge, 2000.

McHugh, Susan. *Animal Stories: Narrating across Species Lines.* Minneapolis: University of Minnesota Press, 2011.

McShane, Clay, and Joel A. Tarr. *The Horse in the City: Living Machines in the Nineteenth Century.* Baltimore: Johns Hopkins University Press, 2007.

Sabloff, Annabelle. *Reordering the Natural World: Humans and Animals in the City.* Toronto: University of Toronto Press, 2001.

Shepard, Paul. *The Others: How Animals Made Us Human.* Washington, DC: Island Press, 1997.

Stefanovic, Ingrid Leman, and Stephen Bede Scharper, eds. *The Natural City: Re-envisioning the Built Environment.* Toronto: University of Toronto Press, 2012.

Swanson, Frederick J., Charles Goodrich, and Kathleen Dean Moore. "Bridging

Boundaries: Scientists, Creative Writers, and the Long View of the Forest." *Frontiers in Ecological Environmentalism* 6, no. 9 (2008): 499–504.

Tallmadge, John. "Linked through Story: Natural Science, Nature Writing, and Traditional Ecological Knowledge." *Journal of Natural History Education and Experience* 5 (2011): 49–57.

Thorsen, Liv Emma, Karen A. Rader, and Adam Dodd, eds. *Animals on Display: The Creaturely in Museums, Zoos, and Natural History.* University Park: Pennsylvania State University Press, 2013.

Velten, Hannah. *Beastly London: A History of Animals in the City.* London: Reaktion, 2013.

Waldau, Paul. *Animal Rights: What Everyone Needs to Know.* Oxford: Oxford University Press, 2011.

———. *Animal Studies: An Introduction.* Oxford: Oxford University Press, 2013.

Waldau, Paul, and Kimberley Patton, eds. *A Communion of Subjects: Animals in Religion, Science, and Ethics.* New York: Columbia University Press.

Social and Natural Science Perspectives on Urban Animals

Beisner, Beatrix, Christian Messier, and Luc-Alain Giraldeau, eds. *Nature All Around Us: A Guide to Urban Ecology.* Chicago: University of Chicago Press, 2012.

Brenneisen, Stephan. "Space for Urban Wildlife: Designing Green Roofs as Habitats in Switzerland." *Urban Habitats* 4 (2006): 27–36.

Chawla, Louise. "Children's Concern for the Natural Environment." *Children's Environments Quarterly* 5, no. 3 (1988): 13–20.

Dearborn, Donald C., and Salit Kark. "Motivations for Conserving Urban Biodiversity." *Conservation Biology* 24, no. 2 (2010): 432–40.

DeMello, Margo. *Animals and Society: An Introduction to Human-Animal Studies.* New York: Columbia University Press, 2012.

Deutsche Umwelthilfe. "Wild Cities: Wildness in an Urban Context." Results from the Wild Cities Project, 2012/2013, Berlin, Germany. May 2013. Available online at http://www.duh.de/uploads/media/Ergebnispapier_WildCities_engl_01.pdf.

Flynn, Clifton P., ed. *Social Creatures: A Human and Animal Studies Reader.* New York: Lantern Books, 2008.

Fuller, R. A., K. N. Irvine, P. Devine-Wright, P. H. Warren, and K. J. Gaston. "Psychological Benefits of Greenspace Increase with Biodiversity." *Biological Letters* 3 (2007): 390–94.

Gehrt, Stanley D., Seth P. D. Riley, and Brian L. Cypher, eds. *Urban Carnivores: Ecology, Conflict, and Conservation.* Baltimore: Johns Hopkins University Press, 2010.

Gleason, Kevin J. "Valuing Common Species." *Science* 327 (2010): 154–55.

Grove, J. Morgan. "Cities: Managing Densely Settled Social-Ecological Systems." In *Principles of Ecosystem Stewardship: Resilience-Based Natural Resource Management in a Changing World*, edited by F. Stuart Chapin, Gary P. Kofinas, and Carl Folke, 281–94. New York: Springer, 2009.

Heneghan, Liam, Christopher Mulvaney, Kristen Ross, Lauren Umek, Cristy Watkins, Lynne M. Westphal, and David H. Wise. "Lessons Learned from Chicago Wilderness—Implementing and Sustaining Conservation Management in an Urban Setting." *Diversity* 4, no. 1 (2012): 74–93.

Hurn, Samantha. *Humans and Other Animals: Cross-Cultural Perspectives on Human-Animal Interactions.* London: Pluto Press, 2012.

Kahn, Peter H., Jr. "Children's Affiliations with Nature: Structure, Development, and the Problem of Environmental Generational Amnesia." In *Children and Nature:*

Psychological, Sociocultural, and Evolutionary Investigations, edited by Peter H. Kahn Jr. and Stephen R. Kellert, 93–116. Cambridge, MA: MIT Press, 2002.

Kark, Salit, Andrew Iwaniuk, Adam Schalimtzek, and Eran Banker. "Living in the City: Can Anyone Become an 'Urban Exploiter'?" *Journal of Biogeography* 34, no. 4 (2007): 638–51.

McGranahan, G., et al. "Urban Systems." In *Ecosystems and Human Well-Being: Current State and Trends*. Washington, DC: Island Press, 2005.

McKinney, Michael L. "Effects of Urbanization on Species Richness: A Review of Plants and Animals." *Urban Ecosystems* 11 (2008): 161–76.

———. "Urbanization, Biodiversity, and Conservation." *BioScience* 52, no. 10 (October 2002): 883–90.

Miller, James R. "Biodiversity Conservation and the Extinction of Experience." *TRENDS in Ecology and Evolution* 20, no. 8 (2005): 430–34.

———. "Restoration, Reconciliation, and Reconnecting with Nature Nearby." *Biological Conservation* 127, no. 3 (2006): 356–61.

Miller, James R., and Richard J. Hobbs. "Conservation Where People Live and Work." *Conservation Biology* 16, no. 2 (April 2002): 330–37.

Mitchell, Joseph C., Robin E. Jung Brown, and Breck Bartholomew, eds. *Urban Herpetology*. Salt Lake City: Society for the Study of Amphibians and Reptiles, 2008.

Nagy, Kelsi, and Phillip David Johnson II, eds. 2013. *Trash Animals: How We Live with Nature's Filthy, Feral, Invasive, and Unwanted Species*. Minneapolis: University of Minnesota Press.

Philo, Chris, and Chris Wilbert, eds. *Animal Spaces, Beastly Places: New Geographies of Human-Animal Relations*. London: Routledge, 2000.

Pickett, Steward T. A., et al. "Beyond Urban Legends: An Emerging Framework of Urban Ecology, as Illustrated by the Baltimore Ecosystem Study." *BioScience* 58 (2008): 139–50.

Rabb, George B., and Carol D. Saunders. "The Future of Zoos and Aquariums: Conservation and Caring." *International Zoo Yearbook* 39 (2005): 1–26.

Rosenzweig, Michael L. *Win-Win Ecology: How the Earth's Species Can Survive in the Midst of Human Enterprise*. Oxford: Oxford University Press, 2003.

Sanderson, Eric W. *Mannahatta: A Natural History of New York City*. New York: Henry N. Abrams, 2009.

Secretariat of the Convention on Biological Diversity. *Cities and Biodiversity Outlook—Action and Policy*. Montreal, Quebec: World Trade Center. Available at http://www.cbd.int/doc/health/cbo-action-policy-en.pdf.

Stanvliet, R., J. Jackson, G. Davis, C. De Swardt, J. Mokhoele, Q. Thom, and B. D. Lane. "The UNESCO Biosphere Reserve Concept as a Tool for Urban Sustainability: The CUBES Cape Town Case Study." *Annals of the New York Academy of Sciences* 1023 (2004): 80–104.

Urbanik, Julie. *Placing Animals: An Introduction to the Geography of Human-Animal Relations*. Lanham, MD: Rowman & Littlefield, 2012.

Vining, Joanne. "The Connection to Other Animals and Caring for Nature." *Human Ecology Review* 10, no. 2 (2003): 87–99.

Blogs and Websites

Animal: Topics in Animal Studies: http://animalstudiesblog.wordpress.com
Biophilic Cities: http://biophiliccities.org
Center for Humans and Nature: www.humansandnature.org
Chicago Wilderness: www.chicagowilderness.org
Chicago Wilderness Habitat Project: www.habitatproject.org

Children & Nature Network blog: http://blog.childrenandnature.org

Cities and Biodiversity Outlook: www.cbobook.org/?r=1&width=1920

City Creatures Blog: www.humansandnature.org/blog/

EcoMyths: http://www.ecomythsalliance.org

Environmental Humanities: http://environmentalhumanities.org

The Expanded Environment: www.expandedenvironment.org

The Metropolitan Field Guide: Ideas and Resources for the Design of Urban Wildlife Habitat: www.metrofieldguide.com

The Nature Conservancy, Volunteer Stewardship Network (Illinois): www.nature.org /ourinitiatives/regions/northamerica/unitedstates/illinois/volunteer/

The Nature of Cities: A Collective Forum on Cities as Ecological Spaces: www .thenatureofcities.com

Next-Door Nature: Your Guide to Wildlife Watching Where the Sidewalk Begins: http:// nextdoornature.org

Outdoor Afro: Where Black People and Nature Meet: www.outdoorafro.com

Project Passenger Pigeon: Lessons from the Past for a Sustainable Future: http:// passengerpigeon.org

Project Squirrel: www.projectsquirrel.org

The Rattling Crow: A Blog on Bird Behaviour: http://therattlingcrow.blogspot.com

Relations: Beyond Anthropocentrism: http://www.ledonline.it/index.php/Relations /index

Sociological Insect: On Bees, Humans & Hybrids: http://sociologicalinsect.com

SustainableCitiesCollective: The World's Best Thinkers on the Urban Future: http:// sustainablecitiescollective.com

Urban Coyote Research: Urban Coyote Ecology and Management, Cook County, Illinois: http://urbancoyoteresearch.com

Urban Ecology Center: http://urbanecologycenter.org

Urban Ecology Research Lab (Seattle, WA): http://urbaneco.washington.edu/wp/

Urban Habitats: An Electronic Journal on the Biology of Urban Areas around the World: http://www.urbanhabitats.org/index.html

Urban Pollinators Project, University of Bristol: http://www.bristol.ac.uk/biology/ research/ecological/community/pollinators/

Urban Wildlife Guide: www.urbanwildlifeguide.net

Urban Wildlife Habitat: http://paper.li/MetroFieldGuide/1340236094

The Xerces Society for Invertebrate Conservation: www.xerces.org

Your Wild Life: Exploring Biodiversity in Our Daily Lives: www.yourwildlife.org

About the Contributors

DAVE AFTANDILIAN is associate professor of anthropology at Texas Christian University. He is the coeditor of *What Are the Animals to Us?: Approaches from Science, Religion, Folklore, Literature, and Art* (University of Tennessee Press, 2007), former co-chair of the American Academy of Religion's Animals and Religion Group, and chair of the Tarrant County Food Policy Council's Working Group on Community Gardens and Urban Agriculture. His research and teaching interests include animals and religion, Native American religions and ecology (past and present), contemplative studies, and food justice.

RENÉ H. ARCEO was born in Mexico and moved to Chicago in 1979. He graduated from the School of the Art Institute of Chicago with a Fine Arts degree and a Teacher Certificate (K–12). For thirteen years he worked for the National Museum of Mexican Art in various capacities including as arts director. In 2000 he started working for the Chicago Board of Education coordinating their art collection, website, and related exhibitions as well as district-wide art student programs. Since 2007 he has been an art instructor at Monroe Elementary School. Arceo has participated in dozens of group and solo exhibitions in the United States, Mexico, Canada, Poland, France, Nicaragua, and Spain. His artworks can be found in public and private collections in Mexico, the United States, Poland, and France. He founded Arceo Press in 2003 to foster international collaborations among printmakers; so far Arceo has published six limited-edition print portfolios with artists. Visit him online at www.arceoart.us.

GREGORY J. AUBERRY writes: "What started out as just a hobby has turned out to be so much more than I had ever imagined. In my particular case, it is my lifeline to life: over the years I've battled heart failure and cancer, but my camera lets me forget all that (for the most part) despite many limitations."

JAMES BALLOWE is an essayist, poet, and editor. His latest two books are a biography of the founder of Morton Salt and the Morton Arboretum, *A Man of Salt and Trees: The Life of Joy Morton* (Northern Illinois University Press, 2009), and an anthology, *Christmas in Illinois* (University of Illinois Press, 2010). A lifelong Illinoisan, he is a distinguished professor emeritus from Bradley University and now teaches creative writing and environmental ethics in the Morton Arboretum's Natural History Certificate program.

REBECCA BEACHY, born in Denver, Colorado, is a recipient of both an MFA in studio arts and an MA in art history from the University of Illinois at Chicago. She has also taught at the University of Illinois at Chicago and currently teaches "Contemporary

Practices" at the Chicago High School for the Arts. In Chicago her ephemeral sculptures, interventions, and installations have been exhibited at Iceberg Projects, 6018NORTH, the Southside Hub of Production, and Gallery 400, among other spaces. Her written work has been published in the literary journal *Puerto del Sol*. As a volunteer specimen preparator and educator, Beachy also demonstrates taxidermy to the public at the Peggy Notebaert Nature Museum for the Chicago Academy of Sciences, Department of Collections. Visit her online at www.rebeccabeachy.com.

DAVID BECKER is senior manager of Learning Experiences for the Chicago Zoological Society, which operates Brookfield Zoo, the Center for Conservation Leadership, and the Center for the Science of Animal Welfare. In 2013 he and his team were honored at the White House as a "Champion of Change" for their leadership in early childhood programming in the zoo, aquarium, and museum field. He is also a proud parent and grandparent who enjoys sharing the love of animals and nature with his family.

SHARON BLADHOLM has explored the intersections of art, science, conservation, and the natural world for over thirty years. Her work has been profoundly influenced by participation in scientific expeditions to the Amazon as well as other wild and remote places. She has run Opal Glass Studios since 1983 and continues to complete many important commissions and show her work in galleries and museums, as well as creating public art installations at venues such as Garfield Park, Lincoln Park Conservatory, and the Museum of Contemporary Art in Bordeaux, France. She has completed sculptural works in glass and bronze of endangered species for the Peggy Notebaert Nature Museum's permanent exhibit *Mysteries of the Marsh*. *Soil: Alive with Life*, an outdoor permanent public art piece based on soil microorganisms, was created in 2011 for the Openlands Lakeshore Preserve. Visit her online at www.sharonbladholm.com.

TERRA BROCKMAN returned to her rural Illinois roots after living in Tokyo, New York, Chicago, and other cities. She is a speaker and an author whose writing has appeared in *Edible Chicago*, the *Christian Century*, *Orion Magazine*, *Zester Daily*, and elsewhere. Her book about her brother's extremely diverse organic vegetable farm, *The Seasons on Henry's Farm: A Year of Food and Life on a Sustainable Farm* (Surrey Books, 2009), was a finalist for a 2010 James Beard Award. Terra is also the founder of the Land Connection (http://thelandconnection.org), an educational nonprofit that is working to ensure that more Illinois farmland will be well-stewarded for future generations. Visit her online at www.brockmanfamilyfarming.com.

JOEL S. BROWN is professor of biological sciences at the University of Illinois at Chicago. Early childhood experiences in Zimbabwe gave him a lifelong love of wildlife. Since then, he and his graduate students have worked from A to Z with aardvarks in South Africa, snow leopards in Nepal, zebras at the Brookfield Zoo, and, of course, squirrels whenever possible.

MICHAEL A. BRYSON is associate professor of humanities at Roosevelt University in Chicago, where he cofounded and directs their program in Sustainability Studies. Bryson's research and writing interests include sustainability within urban and suburban environments, city-based nature writing, the evolving notion of "urban wilderness," and the environmental and literary history of the Chicago region. His publications include *Visions of the Land: Science, Literature, and the American Environment from the Era of Exploration to the Age of Ecology* (University Press of Virginia, 2002). He lives in the city of Joliet, Illinois, with his family.

BRENDA CÁRDENAS is the author of two poetry collections, *Boomerang* (Bilingual Press, 2009) and *From the Tongues of Brick and Stone* (Momotombo Press, 2005). She also coedited *Between the Heart and the Land: Latina Poets in the Midwest* (March/Abrazo Press, 2001). Her work has also appeared or is forthcoming in a number of publications, including *Cuadernos de ALDEEU*; *Mind the Gap: A Portfolio of Poem-Print Translations*; *Brute Neighbors: Urban Nature Poetry*; *Prose and Photography*; *The Wind Shifts: New Latino Poetry*; *The City Visible: Chicago Poetry for the New Century*; *The Golden Shovel Anthology: Honoring the Continuing Legacy and Influence of Gwendolyn Brooks*; and many others. She is associate professor of English at the University of Wisconsin–Milwaukee.

CARLOS ERNESTO URIBE CARDOZO was born in Bucaramanga, Colombia, and grew up in the city of Barrancabermeja. In 1999 he moved to Fort Lauderdale, Florida, and studied art at Broward Community College. During his time in college, he took his first classes in photography. Inspired by his photography teacher Teresa Diehl, and knowing that photography was his life passion, he moved to Chicago in 2008 to continue his studies in photography at Columbia College. He is currently a senior photography student at Columbia College and works at the Museum of Contemporary Photography.

ALEX CHITTY is an artist who stands at about 5'6" and is of average weight and build.
Born = Miami, 1979
Lives = Chicago (mostly)
BFA = Smith College
MFA = School of the Art Institute of Chicago
Work = Educator at Museum of Contemporary Art, School of the Art Institute of
 Chicago, and Columbia College
Before working as an artist and educator, Chitty worked as a field biologist in Miami,
 New York City, Belize, Micronesia, and the Philippines, studying native plants and
 marine ecology.
See more = www.alexchitty.com.

BENN COLKER is a 2010 graduate of Cornell University, where he studied architecture. He writes: "I am a collector of things. I collect round things. Rusty things. Precious things. Things in the midst of some grand journey. I am also a creator of things. Finely crafted things. Functional things. Non-functional things. Things that simply must be made. All these things take up residence in the mysterious world I call home. They live and die. They evolve and decay. They speak of other things they once knew—of remarkable things that I don't understand. With wonder and curiosity, I do my best to participate." You can see some of his things online at www.benncolkerprojects.com.

BROOKE COLLINS is a photographer based in Chicago. For the past seven years, she has been the official photographer for Chicago's mayor. Her photographs have been featured in a variety of local and national media outlets, including *O Magazine*, *Businessweek*, *Chicago Magazine*, and the *Huffington Post*. She has participated in many gallery showings, most notably at the Museum of Contemporary Art in an exhibition entitled *The Journey— The Next Hundred Years*. She has taught photography to students in the Chicago Public Schools and for the Chicago Park District. She has also volunteered for the Heart Campaign, a national project in which professional photographers create portraits of youths in the foster care system in an effort to increase awareness of adoption. You can view some of her photographs online at mayorsphotogallery.cityofchicago.org.

MARK CRISANTI's collage/paintings address evolution and an often-awry coexistence in our rapidly advancing world. By attaching a bird head to a human body, Crisanti blurs our perception between man and animal, yet carefully avoids anthropomorphizing his portrayals. The blank stare of each bird amidst daily vices and activities confronts us with the irony of our own human actions. Crisanti uses various ephemera as backgrounds—dictionary pages, S&H green stamps, game boards, and manuals—to enrich his confrontations. Chicago native Crisanti lives and works in Chicago and is represented by Packer Schopf Gallery. For more see www.packergallery.com/crisanti2/index.php.

MARY CROSS's poems, short stories, and essays have appeared in various journals, including the *Sun*, *Crazyhorse*, *Hotel Amerika*, and Featherproof Press's mini-book series, and have also aired on Chicago Public Radio. She is also the author of the poetry collection *Rooms, Which Were People* (Ohio State University Press, 1990). Cross teaches in the MFA in Writing Program at the School of the Art Institute of Chicago and is currently working on a lyric essay trilogy, which incorporates her photographs from a wild horse sanctuary in South Dakota.

CAMILO CUMPIAN is a multitalented visual artist who works in silk screen, murals, and tattoos. His mentors include (but are not limited to) Francisco Mendoza, Chris Drew, and Carlos A. Cortez, all Chicago-based artists. He currently works at Twisted Tattoo on Elston Avenue in Chicago. You can contact him at C2Ctattoos@gmail.com.

TODD DAVIS teaches environmental studies at Penn State University's Altoona College. He is the author of four books of poems, most recently *In the Kingdom of the Ditch* (2013) and *The Least of These* (2010), both from Michigan State University Press. His poetry has appeared widely in such places as the *American Poetry Review*, *Poetry Daily*, *Gettysburg Review*, *Shenandoah*, *North American Review*, and *Iowa Review*.

CANNON DILL was born in 1991 and is currently living in Oakland, California. Dill attended California College of the Arts and is known for his illustrative and public mural work that can be found throughout the United States.

ALMA DOMÍNGUEZ was born in the state of Chihuahua, Mexico, where she lived most of her life. Her father is a guitarist and awakened her interest in music at a very early age. In 1994 she enrolled at the Universidad Autónoma de Chihuahua in the Institute of Fine Arts, where she earned her BA in music (although her work explores many aspects of the arts). She is also a psychologist with a master's in the social sciences, and both of these disciplines have strongly influenced her artwork. She uses diverse techniques (watercolor, acrylic and oil on paper, canvas, and metal), but predominantly mixed media. She has participated in many exhibitions in Mexico, the United States, Spain, Italy, Nicaragua, Argentina, Santiago de Chile, and Russia. She has lived in the Chicago area for seven years. Visit her online at almadominguez.blogspot.com.

HECTOR DUARTE was born in 1952 in Caurio, Michoacán, Mexico. He studied mural painting at the workshop of David Alfaro Siqueiros in 1977. Since moving to Chicago in 1985, Duarte has participated in the creation of more than fifty murals. He has exhibited his paintings and prints in solo and collective shows at such venues as the National Museum of Mexican Art, the School of the Art Institute, the State of Illinois Gallery, the Chicago Historical Society, and Museo Casa Estudio Diego Rivera y Frida Kahlo in Mexico. Duarte has received a number of awards, including a 1994 National Endowment for the Arts project grant. In 2006 he participated in the Smithsonian Folklife Festival on

the National Mall in Washington, D.C., as an invited muralist. Duarte is the cofounder of the Julio Ruelas Print Workshop in Zacatecas, Mexico; La Casa de la Cultura in Zamora, Mexico; and the Mexican Printmaking Workshop in Chicago. Visit him online at www .hectorduarte.com.

JOAN GIBB ENGEL writes about how we children of nature can preserve the natural world in all of its splendor for the children of tomorrow. To this end, she has contributed personal essays and poetry to a variety of publications and has edited several works that deal with environmental ethics, including *Ethics of Environment and Development: Global Challenge, International Response* (University of Arizona Press, 1990).

J. RONALD ENGEL has been a high school biology teacher, park ranger, community organizer, Unitarian Universalist minister, professor at Meadville/Lombard Theological School and the University of Chicago, and author of several books and numerous essays in the field of religious social ethics and ecology. His book *Sacred Sands: The Struggle for Community in the Indiana Dunes* (Wesleyan University Press, 1983) was a study of the democratic faith that informed the birth of the science of ecology at the University of Chicago and inspired the century-long struggle to preserve the Dunes as state and national parks. In 1992 he and Joan Gibb Engel took up residence in Beverly Shores, a small town within the boundaries of the Indiana Dunes National Lakeshore.

TERRY EVANS has photographed the prairies and plains of North America and the urban prairie of Chicago. Combining both aerial and ground photography, she delves into the intricate and complex relationships between land and people. Evans is a Guggenheim Fellow and a recipient of an Anonymous Was a Woman award. Her work is in many major museum collections, including the Art Institute of Chicago, Museum of Modern Art (MoMA) in New York, San Francisco Museum of Modern Art, and the Whitney Museum of American Art. Recent exhibitions of her work have included a show at the Field Museum of Natural History and a retrospective at the Nelson-Atkins Museum of Art in Kansas City, with a catalog entitled *Heartland: The Photographs of Terry Evans*. She is also the author of *Prairie Stories* (Radius Books, 2012). Visit her online at www.terryevansphotography.com.

TOM MONTGOMERY FATE is the author of five books of nonfiction; the most recent is *Cabin Fever: A Suburban Father's Search for the Wild* (Beacon Press, 2011), a nature memoir. His essays have appeared in the *Chicago Tribune*, the *Boston Globe*, *Orion*, and the *Iowa Review*, among others, and they have aired on NPR, PRI, and Chicago Public Radio. He is professor of English at the College of DuPage in Chicago.

BRETT FLANIGAN currently lives and works in Oakland, California. His background in science and an interest in folklore and natural order/disorder often guide his work, which tends to manifest itself in the form of gouache paintings, 35mm photographs, or large-scale aerosol murals. Brett has spent much of the past few years traveling within the United States and abroad, gaining perspective and influence from the people he has met along the way.

KYLE GATI, principal of Gati Design Inc., is an industrial designer and artist by day, but feels his hobbies are what help him find the balance between nature and urban life. He enjoys fly-fishing, urban gardening, yoga, and beekeeping in Chicago. Visit him online at www.thehivelife.com.

STANLEY D. GEHRT is associate professor of wildlife ecology at the Ohio State University and chair of the Center for Wildlife Research at the Max McGraw Wildlife Foundation. His research focuses on various aspects of mammalian ecology, especially urban systems, and dynamics of wildlife disease. He is principal investigator of the largest urban coyote study conducted to date, in which he and his research team have tracked over seven hundred coyotes in the Chicago area for the past fifteen years.

BROOKS BLAIR GOLDEN (1974–2014) was an artist from Milwaukee who focused primarily on highly detailed drawing and painting. Growing up surrounded by skateboarding and graffiti culture in Milwaukee introduced Brooks to many different styles and avenues through which to express his creative voice. Toward the end of his life, he worked especially on wall painting, bringing his unique brand of nature-inspired symbolism and bold graphic style to the long-standing mural tradition in Chicago and surrounding areas.

JOEL GREENBERG has MA and JD degrees from Washington University and over twenty-five years of experience working on natural resource-related issues in the Midwest. Currently a research associate of both the Chicago Academy of Sciences Peggy Notebaert Nature Museum and the Field Museum, he has authored or edited four books, including *Of Prairie, Woods, and Waters: Two Centuries of Chicago Nature Writing* (University of Chicago Press, 2008); *A Natural History of the Chicago Region* (University of Chicago Press, 2002); and *A Feathered River Across the Sky: The Passenger Pigeon's Flight to Extinction* (Bloomsbury USA, 2014). With director David Mrazek, he coproduced the documentary film *From Billions to None: The Passenger Pigeon's Flight to Extinction* (2014).

SUSAN HAHN is the author of nine books of poetry, two produced plays, and one novel. Among her awards for writing are a Guggenheim Fellowship, Pushcart Prizes, Illinois Arts Council Fellowships and Awards, and a Jeff Recommendation. She was the inaugural Writer-in-Residence (2013–14) at the Ernest Hemingway Foundation in Oak Park, Illinois. She is currently working on her second novel.

LIAM HENEGHAN is an ecologist working at DePaul University, where he is professor of environmental science and codirector of the Institute for Nature and Culture. His scholarly interests are in soils and ecological restoration. He is the coeditor of *Brute Neighbors: Urban Nature Poetry, Prose, and Photography* (DePaul University Humanities Center, 2011). He is also a graduate student in philosophy, an occasional poet, and plays the tin whistle poorly.

DAVID HERNANDEZ (1946–2013) was born in Cidra, Puerto Rico, but grew up in Chicago's Wrigleyville neighborhood. Centering his work on the rhythms of urban life, Hernandez captured universal themes with a humorous and singular voice. He was known as both the first Latino poet to be published in Chicago and as the "unofficial Poet Laureate of Chicago," and was the first recipient of the Gwendolyn Brooks Outstanding Poet of Illinois Award. In 1987 he was commissioned by the city of Chicago to write and perform a poem celebrating its sesquicentennial. He also composed the inaugural poem for the late Chicago mayor Harold Washington. A founding member of the Latino Arts Movement, Hernandez received the Puerto Rican Cultural Heritage Award in 2002. He was the author or editor of numerous books of poetry, including *Satin City Lullaby* (Society for Mad Poets Press, 1985), *Rooftop Piper* (Tia Chucha Press, 1991), *Elvis Is Dead But at Least He's Not Gaining Any Weight* (Mary Kuntz Press, 1995), and *The Urban Poems* (Fractal Edge Press, 2004). Hernandez also recorded several CDs with the poetry-with-music ensemble that he founded, Street Sounds.

RYAN HODGSON-RIGSBEE is a photographer based in New Orleans and Chicago. He grew up in Chicago, raised by social worker parents, and studied photojournalism in college. After graduation in 2005, he worked as a staff photographer at the *Orange County (CA) Register* until 2007 when he left the newspaper industry to return to Chicago and work as an independent photographer. While in Chicago, he began a number of personal projects that he is continuing to pursue since moving to New Orleans at the end of 2011. The photo series *Urban Nature and Music Culture* was born out of a personal passion for nature, music, and community. The essays revolve around exploring the blurring point between nature and urban life and also cultivate new appreciation for and insight into our relationship with the everyday, with the world, and with each other. Visit him online at rhrphoto.com.

MICHAEL S. HOGUE is professor of theology at Meadville Lombard Theological School in Chicago. His teaching and writing explore the meanings, forms, and tasks of progressive religion in the context of the Anthropocene. He is the author of *The Tangled Bank: Toward an Ecotheological Ethics of Responsible Participation* (Pickwick, 2008) and *The Promise of Religious Naturalism* (Rowman & Littlefield, 2010).

NIKKI JARECKI is a celebrated visual artist, educator, and illustrator whose work in embroidery, drawing, design, and facilitation can be seen throughout Chicago. Jarecki's imagery is precarious and plants in the viewer's mind the tensions between the beautiful and the deadly, the exalted and the ordinary. Her work as an artist, teacher, and naturalist gathers deeply personal sources to explore the meanings behind a balance of quiet meditations on relationships with the significant details in the natural world. Visit her online at nikkijarecki.wordpress.com or www.offcolorbrewing.com.

KENDRA LANGDON JUSKUS is an award-winning writer who edits the journal *SEVEN*, published by the Marion E. Wade Center at Wheaton College. Her poetry and/ or nonfiction have been published in *Ruminate, Fifth Wednesday Journal, Seeding the Snow, Books & Culture*, and *PRISM*, among others. She is a poetry graduate of Spalding University's MFA program and lives with her husband and son in Illinois.

JOSEPH KAYNE photographs the American landscape and Native American archaeological sites with a 4 × 5 large format view camera. His latest project, entitled *Chicagoesque*, portrays a unique and artistic non-traditional view of the art, culture, and architecture of his native Chicago. His photographs have been exhibited in galleries, museums, and private collections across the country. His publication credits include *LensWork* magazine, *View Camera* magazine, Coldwater Creek, Sierra Club, Arizona Highways, Audubon Calendars (cover), the Nature Conservancy, *Photo Life* magazine, *Natural History* magazine, and the *Chicago Tribune*. He was a featured photographer and named a "Lord of the Landscape" in *Outdoor Photographer* magazine's landscape collector's issue. He exhibits his photographs at the 4Arts Gallery in the Zhou B Art Building in Chicago. Visit him online at www.josephkaynephoto.com.

MICHELLE KOGAN is a Chicago-based artist and writer, whose interest in nature, gardens, and preservation both inspires her artwork and reflects a sensitivity to endangered species, while also drawing attention to human interdependence with nature. She received her BFA and MFA from the School of the Art Institute of Chicago and Northern Illinois University. She recently had solo exhibits at the United States Botanic Garden and the Peggy Notebaert Nature Museum. She also writes and illustrates nature-inspired picture books. Visit her online at www.michellekogan.com.

MARYNIA KOLAK is a Chicago-born writer, cartographer, and interdisciplinary researcher whose words can be found in *Organs of Vision and Speech*, *Ghost Ocean*, and *Inertia* magazines. After studying geology and picking microfossils to investigate climate change, Marynia earned an MFA in writing from Roosevelt University, where she was an editor for the *Oyez Review*, and an MS in GIS and cartography from John Hopkins University. Her work has taken her from the USGS to the Institute of Public Health and Medicine at Northwestern University. She is currently doing PhD research investigating community health in urban environments at the Department of Geography and Urban Planning at Arizona State University.

ELLEN LANYON (1926–2013), a native of Chicago, trained at the School of the Art Institute of Chicago, the University of Iowa, and the Courtauld Institute of Art, University of London. She had over seventy-five solo exhibitions and three major traveling retrospectives. Her work is included in the collections of the Art Institute and the Museum of Contemporary Art in Chicago, the Brooklyn Museum, the Metropolitan Museum of Art, the National Museum of American Art, the National Museum of Women in the Arts, the Walker Art Center, the Milwaukee Museum of Art, and the Hartford Atheneum, among numerous others. She also created major public art commissions for Chicago, Minneapolis, and Miami Beach.

MASKULL LASSERRE was born in Canada in 1978 and spent his early childhood in South Africa. He has a BFA from Mount Allison University (visual art and philosophy) and an MFA from Concordia University (sculpture). He now works out of a studio in Montreal. Lasserre's drawings and sculptures explore the unexpected potential of the everyday through allegories of value, expectation, and utility. Elements of nostalgia, accident, humor, and the macabre are incorporated into works that induce strangeness in the familiar and provoke uncertainty in the expected. Lasserre has exhibited across Canada, the United States, and Europe. He is represented in the collections of the Musée des beaux-arts de Montréal, the Government of Canada, and the Royal Bank, among others. He also recently participated in the Canadian Forces War Artist Program in Afghanistan. Visit him online at maskulllasserre.com.

KIM LAUREL is a Chicago-based mixed-media artist, illustrator, and graphic designer and has exhibited in the United States, Canada, and England since 1977. She studied at Oberlin College, the Cleveland Institute of Art, Cleveland State University, and Illinois State University. Her works of art are part of various public and corporate collections. Laurel's recent curatorial work includes *Her Way with Print*; *Fletcher Hayes & Kim Laurel Collaborations: Black/White/Gray*; *Element Flux*; *Ethereal Fauna: The Artist's Muse*; *Tool Box Flower Box*; *Integrant Element Lab*; *Redux Loop*; *Wild Things and Beyond*. She is a long-standing member of Woman Made Gallery, the Mid America Print Council, the Chicago Printmakers Collaborative, and the Chicago Artists' Coalition. Her art is exhibited in many Chicago galleries and institutions and is represented by the Workshop Print Gallery—Chicago Printmakers Collaborative. Visit her online at www.kimlaurel.com.

BLAKE LENOIR is a longtime member of Project Onward, a studio and gallery that supports the career development of professional artists with disabilities. His elaborately detailed colored-pencil drawings of nature scenes and people working together have been exhibited nationwide. In addition to his artistic talents, Blake is a passionate gardener, environmental and community activist, and advocate for people with autism. Visit him online at projectonward.org/gallery/blake-lenoir.

NORA MOORE LLOYD spent twenty years in the graphic design business and now expresses her passion for photography by focusing on indigenous cultures, nature, and documenting community or family history through traditional storytelling and photos. Visit her online at www.nativepics.org.

PEGGY MACNAMARA, artist in residence at the Field Museum since 1990, is also an adjunct associate professor in the Visual Communication Design Department at the School of the Art Institute of Chicago. Her artworks are part of the permanent collections of the Field Museum, the Illinois State Museum, the Spertus Museum, and New York State Museum. She has published four books, including three with the University of Chicago Press: *Illinois Insects and Spiders* (2005); *Architecture by Birds and Insects: A Natural Art* (2008); and *The Art of Migration: Birds, Insects, and the Changing Seasons in Chicagoland* (2013). She is also coauthor of *Painting Wildlife in Watercolor* (Watson-Guptill, 2003). Visit her online at peggymacnamara.com.

CURT MEINE is a conservation biologist, historian, and writer who serves as a senior fellow with both the Aldo Leopold Foundation and the Center for Humans and Nature, and as associate adjunct professor at the University of Wisconsin–Madison. He has written several books, including *Aldo Leopold: His Life and Work* (University of Wisconsin Press, 1988) and *Correction Lines: Essays on Land, Leopold, and Conservation* (Island Press, 2004). He is also the on-screen guide in the documentary film *Green Fire: Aldo Leopold and a Land Ethic for Our Time* (Aldo Leopold Foundation, 2011).

JANICE F. MEISTER received her credentials, degrees, and formal training as an artist from Governor State University, the School of the Art Institute, Saint Xavier University, and the Museum of the Art Institute of Chicago, Prints and Drawings Department (associate preparatory of fine works on paper). She is a retired art educator, a gallery artist of 33 Contemporary Gallery in Chicago (www.33contemporary.com), and a member of See.me International.

JULIE MERIDIAN is an artist and self-taught photographer with a reverent curiosity about the natural world. She is a constant collector of leaves, pods, feathers, insects, and other commonplace wonders, mostly gathered near her home in Evanston, Illinois. Rather than simply documenting these specimens as objects, however, her intention is to explore themes of fragility and endurance, beauty and decay, chance and destiny, life and death. Her work has been widely published and exhibited in local and national solo and group exhibitions. Find out more at www.juliemeridianphotographs.com.

MARIANNA MILHORAT is a Chicago-based filmmaker and artist who originated in Vermont. She received her MFA from the University of Illinois at Chicago in 2012 and BFA from the Mel Hoppenheim School of Cinema at Concordia University in 2007. Working in film, video, and photography, she investigates contemporary relationships to landscape and environment through transformations of space and perspective. Her work has been exhibited internationally at festivals and galleries, including the International Film Festival Rotterdam, the Ann Arbor Film Festival, and the Museum of Contemporary Art, Chicago. Visit her online at mariannamilhorat.com.

PATRICIA MONAGHAN (1946–2012) was a scholar, artist, and activist, as well as a professor of interdisciplinary studies at DePaul University's School for New Learning. She was the author, editor, or coeditor of several nonfiction books, including *The Red-Haired Girl from the Bog: The Landscape of Celtic Myth and Spirit* (New World Library, 2003), *Goddesses in World Culture* (Praeger, 2010), *Brigit, Sun of Womanhood* (Goddess Ink,

2013), and *Encyclopedia of Goddesses and Heroines*, 3rd ed. (New World Library, 2014). Her many books and chapbooks of poetry include *Dancing with Chaos* (Salmon Press, 2002), *Seasons of the Witch: Poetry and Songs to the Goddess*, 3rd ed. (Creatrix Resource Library, 2004), *Homefront* (WordTech Press, 2005), *Sanctuary* (Salmon Press, 2013), and *Mary, A Life in Verse* (Dos Madres Press, 2014). Monaghan was active in the Society of Friends (Quakers) and cofounded both the Association for the Study of Women and Mythology (womenandmyth.org) and the Black Earth Institute (blackearthinstitute.org), the latter of which is dedicated to reforging the links between art and spirit, earth and society.

GARY PAUL NABHAN is a high school dropout who grew up in Gary, Indiana, playing hooky in the Indiana Dunes. He is now an Ecumenical Franciscan Brother and founder of Make Way for Monarchs (makewayformonarchs.org), a pollinator recovery and farmland habitat restoration alliance. Since age eight, when he published his first poem, he used to write a lot, but now he is fasting from words to work on food justice issues. This is the last secular essay he will ever write.

AMY NEWMAN is the author of four collections of poetry, most recently *Dear Editor* (Persea Books, 2011). She is a Presidential Research Professor at Northern Illinois University.

XAVIER NUEZ's photographs have been featured in solo and group exhibitions in museums and galleries internationally, including the Illinois State Museum in Chicago, the Marin Museum of Contemporary Art in California, the San Diego Art Institute, and Galerie Lichtblick in Cologne, Germany. The *New York Times* has called his *Alleys & Ruins* series a "masterpiece." His work is in numerous public, corporate, and private collections, including those of the University of Richmond Museum in Virginia; the Vicente Fox Center of Studies, Library and Museum in Guanajuato, Mexico; Danny DeVito; and Angela Lansbury. His family is from Spain; he was born in Montreal and lives in Chicago. Visit him online at www.nuez.com.

STEPHEN PACKARD is an ecological organizer and entrepreneur who was instrumental in setting up Chicago Wilderness, Friends of the Forest Preserves, the Habitat Project, and Wild Things (a biennial conference "for people and nature"). A book focused on his work credits him with "rediscovering a nearly lost ecosystem" (*Miracle Under the Oaks* by William K. Stevens; Pocket Books, 1995). He is coeditor of *The Tallgrass Restoration Handbook: For Prairies, Savannas, and Woodlands* (Island Press, 1997/2007). As a volunteer steward, he is active at Somme Prairie Grove, the Orland Grassland, Spring Creek Stewards, and Deer Grove East forest preserves. He blogs at vestalgrove.blogspot.com and woodsandprairie.blogspot.com.

JIHA PARK is the daughter of an accomplished fine artist in Korea and was encouraged to express herself though many elements of arts and crafts. After receiving her MFA in fine arts from Kookmin University in Seoul, Korea, in metal craft in 2002, she decided to shift her major from craft to painting. She was invited to America on a scholarship from the School of the Art Institute of Chicago. There she began to produce her abstract fine art, exploring the balance between the conscious and subconscious. She graduated from the School of the Art Institute of Chicago with a BFA degree in painting and drawing in 2011 and currently resides in Chicago, where she maintains an active studio and ambitions for broader expression and education. Visit her online at www.jihapark.com.

ELISE PASCHEN is the author of *Bestiary* (Red Hen Press, 2009); *Infidelities* (Storyline Press, 1996), winner of the Nicholas Roerich Poetry Prize; and *Houses: Coasts* (Sycamore Press, 1985). Her poems have been published in numerous anthologies and magazines, including the *New Republic*, the *Hudson Review*, and the *New Yorker*. She has edited or coedited many anthologies, including *Poetry in Motion* (Norton, 1996) and *Poetry Speaks Expanded* (Sourcebooks, 2007), and teaches in the MFA in Writing Program at the School of the Art Institute of Chicago.

WENDY J. PAULSON's career has been in teaching: in the Boston Public Schools, the Potomac School (VA), Barrington (IL) Public Schools as "The Nature Lady," and as director of education for Citizens for Conservation, a community conservation group. She taught yearlong bird classes in two New York City public schools for eight years through Audubon New York and currently teaches them in Chicago Public Schools. She chairs the Bobolink Foundation and serves on the board or advisory committee of multiple conservation and bird-related organizations, both domestic and international. She is also the former chair of both the Illinois and New York chapters of the Nature Conservancy. She and her husband, Hank, have two grown children and are avid hikers, cyclists, and kayakers.

ARTHUR MELVILLE PEARSON combines his twin passions for art and nature in several ways. As a stained-glass craftsman, his designs are inspired by the native flora and fauna of the Illinois prairie. As director of the Chicago Region Program for the Gaylord and Dorothy Donnelley Foundation, he oversees the foundation's grant-making in both land conservation and artistic vitality. And as an active volunteer at Midewin National Tallgrass Prairie, he chronicles his restoration experiences in *A Midewin Almanac* at midewinrestoration.net.

JOHANNES PLAGEMANN earned his PhD in international relations focusing on international and African politics and is currently a postdoctoral researcher at the German Institute of Global and Area Studies (GIGA) in Hamburg, Germany. After high school in 2002/2003, he volunteered in a soup kitchen run by the Franciscan Outreach Association in Chicago. (Back then, military or an alternative social service was still mandatory in Germany so he chose to volunteer abroad instead.) He learned about the Hubbard Street Mural Project via some flyers in an art store and applied. In school he used to do graffiti and comics and so was thankful for the opportunity to leave something behind in Chicago. The scenery in his painting resembles the back of the Marquard Center in Wicker Park where the soup kitchen was located.

COLLEEN PLUMB, a native Chicagoan and mother of two daughters, teaches in the Photography Department at Columbia College Chicago. Her photographs and videos examine ambivalence toward nature and animals and the complex and contradictory ways they are woven through the fabric of American culture. Her work is held in many collections and has been widely exhibited and published. Her first monograph is titled *Animals Are Outside Today* (Radius Books, 2011), and she is currently working on a video project about elephants in captivity. The questions always on her mind are *From what (or where) do we draw strength and sustenance? Do artificial/mediated forms of nature offer a satisfying substitute for the actual? Where does wilderness begin and end?* Visit her online at www.colleenplumb.com.

MELINDA PRUETT-JONES has pursued her passion for studying animal behavior, in particular birds, through basic and applied research ranging across arctic, tropical, and temperate habitats, including her front and backyards. Positions at the University of California, Field Museum, Brookfield Zoo, and Chicago Wilderness have immersed her in

conservation and connecting people with nature. She currently serves as executive director of the American Ornithologists' Union.

JILL RIDDELL writes essays and articles about nature and the environment and writes the ongoing, serialized novel *Acupuncture after the Apocalypse* for the literary magazine *Trop* (tropmag.com). She is on the faculty of the School of the Art Institute of Chicago, where she teaches in the MFA in Writing program. She has been a museum vice president, the cohost of a podcast on green living, and a newspaper columnist. She lives in Chicago.

ROA is a pseudonym for a Belgian street artist whose large-scale murals of animals and birds appear in urban spaces around the world, including three in Chicago. His subjects are generally native to the area where they are painted. Very little is known about the artist, since he prefers to remain anonymous. Some of his work may be viewed online at roaweb.tumblr.com.

ED ROBERSON has taught at Rutgers University, Columbia College Chicago, and Northwestern University. He received the Shelley Memorial Award from the Poetry Society of America in 2008. Roberson is the author of numerous books of poetry, most recently *To See the Earth Before the End of the World* (Wesleyan University Press, 2010); *The New Wing of the Labyrinth* (Singing Horse Press, 2009); *City Eclogue* (Atelos, 2006); *Atmosphere Conditions* (Sun & Moon Press, 2000), winner of the 2000 National Poetry Award series; and *Voices Cast Out to Talk Us In* (University of Iowa Press, 1995), winner of the 1994 Iowa Poetry Prize.

LISA ROBERTS is an educator, writer, curator, and closet artist. She received her PhD from the University of Chicago, where she researched the history and philosophy of education in museum settings. Much of her work in recent years has centered on developing unorthodox ways to help connect people to the natural world, with a special interest in artistic and technological media. She is the former director of both the Garfield Park Conservatory and the Lincoln Park Conservatory, and previously worked at the Chicago Botanic Garden and the Field Museum of Natural History. In 2006 she founded *naturalia, inc.*, which provides consulting services for museums, gardens, parks, and nonprofit organizations.

JOHN ROGNER is a native midwesterner who currently serves as coordinator of the Upper Midwest and Great Lakes Landscape Conservation Cooperative on behalf of the U.S. Fish & Wildlife Service. For ten years he chaired Chicago Wilderness, a partnership of several hundred metropolitan-based organizations committed to conserving the natural communities of the Chicago region. After-hours you might find him at home, working on reconstructing prairie and oak savanna habitat for city creatures in his suburban yard.

ANDREA FRIEDERICI ROSS is the author of *Let the Lions Roar!: The Evolution of Brookfield Zoo* (Chicago Zoological Society, 1997). She is a regular contributor to the Center for Humans and Nature's *City Creatures* blog, as well as the online literary magazine *Mutterhood*. She is currently working on a book about Edith Rockefeller McCormick.

MOLLY SCHAFER is a Pennsylvanian living in Chicago. If she isn't drawing, she is out hiking the natural areas found throughout the Chicago region. In addition to her fine art work, Schafer is the owner of Feral Pony Illustration (feralpony.com) and is cofounder of the Endangered Species Print Project (endangeredspeciesprintproject.com), which creates limited-edition art prints to raise funds for critically endangered species.

SONNET L. SCHULZ is a homeschooling mother of six and part-time nuclear medicine technologist. She has been enjoying the macro setting on her point-and-shoot camera since 2008. Her joy is to find and capture the beauty in God's smallest creations. You can view some of her work online at www.capturemychicago.com/users/sonnetcnmt.

LEA F. SCHWEITZ teaches theology and philosophy of religion at the Lutheran School of Theology at Chicago and directs the Zygon Center for Religion and Science (www .zygoncenter.org). She pursues interdisciplinary questions about how we envision our humanity through relationships with God, nature, and human communities. She is a thoroughgoing midwesterner and an emerging amateur urban naturalist who loves a long walk along Lake Michigan with her family.

STEVE SEELEY was born in a small town in central Wisconsin in 1979. He was raised on a steady diet of hash browns, comic books, heavy metal, and outdoor adventures. He received his BFA in printmaking from the University of Wisconsin–Stevens Point before moving to Columbus, where he received his MFA from the Ohio State University. He currently resides in Chicago, nourishing himself on the same diet as his childhood, with the exception of "outdoor adventures," which have been replaced by whiskey. Seeley's artwork has been shown in galleries across the United States. He is represented by the Packer Schopf Gallery in Chicago. Outside of fine art, Seeley is also an accomplished comic book writer. Visit him online at www.thedelicatematter.com.

JILL SPEALMAN grew up playing in the creeks and fields paved over by the current Interstate 355. She is the author of several computer books and the chapbook *Musings of a Naturalist Wannabe* (2012). Visit her online at www.wordsmith-inc.com/otherwritings .htm.

ELEANOR SPIESS-FERRIS grew up in northern New Mexico, a place where her imagination ran wild as she explored her family's neglected snarl of an apple/plum orchard. The vegetation and the creatures of that place became a valuable part of her visual language. She has exhibited her work locally, nationally, and internationally, and is represented by Printworks Gallery for her gouaches and Packer Schopf Gallery for her oil painting. Recently she has begun exploring ceramic sculpture and writing short stories. Many of her works can be viewed at www.eleanorspiess-ferris.com.

JYOTI SRIVASTAVA was born and raised in Patna, India, where she earned a master's degree in economics. She worked as a lecturer in economics in Patna and then in Mumbai, India. Since 2001 she has been living in Chicago. Photography has been her passion from childhood, a hobby that has now grown into a profession. Although her photographic subject matter ranges from landscapes to portraits to street photography, she specializes in photographing public art, mostly in Chicago. Her photographs have been published in books, catalogs, magazines, and newspapers in the United States and abroad. You can see some of her photographs online at www.publicartinchicago.com.

DIANA SUDYKA (pronounced *soo-dee-kah*) is an illustrator from Chicago who creates editorial, book, and album art, as well as screen-printed gig posters. Musicians she has created work for include Andrew Bird, the Black Keys, Iron & Wine, and St. Vincent. She has also illustrated several volumes of the award-winning children's book series *The Mysterious Benedict Society* by Trenton Lee Stewart. More recently her work was featured in *Gig Posters Volume 1: Rock Show Art of the 21st Century* (Quirk Books, 2009) and *Illustrators Unlimited: The Essence of Contemporary Illustration* (Gestalten, 2011). A deep interest in natural history influences her work, as well as many forms of traditional folk art. When

she is not working in her studio, she volunteers at the Field Museum of Natural History in the bird lab. More of her work can be seen at her blog, *The Tiny Aviary*. Visit her online at www.dianasudyka.com.

STEVE SULLIVAN is senior curator of urban ecology at the Peggy Notebaert Nature Museum in Chicago. His focus is on connecting people to the nature in their neighborhood. He studies the animals, including the most impactful species—humans—and habitats that are found in anthropogenic environments. His goals are to facilitate sustainable relationships between humans and other species, to maximize urban biodiversity, and help an increasingly urbanized population simply see and be curious about the nature that they are surrounded by. He is the principal investigator of the citizen science initiative Project Squirrel, www.projectsquirrel.org.

ELI SUZUKOVICH III is a postdoctoral fellow in the Psychology Department at Northwestern University and the Urban Ecology coordinator at the American Indian Center in Chicago. He is an anthropologist who focuses on cultural resources management, ethnobiology, ethnohistory, and religion. He was born and raised in Chicago's Uptown neighborhood and has spent his life hiking and wandering through Chicago's urban forests and prairies.

STEPHAN SWANSON has been the director of the Grove National Historic Landmark, Glenview Park District, since the summer of 1979. He graduated from Southern Illinois University with a bachelor's degree in zoology and a master's degree in park and recreation management. He has worked in natural history throughout his life with a passion for and specialty in herpetology, the study of reptiles and amphibians, and has joined zoological expeditions to the Soviet Union (1991), the Russian Commonwealth State (1992), Costa Rica (1993), and Peru (1994 and 1998). Swanson was the first recipient of the 2009 Conservation and Native Landscaping Award by the U.S. Environmental Protection Agency and Chicago Wilderness, and the first recipient of the Excellence in Environmental Leadership Award from the Illinois Association of Park Districts and Illinois Park and Recreation Association.

TONY TASSET lives and works in Chicago. He has become renowned for creating work that satirizes our culture of exhibition and display, whether an institution like a museum or the novelty found in American culture and its commodities. His work reckons with the axiom that how our most esteemed objects are displayed or the ways in which our most cherished narratives are told is crucial in conditioning how our history is understood. He received his BFA at the Art Academy of Cincinnati and his MFA at the School of the Art Institute of Chicago. In 2006 he was awarded a Guggenheim Fellowship. His work is included in many notable private and public collections including the San Francisco Museum of Modern Art, the Museum of Contemporary Art in Chicago, and the Museum für Moderne Kunste in Frankfurt. Tasset was also selected as an artist for the 2014 Whitney Biennial at the Whitney Museum of American Art, New York. For more information visit kavigupta.com/artist/tonytasset.

GAVIN VAN HORN was raised on Oklahoma red dirt and is now a part-time contemplative, full-time dad, dedicated beachcomber, story forager, and urban saunterer. He received his doctorate from the University of Florida, with a specialization in religion and nature. As the director of Cultures of Conservation at the Center for Humans and Nature (www.humansandnature.org), he researches and writes about cultural perceptions of wildlife, sustainable food cultures, and place-based ethics.

MARTHA MODENA VERTREACE-DOODY is Distinguished Professor of English and Poet-in-Residence at Kennedy-King College, Chicago, and a National Endowment for the Arts Fellow. She was twice a fellow at the Hawthornden International Retreat for Writers, Edinburgh, Scotland, where Diehard published *Second Mourning* (1998) and *Light Caught Bending* (1995), each of which won Scottish Arts Council Grants. Her most recent book, *Glacier Fire* (Word Press, 2004), was a winner of the Word Press Poetry Prize.

ANDREW S. YANG explores the dynamics of nature/culture through a transdisciplinary art and research practice. He has a PhD in ecology and evolution from Duke University and an MFA in visual arts from Lesley University College of Art and Design. His artwork has been exhibited internationally, including projects for BankART NYK in Yokohama, Japan and the Worldly House at dOCUMENTA (13) in Kassel, Germany; and his writing and biological research have appeared in journals such as *Current Biology*, *Leonardo*, and *Gastronomica*. He is an associate professor at the School of the Art Institute of Chicago and research associate at the Field Museum of Natural History. Visit him online at www.andrewyang.net.

Artwork Credits

1. Backyard Diversity

Janice F. Meister, *Up Not Out*, mixed media (2011).

Colleen Plumb, *Holding Backyard Chicken*, photograph (2012).

Alma Domínguez, *Consumes mi dolor ... mi muerte (You consume my pain ... my death)*, mixed-media installation (2012); photograph by Michael Tropea.

Mark Crisanti, *Fieldguide*, mixed media (2013); photograph by Paul Crisanti.

Cannon Dill and Brett Flanigan, *Fox*, part of the Art in Public Places project, aerosol and latex paint on concrete (2013); photograph by Joseph Kayne.

Maskull Lasserre, *Murder*, burned wood (2012).

Xavier Nuez, *Asha: jewel of the Nile*, photograph (2003).

2. Neighborhood Associations

Johannes Plagemann, *Chicago Wildlife*, multi-surface paint on wall (2003); photograph by James Prinz.

Hubbard Street Mural Project Volunteers: Local film group, *Birds on a Wire* (2006); Leslie Berish, *City Cow* (2003); Augustina Droze, *A Drop in the Pond* (2008); various community volunteers, *The Ducks* (2002); Ricki Hill, *Endangered Birds* (2004); Chris Jones, *Adam the PO'd Salamander, et al.* (2004); Neil Shapiro, *Wild Life in Chicago* (2004); Leslie Berish, *Snake* (2003); various community volunteers, *Fred's Turtles* (2002). All murals multi-surface paint on wall. All photographs by James Prinz.

Brooke Collins, *Noble Horse Stables*, photograph (1998).

Kyle Gati, *Rooftop Beekeeping*, photograph (2013).

Camilo Cumpian, *DH + BH*, tattoo (2014); photograph by Harrison Fried.

Alma Domínguez, *Y ora pa onde chingaos*, acrylic paint on paper (2010).

Alma Domínguez, *Aquí se hace tarde demasiado temprano*, acrylic paint on paper (2009).

ROA, facilitated by Pawn Works, *Ferrets*, spray paint on concrete (2011); photograph by Joseph Kayne.

Brooks Blair Golden, *Owl*, part of the Art in Public Places project, acrylic and spray paint on concrete (2012); photograph by Lisa Roberts.

Xavier Nuez, *Nikki: (hiphop) dancing queen*, photograph (2012).

Joseph Kayne, *The Boarding Stable*, photograph (2012).

3. Animals on Display

Gregory J. Auberry, *Dolphins at Play*, photograph (2012).

Carlos Ernesto Uribe Cardozo, *Puma*, photograph (2009).

Colleen Plumb, *Bushman, Field Museum*, photograph (2013).

Peggy Macnamara, *Specimens*, watercolor (2014); *Snowy Owl*, watercolor (2014); *Herons Fishing*, watercolor (2013); *Heron Migration*, watercolor (2006); *Heron Nests*, watercolor (2007); *Multiple Nests*, watercolor (2007); *Kiwi and Egg*, watercolor (2006); *Specimens and Eggs*, watercolor (2014); *Specimens and Insects*, watercolor (2014); *Collection Monitors*, watercolor (2014); *Frogs/Amphibians*, watercolor (2014); *Kingfisher and Jar*, watercolor (2013); *Specimens and Skulls*, watercolor (2014).

Colleen Plumb, *Chicago Mammals, Field Museum*, photograph (2014).

Sonnet L. Schulz, *Happy Birthday*, photograph (2010).

Benn Colker, *Six Sketches at the Field Museum*, pencil on paper (1998–2010).

Terry Evans, *Field Museum, Drawer of Bluebirds*, photograph (2000); *Field Museum, Drawer of Cardinals*, photograph (2001); *Field Museum, Drawer of Meadowlarks*, photograph (2001).

4. Connecting Threads

Ryan Hodgson-Rigsbee, *Flock*, photograph (2012).

Diana Sudyka, *Birds Spotted While Hiking Wooded Isle, Hyde Park, Illinois*, gouache watercolor painting (2012).

Michelle Kogan, *Wildlife Comes to Lake Shore Drive, Endangered Species*, watercolor paints and pencils (2013).

Blake Lenoir, *Massasauga Rattlesnake*, colored pencil on paper (2011).

Julie Meridian, *Snake 2*, archival pigment print (2006).

Julie Meridian, *Butterfly Collection*, archival pigment print (2007).

Arthur Melville Pearson, *Untitled*, stained glass and photograph (2010).

Sharon Bladholm, single bronze medallion from *Soil: Alive with Life* (2011); photograph by Gregg Woodward.

Sharon Bladholm, *Soil: Alive with Life*, bronze-filled resin cast (2011); photographs by Scott Becker and Gregg Woodward.

Alex Chitty, *The Indomitable Water Bear*, zine (2009).

Jiha Park, *Extinct Animal Series: Schomburgk's Deer, Golden Toad, and Pink-Headed Duck*, mixed media (2010).

5. Water Worlds

Ryan Hodgson-Rigsbee, *Stroll*, photograph (2010).

Colleen Plumb, *Alewives*, mixed media (1999).

René H. Arceo, *Pescado Blanco en Río Chicago (White Fish in Chicago River)*, linocut print (2003).

Kim Laurel, *Heavy Water*, mixed media (2011).

Ellen Lanyon, *Riverwalk Gateway, the South Branch of the River*, ceramic tile mural (2000); photograph by James Prinz.

Ellen Lanyon, *Riverwalk Gateway*, ceramic tile mural (2000); photograph by James Prinz.

Eleanor Spiess-Ferris, *Pond Reflection*, gouache (2008).

Eleanor Spiess-Ferris, *Flood*, gouache (2008).

Ryan Hodgson-Rigsbee, *Bubbly Creek*, photograph (2011).

6. Coming Home to the City

Molly Schafer, *Untitled*, watercolor on paper (2013).

Hector Duarte, *Desenredando Fronteras (Unraveling Borders)*, acrylic on canvas (2009). Photograph courtesy of National Museum of Mexican Art.

Tony Tasset, *Eye and Cardinal*, street banners (2010); photograph by Jyoti Srivastava.

Diana Sudyka, *Monk Parakeet Colony*, gouache watercolor painting (2013).

Jyoti Srivastava, *Flock of Pigeons*, photograph (2007).

Andrew S. Yang and the Small Science Collective, *Pigeon!*, zine (2009).

Ryan Hodgson-Rigsbee, *Care Bare*, photograph (2010).

Ryan Hodgson-Rigsbee, *Nature Calls*, photograph (2010).

Steve Seeley, *Untitled (I Promise to Forget You)*, acrylic on paper (2007).

Nikki Jarecki, *Wolf with Birds*, watercolor on paper (2010).

Blake Lenoir, *Indiana Dunes*, colored pencil on paper (2010).

Index

Note: Page numbers in *italics* indicate artworks.

perch (fish), 248, 274, 280

performance, animal, *130*

pesticide, 183, 280

pet, 15–16, 48, 55–61, 91, 120, 135, 208, 255, 328; death of, 34–42, 172; as predator, 59, 61, 87; trade, 297–98, 306; vs. food animals, 25. *See also* cat; dog; parakeet; skunk

pheasant, ringneck, *159, 161*

photographing animals, 69, 154, 191–92, 205

pig, *24, 46, 87, 127, 264*

pigeon, 4, 46, 60, 68, 71, 91–92, 93, 190, 306, *309,* 310–11, *312;* passenger, 57, 132, 181, 214, 349, 356

pigeon man, 310–11, *312*

Pilsen, 265, 267

play, 26, 30–31, 46, 55, 94, 98, 168–74, *320;* of animals, 55, 94, 98

polecat, 314, 315

Polish American, 313–19

pollination, 200–205

pollution, 7, 204, 246, 248, 249, 263, 264–65, 267–68, 278–80

Potawatomi, 113, 211, 278, 316, 319

prairie, 5, 7, 30, 59, 155, 188, 189, 193, 198, 203, 204, 206, 208, 209, 210, 211, 213, 236–37, 257, 260, 269, 277, 278–79, 282, 283, 285, 334, 338, 339; restoration, 48, 106–12, 200–206, 335, 337, 340

prairie chicken, 214

Project Squirrel, 84–85, 88, 364

puffin, *166*

puma, *138,* 315

pumpkinseed (fish), 274

quail, 28, *151*

Quaker parrot. *See* parakeet, monk

Rabb, George, 143

rabbit, 17, 24–25, 47, 87, 106, 111, 133, 314, *342;* as prey, 77, 324–25, 329, 332

raccoon, 41, 46, 47, 51, 86, 110, *156,* 208, 236, 255, 332

rail (bird), 182–83, 259, 283

railroad, 7, 81, 267, 278, 292–93, 299, 334, 336

Rainbow Beach Dunes, 193

rat, 4, *290*

rattlesnake, *80,* 85; massasauga, *207,* 208–14

recolonization, 325

reconciliation ecology, 6

recreation, outdoor, 118, 265–71

reindeer, *166*

reintroduction. *See* restoration ecology

religion and animals, 16–21, 24–25, 45–49, 98, 100. *See also* soul

reptile, 155, 213. *See also* lizard; rattlesnake; snake; turtle

rescue, animal, 95–96, 162, 180, 303–4. *See also* wildlife rehabilitation

responsibility. *See* ethics, animal

restoration ecology, 6, 8, 46, 48, 106–12, 122, 188–89, 198–206, 271, 283–85, 335, 337, 339–40

rhinoceros, 84, *166,* 167

rice, wild, 67–68, 71, 108, 279

river. *See under name of specific river*

River Trail Nature Center, 209–10, 212–13

roadkill, 318, 323

robin, xi, 35, 58, 109, 150, 322

rodent, 82–84, 192, 325, 329. *See also under common names of species*

rooftop, *90,* 92, 193

Roosevelt University, 265

sacrifice, 20, 24–25

salmon, 18, 249

San Francisco, 26, 247

sapsucker, 193

savanna, oak, 7, 87, 112, 117, 201, 204, 206, 278, 338

scaup, lesser, 191, 285

Schaumburg, 327, 328

Schieffelin, Eugene, 57–58

Schiller Woods, 181, 198, 200, 202, 203

Schomburgk's deer, *240*

science: citizen, 6, 8, 85, 198–206, 256–61, 284; Native, 106–13

seagull, 40, 79, 150, 184, 185, 191, 196

seal, 133–34, 140

sea lion, 133–34, 136

Shedd Aquarium, 154, 188, 244

sheep, *17, 56, 24, 264*

shrike, northern, 189

silphium, 337–38, 340

skeleton, 147, *151,* 155, *159, 161, 163,* 181

skunk, 208, 313–19

Smart Museum of Art, 220

snake, 28, 31, 47, 170, 173, 208–14, *215,* 342. *See also* rattlesnake

soil animals, 31, 122, 225–32, 233–34, 235, 317, 318